Effie

✳

[Handwritten journal entry in cursive, largely illegible]

Extract from Effie's personal journal, describing
'The Blind Girl', 1856, Private Collection.

The Passionate Lives of Effie Gray,
John Ruskin and John Everett Millais

Suzanne Fagence Cooper

St. Martin's Griffin
New York

www.stmartins.com

The Library of Congress has cataloged the hardcover edition as follows:

Cooper, Suzanne Fagence.
 Effie : the passionate lives of Effie Gray, John Ruskin and John Everett Millais / Suzanne Fagence Cooper.—1st U.S. ed.
 p. cm.
 Includes bibliographical references and index.
 ISBN 978-0-312-58173-2
 1. Ruskin, John, 1819–1900—Friends and associates. 2. Millais, Euphemia Chalmers Gray, Lady, 1828–1897. 3. Millais, John Everett, Sir, 1829–1896. 4. Authors, English—19th century—Biography. 5. Socialites—Great Britain—Biography. 6. Art critics—Great Britain—Biography. I. Title.
 PR5263.C78 2011
 700.92'2—dc22
 [B]

 2011005080

ISBN 978-1-250-01625-6 (trade paperback)

First published in Great Britain by Duckworth Overlook

P1

Contents

For Effie's parents and mine: without them, this tale would never have been told.

Illustrations

(between pages 84 and 85)

(between pages 180 and 181)

ix

Acknowledgments

Anyone who is interested in Effie Gray owes a great debt of gratitude to Mary Lutyens. She edited and published Effie's letters for the years of her marriage to John Ruskin in *Effie in Venice* (1965), *Millais and the Ruskins* (1967) and *The Ruskins and the Grays* (1972). Mary Lutyens's scholarship provided the essential groundwork for my attempts to reveal Effie's story to a new generation. However, Lutyens's account stopped at the moment Effie married again. I wanted to look beyond 1855, to see what happened next, in the forty years of her life with John Everett Millais.

In January 2009 Sir Geoffroy Millais generously agreed to lend a substantial portion of the family's papers to the Tate Gallery Archive. For the first time in a century, Effie's letters from her father and mother, her sisters and her children could be seen by someone outside the family. I was given privileged access to these papers. This correspondence has never been made available to historians before; it is a remarkable collection, full of drama and detail. Fifteen bulging brown-paper packages were handed over to me by Adrian Glew, archivist at Tate Britain. They contained thousands of letters, dating from Effie's schooldays right up to her death. I am grateful to Adrian and his colleagues for their patience and good humour, as they helped me to work through the unwieldy bundles.

My archival research has also taken me to the Ruskin Library at Lancaster University. I would like thank Stephen Wildman, Rebecca Patterson and their colleagues who have always been ready to answer my questions and offer advice. Later, when I visited the Morgan Library and Museum in New York, the staff were very welcoming and helpful.

I count myself lucky that I have been able to call on the expertise of many colleagues and friends while trying to unravel some knotty problems. I am grateful for the support I have been given by Jan Marsh; Christina Bashford; Simon Shaw-Miller; Kirsteen Nixon at the Florence Nightingale Museum;

Sonia Hope at the Women's Library; The Zambia High Commission, Steve Grindlay; Sarah Colegrave; Greg Wise; the online community of academics and enthusiasts who subscribe to the Gaskell and Victoria lists; and Chilcott Auctioneers. My research has also been made far more enjoyable thanks to the help I have received from Effie's own family. I am particularly indebted to Julian James, Roger Bowdler and Peter Dolphin for their assistance.

This book was championed at Duckworth by Mary Morris. She believed in the subject, and in the author. I hope she will be proved right. I am grateful to Mary, and to my editor Tracy Carns and copy-editor Richard Dawes, for their help in turning my ideas into something concrete. Ray Davies has also been an ally, pulling the book into shape. And I could not have got this far without the encouragement of my agent, Jonathan Conway. I trust this will be the start of a long and fruitful relationship.

Closer to home, I am sure my friends and neighbours will be delighted to hear that the writing is finished. They have followed Effie's journey every step of the way. Viv and Steve Jackson, Amelia McNair, Ulrike Wray, Anna Gawthorp, Hazel Grant, Penny Kramer, Jonathan Fagence and the village book group all deserve a special mention. I have also called on the erudition and sympathy of good friends from Oxford days, including Clare Griffiths, Susan Skedd and Matthew Grimley. Julia Yates and Elizabeth Player have listened and laughed, and we remain 'ever the best of friends'.

Reading Effie's letters, it becomes clear that her story is really the story of her family. She knew she could rely on her parents. That is what gave her the strength to leave Ruskin and start a new life with Millais. In due course her parents, George and Sophia Gray, kept open house at Bowerswell for their grandchildren. The family home was always alive with chatter and music. The bond between the three generations was affectionate and enduring, stretching over decades and across continents. So this book is, at least in part, a celebration of the love between grandparents and grandchildren. I know it would never have been written without the unfailing generosity and kindness of my own parents.

And now I come to John: thank you for keeping the faith, and for giving me the very best gifts in the world – our two beloved daughters, wise and beautiful Rosalind, and Beatrice, who has taught me cheerfulness and the art of storytelling. May you both live happily ever after.

Chapter One

Spring: 1854

THE MORNING of Tuesday, 25 April 1854 was achingly cold. Effie said goodbye to her husband, John Ruskin, for the last time on the platform at King's Cross Station. Then he helped her into the train. Taking a seat beside her sister, Sophy, she avoided his eye, preoccupied with arranging the cage of her crinoline in the cramped compartment. Effie hoped never to see him again. For a man who had made his name as a visionary critic of modern art, John Ruskin could be remarkably blinkered. His attention was focused on pictures, not people. He was anxious to get back to his parents' house and his books, and noticed nothing unusual in Effie's strained appearance. It had become her habit.

The temperature had dropped the previous night. As Effie's train headed north, John drove south to the suburb of Denmark Hill, where his father was fretting about frost damage to his pear trees.

Leaving London behind, Effie removed her gloves and slipped off her wedding ring. She tucked it inside an envelope addressed to her mother-in-law, together with her house keys and account book. Ten-year-old Sophy was bewildered. She had witnessed her sister's misery during the past months. But Effie had not dared tell her how this journey would end. As far as Sophy knew, Effie was going home to Scotland for a holiday, while John and his parents travelled to Switzerland. Effie did not have much time to explain. Just after ten o'clock the train was due to stop for a few minutes at Hitchin, where her father and mother were waiting. Effie could see them on the platform as they drew into the station. She gave her sister a hurried kiss, then Sophy jumped down to join their father. Effie's mother took her place in the carriage beside Effie. Her father reached up to receive the envelope containing her wedding ring. Effie asked him to post it, together with a few notes addressed to her closest friends. A handful of them knew her plans. She hoped they would defend her actions in her absence. Effie knew that London society would be

1

scandalised by her decision to leave John Ruskin. His writings had made him something of a celebrity. Ever since the summer of 1843, when he had published his tribute to Turner in *Modern Painters*, he had been the most admired art critic of his generation. When Charlotte Brontë had read his words she had exclaimed, 'I feel now as if I had been walking blindfold – this book seems to give me eyes.' Elizabeth Barrett Browning agreed. She thought John Ruskin was 'no ordinary man'. He was inspirational, he was brilliant, he was invited to all the best parties, and he had a handsome private income. So why was Effie running away?

Effie and her mother had a long journey before them, changing at Edinburgh for Perth. They did not expect to be on the road home to Bowerswell until well after midnight. It gave them ample time to mull over the six years of Effie's marriage. Mrs Gray could see the expression of pain above Effie's eyebrows, a twitch that marred her daughter's fine features. She had known from Effie's increasingly disjointed letters that her relationship with the Ruskins was deteriorating. But it was not until early March that the Grays had discovered the secret of Effie's distress. John had refused to consummate their marriage. Writing on 6 March 1854, Effie had entreated her parents to help her escape from this unnatural relationship. In this letter she claimed that John believed she was unfit to be a mother as 'if I was not very *wicked* I was at least insane'. No wonder she was often ill. Effie was only twenty-five, but living a lie had left her exhausted.[1]

Shocked but uncertain how to proceed, Mr and Mrs Gray had dithered for several weeks before deciding to come to London. Her father was unsure whether to confront John directly or seek legal advice about Effie's position: in law, an unconsummated marriage was no marriage at all. The Grays eventually arrived by steamer from Dundee on Good Friday, 14 April. Effie had not told the Ruskins of her parents' arrival, for fear that they would draw the two families into a pointless and poisonous argument. She had already warned her father that old Mr Ruskin would not hesitate to resort to underhand tactics if he thought his family name would be dishonoured. Worse still, if John got wind of her complaints, he might force her to consummate the marriage. Then she would have no hope of escape. She could not divorce him.

The 1850s were a time of upheaval in the laws governing marriage. Effie's story was part of a wider shift in women's roles and expectations. Women as

well as men were benefiting from an information revolution; the arrival of the electric telegraph, the popular press and a daily postal service meant that this generation had an unprecedented view of the world. The old certainties were wearing thin as in London, Leeds and Glasgow women and men rubbed shoulders with people of all classes and many nations. The pace of life was quickening. Effie and her contemporaries felt the buzz of modernity.

The Queen herself drew attention to the novelties and paradoxes of the Victorian age. She showed up the shortcomings of gender stereotyping. Victoria was a wife and mother, as well as Sovereign. Her authority over her nation and her growing empire could have a beneficial effect for other women. They might look beyond the home and the family and see the potential for a wider sphere of influence. As an ambitious wife, Effie had hoped to use her social skills to promote her husband's career, but her talents were stifled by the conventions of an older generation, and she had found herself trapped in a loveless marriage.

In England before 1857, a divorce could only be granted by a special Act of Parliament. It was a costly and time-consuming business. In an open letter to the Queen, published in 1855, the poet Caroline Norton drew attention to the impossible position of women like herself, who wanted to end an abusive marriage. Her account is sobering: an English wife had no property of her own, not even her clothes or jewellery. She could not make a will. If she left her husband, he could bring her home by force. She could sue him for cruelty, but only if he 'endangered life and limb'. If she went back to him, she could not complain if he beat her again, as she had 'condoned' his actions. It was the same with adultery. If she forgave her philandering husband once, she had no legal redress. As a husband was not bound to pay maintenance, a wife often could not afford to leave the marital home, however badly she was treated. According to Mrs Norton, during Victoria's reign only four women had been granted a divorce in order to marry again. In two of those cases the husband had been guilty of incest.

How did the law apply in Effie's case? If John compelled her to fulfil her conjugal duties, there was nothing she could do. Husbands might rape their wives with impunity. As she had been married in Scotland, she was a little better protected in some ways than her English friends. A Scottish wife could defend herself against accusations of infidelity, could demand financial support, and her clothes and 'paraphernalia' belonged to her. However, she could

still only sue for a divorce on the grounds of her husband's infidelity or desertion, and John was guilty of neither. Effie had two options. She could simply leave John, in the hope that he would let her return to her parents' house, or she could seek an annulment and face the indignities of a court case, a messy and intrusive business. If she chose this second course, Effie would need to be examined by doctors to prove that, after sharing John's bed for six years, she was still a virgin. And how would she defend herself against her husband's accusations that she was mentally unstable? John was known to make notes of her mood swings, and some of her recent letters had verged on the hysterical. Effie discussed these difficulties with her parents over the Easter weekend, and they came to the conclusion that they would have to take John Ruskin to court and sue for an annulment. On Monday afternoon she wrote to a friend: 'Papa is quite hopeful about my case, having found a similar one decided last year. The Ruskins have not a suspicion.' She was keenly aware of the hard road ahead, ending the letter: 'Dear friend if I never see you again, God bless and prosper all your undertakings.'²

Effie could have just walked away from the marriage. It seems that her husband hoped she would. In her final letter to her mother-in-law, she revealed how John had threatened to break her spirit and force her to return to her parents. He claimed she bored him. However, it was a shock when Effie refused to go quietly.

Effie could not admit to John's mother the real reason she was pushing for an annulment. She could hardly admit it even to herself. But her friends and family were urging her to expose the sham of this 'pretended marriage' in the hope that she would marry again. They already had someone in mind; her affection for the young artist John Everett Millais was understood by those who knew her best.

Everett Millais was not the first to have fallen in love with the young Mrs Ruskin. Elegant, entertaining and light on her feet, she was much in demand at dinners and dances. In the early days of their marriage Effie had many admirers, and John positively encouraged her social success. From his point of view, if she was invited out for supper or to the theatre, he had more space to write. He had even reassured her parents when, in 1852, some gossip had reached their ears about her friendship with Clare Ford, 'a sort of man about Town'. John had praised her shrewdness in detecting the slightest impropriety. He even suggested that she was more likely to be labelled a prude than a

flirt. He believed that, under Effie's influence, Ford had become more responsible; she had already persuaded him to give up the high life and move to a quiet job in the country instead.

Effie's ability to attract young men did not always have such positive results. On a visit she made to Verona two Austrian officers fought a duel over who should dance with her. One was left nursing a severe sabre wound. Effie treated it as a joke, saying it was absurd how 'these young men think as little of Duelling as they do of smoking a cigar'. However, as her relationship with her husband began to unravel, her desire to walk the tightrope between friendship and flirtation became increasingly risky.

At the critical moment in their marriage, John decided to champion a group of rebellious young artists who called themselves the Pre-Raphaelite Brotherhood. He approved of their attempts to paint with innocent eyes, going to nature 'in all singleness of heart', as he had suggested in *Modern Painters*, 'selecting nothing, rejecting nothing and scorning nothing'. It seemed that this band of artistic brothers had responded to his rallying call. John asked the most precociously talented of the Brotherhood, John Everett Millais, to join them on holiday. As both Ruskin and the handsome young artist were christened John, Effie took to calling Millais by his middle name, Everett. My account of their story will follow this family tradition.

In July 1853 Everett and the Ruskins rented a cottage near Glenfinlas in Perthshire. John wanted Everett to paint him there, choosing a 'lovely piece of worn rock, with foaming water, and weeds, and moss, and a noble overhanging bank of dark crag' as a backdrop. It was to be the archetypal Pre-Raphaelite picture, a detailed study of natural forms combined with a portrait of the art movement's most vocal supporter. But Everett also made numerous sketches of Effie. He painted her sitting beside a waterfall, or quietly sewing, with foxgloves tucked into her hair. He also helped Effie with her own drawings, took long walks with her in the evenings and sheltered with her under a shawl, waiting for the rain to stop. She read Dante to him and even cut his hair.

That summer Everett was well placed to see the cracks in the Ruskins' marriage: the cottage they all shared was tiny. John slept on the sofa, while Effie and Everett each had their own little closet, five feet by seven, to sleep and dress in. Everett was over six feet tall, and in a bedroom 'not much larger than a snuffbox' he claimed he could open the window, shut the door and

shave, all without getting out of bed. Despite the discomfort, he chose to stay close to Effie rather than sleep at the inn with other members of their party. As he admitted to a friend, 'these chilling mountains make one love little soft, warm, breathing bodies'.

After returning to London in the autumn, Everett became increasingly troubled by what he had seen that summer. He began to fear that John Ruskin was 'a plotting and scheming fellow' who had deliberately left him alone with Effie to force her into a compromising position. Before long, Effie was also worrying that her husband was deliberately trying to get her into a 'scrape'. By Christmas, Everett had decided that he should warn Effie's mother about 'the *wretchedness* of her position'. Writing to her on 19 December 1853, he complained of John's selfishness and the way he constantly pointed out his wife's shortcomings. In his haste to catch the post that night Everett let something slip: he knew why Effie was so unhappy. She had already told him the secret of her failed marriage.

So Effie became the heroine of a great Victorian love story. Her life reads like a novel, full of colour, sensation, despair and romance. Her first husband was a damaged genius, her second a handsome rebel. We can chart her journey in every detail, thanks to a vast collection of correspondence treasured by her family since her death. Fifteen bulging parcels of letters, tied up in brown paper and string, were lent to the Tate Archive in 2009. Inside the wrappings lay the raw material for this book. It was a biographer's dream. In the coming chapters, every landscape, every tête-à-tête, every ball gown, is drawn from these astonishing original sources. There has been no need to make anything up, or to embroider the facts. It was all there, down to the last ribbon, waiting to be discovered in the archives.

We hear Effie's voice directly. She writes several times a week to her parents, telling them about her highs and lows. Through the letters we learn about her travels, the sights and smells of her home, her dance partners, her miserable marriage. And later she describes her hopes for the future with Everett and the daily struggles of motherhood. We also hear the other side of the conversation. The tales told by her father guide us through Effie's world, as he keeps her up to date with family news. Sometimes George Gray sounds like Mr Bennet in *Pride and Prejudice*, escaping to his study to avoid the fallout from his daughters' love affairs. Mrs Gray's letters are harder to

decipher. Her handwriting is rapid and spidery. Effie's mother held on to an old habit from before the days of the penny post: to save paper she crossed her letters, writing first in one direction, then when she had filled up the sheet, turning the paper through ninety degrees and adding more lines. Her notes become networks of overlapping words. Trying to read through one layer to reach the other can be almost impossible. It makes us remember that they were written for Effie's eyes and not for ours. But almost miraculously, when we most need to hear her version of events, Mrs Gray's handwriting suddenly becomes legible. From her accounts, we can piece together for the first time the tragic story of Sophy, Effie's sister, and discover why this young girl haunted Everett's art.

Of course there are gaps and mysteries. The letters offer only glimpses of Effie's life, like parts of a jigsaw puzzle that have to be fitted together. But section by section we build up a picture of the past. Sudden snapshots – the look on John Ruskin's face as he falls in a haystack, or Everett's voice as he reads Keats aloud one wet afternoon – add light and shadow. Occasionally we find a message that does not slide neatly into place. Who was the girl who signed herself 'AE', writing to Effie in the dead of night, asking for news of a lover? She said she 'thought of Effie while she read under a Plane tree on Sunday afternoon'. We never find out.

There is also the problem of knowing how the story ends. When Effie boarded her train in the spring of 1854, she had no idea what would happen next. Winning her case against John Ruskin was not guaranteed. There was nothing inevitable about her marriage to Everett. She might have gone back to Bowerswell and disappeared for ever from the public stage. We can look forward to the next part of her life, but for Effie it was a terrible leap of faith. There is another downside to the historian's gaze. We spend a lot of time with Effie's family. In particular, we grow to love her father through his letters, enjoying his humour, admiring his humanity. And yet we see the diminishing pile of correspondence in the parcel. We know he will die in January 1877. Mr Gray feared the end was coming, writing to his daughter that he knew no one could 'lengthen his days artificially'. Still, he was not quite ready to go when he did.

The letters and diaries allow us to walk with Effie, observing sixty years of Victorian life through her eyes. She is good company, a witty fellow traveller through Victoria's world. It is a pleasure to overhear her dinner-party

conversation, or picnic with her by a Scottish mountain stream. She is also a witness to an extraordinary time of upheaval. The teeming city of London is her home for most of her adult life. This place is the focus of world attention, the site of spectacular events like the Great Exhibition of 1851, and Effie is right there to give us her impressions. But she is not just a witness; she is also an agent of change. Her own actions in leaving John Ruskin mark her out as a woman who is willing to defy expectations. She helps to reshape Victorian femininity.

Effie was only one woman among millions, but she showed that it was possible to regain control of her life. With the help of a supportive family, she refused to remain in an increasingly abusive relationship. She suffered physically and mentally, but was able to rebuild her self-esteem in a successful second marriage. While Everett painted, she was in charge of domestic arrangements – running the household, organising parties, managing correspondence. Together they made a great team. His virtuosic technique and 'manly' personality combined with her charm and organisational skills to create a flourishing artistic practice.

Victorian art was a serious business, and Everett and Effie were in the vanguard of a revolution that transformed the status of artists. Until the mid-nineteenth century, most painters hovered on the margins of polite society. Even J.M.W. Turner, the greatest living artist of the 1840s, lived in a house that was unheated, bare and miserly. Effie was shocked by the squalor when she visited him in 1848. Compare this with Everett's studio-home, described in 1881 as a bright and substantial palace. Effie expected to entertain in style. Her social respectability was reinforced in 1885 when the Queen made Everett a baronet. This was an unprecedented honour for an artist.

Perhaps Effie's legacy is best seen in the lives of her sisters and daughters. It is their faces that gaze out at us from Everett's most haunting paintings. They embodied Victorian society's fears about female sexuality and freedom. But their generation also reaped the benefits of Effie's own step into the unknown in the spring of 1854. These young girls grew up in a world where women could begin to choose for themselves. For the first time they could hop on a bus or cycle to work. They might go to university, or train to become doctors. They could even become professional artists, breaking into the masculine stronghold of the Royal Academy schools. Effie never intended to be a pioneer. In fact she fought hard to rebuild her own respectable reputation

and defy her critics. But whether she liked it or not, she gave hope to countless women who had suffered silently.

When Gladstone was once asked about Effie's story, he replied, 'Should you ever hear anyone blame Millais, or his wife, or Mr Ruskin, remember there was no fault. There was misfortune, even tragedy: but all three were perfectly blameless.' It is time to find out if the Prime Minister was right.[3]

Chapter Two

Bright Eyes: Effie's childhood

AY 7TH 1841. Spring sunshine warmed the schoolroom. Through the open windows came the sound of birdsong and the splash of oars from boating parties on the river. Effie lifted her head from her books and, catching the eye of Lizzie Cockburn, she struggled to suppress a smile. The two girls had been scolded by Miss Byerley for talking too much in Scots, and moved to separate desks. Their parents had sent them to school in Stratford-upon-Avon to learn to be ladies, not to giggle and gabble as they did at home.

At one end of the great room, Miss Ainsworth had gathered the older girls around a pair of globes. At the other end, the little ones were stumbling through the Kings and Queens of England. Across the hall, Monsieur Flavet's pupil was practising arpeggios on the piano. Meanwhile Effie's class were preparing for their lesson with Mademoiselle Smith, their pens scratching as they copied lists of verbs. Effie was usually quick at French, but this morning she found it hard to concentrate. She felt hot and itchy in her woollen dress. She longed to escape across the lawn to the summerhouse, where she could chatter with her friends. Today was her thirteenth birthday.

Back home in Perthshire, Effie's parents recalled the bright spring day in 1828 when their daughter was born. George and Sophia Gray had then been married for less than a year. George Gray had been woken by his wife at three o'clock in the morning. He had sent a servant for Dr Cleland and then retreated to the garden, walking in the orchard as dawn broke. Even at this distance he could hear Sophia's muffled cries. Was she strong enough bear the trial of childbirth? The household had waited anxiously for news, aware of the dangers facing the young mother and her baby. They had all heard tales of exhausted women whose bleeding could not be staunched, and tiny lives that flickered out after a few hours. But when the 'young stranger' arrived, the doctor had declared her to be the most beautiful baby he had ever seen. All was well.[4]

11

Sophia's daughter was christened Euphemia Chalmers Gray. Her family called her Phemy. (It was not until she was a teenager that she became known as Effie, and that was John Ruskin's nickname for her.) The little girl grew up at Bowerswell, a Regency villa overlooking the city of Perth. Her brother George was born in the autumn of 1829, followed in March 1831 by baby Andrew. He was named after Sophia Gray's father, Andrew Jameson, a successful lawyer. Until Andrew arrived, there had been no shadow of sadness in the Gray family. Effie's father prospered in law and banking, and Sophia was able to keep in close touch with her own kin. But in November 1831 little Andrew died at barely six months old. Andrew was the first of the Gray children to die young, and we do not know why he faded away. Over the next twenty-three years Sophia carried twelve more babies; her youngest, Everett, was born when she was forty-seven. Sadly, only eight survived childhood. All the bairns born between 1831 and 1842 died before their seventh birthday.

The number of Gray children who died young was unusual even by Victorian standards. Living on the outskirts of Perth, they should have been healthier than babies born in Glasgow or Edinburgh. Urban death rates were thirty per cent higher than in the countryside. At the start of Victoria's reign, two in every ten babies were expected to die in their first year. Those who survived ran the gauntlet of numerous childhood diseases and dangers: about a quarter of children died before their tenth birthday, although girls were more likely to live to their teens than boys. Still, the Grays would never have expected to lose seven out of their fifteen children.

Nineteenth-century advice manuals like Mrs Pedley's *Infant Nursing and the Management of Young Children* outlined the risks that small children faced even in the most orderly households, from scalds, burns and falls, to stings and accidental poisoning. Teething was a perilous time. According to Mrs Pedley, around sixteen per cent of infant deaths were caused by parents and practitioners trying to ease the pain of teething. Popular cures included syrup of poppies, purgatives and lancing the gums. Mrs Beeton, in her *Book of Household Management*, favoured this last method. She advised that cutting through a baby's gums could 'snatch the child from the grasp of death'. She did not take into account the increased chances of blood poisoning caused by this treatment.

Parents also had to deal with the threat of childhood illnesses. Whooping cough was the biggest killer of toddlers, followed by measles. When they were

a little older, epidemics of scarlet fever carried off more children than any other disease. Outbreaks of summer diarrhoea were feared by families in larger towns and cities. Diagnosis was often difficult: whooping cough could be mistaken for croup, and small patients sometimes went down so quickly that by the time the doctor arrived it was too late. Even with medical help, treating these diseases was hit-and-miss. Many remedies, like Dr Collis Browne's Chlorodyne, based on opium and cannabis, were addictive and did more harm than good. Some housewives concocted their own versions, following instructions in their recipe books: half a pound of sliced opium mixed with verjuice, nutmeg, saffron, sugar and yeast, they were told, produced a useful liquor for common ailments.[5]

Unfortunately we know very little about the Grays' lost children, and how they lived and died. It is possible that their deaths influenced the Grays' decision to rebuild the house at Bowerswell in 1842. Perhaps they came to the conclusion that the old house was unhealthy. Later letters show that George Gray fussed about the drains in the new house. But it is frustratingly hard to piece together a coherent picture of the family's desperate attempts to keep their little ones alive, the frantic messages, the weeping. None of this survives. The letters are strangely silent about the details of their deaths. We have no record of how the Grays coped with the pain of losing a well-loved child. When Sophia Gray received a note from her brother in November 1831, less than a week after baby Andrew had died, there was no mention of his last illness or her grief. Instead the focus was on the surviving children: 'give Phemy and George a sweet kissy for me, and tell Phemy that I'll tell her a story about a little lad and lassie'.

The Gray children flit across the pages of the family letters, appearing only briefly, but vividly. We can read Sophia's messages to her husband, away on a business trip to New York, reassuring him that their little boys are thriving. Thanks to her, we can see them running around the kitchen table, little Robert (born 1842) trying to catch his elder brother. Sophia was relieved that her youngest boy had come through the pain of teething. They were all in perfect health, she said, as firm as could be. But it is difficult now to read these loving letters, lodged safely in the archives. Unlike Sophia and George Gray, we know that these sons did not grow up. One died when he was nearly five years old, the other shortly before his seventh birthday.

Very few letters dealing with these difficult times have found their way into

the files. A brief note dates from November 1844, when the second Andrew, born in 1840, was dangerously ill. Sophia Gray and Effie both wrote to young George, away at school. George replied brightly: 'I was delighted to see that the Doctors still had some hope of dear little Andrew's life and I sincerely hope that he will have the strength to bear it.' But Andrew passed away on 24 November 1844, thirteen years after the first little boy to bear that name.[6]

Why did Effie and her brother George survive, when the next seven children did not? Perhaps, in the early days, their mother had had time to nurse them herself. Two children were far easier to watch than three, four or five. Perhaps Sophia Gray began by breast-feeding her older children, giving them better immunity to childhood diseases, but could not keep up this regime as her household grew. Young mothers were advised to continue breast-feeding for up to fifteen months, and to look upon it as a 'period of privation and penance'. However, as Mrs Beeton pointed out, 'in these days of ours few women have sufficient leisure to give themselves up entirely to the infant's convenience'. Sophia Gray probably looked for a local wet-nurse for the younger children, as the next best thing. (This is certainly what happened when Effie came back to Bowerswell to have babies of her own.) Bottle feeding did not become popular until the 1860s, but some babies were raised 'by hand'. They were fed pap from a spoon: sweetened bread and water, or baked flour rubbed into warm milk. Infants brought up in this way did not thrive like breast-fed babies. Could this account for the early death of the first Andrew? We simply do not know why such a 'fine thumping boy' did not live to see his first birthday.[7]

In the end, Effie and George were saved by being sent off to school. At certain critical times the older children were away from the site of infection, while their little brothers and sisters were taken ill. From September 1840, Effie was at Avonbank in Stratford, a school run by the Byerley sisters. She was twelve years old, and hundreds of miles from home. At first she missed the open spaces of Kinnoull Hill, just beyond the garden wall of Bowerswell, where she and George could wander until supper time. She wept for Blucher, her old pony, and the freedom she felt on horseback. But Effie did not feel lonely for long. Avonbank attracted pupils from across the country, and when Effie started there were four other Scottish girls, including Lizzie Cockburn and Maggie Wallace. They became firm friends.

Avonbank had built up a solid reputation since the school was established in 1810. It even was whispered that the Duchess of Kent had considered sending Princess Victoria there. The Byerleys were well connected to the enterprising Non-Conformist community in the Midlands. They were also related to Josiah Wedgwood. Most importantly, the five Byerley sisters led by example. They demonstrated that it was possible for women to be both independent and respectable. They built up their school from only five boarders in its first year to thirty-eight girls when Effie arrived. Sarah Byerley's cheerful letters to Wedgwood gave a taste of their success: her sisters had 'constant applications', she wrote, and 'such a name they were obliged to purchase six new beds last half year, and open fresh rooms'.

Sending a daughter to Avonbank was an expensive business. Although the basic cost of board and instruction was around forty guineas a year, parents soon discovered that French, Italian, Music, Drawing, Dancing, Writing and Arithmetic were extra. As a result, the total could easily top 100 guineas. Of course, growing girls also needed to buy new clothes and have their hair cut. Someone had to pay for their embroidery silks and visits to the dentist. When George Gray received Effie's first bill at Christmas 1840, it included sums for the Mantua-maker and for wine, soap and laundry. The bills showed the division of labour in the Byerley establishment. The sisters were qualified to teach English, Geography and History, but they had to bring in specialists for the other subjects. So Mlle Smith was employed as the French mistress, and the two Messieurs Flavets, father and son, taught piano, harp and singing. When Effie was at Avonbank the Byerleys had five servants plus a house-keeper who ran the domestic side of the school. But they sent the laundry out, so that was an additional charge.[8]

By 1840, when Effie arrived, only two of the Byerley sisters – Maria and Jane – were still teaching. Sarah had never really been well enough, and Katharine Byerley and her sister Fanny gave up when they married. But they did not lose touch with the girls at Avonbank. As Mrs Parkes, Fanny arranged parties for the girls, like Effie, who could not go home for Christmas. She also became a successful author. Her manual for newly-weds, *Domestic Duties or Instructions to Young Married Ladies*, was published in 1825. Fanny's sound advice reflected the style of teaching that was offered at Avonbank. She encouraged women to find time for themselves and their own interests. She assured her readers that applying themselves to their music, reading or

drawing was preferable to the tedious 'family evenings spent in languid conversation and listless magazine reading' that many young wives faced.

Katharine Byerley also began writing when she left Avonbank, publishing under her married name, Mrs Thomson. She specialised in historical biographies and triple-decker novels, where her sharp eye was turned on the marriage market. In her novel *Constance* (1833) Katharine Thomson keenly described the 'amazons of the neighbourhood' who delighted in chasing after partners for dancing, and for life. One of her pupils, Elizabeth Gaskell (née Stevenson), followed her example in chronicling the moral dilemmas of her age.[9]

With Elizabeth Gaskell's help, we can reconstruct a little of Effie's life at Avonbank. In one of her stories Elizabeth described the bedrooms shared by the girls. So we may imagine Effie on the morning of her thirteenth birthday, in her whitewashed room at the top of the house. Woken by the sun, Effie and her bedfellow slide their feet into embroidered felt slippers. Then they smooth the white dimity bed cover. Two chairs stand side by side under the curtainless window, each with a neat pile of folded clothes. Effie shakes out her fawn-coloured dress in *mousseline de laine*. It is rather heavy for a warm day, but it will have to do until she visits London in the holidays. Waiting for her turn at the washstand, she tidies her hair and finds matching ribbons for her long auburn plaits. She is nearly old enough now to twist her hair into a knot and pin it up. She is growing tall and her figure is filling out, so already she looks quite grown-up. Effie wriggles into her double-layered petticoats and stiff stays. She needs help from her friend with the hooks-and-eyes of her dress. Finally Effie fastens a freshly laundered collar at her throat and, picking up her prayer book, she hurries downstairs to join the other girls. At breakfast Effie is delighted to see a parcel from home resting on her napkin.[10]

Although she was fond of school and thought Avonbank was a beautiful place, Effie missed being with her family on her birthday. Her parents always made a fuss of their first-born. She looked forward to opening her present when she had a quiet moment after lessons. As the church clock chimed the hour, the girls lined up and followed Miss Byerley into the schoolroom. Effie loved this room. Today it was filled with benches and heavy wooden desks, its walls hung with maps. But she could dream of a time, fifty years before, when it had been a ballroom, alive with dancing and gossip. Sitting beneath the domed oval ceiling, Effie imagined other girls in their silk gowns and

ostrich plumes being whirled about by young officers. She already had a taste for parties, even though she was really too young to stay up late; the Grays were sociable and enjoyed inviting family and neighbours to Bowerswell. At Avonbank, Effie diligently practised her dance steps and learnt to play polkas on the piano, so that she would be ready to shine as soon as she was old enough.

Late in the afternoon Effie was finally able to run down to the river with her friends. Maggie and Lizzie were eager to see what the Grays had sent for Effie's birthday. Inside the parcel was a note from her father, and a gift bound in ribbon. Effie's mother had found the perfect present on one of her shopping trips to Edinburgh: fine writing paper, and the most exquisite envelopes, tiny and lace-edged. Effie used one of them when she wrote to her mother a few days later about her plans for the summer holidays. The term finished in mid-June. Effie could not travel home alone, so end-of-term arrangements were always very complicated. She explained to her mother that she was keen to stay with Louisa Parker, another of her schoolfellows. Then she could make her way home from London. Effie's decision to accept Louisa Parker's invitation to Larkhill and Little Comberton probably saved her life.[11]

Sophia Gray had hoped that Effie would be back in time to join the family at the seaside. They had taken rooms at Broughty Ferry, just outside Dundee, where the children could swim and explore the beaches. Writing to her mother from Worcestershire, Effie was torn between the delights of the Malvern Hills and the fun she could be having with her little sisters. 'I wish I was with the Children bathing,' she said. 'I am now so fond of it. Do the children find many pebbles?' Effie soon overcame her wistfulness, though, and settled down to enjoy the hospitality of Louisa's family. Her letters were full of sunshine and picnics. The kitchen garden was overflowing with 'young peas and new potatoes, every day there is all strawberries and quantities of cherries'.

In Scotland, meanwhile, a family tragedy was unfolding. Six-year-old Sophia had scarlet fever. In the early stages of the infection her mild pink rash looked like sunburn. But then she started to complain of a sore throat and her temperature soared. Soon the itchy rash with its distinctive sandpapery texture covered Sophia's neck and chest. Far away in the Midlands, Effie began to suspect that something was wrong. Her parents, too busy looking

after her sister and fearful for the other children, had stopped writing to her. Normally she heard from them several times a week. Miss Ainsworth, Effie's teacher, was staying with the Parkers too. George Gray wrote to her directly and asked her to break the bad news to Effie. Little Sophia had died on 2 July 1841. Effie was distraught. In her next letter to her father she sent her love to her poor mother and all the children, and then explained that 'my hand is shaking so I cannot write any more'. The whole family held its breath, waiting for the infection to spread. At first it seemed that Effie's younger sisters and baby brother had escaped. But a month later Effie heard again from her father. The nightmare continued. Mary, who had just turned five, died on 2 August and her sister Jane, who was three, gave up her struggle on the 8th. Only Effie, George and the baby remained.

The shockwaves of this private disaster reached London, where Effie and her uncles Andrew and Melville were now staying. Melville wrote to Bowerswell, expressing the grief felt by the family circle. He and Andrew had both wept when they received news of the latest blow: he remembered 'the dear little pets – a chain of sweetest gems so suddenly broken'. At least, he said, Effie and her brothers were safe, for the time being.[12]

Effie had travelled to London to meet up with her uncles and her brother George. Mercifully he too missed the family holiday. They could mourn together. But their time was short, as George was en route for Germany. Mr Gray wanted his eleven-year-old son to begin brushing up his commercial skills and languages before he continued his schooling at Charterhouse. Effie's father hoped that this would give him the competitive edge in modern business. Melville had volunteered to take George by steamer across the Channel and see him safely lodged with his hosts in Wiesbaden. At this point Effie should have been heading home. Her mother wanted to keep her close and had persuaded Mr Gray to remove her from Avonbank school for good. Melville agreed with this decision. He found Effie rather forward, 'not only in her mere school knowledge but in her observation'. In a letter to her mother he commented on Effie's 'experience'. The implication was that she was a little too worldly-wise, and that this was unseemly in a young girl. Effie was certainly perceptive enough to realise that it might be years before her grieving mother let her out of her sight. She wanted to stay in London a little longer. So she asked if she could take up a long-standing invitation to visit Mr and Mrs Ruskin, who lived in Herne Hill in south London. She had stayed

there the previous summer on her way to Avonbank and was excited about the chance to go back for a few weeks.[13]

The links between the Grays and the Ruskins were complex, going back several generations. Even before Effie met their son, the ancient bond between the two families overshadowed their friendship. It is a bizarre story.

John James Ruskin and Margaret Cox, Effie's future parents-in-law, had both lived at Bowerswell before they were married. They were cousins. John James's mother was lonely, so she asked her niece Margaret to come to Scotland to help run the house. Margaret, the daughter of a Croydon publican, was in an awkward social position, higher than a servant but not quite accepted as family. A tall woman, with a 'skellie' or squint, Margaret seemed hopeful of winning John James for herself. Rumours began to circulate about the propriety of their relationship. It was said that she slept in the same room as him when she nursed him through an attack of scrofula. She reminded him of this when he left for London, seeking work, declaring that she had sacrificed her reputation to care for him.

In 1809, when Margaret Cox was already twenty-eight, she and John James Ruskin were engaged at last. But John James felt unable to marry her until he had settled his own father's debts: John Thomas Ruskin's grocery business had failed. According to John James, his father was extravagant and untrustworthy, impious and unstable. Eight years later Margaret's marriage still seemed as far off as ever. And then her world was turned upside down.[14]

It is worth remembering what happened to Margaret in the autumn of 1817. When Effie knew her, many years later, Margaret was not an easy woman to love. She had a horror of Perthshire in general and Bowerswell in particular. This coloured her feelings towards Effie. However, her almost pathological fear of the house where Effie grew up is understandable when we reflect on the trauma she suffered there.

In late September 1817, Margaret's mother died. Margaret travelled to Croydon for the funeral and then swiftly returned to Bowerswell. A few days later Jessie Richardson, John James's sister, arrived at the house. Jessie was heavily pregnant and had recently buried three of her children. Margaret was on hand for the birth of Jessie's little girl, 'the smallest infant ever seen'. As the baby was not expected to live, her baptism was hastily arranged. On 13 October, family, friends and neighbours gathered in the drawing-room at Bowerswell for the ceremony. Dressed in her finest lace, Jessie's mother

welcomed her guests. Just before the baptism began, she looked in on Jessie to reassure her that all was well. As she turned to leave the bedroom, old Mrs Ruskin suffered a massive stroke and dropped down dead. The midwife tried to revive her, grabbing a pair of scissors and slitting her magnificent dress up the back, lace and all. But it was no use.

Mrs Ruskin's shocking death left Margaret Cox in charge of a houseful of guests, with Jessie and her tiny child upstairs needing constant attention. Margaret herself was already grieving, having lost her own mother barely a fortnight earlier. The worst, however, was still to come. Old Mr Ruskin, John James's father, was severely disturbed by his bereavement. For many years his behaviour had been erratic. Now his mind fractured completely. Two weeks after his wife's death, John Thomas Ruskin stumbled into Margaret's room, dripping with blood. He had slashed his throat with a razor. Margaret somehow got him into his bedroom, and she was found there by the doctor, holding the gaping wound closed with her bare hands. Despite their efforts, the old man died two days later. For the second time that month, Margaret had to break bad news to Jessie, who was still in confinement. Jessie was also worried about her baby daughter. Sure enough, they lost the little girl too, a couple of days after Jessie's father died. Bowerswell was a grim place that autumn. Margaret left for Croydon as soon as Jessie could safely be moved back to her own home, and John James Ruskin returned to work in London.

There was one ray of hope. John James was now free to marry Margaret, and so he did 'one evening after supper, the servants of the house having no suspicion of the event'. Margaret was already thirty-eight, and she must have wondered whether she had waited too long. But her son John, Effie's future husband, was born in 1819.[15]

As a suicide, John Thomas Ruskin had been buried hastily and in secret. One of the people who had helped to arrange the funeral was Andrew Gray. The Ruskin family knew that he was reliable and discreet. Andrew Gray was a business partner of Peter Richardson, Jessie's husband. He was also Effie's great-uncle. Over the next thirty years a relationship of mutual support developed between the Ruskins and the Grays. When Jessie died in 1828, the Grays were on hand again to help the bereaved Ruskins. George Gray, Effie's father, became a trustee for the money that had been left to Jessie's children. And when John James and Margaret Ruskin agreed to offer a home to Jessie's

young daughter Mary, the Grays said she could stay with them for a few weeks before she set off for London.

By then George Gray had bought Bowerswell, the house that the Ruskins had come to hate. Margaret caused a scene by refusing to cross the threshold when she visited the newly-wed Sophia Gray in 1827. After that day she never went back to Perthshire. The memories of the terrible events that she had witnessed there remained raw. In her mind, Bowerswell was for ever associated with bloodied hands, torn flesh, despair. It meant that she could not bring herself to attend her own son's wedding when he married Effie Gray. And it coloured her relationship with her daughter-in-law. Effie, after all, was born in the very room where Margaret had struggled to save a madman's life.

John James Ruskin and George Gray wrote to each other from time to time about matters of business. They were both doing well. After many years of hard apprenticeship John James went into partnership with Pedro Domecq and they established themselves as the leading sherry importers in Britain. George Gray was building his legal practice as well as extending his commercial interests. In due course he became financially involved in the Dundee–London steamer service, banking and insurance, gas lighting and the railways. But when he and John James corresponded, it was usually about Jessie's children or their shared enthusiasm for gardening: they compared notes on growing potatoes and peaches. Margaret Ruskin's voice could sometimes be heard in the background, sending her best wishes to the Gray family, and occasionally she posted a present for Effie. However, it was not until September 1840, on her way to start school, that Effie first met the Ruskins and their son, John.

Effie was twelve when John first saw her. He was twenty-one, but her bright wit and beauty made an impression on him. He was melancholy, and she lifted him out of his misery. For four years John had been infatuated with a young girl, fresh from convent school, called Adèle Domecq. Adèle was the first great passion of his life, and this affair set the pattern for all John's later romantic obsessions – including his love for Effie. Adèle was the daughter of his father's business partner. She did not encourage John's intense admiration and his attempts to woo her were lamentable: he harangued her about her Roman Catholicism and bombarded her with heavy prose. Adèle just laughed at him. But he never gave up hope. Then early in 1840, hearing that she was to marry a French baron, John had thrown himself into a frenzy of work. He

wanted to wipe out the 'absurdity, pain, error, wasted affection'. His health collapsed, he started spitting blood and he was forced to leave his studies at Oxford. When Effie met him, John was recovering at home. She refused to let him wallow in his wretchedness. Effie challenged him to find a new outlet for his teeming brain. He should write her a fairy tale. At first he did not have the heart to do it. But after she had left for school, the germ of an idea began to grow in John's mind.[16]

So, in the spring of 1841, as Effie sat at her desk in Stratford, John wrote *The King of the Golden River* for her while he convalesced at Leamington Spa. It was a fable about greed and good husbandry set in John's beloved Alps. Originally intended 'solely for her amusement', it was not published until 1850, but soon it became the most popular of all his works. Through this story Effie was inducted into John's private world; the landscape of his imagination was set out before her. He chose the mountain passes of an idealised Switzerland as the backdrop for a spiritual struggle. At the heart of the tale lay John's anxieties about the glories of Creation and the impact of men on their environment. Years later he would lament the changes he foresaw in apocalyptic phrases: 'Blanched Sun, – blighted grass, – blinded man'. But the kernel of his concern was already present in Effie's fairy story. For her, he dressed up his troubles in costumes borrowed from the Brothers Grimm. His villains were the Black Brothers, 'very ugly men with overhanging eyebrows and small dull eyes', almost goblins. His hero was a blue-eyed boy. Through the boy's self-sacrifice Treasure Valley was transformed from a desert into a garden. Its 'dry heaps of red sand' bloomed again and 'fresh grass sprang beside the new streams'.

Effie's tale offered the promise of redemption. And perhaps it was not just about the evils of materialism, or the possibility of another road to prosperity. As he fulfilled his pledge to entertain his little Scottish guest, John's heart began to soften. In the wake of Adèle Domecq's marriage, his emotional life had been a wasteland, scarred by grief and bitterness. Now John began to take pleasure in amusing young Effie. The seeds had been sown for a new love.[17]

Chapter Three

A Ghost Appearing at a Wedding Ceremony: Effie's Courtship

WE KNOW a surprising amount about what John Ruskin did, and did not do, in bed. As a young man he agonised over his rising sexual feelings and was apparently addicted to auto-eroticism. He suffered from night-horrors. In his dreams, serpents slipped under his bedroom door and reared up, displaying 'horrible round eyes and Medusa's breasts'. Despite his fears, John knew he was not impotent. He said in 1854 that he was willing to prove his virility in court, although how he intended to do this was not clear. He fantasised about his honeymoon, imagining his bride dressed in white silk, displaying herself for his eyes alone. She was a 'saucy – wicked – witching – merciless – mountain nymph'. But he never had sex with his wife.

John Ruskin loved young girls, innocents on the verge of womanhood. His first love, Adèle, was fifteen when he fell for her. His last, Rose La Touche, was ten when he first noticed her. He became enchanted with twelve-year-old Effie when she visited Herne Hill in the late summer of 1840. The next time he saw her, John felt she was 'very graceful but had lost something of her good looks'. After he had won her hand in 1847 – and she was still only nineteen – he wrote wistfully about the lost years, 'the sight of you, in your girlish beauty, which I might have had'. Already Effie was too old to be truly desirable.

So why did Effie marry John Ruskin? She had plenty of other admirers, young men who danced better than John, boys she had known since childhood who were happy to flirt and gossip. John, meanwhile, was always trying to improve her mind with books and pictures or the promise of foreign travel. He rarely let his guard down. He was pale and almost handsome, his angular cheekbones softened by side-whiskers. John was also a minor celebrity, the author of *Modern Painters*. He had written this work glorifying the landscapes

of Turner while on holiday in the Alps, the summer after graduating from Oxford. (Christ Church had awarded him a bizarre degree – an honorary double fourth.) John was soon being lauded as a visionary and a prophet for teaching, in George Eliot's words, 'the grand doctrines of truth and sincerity in art'. This was perhaps his most attractive feature in Effie's eyes. When she accepted John's proposal some of his fame rubbed off on her. 'I am known at these parties,' Effie told her father, 'as the young lady who is to marry the Oxford Graduate.'[18]

John's wooing of Effie was understated at first. She was not looking for love when she accepted an invitation to visit the Ruskins in the spring of 1847. John and his parents had moved from Herne Hill, where Effie had stayed as a schoolgirl, to a spacious three-storey house in nearby Denmark Hill and Effie was pleased to be asked to stay with them. The new house was rather grand. It was set in seven acres of meadows, orchards and kitchen gardens, and the Ruskins now had enough land to establish a smallholding with a pigsty, a hen-house and a couple of cows. Denmark Hill was also close enough to central London for socialising and seeing the latest fashions. Effie could catch up with some of her old school friends – and their brothers.

Since the awful deaths of her three sisters in the summer of 1841, Effie's life had been restricted. For three years she had stayed away from school, so she could comfort her parents and help them rebuild their lives. Effie learnt to manage the house at Bowerswell, while her mother endured two more pregnancies. The lost children were not forgotten, but soon the quiet nursery came alive again, with new playmates for her little brother Andrew. Robert was born in May 1842. Within two months Sophia Gray was expecting another child: Sophy appeared in March 1843. (She was the second daughter to be given this name.) As she grew up, 'the second' Sophy became Effie's closest ally.

Effie's teenage years spent quietly at Bowerswell made her home a hallowed spot in her memory. Throughout the twists and turns of her life, she felt there was always a refuge in the solid house above the River Tay where she and her brother George had been happy. Neither of them forgot those years, despite the distances they later travelled. For both Effie and George, it became their last resting place.

In the mid-1840s Effie's parents tried to blot out the trauma that the house

had seen – ghastly suicide, dying infants – by wrapping new rooms around the original building. A library, drawing-room and extra bedrooms were added to the core of Bowerswell House. They represented the promise of a prosperous future and a growing family. The house looked stylish and substantial. Mr Gray enjoyed the impression created by the three-storey Italianate tower that welcomed his visitors. Bowerswell's balconies and elegant chimneys gave it the air of a Renaissance villa, although the bay windows overlooking the terraced lawns were a more modern touch. On her rambles up Kinnoull Hill, Effie could turn and look down upon the tiled roofs of her home, the parkland and the greenhouses, and then across the river valley to the city of Perth. This view would sustain her. As her schoolfellow Elizabeth Gaskell explained, Effie's love for 'her home-people' coloured her world. This was an enduring affection, transcending all others.

It was only in the New Year of 1844, during a lull in her mother's pregnancies, that Effie's horizons began to expand again. (It was no coincidence that this respite came after George Gray spent several months away in New York promoting his business interests.) Effie went back to Avonbank for a few terms, and renewed her schoolgirl friendships. She was especially fond of Louisa Parker and her cousin, Mary Paget. The Parkers had looked after Effie with great kindness: she had been staying with them when her little sisters had died.

Effie found Avonbank changed. And she had changed too, in the three years she had been away. Some of her old friends were still there, but the Misses Byerley had retired and handed over the school to Miss Ainsworth. The new headmistress was stricter and better organised than her predecessors. The teachers were glad to have Effie back: they remembered her as an artless, affectionate girl who had shown real promise before she was obliged to break off her studies. But Effie found it hard to return to dull routine and drudgery, especially after the liberty she had enjoyed as her mother's deputy at Bowerswell. She had grown up. She was now a young lady fast approaching her sixteenth birthday, who was 'extremely admired in her appearance and manner'. Effie was a quick learner, catching up on her French and beating several girls who thought themselves 'far superior to her in knowledge of the language'. She was also finding out that she could make enemies as easily as she made friends. Her confidence did not always endear her to other girls. In fact she was reinforcing her reputation for being 'too forward for her years'.

Effie returned to Avonbank for just two terms. By the summer of 1844 she had acquired all the accomplishments expected of a young lady in subjects ranging from modern languages to music. Her carriage and presentation were correct. She had a wide circle of friends who were willing to introduce her into English society. But she was not always quite well. When she left school, her brother George thought she looked thin, although she seemed in good spirits. Miss Ainsworth had become concerned about Effie's health and had begun dosing her with 'strengthening medicine'. Effie was suffering from tightness in her chest and at the school they were worried that she might become 'delicate'. To some Victorians, delicacy was a positive feminine virtue, one that should be cultivated. However, Effie, who loved dancing and riding, refused to submit to the ideal of the fragile female. She shook off her indisposition and threw herself into the fun of teenage friendships. She had discovered that vitality was one of her most captivating characteristics.[19]

Young men, including Louisa Parker's cousins, began taking an interest in Effie. By the time she turned nineteen she was rumoured to have had twenty-seven offers of marriage, 'but she never cared for any one of them'. Her behaviour set tongues wagging. While Effie was in England, her mother could not keep an eye on her, and relied on hearsay and hints from Effie's hosts. Word got back to Bowerswell that Effie was spending too much time in the arms of Parker Howell, Louisa's cousin. Effie was surprised: 'What could poor Mr Potter have said about Parker and I?' All the girls loved dancing with Parker. He swept them around the room, making them dizzy with delight. Louisa, Mary Paget and Effie vied for his attentions when he was staying at Little Comberton. But Effie did not take him seriously as a suitor. Like Arthur Paget, Mary's brother, he was one of a crowd of teenage cousins who spent their holidays together and enjoyed rolling up the drawing-room carpets for a dance or heading into London for fun. Effie's descriptions of carefree weekends in their company have a surprisingly modern ring. One Friday afternoon while she was shopping in Regent Street, she bumped into the young Parkers and Pagets, and went off to see a show with them. The next day Arthur Paget took her for a stroll through Green Park, people-watching. The whole of London seemed to be out enjoying the fine weather. Effie must have been looking her best, for she caught the eye of a couple of gentlemen along the way. She teased her father with her

throwaway line in a letter: 'Prince Albert bowed to us, and the Duke of Wellington touched his hat.'

The schoolgirl who had entranced John Ruskin was blossoming into a striking young lady. According to Elizabeth Gaskell, Effie was 'amused as well as flattered by the rapturous admiration she created'. Effie was taller than most of her school friends – she was five feet six inches – and wore her thick copper plaits wound around her head, adding to her height. Her eyes had rather a dreamy look, with heavy lids under elegantly arched brows. Her nose was perhaps a little long for classical taste, but it was straight and fine, and her lips were carefully drawn. Her lower lip was full, with a slight dimple beneath that gave a suggestion of sensuality. She was careful about the cut of her clothes and paid attention to the details of fashion – she could recall the exact colour of a straw bonnet 'between bright gold and maize' or the daring plunge of a neckline.

The effect on the young men around Effie was electric. From time to time we are treated to a tantalising glimpse of her at a party surrounded by admirers eager to dance, or to sit next to her at supper. She particularly enjoyed the impromptu balls held at Ewell Castle, near Epsom, the home of her father's friend, Mr Gadesden. On one occasion handsome young officers who 'danced the Polka delightfully' were keeping Effie entertained, so that she barely noticed a shy teenager who tried to talk to her. He had been standing on the sidelines, tall and fair, slim and elegantly dressed. He watched Effie as she worked her magic. She seemed effortlessly graceful, full of life, bestowing smiles on her favoured dance partners. The young man approached his hostess, and asked for an introduction to 'the lovely girl with auburn hair'. And so John Everett Millais was presented to Effie for the first time. They had mutual friends, the Lemprière family who knew Everett from his childhood in Jersey. But she was distracted, and he drifted away.

Everett was only a boy compared with most of Effie's admirers. He could not compete with fellows like 'Snob' Gardner. Six feet tall, Snob looked good on horseback and he knew it. He took great care of his appearance, at least when Effie was around. Effie thought she must look rather shabby beside him, for Miss Rutherford, her dressmaker in Pall Mall, had not quite finished her new dress, and her tired pink muslin was the only thing cool enough to wear in the glaring London streets. But he enjoyed squiring Effie around the city and introducing her to his Cambridge friends.[20]

Snob Gardner could not hope to keep Effie to himself in the early summer of 1847. Effie was in London, paying her first grown-up visit to the Ruskins. Gardner knew that there were plenty of other gentlemen in town vying for her attention, including friends from Perth like 'Prizie' Tasker. Prizie came down to Denmark Hill to try to see Effie and finally found a chance to talk to her alone one evening. They were returning home with a group of friends, when his eager look gave him away. Effie had seen it before in the eyes of young men and wanted to save him the mortification of a direct refusal. She liked Prizie, but not enough to marry him. Before he could make his passion plain, Effie increased her stride and walked as fast as she could to catch up with the others. It was not easy. Encumbered by her flounced skirt, wide shawl and tightly laced bodice, she could barely catch her breath. But it was worse to lag behind, lulled by the warm June evening, and find this young man taking her hand and declaring how he loved her. After all, she was already, ever so discreetly, engaged.

Before she left Scotland to visit the Ruskins, Effie had come to an understanding with William Kelty MacLeod, a neighbour from Kinnoull Hill. When Effie first accepted his offer, it had seemed so romantic. Willie was an officer in the 74th Highlanders, with good prospects. (He eventually rose to be Lieutenant General of the Highland Light Infantry.) He was a splendid dancer and looked dashing in his tartan trews. Willie's regiment was posted nearby, but he could not afford to marry her immediately, so Effie agreed to wait for him. But in London she was surrounded by suitors. She successfully resisted the charms of any number of undergraduates, and laughed at the boys who left her breathless on the dance floor. However, she found it harder to hold out against the attentions of an older man. She was flattered and surprised. Almost imperceptibly, Effie was drawn closer to John Ruskin.[21]

Effie did not expect John to fall in love with her. She treated him as an old friend and felt comfortable in his company. They could sit quietly together for hours while he drew and she knitted. After dinner Effie played Mendelssohn until the older Ruskins fell asleep, and she and John were left together, chatting by candlelight. She did not need to sparkle and flutter with him. She had been told by Mrs Ruskin, on the day after she arrived at Denmark Hill, that John was engaged to be married. (Later it emerged that Mrs Ruskin had only tipped Effie off about the engagement because she did not want her pretty house guest interfering with John's hopes of marrying an

heiress. Effie's reputation as a flirt had reached Mrs Ruskin's ears.) Effie viewed John's affair with wry amusement. She saw from the outset that this was no love match. On her nineteenth birthday Effie confided to her mother: 'I have not had the courage to ask John who his Lady-love is [but] I suspect from what is said that the Lady has a fortune and that love must come after marriage.' Effie was aware that her hosts would not appreciate gossip about John's half-hearted romance being spread around the morning-rooms of Perth, so she added, 'be sure it goes no further'. Effie was particularly concerned that her father should not reveal to the Ruskins that she was writing about their private business. She was canny enough to realise that the older Ruskins could be touchy and unpredictable. Still, Effie's comments about John and his lady-love showed not the slightest trace of jealousy. Effie was curious but unflustered by his interest in another young woman.

The girl in question was Charlotte Lockhart. She was the granddaughter of John's hero, Sir Walter Scott, and in line to inherit the fabled house of Abbotsford, where Scott had written his novels. John was as delighted by her literary associations as he was by her daintiness. He called her 'a little harebell' and 'a Scottish fairy'. Charlotte was unmoved. As John explained later, 'with my usual wisdom in such matters', he attempted to endear himself to her by writing a scholarly article for her father's journal. Sitting in the wings, Effie thought John was 'the strangest being I ever saw, for a lover'. She had seen enough besotted young men to know that something was amiss. The whole episode seemed driven by John's desire to marry into a literary dynasty and to satisfy his parents' ambition. As Effie grew more at ease in John's company, she decided to quiz him about his engagement. She discovered that John was prepared to marry out of 'a false notion of duty'. 'He has only seen the young Lady six times at parties in his whole life,' she wrote to her mother, 'and does not love her a bit.' But Mr Ruskin expected John to 'marry rather high' after all the opportunities he had been given, and Mrs Ruskin looked forward to acquiring a 'very elegant and high-bred' daughter-in-law. John's parents wanted some return on their investment in his gentlemanly education.[22]

It is not clear exactly when John's allegiances changed. He seemed fond of Effie from the start of her visit, even when he was supposed to be devoted to Charlotte. He would wait outside Effie's room in the evening while she dressed for dinner, so they could walk downstairs arm in arm. He was even prepared to risk his mother's displeasure for Effie's sake. ('Do you recollect

my getting a scold,' John wrote to her later, 'for waiting for you – and being too late to say grace?') John was keen to introduce Effie to his friends in the art world: Turner, Richmond and George Dunlop Leslie were all invited to dine at Denmark Hill during Effie's stay. She was impressed. She could not resist name-dropping in her letters home: John had been sent a ticket to the Royal Academy's private view by Turner, which she thought was 'the highest compliment paid to any man in London'. On another night he was at a grand reception hosted by Sir Robert Peel. And then Effie told her parents excitedly how she had gone with John to an exhibition of water-colours and met 'Mr Prout, who is the famous artist [and] a nice old man who walked round with us'.

Effie was enjoying her new life with the Ruskins. London seemed to buzz with cultured conversation, beautiful pictures, private views and concerts. Here was a chance for her to shine more brightly, surrounded by celebrities, admired for her wit as well as her beauty. Effie had a vision of herself as a fashionable hostess, presiding over gatherings of great men and their wives. Those few weeks at Denmark Hill were perhaps a foretaste of her future. It seemed the recipe for happiness: quiet days spent playing the piano and reading in John's company, spiced with literary tea parties and nights at the Opera. Effie recognised that her tastes were already changing under John's influence. The fun she had with the young Gardners seemed rather vulgar when compared with his artistic pursuits. John described her friends as 'boys who think too much of themselves'. Now she was coming round to his way of thinking. She admitted to her brother that she liked the Gardner family on the whole, but 'after being with the Ruskins it makes one rather particular'.

Effie was aware that she too was being judged by John's parents. They liked to interfere. Old Mr Ruskin's interest in Effie's appearance was more than avuncular. At times it was almost prurient. He was concerned about her discomfort in the heat of the city, so he suggested that she discard her flannel petticoat. She should buy a stiffened-horsehair crinoline instead. Effie duly visited Miss Rutherford and ordered one. According to the Ruskins, Effie also needed a new low-cut, silk dress for dinner parties, even though twenty-two yards of fabric were required to create the latest bell-shaped silhouette. Her white evening dress apparently would not quite do in polite London society. Effie's father had to send her an extra £10 to cover the cost of the dress and a matching shawl in pale blue.

John James Ruskin and his wife blew hot and cold about Effie. They invited her into their house, but then they tried to mould her behaviour. They began to suggest she was flighty and to criticise her for gadding about without a proper chaperone. After all, she was now a young lady of nineteen. In the weeks she was at Denmark Hill, the tone of Effie's letters to her own parents changed. She started voicing the Ruskins' opinions. They objected to the 'extreme impropriety' of her travelling home to Scotland by train alone. For the first time, Effie began to worry about 'what some people will think'. The implication was that Effie's father did not care enough about his daughter's reputation.[23]

Why should the Ruskins' opinions have mattered to Effie? She would soon be in the familiar surroundings of Bowerswell, preparing for her marriage to Willie MacLeod. But in the last weeks of her visit something shifted in her relationship with John. Effie could see that he was not in love with Caroline. But then he did not appear to be in love with her either. He took pleasure in showing her around town and arranged treats to entertain her: tickets to hear Jenny Lind singing Bellini's *La Sonnambula*, or to see the Queen's new portrait by Winterhalter. Perhaps John felt that Effie filled the gap in the family circle left by his cousin Mary Richardson. She had recently married and was now established in her own home. Mary had lived with John and his parents since she was a child, and they all missed her.

Effie's feelings for John were bound up with her love of London life. Her head was turned by grown-up conversations with his friends. The blushes and stammers of Effie's dance partners could not compete with John's erudition. Denmark Hill was a world away from the larks and giggling of her home life. And Mrs Gray was expecting another baby in the late autumn, so Effie knew she would be thrown straight back into managing a houseful of children. She was not looking forward to going home.

John had not spoken openly to her, and as far as she knew, he still thought of her as his 'sweet sister'. (That was what he had called Effie in the birthday poem he had written for her only six weeks earlier.) But John's parents could see the change in him. They noticed that he was 'too sensibly affected by Miss Gray's presence for his own peace'. They even tried surreptitiously to shorten her visit, fearing that she was upsetting their plans for John's marriage to Charlotte Lockhart. But they stopped when they found that sending Effie home might distress John so much that his health would suffer. They were

haunted by the memory of their son's blood-splattered handkerchiefs when he lost Adèle. As John spent more and more time with Effie, despite his parents' best endeavours, hopes for a union with the Lockharts faded. Eventually, on 30 June 1847, Effie boarded the steamer bound for Dundee, and left John alone. Within a few days the Ruskins heard that Charlotte's affections were now engaged elsewhere. She and John were not bound by the informal understanding that their parents had made, and Charlotte had found a more competent suitor.

The Ruskins waited for their son to suffer a catastrophic breakdown, as he had after Adèle's defection, and true to form, John began sinking into depression. Then suddenly he had a flash of inspiration. He began to plan a walking tour of Scotland. Remembering Effie's descriptions of Perthshire, he decided he should experience the singular loveliness of the Scottish hills with his own eyes. John's parents recognised that the real attraction was Effie herself. She had helped him through heartbreak before, when she was a girl. Now she was a grown woman, and a beauty. It was time for the Ruskins to rethink their attitude to Effie. Perhaps she was the best choice after all.

Mrs Ruskin spelt it out to John. Effie, she wrote, would 'soon come up to your standard, after she is your wife', adding ominously, 'unless you are unreasonable indeed'. John's mother had decided that he should marry and it was unlikely that he would find anyone better than Effie. Miss Gray was 'lovely, open, frank and upright' and she had put up with John's fault-finding with good grace. Mrs Ruskin also pointed out that Effie would keep her slim girlish figure, for 'neither her father or mother have increased in fatness'. She must have been aware of her son's tastes.

John James Ruskin could not resist having his say too. Although he had hoped for a more lucrative settlement, he could see some advantages in John marrying Effie. The two families moved in the same circles: Mr Ruskin was acutely sensitive to his position in society and was bothered that people like the Lockharts looked down on him because he was in trade. But there were also whispers about the Grays' own financial position, rumours about specu-lation and share-dealing. Mr Ruskin advised his son to be cautious. Do nothing hasty, he wrote, and be aware that George Gray might see Effie's marriage into the wealthy Ruskin family as a way out of financial difficulties.

John dithered. He went over the scenes of the early summer in his mind. He hoped that Effie cared for him. Yet he feared that she was driven by

'motives of ambition more than Love – or of tutored affection'. Perhaps he was simply not lovable. He was now approaching thirty, and his previous romances had been humiliating failures. John had been charmed by Effie. He remembered her as a child and he valued her as a companion. More importantly, he had seen that she could fit in at Denmark Hill. John's relationship with his parents was close to the point of claustrophobia and he could never marry a woman who would be jealous of his mother's hold over him. Was that good enough reason to ask Effie? Still irresolute, John set off on his Scottish tour. He wanted to be close to Effie, but he held back from seeing her. His actions were baffling, rude even. In August he went all the way to Perth. He called on Mr Gray at the office, but then bypassed Bowerswell.

We do not know what Effie made of John's behaviour, as none of her letters from the late summer of 1847 has survived. John wrote to Effie's mother, trying to justify his discourtesy. He was torn. Loyalty to his mother meant that the whole neighbourhood of Bowerswell carried painful associations, but John's own 'dearest interest in its many lovely localities' tempted him to linger. He tried to throw himself into botanising, finding 'perfect beauty in the bell heather whose opalescent softness and depth of colour' he thought lovelier than the fuller flush of the Alpine Rose. This was a declaration of love, of sorts.[24]

Eventually, after nearly two months in Scotland, John accepted Mrs Gray's invitation to stay. He needed to know whether Effie cared for him. John arrived at Bowerswell on 2 October, with his valet George. Seeing Effie among her own friends was a shock. She was surrounded by people who, in his words, were far more calculated to catch a girl's fancy. John admitted in a letter to his walking companion William Macdonald, 'I love Miss Gray very much'; this was the first time he had ever said so openly to anyone. But he worried that 'in many respects she is unfit to be my wife unless she also loved me exceedingly'. Given their later trials, John's reaction was probably the right one. Rather than making her an offer of marriage straight away, he decided to wait for six months and then invite her to join him and his parents on their next Continental tour. In the meantime he would see if Effie went ahead with her marriage to Willie MacLeod.

But in July, just after Effie had returned home from London, Willie's regiment was posted to Ireland. Effie was in limbo. Her fiancé was hundreds of miles away, with no prospect of a wedding for a year, possibly two. And

now here was John Ruskin, moping about Bowerswell, awkward and argumentative. Why had he come to Scotland? Was he just trying to forget his abortive engagement to Charlotte Lockhart? Or had he missed Effie as she had missed him?

John left Bowerswell after a week, without telling Effie that he loved her. He felt dreary and hopeless as he travelled south to Berwick. But by the time he reached home only a few days later, everything had changed. He had written to Effie, asking her to marry him, and she had said yes. We will never know what finally prompted him to make her an offer. These most private and mysterious letters have not come to light. Maybe John realised that it would be impossible to take Effie travelling, even with his parents, unless they were man and wife. His mother had said that it would be neither proper nor wise. But this alone would not have made him take such a dramatic step, especially after the miserable time he had spent at Bowerswell. The big clue to his change of heart comes in a letter he wrote to Mrs Gray. This note was so sensitive that it was held secretly in the Bodleian Library for nearly seventy years after John's death. In it he repented of his rudeness and sent his love to the whole family, especially Alice and Effie. Then came the telling line: 'Alice may have it all if Effie does not want any.' In despair, he was challenging Effie to reject his love.

As her mother read the letter aloud, Effie realised that this was her last chance. John had behaved badly at Bowerswell, but she too had been cold and changeable. He had offered his arm as they strolled up Kinnoull Hill, and she had ignored him. All the old openness between them seemed lost. And now he was slipping away, leaving her to a life of quiet sociability in Scotland. Effie did not love John, but she admired him. She was flattered that he cared for her. His distress moved her. And as she told him later, 'it almost made me weep with joy to think myself so beloved'. Effie also believed that, because John was such a kind son, he would be a perfect lover and husband. She had grown blasé about the attention she received from ardent young men. But with John it was different, far more serious. She had to make her choice. Would she wait another year for Willie to come home and claim her? She could settle for secure domesticity, close to her family. No, the lure of London was too strong. Effie had proved that she could dazzle John's friends, the poets and painters of his circle. She knew John could be gauche, but his writings were luminous and were now being noticed by men who mattered.

She would smooth his passage through society. Together they were the perfect partnership. Effie made sure that her mother's reply to John gave him the encouragement he needed to make a formal offer. A few days later they were engaged.[25]

Effie and John did not see each other again for five months. Their courtship was conducted on paper, which suited John; he felt happiest with a pen in his hand. So there were no caresses, no blushes, no brief moments of intimacy, except those he conjured up in his letters. John wrote almost daily, overwhelming Effie with endearments: 'My mistress – my friend – my queen – my darling – my only love.' He wanted to announce their news immediately, but Effie hesitated. She thought it fairer to wait until she could talk to Willie MacLeod in person. He was expected home briefly in November. In the meantime she asked that her decision to marry John be kept secret. Only close family members were told. It was not until the start of the Christmas party season that word got out. None of her letters from this busy time has survived, but in John's replies, we catch glimpses of her encounters with young men. After one ball John declared she was a 'cruel, cruel girl' for her careless treatment of an eager admirer: 'You knew he would have given a year of his life for a touch of your hand.' There was an uneasy mixture of smugness and anxiety in John's attitude to Effie's beaux. He felt responsible for the 'two grieved hearts' of Willie MacLeod and young Prizie Tasker. Was he worth the sacrifice that Effie was making in giving such pain to old friends? 'I wonder,' he wrote on 15 December 1847, 'if you will ever look back ...'[26]

Of course, such sentiments are commonplace in love-letters. At one level John knew that Effie would be bound to reply that she was sure she had made the right decision. But underlying the affectionate phrases and reassurances, there was a constant tension. Effie certainly wrote lovingly to John; we can see that from his side of the correspondence. But they were both fretful. Effie's concerns were not initially to do with John at all. She was relieved to have accepted his offer, but now she had to concentrate on looking after her family at Bowerswell. Her mother's confinement was imminent and all the children had colds. Effie was struggling to keep up with managing the house. With her mother stuck upstairs, Effie was nursing the little ones, ordering dinner and acting as hostess when her father had guests. She had headaches and was finding it hard to sleep. Chronic insomnia dogged her from this

moment on. It is as if her engagement to John triggered her sleeplessness, and to the end of her life she was never able to shake it off.

Effie's brother Melville was born on 30 November 1847. But when John wrote to congratulate Sophia Gray, he laughingly expressed his coolness towards babies: in his experience, he said, few infants could be described as pretty. John disliked small children and was not afraid to show it, even to his prospective mother-in-law. He was also beginning to wonder whether Effie's expectations of married life in London were overblown. He admitted as much to Mrs Gray. John hoped Effie would be happy with the retired life that they might have to lead. If he intended to make a success of his writing, he said he would need to spend many hours shut away with his books. He already realised that only strong affection would make seclusion from society tolerable for his young bride.

John had very particular ideas about how a wife should behave. He made them clear to Effie in the avalanche of letters she received during the six months of their engagement. He began by asking that other young men should stop calling her 'Effie'. That was his pet name for her, and he was jealous of it. Then he tackled her wardrobe. For their wedding tour she would need dresses of the plainest kind that would not crush, cut high at the throat and with the flounces neither too full nor too long. John wanted Effie to be able to walk beside him in Switzerland without constantly catching the hem of her skirt. After consulting with his mother he decided that Effie would need only one smart evening dress, for the Paris Opera perhaps. And then John made an odd comment. It would be best if Effie tried to dress as simply as possible, 'so as to escape unobserved'. Here was a girl who had grown up as the centre of attention, and now her fiancé wanted her to hide her loveliness. He expected her to be demure, modest, for his eyes only. John thought he was being reasonable. He argued that Effie was so pretty that the slightest hint of over-dressing would imply that she wanted to be looked at. She should, in his words, appear graceful, occasionally piquant, but never conspicuous. John acknowledged that his advice might seem impudent and tried to couch it in loving phrases. Even so, Effie's appearance became a focus for the tensions in their relationship: her visibility, her dress, her ease in attracting admirers were flashpoints in their marriage. Effie recognised it as a problem early on and raised it with John. After all, he had built a career on analysing the beautiful. Had he chosen her for her lovely face alone? He tried to reassure her. He was

charmed, he wrote, by her 'sweet, kind, half-pensive depth of expression', which meant more to him than superficial beauty. Yet his words were troubling. John imagined Effie sitting next to him on their honeymoon, with a bud of bridal orange blossom tucked into her hair, their little fingers just touching. And he would see everyone gazing at her and think, 'She is *mine* now, *mine*, all mine.'

This was little comfort to Effie. She was unsettled and, judging by John's replies, her lost letters were scattered with sad thoughts. To begin with, her anxieties were only partly bound up with John: she knew that her father was facing financial difficulties. But she found little relief in loving John. He tried to soften her with sweet words. He imagined being 'folded and gathered into a little box' and kept safe on her toilet-table. He was faint, he said, for love of her. Yet at other times he was adamant that she should be squeezed and prodded into the semblance of the model wife. A wife, he told her, had it in her power to make her husband love her more every day: this was Effie's duty. Very soon her engagement became another thing to worry about.[27]

Effie's health began to suffer. John diagnosed that she was taking on too many responsibilities at home. She was also, he felt, agitated about her disappointed lovers. He advised her to return to the life of a schoolgirl, with 'regular exercise, a great deal of play and bed at nine o'clock every evening'. This was part of his attempt to mould Effie, to impose his discipline on her thoughts and actions, and to fulfil his desire to marry a young girl whose only concern was pleasing him. But already it was too late. By mid-February 1848 John was upbraiding Effie for her lack of attention to his demands. 'You have not done anything for me or with reference to my wishes,' he wrote, since they had been engaged. He had asked her to work on her French, Italian and Botany, as essential tools to help him with his researches. He thought she would fall in with his plans, as he said, 'to occupy your mind and (forgive the impertinence) to please me'. But, burdened with the running of Bowerswell, she barely found time to answer his letters and to practise the piano. John made no attempt to hide his displeasure. He decided she was making herself miserable by playing melancholy tunes in a minor key. It was absurd and wrong. And Effie should cut down on her correspondence. John had stopped writing to other friends, and 'you ought to have done the same', he told her.

Effie did her best to make a joke of it. In one of the very few notes that survives from the tail-end of her engagement, she reassured John. 'I think I

know all that I have to expect, and I shall see your coat brushed and mend your gloves,' and, she added, 'I shall promise never to wear an excessively Pink Bonnet.' She bowed to his 'superior discernment' in such matters. Effie also attempted to laugh off John's jealousy. It was preposterous, she wrote, that he should feel slighted by her affection for old friends. Effie was struggling to convince herself that it would all be easier after they were married.[28]

And when would that be? Setting a date seemed the hardest task of all. Of course John and Effie would have a private honeymoon. But they were also expected to accompany John's parents on their Continental tour, and the Ruskins were planning to leave for the Alps in the spring of 1848. In his early letters John talked eagerly of a wedding in March. Unfortunately this seemed impossible. Effie and John could not marry in Lent. That year Lent started on 8 March and lasted until Easter Sunday, 23 April. As it was supposed to be a season of fasting and penance, Lent was no time to arrange a wedding feast. For both Effie and John, religious faith was the bedrock of their being. They tussled over biblical texts and gossiped about preachers in their love-letters. In one, John imagined bringing Effie back to his old home, and how he would welcome her 'with such a long – long kiss'. And then the newly-weds would be blessed by the servants. At last, duty done, he hoped they would go up to Effie's old room, just the two of them, and kneel down together to thank God. Sensuality, ardour, service and worship mingled in John's dreams of married life, so that Effie's bedroom became a site of prayer as well as passion.

Uncertainty about the date of the wedding came to dominate their correspondence. Mrs Ruskin warned the couple that marrying in Lent would make them miserable. They could not, in good conscience, throw themselves into the joy of marriage at such a time. Even in early March 1848, the arrangements had still not been finalised. John's loyalty to his parents already overshadowed Effie's hopes and desires. He dismissed her suggestion that they should spend more time honeymooning in the Lake District: 'You say – my pet,' John wrote, 'that you would like to be alone with me a little longer.' That was impossible, he explained, as they had to be home in Denmark Hill to celebrate his father's birthday on 10 May. It would be a shame, he wrote, if his affection for Effie should make him 'less fit for any religious duty'. No, the only way to keep his parents happy was to 'lose no

time in petting each other among those Cumberland fishponds, but to dash straight at the Alps'.

To add to the complications, the political situation on the Continent was becoming unstable. There was rioting in Paris and Lombardy was troubled. John thought that they might reach Chamonix 'before anything serious takes place', but only if they moved swiftly. Even London was not immune to the political upheavals that were gripping Europe. It seemed that the working men of Britain were agitating for the vote. Some activists wanted to present a petition or charter to the Prime Minister. The capital was anxiously waiting for the great Chartist demonstrations planned for early April. The Government was so concerned about the processions and open-air meetings becoming violent that they drafted in thousands of special volunteers to guard the Queen and Parliament and prevent looting.

In the end, Effie was married on 10 April 1848, the same day that the Chartists marched on Hyde Park. She and John were bounced into setting a date in Lent because of the revolutionary upheavals engulfing France. Uncle Andrew summed up the mood of many people, watching as chaos swept the Continent: 'It appears to me,' he wrote, 'very like the commencement of the desolations predicted by the Apocalypse.' Political, spiritual and personal difficulties collided, so that the timing of Effie's marriage could hardly have been worse. Her father was close to bankruptcy. He had invested in the new Boulogne–Amiens railway company. It should have been a sure-fire winner, but as revolutionary fever took hold in France, King Louis-Philippe was driven out of Paris and fled to England. In the turmoil that followed, Mr Gray's speculations turned sour. And now he had to pay for Effie's wedding party and her trousseau.

John and the Ruskins had known about Mr Gray's financial difficulties for several months, although they later accused Effie of keeping them in the dark and then 'breaking her faith to a poor lover' so she could marry John for his money. At the time, however, the Ruskins' letters showed some sympathy towards Mr Gray and his money troubles. John admitted that he was aware of them when he proposed to Effie. In fact, he wrote, it spurred him on to ask for her hand sooner. John James Ruskin criticised George Gray for gambling on the railways: he called them a deformity on the face of a beautiful country. Still, he was relieved to hear that Effie's father was not entirely ruined, as he had feared. Mr Ruskin agreed to settle £10,000 on Effie, so that

she would have a quarterly allowance of £25, and he would pay all the travel costs for Effie and John's honeymoon. He also presented Effie with a necklace worth nearly £50 as a wedding present. But John's friends were mistaken when they later reported that Mr Ruskin paid off George Gray's debts. This was just another piece of malicious tittle-tattle spread abroad when the marriage failed.[29]

As the wedding day approached, John travelled north to see Effie and her family. The engaged couple managed to snatch a few moments alone together in Edinburgh at Andrew Jameson's house. This was the first time they had set eyes on each other since their engagement. Like true lovers, 'they seemed wonderfully insensible to the obtrusive world' around them. According to Uncle Andrew, the bridegroom was a changed man. He had shaken off his habitual air of suffering and sadness, and in Effie's company at least, he was happy and affectionate. While John was visiting the Jamesons it became clear that his parents were not going to make any attempt to witness the wedding. Old Mrs Ruskin simply refused to set foot in Bowerswell, and her husband claimed that he hated staying away from home. Oddly, this homesickness only seemed to afflict him when he was expected to travel to Scotland. He was perfectly willing to sleep in a strange bed when he set out on his grand tours of Europe. So, as the marriage day dawned at Bowerswell, John only had one friend, William Macdonald, to support him. Effie, for her part, was surrounded by her parents and little sisters, intensifying John's feelings of isolation. He was also suffering from a dreadful cold which made him uncomfortable and crotchety.

While Effie was helped into her bridal gown by her mother, John paced about the gardens, contemplating the ordeal to come. In his mind, Bowerswell was haunted by his mother's tales of ghastly death and madness. It was hardly an auspicious place for him to start married life. We find an echo of John's gnawing fears in a drawing made a few years later by his young protégé John Everett Millais. In his sketch of *A Ghost Appearing at a Wedding Ceremony*, Everett imagined a bride at the altar refusing to say 'I do'. Terrified, she is pointing to a figure standing behind the bridegroom, a figure only she can see. It is the spectre of her former lover, clutching his breast. The bride has broken her promise to remain faithful to him in life and in death, so now her lover has appeared, shattering her hopes of happiness. The themes that Everett teased out in this picture can be read as a perceptive commentary on John and

Effie's wedding day, tainted as it was by memories of untimely death, undercurrents of insanity, even the refusal to fulfil the marriage vows. At the time, of course, Effie had more immediate and tangible worries. It was only in hindsight, as both she and John confided in Everett, that the wedding seemed ill-starred.

At 4 o'clock on 10 April 1848, Effie appeared at the door of the drawing-room at Bowerswell, with little Sophy and Alice by her side. All eyes were upon her as she stepped into the over-heated room, crowded with friends and neighbours and heady with the scent of flowers from her father's hothouses. She saw the familiar face of the minister of Kinnoull, waiting for her by the bay window, and then John coming forward to take her hand. The service was short, but, according to Mrs Gray, trying. Effie and John both seemed apprehensive as the Reverend John Edward Touch blessed their union. And then, as soon as it was over, they were away, leaving the wedding party to drink their health and enjoy the bridal cake.

Alone, exhausted and headachy, they arrived at Aberfeldy in the early evening. John persuaded Effie that they should not tell the hotel that they were on honeymoon. 'Newly-married people,' he said, 'who are much in love make themselves ridiculous.' Effie was too tired to argue. At bedtime she was relieved that John took one look at her, standing white and shivery in her chemise, and turned away. In the letter she wrote to her mother the next day, nothing appeared amiss. John, she confessed, was exceedingly kind and thoughtful. For his part, John told a friend that he was enjoying a rest with his wife among quiet hills, recovering trust and tranquillity. But night after night, as the same thing happened, Effie started to become uneasy. She claimed later that she knew little about 'the relations of married persons', but she had watched her mother go through enough pregnancies to know that there was more to marriage than walks by the water's edge and suppers by the fire.[30]

What went wrong at the critical moment on their wedding night? This is the central mystery of Effie's life with John. The answer lies hidden behind the curtains drawn tight around her canopied bed. But we can piece together enough snippets of evidence to construct a plausible explanation for John's bizarre behaviour. At first his reluctance to consummate the relationship appeared quite reasonable. He was feeling unwell from a head cold that he could not shake off, and Effie was worn out with worry about her father. It

would take a while for her to come to terms with leaving home while her family's finances were so precarious. John did not want to shock Effie by forcing himself upon her. He also realised that it would be very inconvenient if Effie became pregnant before they reached Switzerland. Given her own mother's fecundity, Effie could have expected to conceive fairly easily. She would be no help to John in his researches if she was carrying a child. He wanted Effie to keep up with him on his stiff Alpine climbs. At least in the early days of the marriage, John seemed to be motivated by concerns for Effie's well-being. Sex was not ruled out, it was just postponed until they had finished travelling. Then he would explore and conquer her. John imagined his bride as a glacier, 'soft, swelling, lovely, heavenly to the eye, but beneath there are winding clefts and dark places where men fall'. He day-dreamed about Effie's 'next bridal night': 'I shall again draw your dress from your snowy shoulders,' he wrote to her, 'and lean my cheek upon them.' But even in this erotic fantasy, John imagined her as pure, pale, intact.

As the days turned into weeks and then into months, Effie became unsettled. She started to question John: why would he not touch her? At first she could take refuge in the knowledge that they had married in Lent. It was unwise to begin a physical relationship at a time of strict self-discipline, when pious couples abstained from sex. Yet even after Easter Sunday, John still refused to make her his wife. No longer able to play the religious card, John came up with alternative excuses: he disliked small babies; having a child would interfere with the routines of his working life; pregnancy would destroy Effie's girlish beauty. And then, as she pestered him for an answer, he delivered a blow from which Effie never fully recovered. John told her that he had been 'disgusted with her person' when he first saw her on their wedding night.

What did John mean by this? Did he really believe that his bride was as hairless and smooth as a classical nude? Ever since this comment became common knowledge, Effie's pubic hair has been blamed for the breakdown of her marriage. More recently some historians have shifted the focus of attention a little higher: perhaps John did not even see Effie fully naked, and it was her hairy underarms that repulsed him as her nightgown slipped from her breast. Both of these theories seem far-fetched. John was not as naive as some of his supporters have suggested. He admitted quite openly to his mother that he had seen drawings of 'naked bawds' while he hobnobbed with

aristocratic young men at Oxford. These pornographic pictures showed real women, not idealised, unyielding, marble statues. It must have been something else that made him recoil from Effie.

It seems likely that all the toing and froing about dates was the real reason for the failure of Effie's honeymoon. Effie miscalculated. She married at the wrong time of the month. Effie's hairiness was not the problem; John would have been prepared for that. But if Effie was menstruating, John's shocked reaction seems much more understandable. Effie would have struggled to conceal her bleeding. It was a messy business of torn rags, crimson against the whiteness of her fine linen. John was a fastidious man, and he found he could not cope with his flesh-and-blood wife. The marriage was effectively over as soon as it began.[31]

Chapter Four

The Ruling Passion: Effie in London and Venice, 1848–50

I N THE FRAGILE SUNLIGHT of an April afternoon, John rowed Effie across
Lake Windermere. They came to the shores of an island, where anemones
and primroses carpeted the ground beneath budding trees. Entering this
temporary Eden, they discovered tiny, star-like flowers, the promise of wild
strawberries. In their small boat they had found peace. The wedding had been
so rushed, and everyone so upset and unwell, that Effie hoped to stay here a
little longer. But John was eager to show her real mountains that dwarfed the
peaks of Skiddaw and Cawsey Pike. He hurried her home to Denmark Hill.

Effie felt she barely had time to catch her breath as Mrs Ruskin began
fussing around her. Still grubby and stiff from her train journey, John's bride
faced a welcoming party of maids and kitchen staff in their neat white caps
and green ribbons. As they bobbed their curtseys, the gardener presented Effie
with a vast bouquet. He had chosen with care, each bloom fitting for a new
wife: orange blossom, myrtle, delicate heathers and geraniums. Over dinner,
John's parents fretted about the latest news from France. There were barri-
cades on the streets of Paris and stirrings of republicanism to the borders and
beyond, into Hungary and Italy. Having urged Effie into an early marriage so
that they could honeymoon in Switzerland, John announced that the plan had
changed. He feared it might be ten years before they could cross the Channel
in safety. So he and Effie were going to stay in London and attend the private
views of the annual exhibitions.

John tipped Effie into the heart of the art world and left her to sink or
swim. Only her charm and quick-wittedness saved her. John decided that
Effie should make her London debut at the Old Watercolour Society's
Exhibition. Effie took old Mr Ruskin's arm, and nodded and smiled as John
sauntered off to the far side of the gallery. She had been married little more
than a fortnight. She had done her best to satisfy John's exacting eye. Nothing

45

too conspicuous, he said, nothing too bridal. The sheen of her pale silk gown and gloves echoed the quiet pleasures of the landscapes and still lifes around her. John walked slowly around the room, stopping occasionally to consider the beauties of a bird's wing or the shading of a sunset. Standing near the door, separated from her husband by the press of bodies, Effie could barely see the pictures. She was too busy remembering names and faces, sorting the painters from the patrons. Her father-in-law pointed out three duchesses and Effie took note of how they trimmed their bonnets, to pass on to her mother in her next letter. She shook hands with a succession of greying men, the artists of the Academy: Landseer, Roberts, Taylor, Cox, Prout. They made weak jokes about John's improved appearance.

John was uninterested in the niceties of London life and ignored the overtures of influential gentlemen. As his own father acknowledged, John was more impressive in print than in person. But Effie wooed these men on John's behalf. One of her conquests was the elderly poet Samuel Rogers. Seeing her adrift among the watercolours, he immediately invited her to one of his famous literary breakfasts. At eighty-four, his memory stretched back to the days of Byron, Shelley and Wordsworth, and he was proud of his Romantic friends, long dead. So Effie found herself a few days later sitting at the poet's right hand, as he busied himself cutting the crusts off her bread. Rogers's breakfast table was a thing of beauty. Effie admired the sparkling cut-glass dishes brimming with warm rolls, preserved fruit and exotic flowers. Rogers said he liked to save the crumbs for the birds that flew over to his window from the Palace gardens. Effie was enchanted by the old poet's mixture of whimsy and erudition, and she was flattered by his attention. As she looked through a portfolio of prints, Rogers patted her on the cheek and declared she had fine taste. Her delight in his drawings by Lawrence, or his painted panel by Giotto, or his letters from Washington and Dryden, went beyond a simple appreciation of their rarity. She was learning from her husband and her eye was becoming more attuned to the beautiful.[32]

John had a particular interest in Rogers because of his collaboration with J.M.W. Turner: Rogers's reminiscences of his travels in Italy had been illustrated by Turner. In 1831 John was given a copy of this book as his twelfth-birthday present. It had sparked the start of his love affair with Turner's work. In the opinion of Rogers, Turner was 'a man of first-rate genius in his line'. For John he was the ideal artist, the hero of *Modern*

Painters, 'the greatest man of our England'. Making their way home after breakfast, John was moved by the morning's conversation to suggest that they should look in on Turner. He lived close by, in Queen Anne's Square. Effie had met the painter at Denmark Hill on her last visit: John had engineered a dinner party so the great seer could cast his eye over her, but she had never been to his house before. She was unprepared for the poverty. The contrast with the splendour of Rogers's parlour was shocking. Effie and John stood on the shabby front doorstep, knocking and knocking again, hearing movements deep within. Eventually Turner himself unlocked the door warily. He kept no servant. He led them into his workroom, 'without a fire, and bare and miserly'. But he was pleased to see them, hurrying off to find wine and biscuits. He toasted the newly-weds and then offered to show Effie his pictures. The most exquisite paintings, works he could not bear to part with, were stacked up in odd corners, leaning against the walls, haphazard, half-hidden. Effie found *The Fighting Temeraire*, 'a steamer drawing a wreck through calm water, and such a sunset as you never see in any pictures but his own'. She told her parents she would have pawned all she had, if only she could take it home. It was not for sale. Sketches were rolled up and stuffed in drawers, only to be exhumed after Turner's death, rotted into holes, falling into dust at the edges, worm-eaten, mouse-eaten. It was John's job, in after-years, to pick his way through them. (John decided to destroy the erotic pictures he found bundled up in Turner's papers, when they were delivered to his desk in the National Gallery in 1857.)[33]

Effie's visit to Turner's home was the most memorable of her outings in the early summer of 1848, because it stood out in sooty black and crimson against the glitter of the London season. Two or three times a week Effie and John took the carriage into town for a party. Effie sent her mother breathless reports of evenings at Lord Lansdowne's house in Berkeley Square. She was a quite a sight herself, in her white tarlatan gown, laurel leaves woven into her auburn hair. Miss Rutherford had layered four flounces of stiffened muslin over shimmering glacé silk, and scattered pale green bows over the skirts and bodice. Effie said her dress looked like silver at night. She relished the spectacle of the gorgeous crowded rooms, lit by clusters of wax lights, the desserts of peaches, melons and sorbets, the frosted silver wine-coolers, the conversations with 'the little Countess, sitting chatting French who ran up to me and said, "Oh! I am so glad to see you again"'. But Effie retained her sharp

sense of the absurd. In her letters we see the two daughters of the Grand Duchess of Saxe-Weimar, tedious-looking young ladies, sitting dumb and uncomfortable beside their mother, and little Lady Morgan, painted up to the eyes, with white net streamers hanging from each side of her head.

Constantly Effie was reminded of the social and intellectual distance she had travelled as John's wife. At home in Perth, her family were respectable and, until very recently, prosperous, but now she was dining and dancing with the English aristocracy while the Grays faced ruin. At this level at least, the marriage was working in her favour. 'I am happier every day,' she wrote to her mother, because John 'really is the kindest creature in the world and he takes a great deal of trouble in teaching me things'. But she could not help imagining what might have been, if only to reassure herself and her parents. Hearing that Prizie Tasker had been at Bowerswell, Effie reflected, 'I think he must have felt it a little, but I never could have been anything to compare so happy or so comfortable with him as with John'. She added, 'John thinks we are quite a model couple and we don't do at all badly together.'

Effie had brought nothing to the marriage except her wit and good looks. John gave her status and purpose, and Mr Ruskin's investments promised her financial security. In many ways she had got out just in time, as her own father was still losing money. Feeling far from home, Effie suggested to John that they should go back to Scotland to see her family, and then on to the Highlands to continue their honeymoon. But, as she told Mrs Gray, 'he shrieks with horror whenever I mention it, so it is no use'. Despite her superficial gaiety, Effie admitted crying herself to sleep at times, distressed by fears for her family. The only thing she could do was send cash, saved from her own quarterly allowance. Effie could not risk offending her father's pride and sense of responsibility. So she posted £10 to her mother, suggesting she split it between charitable subscriptions, and a birthday present for her brother George. She even offered to pay the rent on George's lodgings in Edinburgh, explaining that John never asked what she did with her money once he had handed it to her.[34]

It was on account of George that the Ruskins and the Grays first fell out. Effie's brother was about to turn nineteen, and his parents were naturally concerned about his career. They had paid for his English public-school education, and sent him to study in Germany to improve his chances in commerce. He was expected to earn his living in the City of London. Effie's

father wrote to old Mr Ruskin asking for his advice about the best companies to approach. He even hinted that the Ruskins might offer George some hospitality while he was job-hunting. John James Ruskin did not like to be reminded that his wealth was founded on the wine trade. He had done everything he could to raise his own son above the grubby world of the warehouse and the counting-house. As he said, John might have been a bishop. If young George was training to be a lawyer, following the family line, he would be welcomed at Denmark Hill, but as a broker's clerk it would be difficult: the social chasm was too great. John and Effie were admitted to the tables of Ministers and Ambassadors, as old Mr Ruskin put it. They were moving in 'distinguished Circles or Coteries'. George could not hope to join his sister's 'Set'. The best the Ruskins could offer George was an occasional Sunday dinner. John agreed. 'I shall make George understand his position,' he declared. 'Effie will have to choose between him and me.'

This disagreement set the tone of many future misunderstandings between Effie's family and John's. The Grays were free and easy in their personal and business dealings. Their quarrels tended to blow over quickly, while the Ruskins stood on their dignity and held grudges. Both families made things worse by circulating letters, especially offensive ones: so Effie saw notes meant for her parents and Mr Ruskin sent his letters to John to forward to Bowerswell. Irritable phrases, written in haste, were chewed over and began to poison the tone of the correspondence between Perth and Denmark Hill. The difficulties about George rumbled on throughout the summer and followed Effie as she packed her bags for the next leg of her wedding tour.[35]

John had a new project in mind: he wanted to tackle the history of Gothic architecture. In part this was a natural progression from his passion for Alpine scenery. John delighted in the essential Northernness of Gothic architecture, its savage beauty, its naturalism. He saw a 'look of mountain brotherhood between the cathedral and the Alp'. As the Continent was still out of bounds, John decided to start with a study of Salisbury Cathedral. So in early July he and Effie set off, staying en route with Dr Henry Acland in Oxford. Here Effie enjoyed teas on the college lawns, dinners in hall and scientific pleasures: she studied the circulation of a living frog under a microscope and visited the hothouses of the Botanic Gardens. John consented to accompany her to a concert in the Sheldonian Theatre. They heard Haydn's *Creation*, which pleased Effie very much, but John thought the music was detestable. It was a

sweltering evening, the theatre was crowded and he read a book throughout the performance. But at least John sat beside her, and was happy to see her smile. The newly-weds might have resumed their interrupted honeymoon on this working holiday, and all would have been well. But Effie had reckoned without John's parents. The Ruskins announced that they would be joining Effie and John in Salisbury.

The ten days in Salisbury were a disaster. John's father had a stomach upset and his mother was suffering from a heavy cold. John developed a cough. Effie watched as Mrs Ruskin fussed over him: 'Don't sit near these towels, John, they're damp' and 'John, you must not read these papers till they are dried.' Effie claimed she barely heard him cough when his parents were out of the room. But her husband liked being tucked up in bed, reading, being read to. He had a bedroom to himself and Effie would sit by him all morning, sewing or chatting, drawing or practising her French. As she was the only one of the party who could enjoy the good weather, she took a walk in the afternoons around the town. The Ruskins insisted that Effie be chaperoned by Anne, her mother-in-law's maid, who could never keep up with her. In the summer of 1848 Effie was fit and well, able to stride out and shake off the atmosphere of the sickroom. But by Christmas she was chronically ill.

What was the reason for Effie's declining health during the autumn and winter? We find a clue in a callous joke that John made in Salisbury. Mrs Ruskin suggested that the young couple should occupy separate bedrooms in the hotel, because John was poorly. But his father hinted that there was another reason. Mr Ruskin thought that John was being a considerate husband: having recently had sex with his bride, he was giving her a few nights off. When John told Effie about this, he laughed and said 'his father was imagining things very different to what they were'. John was beginning to tease Effie about their lack of lovemaking.[36]

The Ruskins cut short their time in Salisbury and returned to Denmark Hill, cross and feverish. John was sent to bed, smothered in coverlets. His mind was seething with details of spires and tracery, trying to unravel the complex lines of the cathedral he had been studying. He longed to compare Salisbury and the other English shrines with Continental examples. The newspapers said that the troubles in France were over, for a while. John was triumphant when he heard about mortars and howitzers pounding the streets

of Paris, and the rumours of 15,000 dead: 'it has shown to the mob that they are not omnipotent'. Now that the revolutionaries had been beaten back from the barricades, John could take Effie across the Channel at last.

Effie always dreaded sea voyages. She had spent unhappy nights steaming from Dundee to London Docks as a child. Her passage to Boulogne was no better. Effie, John and Mr Ruskin travelled together on 9 August 1848. It was a fine afternoon, but as soon as the ship left port Effie had to go below and lie down on a bunk. Both cabins were crowded, and Effie had gentlemen lying at her head and her feet, she said, and a number of fellows squashed on the floor. After two or three lurches all the unfortunate passengers were heaving. Effie reckoned she was dreadfully sick about eight times. John and his father, seasoned travellers, stayed on deck. Old Mr Ruskin came down once to check on Effie and said that it looked 'like a scene of the plague'. Once on dry land, the Ruskins broke into raptures about being back in France. John's father put the young couple on a train for Abbeville, and Effie was finally alone with her husband.[37]

John began to work frantically, from six in the morning till the light failed, sketching, writing, ranting about the destruction of the medieval buildings around him. Effie could see his despair: men were 'actually before our eyes knocking down the time-worn black-with-age pinnacles'. She worried that she would have to step in to stop John doing something desperate. He was threatening to throw himself at the workmen on their scaffolds. She followed him through the backstreets of Abbeville, Rouen and Falaise. John praised her fearlessness of dark passages and dirt. He seemed not to see that Effie had no choice but to go with him, otherwise she would be left alone all day in the hotel. It would have been quite improper for her to explore on her own. John grudgingly accepted her presence and carried a camping stool for her in his pocket. So she sat quietly day after day in chilly abbeys or on hot steps, copying John's notes, attempting some slight drawings of her own, while he scrambled about the stonework. John made no concessions to his wife. He claimed he had no idea of the effect of fatigue on women. He refused to 'stop with Effie to look at the shops, the flowers or the people'. He reduced her to tears, and did not know why.

Effie bore the expedition well enough for the first month. She was amused, fascinated and appalled by the strangeness of Normandy. Effie described the dreadful smelly cheese of Lisieux, 'small, made of cream and kept until it is

in the last stage of decay'. She braved an inn where the floor was so filthy that the hem of her gown was soiled as soon as it touched the ground. She drank her breakfast tea out of a bowl. She sat through her first Mass, reading her English prayer book during the service, confounded by the mixture of the solemn and the ridiculous she saw there. She talked to the old women of St Lô in their long lace caps, while John made a sketch of the façade of the cathedral, sitting in a wool-comber's shop, 'not a very healthy or clean place'. She looked forward to an evening walk with her husband. She filled her time.

Then, as the weeks passed, sad news started to cloud the letters that Effie received from Perth. Her Aunt Jessie's newborn son died on 21 August 1848. It had been a difficult birth. Jessie was in an exhausted and precarious state and, after a month-long struggle against puerperal fever, Effie's aunt passed away. The Grays wrote to John, thinking it best that he should tell Effie gently. He kept the news to himself for two days, and then, when he did break it to her, he was irritated by his wife's grief. She was blinded by tears, and her head ached so, she could scarcely write to her mother. Obliged to stay with her in the hotel while she sobbed, John complained that he had lost the best part of the working day. Later he admitted to his father that 'even when Effie was crying last night, I felt by no means as a husband should'. It was a bore, but he comforted her in a dutiful way, he said. John was bound up in his own agony of measuring, analysing, copying, rescuing the relics of a medieval world that were being pulled down around him. He was fighting a single-handed battle against the Restorer and the Revolutionary.

Effie's heavy coppery hair started falling out in handfuls as she brushed it. John merely noted it as an additional expense: eighty-two francs for a hair-piece to pad out her thinning tresses.[38] He bought the artificial hair in Paris, where the couple spent a few uneasy days before they turned towards home. The city still bore the marks of fighting. The political situation was volatile and there were few tourists. Even respectable travellers were looked upon as potential insurgents. Effie had to stand aside while her bags were unceremoniously opened and rifled through by soldiers; they seemed to think she might be running guns to the radicals. But for John it was a price worth paying if it meant he could stand in the shadow of Notre Dame. This, he said, was an essential part of his research for *The Seven Lamps of Architecture* (1849). Effie was unimpressed by her first sight of Paris. In the aftermath of

the June massacres, she found none of the gaiety here that she loved in London. She was happy to leave for Calais and the steamer home.

This crossing was more comfortable, and Effie had the Ladies' Cabin to herself. The ship docked in Dover at one o'clock in the morning. Then the captain announced that he expected all his passengers to get ashore by crawling on their hands and knees across a ladder. It was pouring with rain and the deck was slippery. Effie watched silently as a young man ahead of her began to slide off the ladder. He clung on above the black water while the boat pitched up and down, and was only saved by a sailor grabbing him and pulling him back. Then it was her turn. She crept across, her skirts tucked up as best she could, grateful for John's advice about simple travelling dresses. Later, writing from the stifling security of Denmark Hill, Effie told her mother that she shuddered to remember that moment.

At least Effie would not be living under the Ruskins' roof for much longer. Very soon she would be mistress in her own home. Her father-in-law had agreed to pay the rent on a stylish townhouse just off Park Lane. At 31 Park Street she would be a few doors away from Lady Davy, the charming widow of the inventor Sir Humphry. Lady Davy liked to gather literary and scientific men around her, and she offered to take Effie under her wing. Over tea she would gossip about the Queen, politicians and courtiers and the exiled French king, Louis-Philippe. She introduced Effie to her grander neighbours and showed Ruskin's young wife how to make connections that would be both pleasant and useful. Old Mr Ruskin was delighted. It was worth every penny he paid for Park Street, if John and Effie could place themselves at the heart of London society. When John told his father that he had received a letter from Lord Eastnor saying, 'I heard of your Marriage last month quite accidentally from Lady Stratford Canning at Constantinople', Mr Ruskin could hardly contain himself. He wrote to Mr Gray to let him know that their children were being talked about in the best circles. This visibility would backfire when John's marriage began to falter. But for now, his son and daughter-in-law seemed content.[39]

Whenever she was free from the watchful eye of Mr and Mrs Ruskin, Effie was able to bloom a little, and John also breathed more easily. One afternoon when the old couple were away, John and Effie slipped into the garden at Denmark Hill and climbed a haystack. Their little dog Mungo jumped all over John as he fell deep into the straw, and they collapsed in giggles. They dusted

themselves down, before feasting on strawberries and cream. Then they strolled to Dulwich to feed the swans and watch Mungo swimming in the pond. Effie loved having a dog at her heels. After Mungo, she was given a little white spitz called Zoe, who was hurt jumping from a window of the Hôtel Meurice in Paris in the summer of 1852. Then Effie owned Roswell, a great Irish wolfhound who loped along beside her; and, much later, Bodo and Dachs became her family pets. John seemed happy enough to have a dog in the house, even though he had been bitten by a Newfoundland called Lion when he was a little boy. The left side of his mouth still bore the scar.

In Dulwich, John took Effie to the Picture Gallery for the first time, and they quietly looked at the paintings together. On days like this it seemed that their partnership might prove successful at last. Effie was eager to settle into her new home. She asked her mother to send bed-linen from Bowerswell to get them started, and she wanted advice on hiring servants and entertaining. She had learnt the art of housekeeping from watching her mother, and had stood in for her when she was confined, but Effie was still excited to have her own establishment. She sent notes about her party plans for Mrs Gray's approval: roasted snipe for supper one evening, then a more elaborate menu for her old friends the Pagets. Their dinner started with sole in shrimp sauce, then pheasant with bacon (a French recipe, Effie said), mutton, little tartlets, custard and very fine pancakes. They finished with fresh and preserved fruits, nuts and sweetmeats, because John always liked dessert. As he explained to his father, Effie 'seems to like the idea of keeping house'. John went on, 'so should I well enough'. But then he faltered, 'How will you and mother manage – at all – when I am so near and yet not with you in the evenings?'[40]

There were four people in Effie's marriage: the young couple and the old Ruskins. Effie and John were unprepared for the realities of married life, but they would probably have forged a working relationship if they had been left in peace. It was never going to be easy for Effie, being yoked together with a man she barely knew. Yet John might have been persuaded, in due course, to overcome his dislike of babies. He even revealed, in one surprising letter, that he would like a little girl of his own. But Effie could never cut the cord that attached her husband to his home. John's parents would always come first. When she married him, the older Ruskins hoped to gain a daughter, but they were not prepared to lose a son. He was their only child, and as they got older they needed him more, not less. They wanted Effie to join their inner circle,

to sacrifice everything to her duty to them. But she was reluctant to become enslaved to the Ruskins. She had an independent spirit. In an unguarded moment Effie confided to Mr Ruskin that she day-dreamed of flying across a desert on horseback, rather than sitting at her husband's feet.

The Ruskins began to voice their disappointment: they were puzzled by Effie's petulance, vexed and wounded. They started to question the match, suggesting that the young people 'never appeared to have more than a decent affection for each other, John being divided between his pictures and his wife, and Phemy betwixt her husband and her dress'. Effie's own father tried to warn the Ruskins that the best way to see the young couple happy was to leave them alone. Mr Gray wrote to them when he began to realise that Effie was struggling: his daughter 'would like to be treated with the respect due to a wife and not to be treated like a child'. He reminded them that, at Bowerswell, she had shown sense beyond her years. The Ruskins decided that her own parents had spoilt her. This was a battle that Effie was never going to win. John refused to move his books and papers to Park Street and went back every day to Denmark Hill to work.

At Christmas-time 1848, Effie followed John home to his parents. She was expected to stay for a fortnight and fit in with the Ruskins' regime. At Park Street, Effie and John preferred to eat an early dinner at one o'clock, and then have tea in the evening. But old Mr Ruskin liked to dine late and sit up until midnight when he had company. Effie was feeling poorly when she arrived, and the lack of sleep began to tell on her. Her eyes were inflamed and she was coughing and now constantly tired. On New Year's Eve she felt wretched, 'burning hot in the skin, and shivering whenever I moved in bed'. She could take nothing but beef tea. She and John decided it would better if she missed the next big dinner party and went to bed instead. But, as she told her mother, 'I am not allowed'. The Ruskins insisted that Effie dress and come downstairs looking presentable. Mrs Ruskin scolded her and there was a row. The next day Effie was much worse. She had seen two doctors, who could not agree on her treatment, and she was being dosed with a combination of laudanum pills, ipecacuanha and spa water that made her nauseous. Most of all, she resented the way her mother-in-law talked to her like a truculent child. Frustration compounded her physical symptoms.

The only thing that would make Effie feel better was a visit from her own mother: 'Seeing you, and going about with you, will do me all the good in the

world,' she wrote. Mrs Gray arranged to leave the little children at Bower-swell and she came to London in the second week of January 1849. She had not seen her daughter since the marriage last April. It is likely that her mother imagined Effie was pregnant. Only Effie and John knew that this was impossible. Everyone around them was waiting for an announcement that never came.

Effie returned to Park Street to meet her mother, and, as she hoped, began to recover her strength. But back in Scotland, the news was not so good. Andrew Jameson's wife Lexy died in childbed just after Christmas. Sophia Gray received a letter from her grief-stricken brother, describing the baptism of his tiny son. His other little boy had asked, 'Who will teach the baby the pretty hymns our mother used to sing?' Andrew Jameson admitted that he was only keeping himself together by taking regular sips of brandy and laudanum.[41]

Effie's father was also struggling. The Gray children had caught whooping cough from their cousins, but Mr Gray did not want to worry his wife while she was looking after Effie in London. He and Jeannie, their nursemaid, hoped it would pass. His letters convinced Sophia Gray that all was well in the nursery: 'I found them all finishing a hearty dinner and beginning a wild romp,' he wrote. Then Sophia Gray had another note from home. The first part was dictated by six-year-old Robert to Jeannie. Jeannie's spelling reveals her Scots voice, remembered with great affection by all the children she cared for. The note read: 'I have not been very well since you left home, but I am happy to say that I am always able to go Down Stayrs to My Lesson. I have got a new Slate and have begun Figrs. Is there any word of my Ponny for I would like very Much to get one.' Jeannie then added that all the dear children had been suffering from colds. But, more importantly, little Sophy wanted to be sure that her mother would bring her home a doll's bed, and Alice hoped her big sister Phemy would visit soon. And their father seemed happy enough to go out in the evening to hear a lecture on the new-fangled electric light. Mr Gray wanted to find out if it would supersede gas lighting, in which he had a financial stake. (He came to the conclusion that 'it will never do for domestic purposes and I question whether for anything practical'.) Then, after three weeks of dissembling, George Gray admitted that he could not cope. The children were not recovering. They had all lost weight and he was frightened by little Melville's feverishness. He needed his wife at home.

Effie left London with her mother in the first week of February 1849. In one of Mr Gray's letters it emerged that Effie had been planning to go anyway, even before she heard about the crisis at Bowerswell. But she decided to stay on in Scotland because, days after she arrived, her little brother Robert became critically ill. He had hoped for a pony for his birthday, but he died on 1 March. Effie could not leave her mother now. In the past year Mrs Gray had buried both her sisters-in-law, and now her son. She had seen her husband's business ventures turn to dust and she still had four small children to care for. John had already decided to tour Switzerland with his parents in the spring. This was the postponed trip, Effie's original honeymoon that had come to nothing. John doubted that Effie would keep up with his packed itinerary, so he set off without her: eight hours in a carriage from Boulogne to Paris, ten hours from Dijon to Champagnole, nine hours the following day to Geneva. It was worth it, though, for the views when the Ruskins finally reached Chambéry, all the peaks of the mountains as clear as crystal and a cluster of gentians to study. John was in his element. He ended his first letter from the Alps with 'a thousand loves and fond wishes' to his wife, far away in Scotland. They were apart for five months.[42]

This separation set tongues wagging. After it became clear that Effie was not pregnant – the only reasonable excuse for her return – her friend, Jane Douglas Boswell, questioned why she was back at home so soon. John grumbled that his London friends were astonished by Effie's behaviour. Afterwards John and Effie could never agree whether she had planned to go to Bowerswell before he announced that he would be off to the Alps. 'It was not I who left you, but you who left me,' John wrote irritably from Geneva. 'You could not be happy unless you went to Perth.' He called her a foolish little puss and accused her of being proud and impertinent. Then his tone softened. He promised he would always have Effie with him when he travelled in future, if he thought her health would stand it. She took him at his word. When John came to Bowerswell in September 1849 to collect her, fresh from the glaciers of Chamonix, Effie had an inspired proposal. They should see Venice together. And they should set off as soon as possible. Without his parents. He could work and she would entertain herself. He must not worry that she would be bored. She had decided to bring a friend, and together the two young ladies could safely explore the magical city, the 'Queen of Marble and Mud'.

Effie knew it was John's desire to discover the true nature of the Gothic. He needed to get to grips with the architecture of Venice to clarify the ideas that had started to germinate in Salisbury and Normandy. While she was convalescing at Bowerswell, John had asked Effie to help with his research. Would it be very irksome, he asked, for her to note every Venetian gentleman mentioned by Sismondi in his history of medieval Italy? Now she could use her homework to her advantage. In Venice Effie could support her husband's writing and broaden her own horizons, without her mother-in-law looking over her shoulder.[43]

Effie and John had barely a week between leaving Bowerswell and setting off for Venice. On the way, however, they found time to stop in Edinburgh to consult Dr Simpson. Effie had already visited him earlier in the summer. Then he had diagnosed that her sleeplessness, headaches and stomach upsets were caused by an underlying nervous complaint. But he did not pry into the cause. Even though Dr Simpson was the Queen's gynaecologist, he had clearly not asked the right questions. It was awkward for Effie to speak out, and perhaps she could not put her predicament into words. To make her situation harder, on Effie's first visit her mother was sitting just a few feet away. Now her husband was hovering in the background as the doctor examined her. John wanted to talk to Dr Simpson himself, to see whether he approved of Effie's travel plans. The doctor was happy to let her go. So they caught the train to London. John James Ruskin arranged the hire of two carriages to take them across the Channel: one for John, his valet George Hobbs and all his books, and the other for Effie and her friend Charlotte Ker.

Charlotte is a figure who comes briefly into focus and then disappears again. We know very little about her, except that she lived near the Grays in Perth and her father was Secretary of the Scottish National Railway. We read that she sang at Effie's first wedding, but we rarely hear her voice. Her letters have not found their way into the archives. Charlotte embodies the many difficulties of writing about women of the past.

Effie is exceptional. She leaves so many traces – we can see her face, follow the line of her thoughts through the fading ink of her letters, almost hear her laugh. But most women, like Charlotte Ker, or Lexy Jameson, or Jeannie the nursemaid, led unrecorded lives. Their names changed if they married, making it even harder to follow their paths. It seems that Charlotte remained Miss Ker all her life, but even so we soon lose sight of her. She was Effie's

quiet companion, watching as the young Mrs Ruskin dazzled the officers in Venice. She speaks out only once. Effie recorded jokingly that Charlotte was thinking of 'writing a pamphlet on what a husband ought to be, and giving John as a model'. Effie, at this point, seemed to agree with her friend. She knew John was 'peculiar in many ways', but told her mother that 'his gallantry of behaviour to us both is most charming'. Perhaps the key phrase here is 'to us both'. John could be good company, when he wanted, but did not show any special affection towards his wife. In the same letter Effie described her husband as 'considerate'. Did she choose this code-word for sexual restraint deliberately? Was Effie offering her mother a clue to the tension at the heart of her marriage?[44]

Effie had been right to ask John to take her to Italy. On this trip they almost managed to fix their relationship. Effie enjoyed having a new stage on which to shine, and for John, the expedition was hugely productive. John brought his theories to life in *The Stones of Venice* (1851), a beautiful book filled with his own drawings and exquisite passages of prose. It was a radical reimagining of the relationship between life and art. On the surface John's work was a study of Venetian architecture, but at its core was the message that 'art is the expression of man's pleasure in labour'.[45] His celebration of the vitality of the Middle Ages challenged the modern world. Those who read it were forced to feel the gulf between the repetitive tasks endured by a nineteenth-century factory worker and the comparative freedom of a fourteenth-century stone-mason. According to John, Venice was built by men who took delight in the natural world, enjoyed a thriving spirituality and were free to express themselves in their work. The result was a city of healthy and beautiful buildings. John pointed to the carved capitals of Venetian palaces to show what was possible: the best Gothic architecture was joyful, varied and spontaneous. It could 'shrink into a turret, expand into a hall, coil into a staircase, or spring into a spire, with undegraded grace and unexhausted energy'.[46] The Gothic was not just a style, it was a whole way of life. In Ruskin's hands, it could overturn Victorian assumptions about working, thinking, seeing.

When William Morris later read John's chapter on 'The Nature of Gothic', he was smitten. Morris called it 'one of the very few necessary and inevitable utterances of the century'. John seemed 'to point out a new road on which the world should travel'. It is hard to overestimate the importance of this book. John's eye for detail was revelatory. His prophetic tone was inspira-

tional. Some heard it as voice of conservatism, calling a halt to the destruction of the past. For others, like William Morris, Gandhi, even the modern Green Movement, John's words became a rallying cry for the creation of a new world order. Sometimes it is too easy to write John off as a fool, or worse, as a monster. Reading *The Stones of Venice*, even today, his sensitivity and passion become abundantly clear. He was a great lover of language and art and nature. He had a vision of delight, free expression, beauty. Sadly, he was so bound up with the big picture, he failed to see what was needed on a domestic scale. As Effie acknowledged, with half a smile, he was a remarkable writer, but utterly unfit to be sent out to the shops.

John was only able to work if he was left in peace. Effie, John and their companions took rooms at the Hotel Danieli, facing the lagoon, a few yards from the Ducal Palace. Every morning John breakfasted alone, behind the closed door of his study. He often stayed there until dinner. According to Effie, he kept his room so hot that she found it unbearable to spend time with him. He and George Hobbs made forays into the piazzas and churches with notebooks and measuring tapes. While they went in one direction, Effie and Charlotte went in another.

Effie had found the journey arduous. Travelling over bumpy roads in a closed carriage made her feel sick, and her sore throat was troubling her, but they had to keep moving to be sure of crossing the Simplon Pass before the winter closed in. Effie sat with her feet snug inside soft furs and watched a sunset colouring the slopes of Mont Blanc. Whenever they halted she tried to take pleasure in the novelties of each place. In the earliest days of their courtship John had talked to her about the glories of Chamonix. Now at last they found time to walk together in the pine woods, picking cloudberries and speaking to each other in Italian. John introduced Effie to Joseph Couttet, the man who had accompanied him on his Alpine expeditions for the past five years. John valued him not only as a guide, but as a philosopher, friend and doctor. They would continue to walk the mountain passes together until 1876.

Couttet took John, Effie and Charlotte to a wood behind his house. He claimed that it was haunted. He told them that several village children had recently seen a young woman in black standing by the fence. Some of the locals had tried dowsing with hazel twigs over the spot where the ghost had appeared. Couttet's daughter Judith showed the tourists how it was done. They

all wanted to try it. Neither John nor Charlotte found that the dowsing wand worked for them. But as Effie walked to the edge of the wood, she felt the hazel twitching and then slowly turning in her hands. It was an uncanny experience, akin, she said, to mesmerism or natural magic. She could not account for it.[47]

So Effie's abiding memory of Chamonix was not of snow and sunshine, but of deep shadows. In some ways this topsy-turvy experience also set the tone for her time in Italy. In the winter of 1849–50 Venice was struggling back to life after a devastating siege by the Austrian army that had only been lifted in August. Destitute families were sleeping 'packed together at the edge of the bridges, wrapped in their immense brown cloaks'. Old women were forced to sell their heirlooms. Effie was offered a fine lace scarf, 'exquisite, like a gossamer web', for a fraction of its value by an elderly, careworn lady. Yet she barely acknowledged the misery around her, even when she stumbled across it on her way to a party. Effie could hardly have been happier here, waltzing with moustachioed officers, picnicking on the Lido, listening to the organ in St Mark's. For her, Venice was a 'capital place for playing hide-and-seek', and a city where art and life seemed to mingle: 'everywhere you see men, women, children and dogs here that you think have stepped out of the canvasses of Titian and the Bellinis'. Meanwhile these same Venetians went hungry and could only stand and watch as their worthless paper money was thrown onto bonfires.

Effie's paradoxical relationship with Venice was personal as well as political. She often complained of being ill, with stomach aches and bad dreams, nosebleeds and blisters at the back of her throat. Yet this never seemed to stop her attending balls or the Opera, and staying out until the early hours. She lost her voice, but in the privacy of her hotel, Effie danced and jumped around with Charlotte to keep warm. She invested in a couple of badminton rackets so that she could hit shuttlecocks to John across their sitting-room. In her letters she conjures up the strange image of her husband running around a table in a furious game of Tig. Perhaps the greatest paradox was that in Venice, Effie and John were content. As Effie told her parents, 'we follow our different occupations and never interfere with one another and are always happy'. Evidently, their happiness depended on accepting their differences. John had his work, and Effie passed her days, and evenings, in the company of other admiring gentlemen.

Effie had the most extraordinary affect on men. Crossing St Mark's Square in quiet conversation with Charlotte, she was startled to find a bouquet thrust into her hands by a stranger. Even with George Hobbs as her chaperon, men would call out 'dear creature' as she walked by, and follow her back to her hotel. Her gondolier, eyeing her dreamily, complimented John: 'Ah Monsieur, comme votre femme est belle.' During their courtship John had written passionate, possessive letters to Effie. But once she became his wife, his ardour had turned to amusement, and then to indifference. In Venice, Effie declared that her husband was perfectly devoid of jealousy. At the Opera, she said, he liked to see the lorgnettes all turned in her direction, scrutinising her beauty. Her novelty never seemed to wear off. One evening, after she had been in Venice four months, John refused to accompany her to La Fenice, so Effie was obliged to ask her valet not to let any gentlemen into her box. She and Charlotte tried to concentrate on the sublime dancing of Marie Taglioni. But through the closed door they could clearly hear the indignant remarks as gentlemen were turned away, one after another: first a louche Russian prince, then an Italian banker and a Saxon diplomat, and finally several handsome Austrian officers. Effie assured her mother, 'I have no wish for such celebrity.'[48]

But Effie did draw attention to herself. It was unusual to see British ladies in northern Italy that winter, visiting cities scarred by revolution and street-fighting. It was even more unusual to see a beautiful young woman like Effie propelling a gondola along the Grand Canal. John was more than happy to sit back and let Effie take the oar. He thought the exercise would do her good. His father, on the other hand, when he heard, shrank from the idea of 'the Loveliest part of Creation unsexing itself'. John James Ruskin asked what the Venetians would say about Effie's actions. There was a similar question mark hanging over her behaviour when they stayed briefly in Milan. Effie was delighted to pass along the Corso in an open carriage as officers turned their horses to trot behind her, and gentlemen stared open-mouthed, taking cigars from their lips to look at her. She said she felt like a queen. Charlotte, sitting beside Effie, was eclipsed by her friend. She was not elegant. Her gowns were pulled a little too tight across her thickening waist and broad hips. To make matters worse, Charlotte was hopeless at picking up new languages. So, while Effie chattered to all her new acquaintances in a mixture of English, German, French and a smattering of smiling Italian, Charlotte sat mute.

Time and again Effie felt she needed to reassure her mother that her behaviour was perfectly proper. She could not help it if she was accosted by every man with a moustache and a sword that came near her at a café-concert. John, she said, was not bothered by the attention shown to her. In fact Effie thought he would be pleased to see his wife amusing herself with half a dozen of these officers. Unconvinced, Mrs Gray expressed herself more firmly and made plain her concerns about decorum and Effie's duty to her husband. Because, although Effie was reluctant to admit it, there was a problem. His name was Lieutenant Charles Paulizza.[49]

Effie asked Charlotte not to mention Paulizza in her letters home. Did she feel she had something to hide? Effie understood the dangers facing women who loved unwisely, or too much. She met several women in Venice, including the dancer Augusta Maywood and the Baroness Wetzlar, whose affairs were tolerated in Italy but who would not be received in polite society back home. Effie was neither a showgirl nor a Hungarian aristocrat, and she needed to maintain her respectable position. She knew that tales of an Austrian officer's intimacy with a young Scots lady might be misconstrued by the matrons of Perth. So she persuaded Charlotte to keep quiet about her evening games of chess with Paulizza and their pleasant excursions to the outer islands. But she could not conceal her fondness for her new friend from her mother.

We can look over Effie's shoulder as she stands at her open window on Twelfth Night 1850, watching as Venice is transformed by snow. Across the lagoon, San Giorgio Maggiore stands clean and cold, a silhouette against the storm clouds. Effie pulls her blue velvet jacket around her bare shoulders. As she begins to turn back towards the warmth, she spots the tall figure she has been waiting for, pushing through the whirling whiteness. It is Paulizza, half-covered in snow. He is wrapped in a great grey cloak and the scarlet silk lining flashes as he strides towards the door of the Danieli. Effie smiles and steps back into the room, shutting out the wind. By the time Paulizza is shown upstairs, Effie has smoothed her hair, arranged her skirts and is sitting by the fire, reading her Bible, as she does every Sunday evening. When Effie looks up she sees, standing in the doorway, a fair gentleman with bright eyes and long, curling moustaches that mask his mouth, so that she is never quite sure of his expression. Effie and Charlotte agree that he is the most handsome man in Venice. At thirty-eight he is much older than her, older even than John, but

he is so upright and energetic that he seems barely to have reached his thirties. He bows and asks, in German, if Effie is well tonight.

They had met a few days earlier, in the half-light of St Mark's. Effie was listening to an organ recital with Charlotte, when she heard the 'peculiar clank of the Austrian sword on the marble floor'. In a side chapel she saw Paulizza on his knees, crossing himself. As he rose, Effie caught his eye. He had seen her before in the Botanical Gardens, and they had spoken a little then, hesitantly, hampered by his strong Viennese accent. But they liked each other and Effie was pleased to find him again, a friend in a city of strangers. Now she looked forward to his evening visits.

On the surface it was a most unlikely friendship. Paulizza was the officer in the Austrian artillery who had commanded the bombardment of Venice. It had been his job to shell the city, destroying the very buildings that John had come to study. Paulizza embodied the occupying forces that had humiliated and disfigured the Veneto. He even took Effie on a day trip to visit his former headquarters on the island of San Giuliano. Here the ugliness of the war finally came into focus for Effie. Standing on the site of an old walled garden, she could now see only sentry boxes and frozen puddles, earth embankments, 'and I suppose men's bones lying about'. Seven hundred of Paulizza's men died on the little island. It was hard to imagine the softly spoken officer, who so thoughtfully provided Effie with a hot-water bottle for the gondola ride, clambering over the broken bodies of his comrades and ordering his cannons to be directed against the great Piazza. Perhaps that was the reason he sometimes seemed melancholy. For Effie, his complexity made him undeniably romantic.[50]

But why did John encourage Effie's friendship with Paulizza, an enemy of Venice? From the moment he discovered that Paulizza had an eye for the beautiful, he forgave the Austrian his role in the blockade and bombardment. According to Effie, Paulizza was a poet and a singer, a brilliant chess-player and a delightful dancer. He drew, he etched, he could even sew. He also claimed to be a healer. With John's blessing, Paulizza began to treat Effie's chronic ill health.

One of her letters described in breathtaking detail how Paulizza checked her pulse. He rested his fingers first on her wrist and then delicately moved his hand to the nape of her neck, feeling for her heartbeat just below her ear. He noted that Effie's pulse quickened when he touched her gently along her

hairline. 'My dear little sick one,' he said, 'do let me treat you.' John agreed this was a reasonable request. Paulizza thought for a while, and then suggested that Effie should be bled. He offered to attach the leeches to her skin himself, placing eight cups containing the little creatures around her waist. Effie blushed at the suggestion. 'With us, women did these things,' she explained, but Paulizza persisted: 'I shall be as tender to you as any woman.' John laughed. After all, he said he trusted the officer, and he was pleased that such a talented man should flirt with Effie, desire her even. It raised her in John's opinion. She became a more valuable possession.

Many years later Effie's brother George alleged that John had deliberately tried to compromise his wife's reputation. John's attitude to Effie's relationship with Paulizza certainly can be read in these terms. Effie herself confided to her mother that John needed a wife who could take care of her own character. He appeared oblivious to the awkward situations he put her in. John would agree to accompany Effie and Charlotte to a ball. Then, bored, he often left early, expecting the ladies to make their own way home. On one occasion Effie found herself pressed into a quiet corner, fending off Prince Troubetzkoi, who, she said, started making love to her so cleverly that she fled to the safety of the crowded ballroom. She believed he was 'extremely répondu and goes everywhere', but she thought him 'as bad a man as ever I knew'. Soon afterwards she heard the Prince and Paulizza squabbling over who should waltz with her. Still, Effie's flirtatious encounters did not dampen her enthusiasm for these parties. Compared with the fashionable ennui of the London season, the vivacity of Venice was a relief. She relished seeing 'Princes and Princesses, Counts and Hussars, all dancing and enjoying themselves'.[51] At last, tired out and with aching feet, Effie and Charlotte would ask Paulizza to take them home. He walked them back to the Danieli in the early hours, and bade them goodnight.

Neither Effie nor John worried about this arrangement, but it seems they had misjudged the easy manners of the Italians. Young George had been right to question whether Effie should be out late at night with a single man. Effie would not listen to her brother and laughed off her mother's concerns. But then she was warned about her behaviour 'in the gravest colours' by a English new acquaintance, Mr Rawdon Brown, whose good opinion mattered. He was Effie's entrée into Venetian society. Rawdon Brown had come to Venice as a young man in 1833 and fallen in love with the city. He devoted his time

to the archives, cataloguing and editing correspondence between Venice and the Tudor Court. Rawdon Brown had remained in his Palazzo throughout the eighteen-month siege. He even had a tree-house built in the Botanical Gardens so that he could watch the Austrian manoeuvres and see where the shells fell.

Effie and John had been at a disadvantage when they arrived at the Danieli, a mere three months after the end of the bombardment. Unsurprisingly there were only a handful of English people in residence. They could not go into polite society without letters of introduction and they knew no one. Effie wrote to Lady Davy, her London neighbour, to see if she could help, but her replies were a long time coming. Rawdon Brown heard that the Ruskins had arrived, and stepped in. Relations between the Italians and the Austrian occupying forces were naturally strained, but he helped Effie to pick her way through the social minefield. For John, Rawdon Brown was also a great catch. He was scholarly and well connected, with access to the Library of St Mark's and many private houses. He must have been a man of real charm and discretion, as he was one of the very few friends of the Ruskins who managed to remain on good terms with both Effie and John after their marriage ended. He was in London in the spring of 1854 and supported Effie through the difficult days of the annulment. However, unlike her other gentlemen friends, and she had many, there was never a sexual frisson between Rawdon Brown and Effie. He was a bachelor and apparently not the marrying kind. He admired Effie for her perseverance, her cleverness and her beauty. He explained to Effie that she might have difficulty in moving in the very highest circles in Venice as she had not been presented at the British Court. That was perhaps something Effie could address when she returned home.[52]

By early March 1850 John had finished his researches and decided it was time to leave Venice. The night before they set off, Effie invited Paulizza to dine with them at the Danieli. She dreaded saying goodbye. When John bade him goodnight, Paulizza seized his friend in his arms and kissed him on both cheeks. Charlotte, hoping to avoid such a scene, slipped off to bed. Effie and Paulizza were left alone. Her letter home was coy about what happened next. Did he clutch her hand and raise it to his lips? Did he try to kiss her? We will never know, because John suddenly came back into the room and interrupted Paulizza's leave-taking. But Effie did admit that it was terrible to see a strong man weeping, his tears running through her fingers as he took her hand in

his. She wept too. But she was relieved when he left at midnight. The next morning, as Effie was finishing her packing, John appeared in her room with a surprise visitor. It was Paulizza again, cradling a flamboyant bouquet with a white camellia at its heart. He was more composed, and they chatted for a while. He joined Effie by the window as she took a final look across the lagoon, then, taking her hand, he helped her into her gondola. It was the last time Effie ever saw her officer. He was saluting as she drifted away under the Bridge of Sighs.[53]

A Dream of Fair Women: Effie in London and Venice, 1850–3

E FFIE HELD HER BREATH as her maid laced her corsets a little tighter. Effie's room was hot and full of glinting light. In her cheval mirror she could just see the new gown laid out on her bed, yards of billowing white silk and lace. Her gloves and ostrich plumes, still in their tissue-paper wrappings, waited on her dressing table. Melina, her maid, gave another tug and tied the laces firmly. Effie was now ready to step into her petticoats. There was a tap on the door and Miss Rutherford was shown in. She had come to drape Effie in her Court dress. Grace Rutherford looked approvingly at Melina's handiwork, then began to ease Effie into her low-cut bodice. Effie dared not move as the maid and dressmaker circled her, their deft hands fastening and straightening the complicated gown. They fixed the feathers in the twists of her hair. They pinned Effie's train to her shoulders, three yards of gorgeous silk, and looped it over her arm. Now she was a sight fit for a queen.

Since Effie was spending the summer of 1850 in London, Lady Davy had decided that it was time for her young protégée to be presented at the Palace. Until she had the Queen's blessing, the young Mrs Ruskin would not be invited to the very best parties. Effie's neighbour mentioned her plan to a dear friend who was a Lady-in-Waiting to the Queen, and Lady Charlemont agreed to present Effie at the Drawing-Room on 20 June 1850. Effie carried herself magnificently. The whole event was very badly managed, but Effie's letters show that she was amused rather than overawed by the jostling, the heat and the tedium. She watched with astonishment as one young lady became hysterical and was carried out, laughing like a lunatic. Several others collapsed under the weight of their skirts and head-dresses. Effie described the dense crowd, decorated with waving plumes and diamonds. The brightest and best of the Queen's subjects were wedged into the Reception Room at

Buckingham Palace for two hours, waiting for the Guards to let them pass. Effie said she was lucky to find a seat by the door, so that she and John could watch the new arrivals. Ladies elbowed their way through in a most unseemly manner. The carpet was littered with torn lace and crushed feathers.

It was nearly three o'clock when Effie entered the Throne Room alone. Her train was spread out behind her and she heard her name called. At the far end of the great gilded salon, Effie saw the reassuring figure of Lady Charlemont, standing behind the Queen. Effie moved gracefully, tall and unflustered among the ranks of courtiers. She heard whispers of admiration: 'Oh! What a beautiful gown!' She had time to cast her sharp eye over the Queen, 'intensely stout and red', before she kissed Her Majesty's hand, 'fat and red too'. Then her train was flung over her arm by a gentleman-in-waiting and she escaped into the Gallery. Effie found John chatting to friends and together they listened to the music drifting up from the courtyard. By five o'clock she was back in her own room in Park Street. She could breathe again. Effie spent the evening writing home and fighting off a nervous headache. Still, she felt rather pleased with herself.[54]

As Lady Davy had promised, Effie and John found that they were now welcome at the most lavish dinners, receptions, crushes and balls in town. Effie was in her element, her presence requested by the leading hostesses. Effie's letters to Bowerswell gave a taste of the colour and bustle of her London life. One day she breakfasted with Lady Westminster, 'swallowed a mouthful of dinner' at home and then hurried off to the Opera. On another occasion, when she was taken into dinner by William Gladstone, Effie listened anxiously to his defence of Roman Catholic emancipation. And she enjoyed eavesdropping on the Duke of Wellington's flirtatious chatter at the Countess de Salis's party. She also made time to be seen in Rotten Row between five and six most evenings. Effie's figure-hugging riding habit attracted the eye of many smart gentlemen out exercising their horses.

Her husband had mixed feeling about Effie's social success. John was happy enough to see Effie presented at Court and was pleased that Prince Albert had acknowledged her beauty and bearing in the way he bowed to her that day. John even went through the process of attending a royal levée himself on 3 July 1850. He realised that Effie was gathering some useful admirers. She became a favourite of the Prussian ambassador; she was a good friend of the President of the Royal Academy, Sir Charles Eastlake, and his

wife; she amused Thackeray and Dickens with her lively chatter. Soon Effie had 'such a quantity of clever and nice acquaintances' that she was able to establish a small soirée of her own. On Fridays evenings her Park Street drawing-room buzzed with news of the latest novels, pictures and politics. Effie kept an anxious eye on Melina and George as they offered tea and coffee to her guests. She had never entertained on this scale before. Here were thirty of the finest minds in England, all enjoying her hospitality. At last she was starting to realise her ambitions. This was why she had married John Ruskin.

John enjoyed the erudite chit-chat of Effie's Friday 'At Homes'. After all, he had some say in the guest list, and was able to engage with an appreciative audience. But he loathed other people's parties. He would not compromise in conversation and was easily bored. John complained to his mother about a 'horrible party last night, a stiff – large – dull – know-nobody sort of party. Naval people. Very sulky this morning.' He dealt with these situations in the only way he knew, standing with his back to the wall, looking at his watch until he could slip away home to his writing. When they had first returned from Italy in the spring, Effie tried to persuade her husband to stick by her side. But within a few months they had fallen back on the arrangement that had worked in Venice. Effie explained to her mother that 'I think it better to enjoy myself and leave him to his book. He has given me a general order to refuse all invitations for him, and go out every where I like, which I am very happy to do.'[55]

So this is how Effie found herself alone in her room, waiting for a knock at the door. It was the morning of 1 May 1851, and the eyes of the world were turned on London. At the heart of Hyde Park, barely half a mile away from Effie, the treasures of the Crystal Palace were about to be unveiled. It was the opening day of the Great Exhibition of the Works of Industry of All Nations. John refused to have anything to do with the massive public enterprise. He left the house early, as usual, struggling against the stream of traffic to reach his parents' home. In his old study he listened to birdsong floating through the open window. John contemplated the next phase of his Venetian project. In his mind's eye he conjured up details of tracery, mosaics, marble columns. They were the building blocks of his argument, the very stones of Venice that demonstrated the strength and vitality of the Gothic. The contrast with the artificiality of his own time was painful. Contemporary

designers seemed obsessed with surface rather than substance, using veneers and imitations because they were cheaper than the real thing. Sorting through his notes and sketches only reinforced John's sense of dislocation. He wrote later that the Crystal Palace, the wonder of the age, seemed to him merely a magnified conservatory. It was all sparkle and space. How could he celebrate the novelties of Victoria's empire while his beloved Venetian paintings were rotting in the rain, their canvases rent by cannon-shot? As he embarked upon the latest part of his hymn to Venice, John wrote, 'May God help me to finish it – to His glory, and man's good.'[56]

Meanwhile there was little peace in Park Street. Effie could hear the traffic building up around the West End as she dressed to go out. The jam of cabs and carriages stretched along Piccadilly and the Strand, and up to Seven Dials. Half a million people were on the move. Effie for once was grateful to her father-in-law. He had had the foresight to buy her a season ticket to the Great Exhibition, which meant she could also attend the opening ceremony. And despite her husband's misgivings, she was looking forward to it. The Exhibition had been the talk of every party since it had first been mooted over a year ago, and both Lord Glenelg and Charles Newton, an old friend of John's from Christ Church, had offered to escort Effie. She waited for her chaperons to arrive.

It was a little before eight o'clock when the two gentlemen reached Effie's front door. Taking Newton's arm, Effie stepped out into the mêlée of the street. The brougham could make no headway in the mass of traffic, so Effie and her friends walked to the Crystal Palace. As they got closer, she could see the vast iron-and-glass showcase glittering in the early morning light. Effie thought it was quite perfect. She had plenty of time to admire the building, as they had to stand outside the entrance for half an hour, waiting for the gates to open at nine o'clock. Effie was glad of the gentlemen's assistance when she tried to squeeze through the turnstiles, as she was hampered by the swinging cage of her crinoline. Writing to her mother the next day, she said the crush and confusion were as bad as parties at Court.

But Effie fared better than most. Many of the gentlemen she knew had four ladies apiece to look after, and she watched them trying to find seats for all their party, taking charge of cloaks and bags and directing the ladies towards the public conveniences. (These new-fangled water-closets became quite a feature of the Exhibition. For many visitors to the Crystal Palace it was the

first time they had encountered a flushing toilet. The gentlemen's urinals were free, but ladies had to 'spend a penny'.) Lord Glenelg secured a seat for Effie on the judges' platform, and stood behind her. From her vantage point, Effie could take in the whole panorama.

Ladies dominated the scene. *En masse*, their bright cashmere shawls, large bonnets and skirts seemed to fill the galleries and aisles. The Queen's Ladies-in-Waiting were particularly prominent, in their jewel-coloured silks, raised above the crowds on the royal dais. Effie admired the gowns of Lady Douro and Lady Charlemont, both dressed in golden-yellow and decked with diamonds and feathers. The sheer number of women was impressive. They had clearly taken advantage of the reduced rate for ladies' season tickets – two guineas rather than the three that gentlemen had to pay – and they brought their children too. Effie waited and watched as the fluttering crowds finally settled. By midday it was growing warm. The Crystal Palace was, after all, a giant greenhouse. The organisers hoped that the newly fitted blinds in the vault would help.[57]

Effie looked over the heads of the crowd and considered how she would describe the building to her parents. It was cross-shaped like a cathedral, with a nave and two transepts. The royal party's chairs were arranged on the spot where the high altar would stand in a church. But it was also like a railway station. The building was put together by the team at Fox, Henderson & Co., who were now working on the great arches of Paddington Station. The Crystal Palace's massive iron girders were painted in primary colours and the galleries were hung with red and gold banners, and lit by crystal chandeliers. Perhaps the most impressive things inside the structure were the elm trees. Effie had written to her mother some months before about her concern that they should be 'saved from the hatchet'. And here they were, dwarfing the marble sculptures and fountains clustered around the crossing point in the middle of the building. It was a tribute to the flexibility of Joseph Paxton's design that he had been able to turn a flat roof into a barrel vault, taking the iron skeleton up over the tree tops. Potted palms placed under the elms increased Effie's impression that she was sitting inside a hothouse.[58]

A great crescendo from the organ announced the arrival of the Queen and the Prince Consort. The Exhibition was Prince Albert's project: it gave him the chance to demonstrate his unrivalled skills as a manager and motivator to a sceptical British public. The plans for the Exhibition were initially con-

demned as an expensive catastrophe, but once the building began to rise in Hyde Park, the press changed its tune. Paxton's pre-fabricated palace was slotted together with astonishing speed. The *Illustrated London News* kept its readers abreast of every development. In January it reported on the raising of the roof girders in the nave. As soon as teams of horses had hoisted the great girders into position, pairs of glaziers, perched in little trolleys suspended from the roof, began fitting the panes of glass into each new section. In April it was announced that the Prince Consort and his committee had achieved the impossible: the Exhibition building was delivered on time and under budget.

It was no wonder then that the Queen and Prince Albert seemed delighted as they walked the length of the Crystal Palace. Effie thought she had never seen Her Majesty looking so happy and so well. The royal party were greeted by loud cheers, waving handkerchiefs and shouts of 'Vive la Reine' from French visitors in the crowd. The applause almost drowned out the music of the organ, and a performance of Handel's 'Hallelujah Chorus' by a 600-strong choir could only just be heard. The cheering was echoed by the multitude outside, waiting for the Great Exhibition to be declared open. At that moment the hot-air balloonist Charles Spencer released his guy-ropes and rose up above the crowds. Yet another spectacle was added to the visual feast.[59]

That afternoon, back in Park Street, Effie drew her curtains, shutting out the glare, the dust, the noise, and lay down on her bed. She had to be ready to face the world again in the evening. She had tickets for the Opera. John was not expected back for dinner, so she could not share her impressions with him. Anyway, Effie knew that the Exhibition depressed him. According to John, the Crystal Palace was filled with the 'petty arts of fashionable luxury' and he had no wish to go and gawp at them. He was resolutely swimming against the tide of opinion. Effie, on the other hand, had thrown herself wholeheartedly into the social whirl. She was making a success of her chosen career as a society hostess. She was remarked upon. In the summer of 1851 her face was seen for the first time on the walls of the Royal Academy, in portraits by G.F. Watts and Thomas Richmond. Charlotte Ker, her friend from Venice, bought Richmond's picture. These images showed a demure young lady with heavy-lidded eyes and a rosebud mouth, betraying no suggestion of her turbulent state of mind.[60]

For Effie was deeply discontented. On her visit to Bowerswell in the

autumn of 1850, Dr Simpson had advised her to start a family. Effie kept house for her little brothers and sisters while her own mother gave birth to yet another little boy, Albert. Effie agreed with the doctor that 'if I had children my health might be quite restored'. She tried again to talk to John about her hopes and fears. But to Rawdon Brown, who knew them both well, she admitted that John hated children and thought they would interfere with his plan of study. Her letter concluded sadly, 'I often think I would be a much happier, better, person if I was more like the rest of my sex in this respect.' Yet, despite her hints, none of her friends thought to ask Effie about the real cause of her childlessness.[61]

Effie began to dream of Italy. 'People are very kind to me wherever I go,' she told Rawdon Brown, 'but I would much rather be at Venice.' She longed to look out at the calm, melancholy beauty of the Grand Canal from the window of his palazzo. She missed her Venetian friends. She watched eagerly for their letters in the post. Rawdon Brown was a good correspondent, ready to pass on a little gossip, nothing too nasty, but always amusing. And there was another gentleman Effie was waiting to hear from, another hand she hoped to see on the breakfast table. Paulizza had promised to write, but he had been gravely ill.

Just after Effie left Venice in 1850, Paulizza had been struck down with brain fever, blinded and bedridden for six weeks. His letters were painful to read. He now had only two desires in the world, he said: to visit his mother and to see Effie again. Effie urged her husband to take her back to Venice as soon as the London season ended, but John said he could not possibly go so soon. He needed at least another year to work through his notes. Effie had to bite her tongue and wait. But at least one of Paulizza's wishes was granted. He went home to Graz and seemed to recover a little. His eyes had cleared but his depression never lifted. In the evenings he sat by the fire staring at a daguerreotype of Effie, telling his mother about his beautiful Scottish friend. When spring came again, he was called back to Venice. Paulizza wrote to Effie often, in Italian and in German, but in early July 1851 he suffered a series of paralysing strokes. He died on Friday, 11 July and was buried in the cemetery on the island of Murano. If only Paulizza had held on a few more weeks, he and Effie would have been reunited. By mid-August she and John were on the road back to Venice. They arrived at Rawdon Brown's palazzo on 1 September.[62]

Rather than staying in an expensive hotel like the Danieli, Effie had asked Rawdon Brown to find rooms for them. On this visit they lodged in the Casa Wetzlar, near the mouth of the Grand Canal. Baroness Wetzlar charged them £17 a month for a one-bedroom apartment with a study on the *piano nobile* and servants' quarters on the ground floor. They had use of Rawdon Brown's own cook, and a servant called Beppo who helped Effie with everything from rowing the gondola to roasting coffee. Effie was delighted by the *belvedere* in her apartment, a tiny enclosed balcony overlooking the Grand Canal. She bought a thick white rug and rose silk curtains, and stitched her own cushions for the window seats to make it cosier. Sitting there, in the winter sun, surrounded by pots of orchids, geraniums and camellias, she could listen to the seagulls and dream of absent friends.

Effie and John were conscious that they needed to save money. John's parents had started to mutter about the expensive tastes of their son and daughter-in-law. Was it really necessary, they asked, to travel with a Swiss maid, a side-saddle and so many boxes of books and clothes? John James Ruskin grumbled to Effie's father in one of his letters that 'my son is too fond of pictures and Effie is too fond of dress'. John and Effie were entirely dependent on Mr Ruskin for their income. Sales of John's essays and archi-tectural studies were slow, and certainly did not pay the bills. (Effie claimed that the engravings for the two volumes of *The Stones of Venice* cost £80 to produce, and as each book was being sold for £12, they were losing money.) The older Ruskins were still paying rent on the Park Street house, even though John and Effie only ever lived there for a few weeks at a time. When Effie had gone home to Bowerswell, for instance, John returned to his old room in Denmark Hill. The same thing had happened when she visited the Countess de Salis near Uxbridge at New Year 1851.

In Venice, Effie tried to be thrifty. She calculated that they could live comfortably on £32 a month. At Christmas she told her mother that they never gave parties themselves and she had been careful not to buy new clothes for this trip. Effie fashioned her own accessories, like the little *coiffure* she constructed from scarlet velvet with a fringe of pearls. (John was particularly taken with this head-dress. He said it was 'decidedly Moyen-Age and the prettiest thing he ever saw'.) She even offered to give up her music master, although she never suggested sending back her Viennese piano: it was a lifeline for her. Effie did drop the lessons she had been taking in model-mak-

ing. She had not been making much progress anyway, having learnt to mould only ears and toes. But her plans to retrench were often thwarted by her husband, who had 'a mania for buying old books' to help in his research.

Effie herself was not always quite as careful as she claimed. She had, after all, bought several dress lengths of deep brown velvet at ten shillings a yard when they stopped in Milan. She dressed wonderfully well. One of her most ravishing *toilettes* was a black velvet gown worn with a golden hairnet. Strands of pearls encircled her arms and neck, and were woven through her hair, in imitation of a favourite painting by Giorgione. And Effie did host small soirées for her friends. She was soon mixing with aristocrats and minor royals, and liked to return their hospitality. Her guests for one evening party included the Countess Pallavicini, Princess Jablonowska and General Reischach. Effie had learnt a great deal during her London season. Her entertainments were stylish without being showy. She made the tea herself, as she had done for her Friday salons in Park Street, and her valet handed round fruit and preserves. She took care to notice her guests' little foibles. The Princess, for example, liked to eat only grapes. As usual, Effie managed these events alone. John was often out, or tucked away in his study. He did, as he wrote to his father, 'condescend to go in at the end of the evening – merely to show that I wasn't a *myth*'.[63]

At times when he thought it mattered, John made an effort to be seen with Effie. He accompanied her to the balls held in honour of Field Marshal Radetzky, the Austrian victor in the recent battles for Venice, Verona and Milan. Effie was declared 'Reine du Bal' at Verona. It was after one of these dances that Radetzky's *aide-de-camp* fought a duel with another young Austrian which left him with a nasty sabre wound; they had apparently quarrelled about who should have the pleasure of waltzing with Effie. John was flattered that Radetzky and his officers so obviously admired his wife, and explained in a letter to his father that he took 'pride in seeing her shining in society'. But then he added ungallantly, 'the Alps will not wrinkle – so my pleasure is always in store – but her cheeks will'.

Effie's frantic social life masked the widening gap between husband and wife. Any residual sympathy John felt for his bride had evaporated. Now his work and his parents took priority. In the same letter to his father, written at Christmas 1851, John made plans for the return to London. Number 31 Park Street was given up. The Ruskins would look for a house for their son and

daughter-in-law, close to their own home in Denmark Hill. But John did not breathe a word of this to Effie. He reasoned that the arrangement 'is a necessary one – and therefore I can give her no choice. She will be unhappy – that is her fault – not mine.' John's father agreed, and in his next letter to Venice revealed that 'Mama pronounces *definitively* – she and Effie could not be in one House'. However, the Ruskins could not bear to be far from their son. They came to a compromise that suited them, but put Effie in an impossible position. Without Effie's knowledge, John James Ruskin took a seven-year lease on a house at Herne Hill. It was number 30, next door to the house where her husband had grown up, and within walking distance of his parents. But it was a long way from Effie's friends. John acknowledged that 'her London society will be out of reach'. Suburban life was going to be a dreadful let-down after the glamour of Venice.[64]

Effie's homecoming was lonely and upsetting. John had accepted an invitation to stay on in Strasbourg for a few days, so Effie travelled to Paris by herself, with the servants and luggage. It was a twenty-seven-hour journey, overnight by coach and railway. Effie did not arrive at the Hôtel Meurice until six in the morning on 10 July 1852. She was pursued to Paris by some English friends, Viscount Feilding and his wife, who wanted to convert Effie and John to Roman Catholicism. Effie was willing to discuss her faith, but refused to take the miraculous medal of the Virgin Mary that Lord Feilding offered, and would not say the Ave Maria. Feilding harangued her, calling her 'a Lutheran, a pupil of that evil spirit Knox and on the high road to the bottomless pit'. John evidently thought the whole thing rather amusing. He was curious about the Catholic revival in England and abroad, and happy to hear accounts of recent visions and prophecies. Effie, however, remained sceptical about Lord Feilding's stories of 'bleeding roses, blushing stones, Appearances'.

Effie eluded her fervent friends and travelled back across the Channel with John, reaching the Ruskins' house on 13 July 1852. She was concerned about what awaited her. Effie knew that her father-in-law had been accusing her of extravagance. John James Ruskin complained to Mr Gray that 'the young people spend nearly double their income in a ceaseless round of dressing and gaiety', adding that Effie 'does not lead the life I could have wished my daughter-in-law to lead'. It was hardly surprising that Effie wrote to her father: 'I confess I do not get fonder of them as I get older.' But she could not have anticipated the reception she was given. Mr Ruskin was angry when he

heard that Effie had accepted the gift of a toy dog from an Austrian admirer, Count Franz Thun. He was even more furious when he heard that this count had challenged John to a duel. John had declined to be called out. How could this outrageous situation have arisen?[65]

John tried to explain. When Effie was packing to leave Venice, her jewels had been stolen. She had left their apartment briefly to visit a young Venetian beauty, the Countess Venier, and when she returned she found that all her best things had been taken from her dressing table. She lost a diamond dove, a jewelled serpent, a ruby heart, a string of pearls and her blue enamel earrings. John's diamond dress-studs were also missing. Mary, her maid, said that an English gentleman had dropped by while Effie was out, and asked to leave a goodbye note. She had let him into Effie's room. The gentleman, a Mr Foster, was in the service of the Austrian army. Effie claimed that she 'never thought him particularly *bien élevé*, but John liked his conversation which was always sensible, and for ladies he was always a very correct visitor'. She admitted that 'it seems so dreadful to suspect a gentleman, a soldier, and a friend of our own'. John had gone to the police. But Rawdon Brown sensed that the case could become very awkward. The occupying military authorities would not like to see one of their men caught up in a scandal. Rawdon Brown had advised Effie and John to leave Venice as quickly and quietly as they could. He had heard some unsavoury gossip about Effie and her admirers. Why was Foster admitted to Effie's room when John was not at home? Did this happen often? When Count Thun heard that his fellow officer was being accused of theft, he stepped in to defend Foster's honour. That was how John came to be challenged to a duel.

Effie's diamonds were never recovered, and her memories of Venice were tarnished by the robbery. But the long-term implications were even more troubling. Rumours about her conduct followed her back to London, where the incident was reported in the *Morning Chronicle* of 21 July 1852. The newspaper suggested that John had given Foster's name to the police in a fit of jealousy. Within a week the story was reprinted in at least six other publications. John James Ruskin thought the journalists were insinuating that Effie had visited Foster in his barracks and mislaid her jewels in the officer's quarters. That, of course, was intolerable. He made John write his own account of the theft and send it to *The Times*. John's letter was published on 2 August, but it failed to lay the matter to rest. Foster persisted in telling his

friends that he 'had not proceeded in the affair in mercy to Mrs Ruskin's reputation'. Questions were being asked, in Italy and in London, about Effie's conduct. John had always left her to go about unchaperoned. He had admitted to his father that he 'let her do as she likes, so long as she does not interfere with me'. Just a few months earlier he had written, 'I am always either kind or indifferent to Effie – I never scold. If she did anything definitely wrong – gambled – or spent money – or lost her character – it would be another matter', but according to her husband, Effie was 'very good and prudent'. Now Effie was paying the price for John's policy of indifference. And it brought home the awfulness of her situation. It was almost laughable: despite the whispers, her virtue was entirely intact. No one, not even her husband, had touched her.[66]

Ever since Mrs Gray heard of Effie's independent life in London and Venice, she had worried about her daughter. Effie recognised her mother's fears and tried to explain, without giving away her secret. 'I am so peculiarly situated as a married woman,' she wrote, 'most men thinking that I live quite alone.' Effie was careful. She could not risk 'the only fortune I possess, viz – a good name'. She cut anyone who flirted too ardently. She refused to dine alone with a gentleman – although she made an exception for Rawdon Brown on his rare visits to London. (Evidently it was clear to both Effie and John that their Venetian friend was not likely to threaten Effie's good name.) And she was quick to squash any gossip that reached her ears. She was sharp with her brother George when he told tales about a spoilt young man called Clare Ford whom she met in 1851. Clare liked to follow her around when she was in London, but she assured her family that 'I do not see him at all whilst I am by myself'. Effie was very firm with Clare, refusing to go dancing with him. At one point he became so frustrated by Effie's coolness that he left town for two days, saying she would die of propriety. But Clare's name came up again in the summer of 1852, in the aftermath of the Venetian robbery, and this time John had to step in to calm the fears of Effie's parents. John claimed that it was Effie's good influence that had rescued Clare from becoming an idle lounger in the London clubrooms. And John also promised that he would be working at home more often. Now they were moving nearer his parents, he would not need to leave Effie alone as he had done in the Park Street days.[67]

Perhaps John really did mean to spend more time at home in their new

house in Herne Hill. But he soon drifted back to his old ways. He still kept most of his papers and precious Turner drawings at his parents' home, where the light was better, he said. So Effie had to get used to passing her days in the suburbs. Her new home was ugly and drab. John hated it, saying it was only fit for a clerk to live in, 'a numberless commonplace of a house'. No wonder he went back to Denmark Hill to work and meet his friends. Neither John nor Effie could bear to entertain at Herne Hill, and most evenings they dined with his parents. John James Ruskin had given more than £2,000 to an unscrupulous decorator, who had filled the house with vulgar, overstuffed furniture and 'frightful Kidderminster carpets'. For Effie, the only saving grace was a small conservatory and garden, overshadowed by the neighbour-ing houses. She wrote to her mother that 'the place is inconceivably cockney after Venice', but she went on, 'my flowers amuse me'.

And so the winter of 1852 passed. Effie hardly ever went into London these days. She was worn out with the effort of negotiating with her father-in-law over the cost of hiring a carriage. The Ruskins said she could go wherever she liked so long as she did not 'degrade John by taking him into society'. She could see no way out of her melancholy. Effie was in exile in the suburbs. Her hopes of helping John in his work, as a hostess, as his secretary, as his partner, had all been dashed. He did not want her help. And then one evening, early in the spring of 1853, her husband mentioned that he had been talking to a young artist called Everett Millais. Perhaps she remembered seeing his painting of *Ophelia* at the Royal Academy the previous summer? They had both rather liked it. John had settled with Everett that Effie would model for him. And then perhaps they could all go on holiday together. Surely she could not have any objections?[68]

Chapter Six

Effie with Foxgloves: London and Scotland, 1853

THURSDAY, 14 JULY 1853, Brig o' Turk, Scotland. It was raining again. Effie listened to the steady dripping outside as she sewed. Turning the red woollen fabric, snipping a length of thread, working with her needle along the seam, she kept her eyes lowered. But she found it hard to concentrate, knowing that Everett was observing her. The picture propped up between them acted both as a barrier and a point of contact; the delicate touch of his sable brush was stroking her into life as he mapped the line of her lashes and the movements of her fingers. He studied the changing colours of her hair, learning its variations from chestnut to deepest brown. He explored its weight and softness, and the texture of the foxgloves tucked into its folds. He analysed the curve of her eyelids and lips, her fine straight nose, the surface of her skin. Effie was conscious of the intensity of his look. She was used to Everett's Pre-Raphaelite principles, how he built up his pictures with tiny brushstrokes, rich colours and minute attention to detail. She was glad that she could help to occupy him until the rain stopped, and he could paint by the river again. Yet, in the cramped cottage, this scrutiny of her face, hands and clothes felt more intimate than when she had sat for him in London. There she had been modelling for a large-scale public painting. Now the picture was personal, made for the artist's own pleasure. It was a record of their holiday and an acknowledgement of the growing affection between Effie and Everett.

On the other side of the small sitting-room, her husband John continued with his work, apparently oblivious to the interplay of gaze and averted eyes. He was trying to complete the index for *The Stones of Venice* and was pleased that Everett was keeping his wife company. It meant that he could attend to his notes. John was expecting the first copies of his book to arrive from London any day. He was planning to have one specially bound for

Everett in dark green leather lined with silk. Ruskin wanted to thank his young friend for the numerous little sketches of Effie that he had made over the past weeks.

This second volume of *The Stones of Venice* was about to transform the way artists like Everett thought about their calling. Ruskin was already well known as an opinion-former in Victorian society. With the publication of *The Stones* he became a prophetic voice, crying out against the effects of industrialisation. He wanted to save art from the oppression of a 'quick-fix' commercial mentality.

That summer in Scotland John was trying to discover how the beauty of the Gothic world could be resurrected in Victorian Britain. Ideas of interconnection underpinned his writing in *The Stones of Venice*. They also help to explain his interest in the Pre-Raphaelite painters, and his desire to work closely with Everett Millais. But John was so busy addressing these grand themes that he failed to see the personal drama unfolding in the cottage: Everett was falling in love with his wife.

John's way of looking at the world was shaped by his study of the medieval. However, since his encounter with Everett and his Pre-Raphaelite friends in 1851, John had begun to hope that this 'new and noble school' of British art could take the best that the Middle Ages had to offer and make it live again in modern art. John's perceptions of the Pre-Raphaelites were based on his preoccupation with the Gothic interweaving of art, nature and faith. This coloured his relationship with Everett from their first meeting in June 1851 until their acrimonious parting in December 1854.

We know what John originally thought about the Pre-Raphaelites because in May 1851 he wrote twice to *The Times* to defend them against savage criticism. He refined his ideas in a pamphlet published at the end of 1851, when he compared Everett's art to that of his hero J.M.W. Turner. Then in 1853 John was invited to give a series of lectures in Edinburgh. One of the lectures examined the development of the Pre-Raphaelite project. John wrote this on one side of the room at Brig o' Turk while Everett was obsessively sketching Effie on the other.

Seven art students and aspiring writers made up the Pre-Raphaelite Brotherhood. Everett, his friend William Holman Hunt, Dante Gabriel Rossetti and James Collinson were painters, and Thomas Woolner was a sculptor. Rossetti's brother William Michael and Frederic Stephens wanted to write.

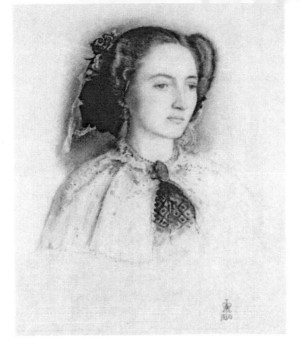

1. John Everett Millais, *Effie Ruskin*, 1853, pencil with watercolour, Geoffroy Richard Everett Millais Collection (© Tate, London, 2010).

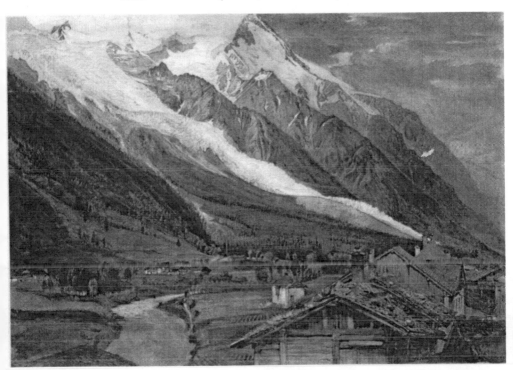

2. John Ruskin, *Glacier des Bossons, Chamonix*, c.1849, pencil, brown ink, ink wash and body-colour, The Visitors of the Ashmolean Museum, Oxford.

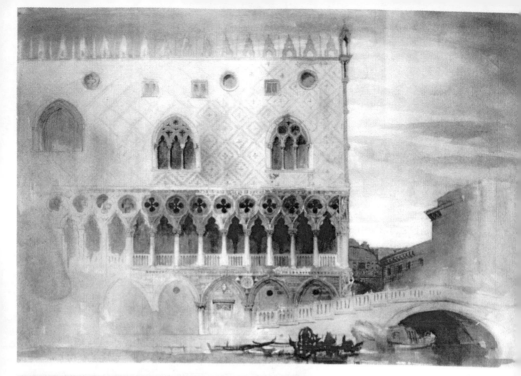

3. John Ruskin, *Exterior of the Ducal Palace, Venice*, 1852, pencil and wash with some ink, The Visitors of the Ashmolean Museum, Oxford.

4. John Everett Millais, *The Order of Release*, 1852-3, oil on canvas, © Tate, London.

William Holman Hunt, *Portrait of John Everett Millais*, 1853, pastel and chalk, National Portrait Gallery.

6. John Everett Millais, *Effie with Foxgloves*, 1853, oil on board, Wightwick Manor, The Mander Collection (The National Trust), © NTPL/Derrick E. Witty.

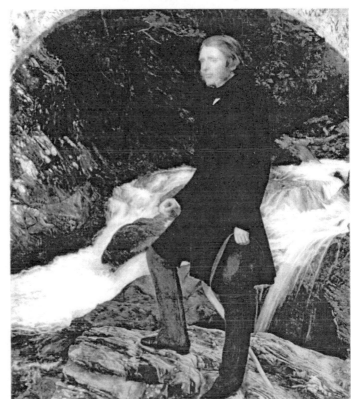

John Everett Millais, *Portrait of John Ruskin at Glenfinlas*, 1853-4, oil on canvas, Private Collection.

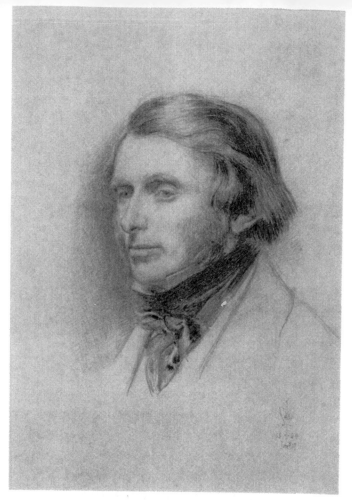

8. John Everett Millais,
Portrait of John Ruskin,
17 January 1854,
pencil, pen and brown
ink and touches of
watercolour, Morgan
Pierpont Library,
New York.

9. John Everett Millais,
The Countess as Barber,
25 July 1853, pen and
brown ink, Morgan
Pierpont Library,
New York.

10. John Everett Millais, *Highland Shelter*, 25 July 1853, pen and brown ink, Private Collection.

11. John Everett Millais, *A Ghost Appearing at a Wedding Ceremony*, 1853, pencil, pen and black and sepia ink, V&A Museum, London.

12. John Everett Millais, *The Race Meeting*, 1853, pen and sepia ink, The Visitors of the Ashmolean Museum, Oxford.

13. John Everett Millais, *Accepted*, 1853, pen and black and sepia ink, Yale Center for British Art, Paul Mellon Fund.

14. John Everett Millais, *The Blind Man*, 1853, pen and sepia ink, Yale Center for British Art, Paul Mellon Fund.

15. John Everett Millais, *St Agnes Eve*, 1854, pen and sepia ink with green wash, Private Collection (© Tate, London, 2010/Tate Photography/Marcus Leith and Andrew Dunkley.)

16. John Everett Millais, *The Young Mother*, 1856, etching on paper, Geoffroy Richard Everett Millais Collection (© Tate, London, 2010/Tate Photography/Rodney Tidnam.)

17. John Everett Millais, *Autumn Leaves*, 1855-6, oil on canvas, Manchester City Art Galleries.

18. John Everett Millais, *Spring (Apple Blossoms)*, 1856-9, oil on canvas, National Museums Liverpool, Lady Lever Art Gallery.

They were young and ambitious, and tired of being told what to do by their teachers. The idea of the Brotherhood emerged in 1848 from late-night conversations at Everett's family home about the future of art and literature. What started as a student lark began to be taken seriously. In 1850 they set up a magazine called *The Germ* to publish their own poems, reviews and illustrations. It lasted for only four issues, but it gave a sense of coherence to the group. Some of their paintings were signed with the obscure initials 'P.R.B.', which made them seem more subversive, like a secret society.

Why did John pick this group of student rebels to be the great hope of their generation? Apart from Everett, they hardly seemed a promising lot, and their early paintings had attracted a great deal of adverse criticism. But, like John, the Pre-Raphaelites were disillusioned by the state of British art. In particular, the young artists had grown antagonistic towards the training provided by the Royal Academy schools. Everett had been studying at the Academy since 1840. He was only eleven years old, a child prodigy, when he was admitted as the youngest pupil ever. Hunt had joined him in 1843 and Rossetti started his studies as a probationer in the summer of 1844. Students were expected to spend up to three years in the 'Antique school', producing meticulous drawings copied from classical busts. Only then were they allowed to sketch from life. This system of training encouraged artists to hide the imperfections they found in living models. They were taught to admire Raphael's art above all. Raphael (1483–1520) represented the high point of the Renaissance, when grace, proportion, harmony of colour and elevated subject matter combined to make the perfect picture. But this left little room for young artists to discover new subjects. And how could they hope to represent the anxieties of industrialised Britain using sixteenth-century techniques?

This was why the Pre-Raphaelites chose their name: these young British artists were sick of looking at the world through the prism of the Renaissance. Instead, like John, they were attracted to the Middle Ages, the world before Raphael and his perfect harmonies. In truth, they had very little first-hand experience of early Italian art. They had to make do with a few prints of frescoes and a fifteenth-century altarpiece by Fra Angelico that Rossetti and Hunt had seen in the Louvre in Paris. To the young artists these images seemed fresh and full of life. They appeared to have been painted with innocent eyes. Each model, from the smallest leaf upwards, was treated as an individual. But when the Pre-Raphaelites began to paint in this way they were

severely criticised for not conforming to academic standards of beauty. This was a real problem when they decided to depict the Holy Family. When, in 1850, Everett imagined the Virgin Mary as a skinny working-class girl in *Christ in the House of His Parents* he was condemned by the critics. Charles Dickens called his work a 'pictorial blasphemy'.

John Ruskin decided to champion the Pre-Raphaelites not because he thought their art was beautiful, but because it was sincere. In his eyes, they painted nature directly, combining modern scientific observation with the earnestness of medieval craftsmen. In their paintings, John was pleased to see that art and nature went hand in hand. He cared for Gothic architecture because artists of the Middle Ages had also clearly loved the natural world. You could see it in their carvings and construction. This was one of his fundamental arguments in 'The Nature of Gothic'. So John was delighted to find the same love of natural objects for their own sake in Everett's paintings, such as *Ophelia*. John praised his attention to the smallest detail: 'the leaves on the branches, the veins in the pebbles, the bubbles in the stream'. Everett was looking at the world with fresh eyes. Truthfulness, sincerity, honesty – these qualities were more important to John than conventional beauty.[69]

We have to remember that John's attitude to art was grounded in his religious faith. For him, good art had to be God-centred. And John saw the natural world, from individual blades of grass to Alpine glaciers, as God's handiwork. As a result, he condemned those artists who tried to smooth out the lumps and bumps of the created world: in their pride, they believed they could do better than God. John wanted painters to get to grips with the idiosyncrasies of their living models, and the Pre-Raphaelites had risen to that challenge. By concentrating on the created world, they seemed to John to have put God back into modern art.

When John first commented on the paintings of the Pre-Raphaelites, in May 1851, he did so as a detached observer. But his dealings with them soon became more personal. He hoped to mould these men to fit his vision for British art, and within days of beginning a correspondence with Everett and Hunt, he was visiting their studios. John wanted to watch Everett at work and guide his choice of subject. He was impressed by what he saw. Everett was always charming. His good looks and natural ability gave him confidence, even in the alarming presence of England's leading art critic. Everett was sociable and gentlemanly, not at all like the bohemian stereotype of the art

student. John enjoyed the time they spent together, and by early July 1851 he had already invited the young painter to join him on holiday in Switzerland later that year. Everett found he was too busy, but the idea of a summer away, painting, writing and enjoying new scenery clearly appealed to both men. What Effie thought about having this young man as a travelling companion, we do not know. Apart from a single brief comment about his *Ophelia* she does not mention Everett at all until March 1853.

And then suddenly we find Effie modelling for him. Day after day, she sits from immediately after breakfast to dinner, then all afternoon until darkness falls. Everett has set up a temporary studio in the Ruskins' house in Herne Hill, so that he can paint Effie. He wants her to model for the wife in *The Order of Release*. According to Pre-Raphaelite principles, he needs a true Scotswoman to represent the determined figure who has come to claim her husband, imprisoned after the defeat of the Jacobite rebellion in 1745. John clearly approved of this arrangement, since it was happening in his own home. He may have thought that it would give him a chance to have a closer oversight of Everett's maturing style.

This was not the first time that Effie had sat for an artist. Just after her marriage, in December 1848, Thomas Richmond had painted her portrait. He drew her again in 1851, and so did George Frederic Watts, whom Effie described as 'the great man of our age in painting'. Effie was flattered by these images, but not entirely convinced. She thought Richmond's picture 'much prettier than me. I look like a graceful doll.' She was unfazed by the fact that both were put on public exhibition at the Royal Academy's summer show. As John Ruskin's wife, she knew that she would always be the subject of artistic interest; it was one of the perks of her position. And her time in Venice had taught her that she liked being visible in society. She had married John in the hope that at least some of her personal ambitions might be fulfilled. To be admired and courted by artists and gallery-goers was a pleasure.

When Everett came to paint her for *The Order of Release* in the spring of 1853, he wanted to present a new vision of Effie. Watts and Richmond had produced conventional portraits of a handsome young lady. Everett wanted to reflect her strength of character and what he called her 'curious' features, by painting her with 'half a smile'. Her face is the strong, pivotal point in the picture. She supports her exhausted child, her humiliated husband and even the dog. Relief, determination, affection all have to be visible.

Everett had left her face till last. The rest of the picture was painted in his studio using professional models, including a contrary baby who 'squalled and foamed at the mouth' until finally falling asleep. Everett decided to paint him like that, collapsed on his mother's shoulder, and be done with it. The dog was no more biddable than the baby. Everett was worn out by the effort of trying to turn these models into a satisfying composition. He complained to a friend that his head ached and he felt as tired as if he had walked twenty miles. But by mid-March he was ready to begin the final section. He had to press ahead as the deadline for submissions to the Royal Academy exhibition was looming.

So Everett arrived in Herne Hill just after breakfast. He needed help getting his canvas out of the cab and up the stairs to the north-facing room that John had set aside for him: the light in here would be even throughout the day, with no sudden bursts of brightness. Everett sat with his back to the window, the cool spring sunshine falling over his shoulder on to the canvas. Effie watched him as he ordered his materials, fanning out his pencils on the table and pinning the heavy sketching paper to a board. Then he moved towards her. He asked her to sit facing him, and then gradually turned her, so that her face was nearly in profile. A gentle shadow fell across her right cheek and a strand of hair brushed her temple. She went to tuck it behind her ear, but Everett stopped her. It softened her fine features. So they began.

He drew confidently. The outline was soon fixed on the paper as he mapped the contours of Effie's distinctive straight nose and arched brows. How could Everett encourage her to keep that strange half-smile that had drawn him to her? He asked her about her family and her home in Scotland. As she thought of her childhood friends, the music and dancing, and the little ones back at Bowerswell, her face showed her remembered happiness. By lunchtime the first sketch was complete.

John was out as usual. He had gone to his parents' house in Denmark Hill to work on *The Stones of Venice* soon after Everett had arrived. So Effie and Everett ate alone. Effie always enjoyed the company of young, talented men, and was keen to hear about Everett's ambitions and his Pre-Raphaelite friends. She knew how to listen. Everett reminded her of their first meeting. Seven years ago they had both been invited to a dance at Ewell Castle. He had been captivated by one of the party-goers, a girl with auburn hair, and longed to be introduced to her. It was Effie. She had forgotten this conversation with

the sixteen-year-old schoolboy. But now Everett was the rising star of the art world, twenty-three and very good-looking. Effie was impressed. When she wrote to her mother, she echoed the opinion of all his friends: 'He is so extremely handsome.' He was well over six feet tall, slim, with clean-cut, boyish features, and his unruly fair hair curled up like a cockatoo. While Rossetti and the other Pre-Raphaelites adopted a deliberately 'artistic' scruffiness, Everett was always smart and gentlemanly. We can see him as Effie saw him, thanks to a pastel portrait drawn by his friend Hunt on 12 April 1853. He wears a neat white stand-up collar and tie, fastened by a fancy pin. Hunt emphasised Everett's soulful expression and his classical profile: he looks like an Adonis in Victorian dress.[70]

After lunch Everett went upstairs to prepare for the next stage. He spent the afternoon transferring the sketch on to the canvas, and then came to say goodbye. John was still not back from the British Museum: he was spending many afternoons there at the moment, sorting through Turner's papers. 'Until tomorrow,' she said.

The next day, when Effie entered the painting room, it smelt different. Everett was preparing his colours, squeezing them out of the tubes and thinning some with linseed oil. These were the raw materials of her likeness. She could see the pale creaminess of her skin, the flush of her cheeks and lips laid out carefully on the palette. The canvas was covered by a cloth. When Effie asked to lift it, Everett said no. He wanted to finish the picture before he showed her. So she took her seat, her head turned away slightly. She was aware of Everett's movements, the deft strokes on the canvas, but could not see him clearly. They spent the morning mostly in silence. She did not speak, for fear of disturbing him and disrupting the image, so she sat and thought. She was used to sitting in silence, watching her husband at work. She had spent many days like that early in their marriage, as John sketched in the draughty market-places of northern France. But here at last she felt useful. She wrote to her mother that she was anxious to be as much help as possible, knowing that the sending-in day for the summer exhibition was less than a fortnight away. After a break for lunch, Everett wanted to press on. By mid-afternoon the light had begun to fail, and they had to stop.

The sittings continued for several days. Occasionally John would come up to ask how the picture was progressing, but Everett still refused to let either of them see it. Unable to give Everett the benefit of his wisdom, the critic set

off for Denmark Hill again. Effie was left to her thoughts. Holding the same pose tired her. At the end of each session, as Everett tidied away his brushes and cleaned his palette, she would walk around the room, easing her stiff neck.

By the last week of March, Everett was ready to return to his studio to add the finishing touches. On Saturday the 26th, Effie went to his family home in Gower Street. She was shown through to Everett's painting room at the back of the house, overlooking the garden. He explained that he had not been quite happy when he got the canvas home, and wanted to make a few changes. So he settled her again in front of him. From her seat she could see the spring flowers and the budding trees, while her mind wandered back to Bowerswell. By the end of the day Everett was satisfied and finally willing to show it to her. Effie walked over to the easel and stood beside him. It was a bold picture, full of emotional tensions and compositional challenges. There was no prettiness, but instead a study of strength, determination, suffering. Everett had seen through her. This was a shock, and a moment of recognition.

Effie thought it wonderful. When she wrote to her mother the next day, her excitement at being part of such a picture spilled over into her letter. She described how *The Order of Release* was full of expression, sympathy and incident. It would surely increase Everett's fame. Now they both had to wait for the art-viewing public to give its verdict. Unlike her previous pictures, this was no ordinary portrait. Effie's face was recognisable, but her hair had been changed from auburn to black. Her features were not pretty, because the strength of her character was an essential part of the story. And this lack of refinement was an important issue. Sitting for a dramatic painting like this could be read as a step away from the path of respectable behaviour. Certainly Effie's enemies later held it against her.

Victorian attitudes to models and modelling were complex. It was quite normal for the Pre-Raphaelites to use friends and family as models. Even the impeccable Christina Rossetti sat for the figure of Mary in her brother's painting of *The Girlhood of Mary Virgin*. But what exactly went on in the intimacy of an artist's studio? It was a mysterious space, where young men had unchaperoned access to beautiful women. Beyond the narrow world of artists and critics, professional modelling was sometimes seen as little better than prostitution. After all, what sort of girl would accept money to take her clothes off?[71]

Within Everett's own circle, attitudes towards models were more nuanced.

But still the artist–model relationship was often the starting point for something else. Everett only had to look at his closest friends to see what might happen behind the closed doors of the studio. He knew about the troubled on-off relationship between Rossetti and Lizzie Siddal; since 1850 she had been Rossetti's pupil and model. In early 1853 Everett's best friend Hunt was also entangled in a complicated and unsatisfactory relationship with his model Annie Miller. He hoped to marry her, once she had learnt to be more ladylike. Everett was also close to Ford Madox Brown, who had made his teenage model Emma Hill pregnant. Brown and Emma lived together for several years before they married. So Everett knew all about the sliding scale of respectability, from the ideal 'Angel in the House' to the 'Fallen Woman'. Victorian morality was not always black and white. Evidently there were many shades of grey.

Contemporary unease about sexuality and virtue were subjects that bothered Everett and his friends. Everett tackled the issue of marginalised women in a drawing he made after a day at the races. With thousands of other Londoners, he travelled to Epsom on 25 May 1853 for the Derby. The carnival of Derby Day allowed rich and poor to rub shoulders. But Everett was upset by the tragic scenes he saw on the course: the gambling and the drinking, the hungry children, the feckless men and the fast women. The holiday atmosphere was only a veneer. Everett could see the cracks, and his drawing of *The Race Meeting* focused attention on these fault-lines in Victorian society.[72]

Everett's picture is claustrophobic. Men are crowding around a carriage, climbing over it, demanding money, overwhelming the couple inside. He is drunk and she is in despair. She knows that her lover has gambled everything away. He can no longer afford to keep her; she will be dumped and left to fend for herself. The woman covers her face with her hands, so we can only imagine what she looks like. The composition is crammed with men, and Everett deliberately pushes the faceless mistress up against the only other woman: a beggar with her child. Will this be her fate too?

While Everett was reflecting on his experience of Derby Day, his paintings were causing a sensation at the Royal Academy exhibition. Since the private view on Friday, 29 April, there had been a large crowd of admirers in his little corner of the gallery. *The Order of Release* was a show-stopper. When Crawley, John's new valet, went to see it, he had to elbow his way through

the throng. Everyone was saying, 'Have you seen Millais's picture?' Eventually the Academy authorities had to put up a barrier to stop visitors pressing too close to the painting. Most of the time Effie was pleased to be recognised as the model. It gave her a certain cachet among her friends; she was complimented on her part in the painting's success by many of the guests at her birthday party on 7 May. However, the fact that this was not exactly a portrait could make her position awkward. For one thing, the woman in the painting had bare feet and legs. Everett would never have asked Effie to take off her slippers and stockings, would he?

Everett's letters to his friend Hunt make clear that Effie was not the only woman to pose for this picture. Most of the figure had already been painted from a professional model before he added Effie's face. It was probably Anne Ryan who was paid to put her bare legs on display. But the Academy audience would not have known that. By making a spectacle of herself, Effie was now the subject of speculation and banter. She had to accept the unflattering comments of some of the critics. The notice in *Blackwood's Edinburgh Magazine* was particularly nasty: 'her face is plain to a degree, and blotched with red', and she was described as 'the hardest looking creature you can imagine'. This review was especially hurtful as it was published in a Scottish journal, read by her parents and their friends.[73]

Effie was also bothered by comments made by her father-in-law. John James Ruskin's behaviour towards her had always been erratic, but it was becoming more than that. She began to suspect that he was trying to find a way to discredit her. Shortly after her fifth wedding anniversary on 10 April 1853, Mr Ruskin had written to his son about her. Effie was upset by the way her father-in-law wrote about her modelling for Everett. In fact she could not bear to reveal all that he had insinuated about the relationship between the artist and his model. When she told her mother about it, her account ended abruptly: 'he had never seen anything so perfect as my attitude as I lay on the sofa the night before and that no wonder Millais etc. etc. but it sickens me to write such nonsense'. To write down his comments would make them more concrete. She tried to dismiss John James Ruskin's innuendoes as nonsense, but she also admitted to her mother that they worried her. She had enjoyed the intimacy of the artist's studio and now her face was on public display. Perhaps this was not appropriate behaviour for a virtuous wife. After all, when Christina Rossetti had modelled for a painting, she had been sitting at

home for her brother, and appeared as the Virgin Mary. Effie, on the other hand, had spent whole days alone with Everett, a young, handsome friend of her husband's. And she was sitting for the figure of a defiant, bare-legged Scotswoman. So, while her father-in-law's comments were unwelcome, they may also have highlighted the potential danger in her friendship with Everett.

For Effie did not want this friendship to fade. If anything, the suggestion that Everett admired her added a frisson of excitement to their encounters. It is hardly surprising that she missed him. She had spent an intense week in his company, knowing that his eyes were upon her as long as the light lasted, learning about his family and friends over lunch, worrying about the progress of his picture. Although she did not openly seek him out, he was clearly on her mind. She talked about Everett to her friends. When the Marquess of Lansdowne called on her, she told him all about this bright young artist, in the hope that he might be invited to dine at Lansdowne House. Who knows, perhaps she would meet him there? And when she was again chattering with the Marquess and the Member of Parliament Chichester Fortescue at a party a few days later, she was delighted when she spotted Everett. Now she could present him to her influential friends.

That summer Effie's skills at social networking really came into their own, as John decided to take an apartment in central London for the social season. For a while she was able to escape Herne Hill. She had felt poorly for most of April, complaining of weakness and pains in her bones. She could no longer look forward to the daily presence of Everett, and John was preoccupied with the imminent publication of *The Stones of Venice*. She doubted whether she would be well enough to attend many of the events that were planned for May and June. However, she hoped to encourage John to go out as much as possible. Her husband had woken up to the advantages of being more sociable. He had announced to Effie that he wanted to meet everyone who might have Turners or missals in their collections, so he could wangle invitations to their houses. His artistic enthusiasms gave him a motive for agreeing to accompany Effie to dinners and dances. He and Effie could also use the parties and private views to remind their friends that the second volume of *The Stones of Venice* would shortly be available. In early May they moved into their lodgings at 6 Charles Street, just off Berkeley Square.

In the first week Effie seemed to have recovered her health. She had stopped coughing. Perhaps it was because she had 'taken to drinking Portwine

these last three days' or, more likely, she was reinvigorated by the admiration of rich and clever men like the Marquess of Lansdowne. Within a fortnight she was again feeling weak and suffering from headaches. But she found the strength to entertain afternoon visitors and accept invitations to evening parties. As she had anticipated, she was able to struggle on once she was in town.

One great incentive was the chance to be seen in the latest fashions. Effie had written excitedly to her mother in April about visiting her dressmaker Grace Rutherford in Pall Mall. As she studied the *modiste*'s magazines, recently arrived from France, she was enveloped by the comforting scent of warm irons. Knowing that her client was going into society this summer, Miss Rutherford brought out her most elegant fabrics. Effie ran her hands across the bolts of gold on silk and wondered whether she could afford to have a dress made up. Skirts were still so wide this year, and she needed several flounces to be really smart. She could of course wear the gowns she had taken to Venice. Her white glacé silk had seen good service. Even John had noticed her when she wore it trimmed with tiny rosettes of many-coloured ribbon. It looked as if she had been showered in sugar-plums, he said. She would certainly need a new bonnet, as they were very different from last year, absurdly small and worn on the back of the head.[74]

Effie wanted to look her best. She knew from her visits to Venice that she could shine at evening parties, and she felt valued. Hostesses liked to see her elegant figure as she worked her way around the room. She was nimble-witted enough to hold her own in conversation with the gentlemen, but careful not to antagonise their wives. This summer there was an additional incentive. The other guests would be looking at her in the knowledge that she was the face in the Royal Academy's 'Picture of the Year'. She did not want to disappoint Everett. As soon as it was known that she and John were in town, they received invitations to more parties than her husband could bear. However, despite his best intentions at the start of the season, the incentive of finding fellow art enthusiasts among the crowds wore off. John would frequently return to Denmark Hill to dine with his parents, while Effie went out on her own. These London parties were far more entertaining than an evening spent with her mother-in-law. And the older Ruskins liked to be left alone with their son.

In John's absence Effie was able to catch up with the celebrity gossip.

Harriet Beecher Stowe, author of the anti-slavery novel *Uncle Tom's Cabin*, was in town. She caused a traffic jam outside Stafford House, near St James's Palace, when a reception was held in her honour by the Duchess of Sutherland. Samuel Rogers the poet, who had breakfasted with Mrs Stowe, told Effie confidentially that 'her countenance is quite beautiful from its excessive humility' – a rather back-handed compliment. Effie could not quite account for her popularity, as she thought the author had not said or done anything remarkable.

Effie was equally unimpressed by the other American import of 1853: séances. Since the Fox sisters of Rochester, New York, had first heard unexplained rappings in 1848, a wave of interest in the supernatural had spread across the United States. Now it had reached London. Mrs Maria Hayden, a medium from Connecticut, fuelled the craze in Britain, claiming that she was channelling messages from spirit guides through wobbling furniture. By the summer of 1853 table-turning had become all the rage. Dinner parties were transformed into séances as hosts dimmed the lights and invited their guests to place their hands on the coffee table. By the fire's glow, ladies and gentlemen lightly touched little finger to little finger, making an unbroken circle, and waited. Would the table stir? Would it start moving backwards and forwards, or spin rapidly on its castors under their hands? In some cases, tables were said to have lifted completely into the air. So many people seemed convinced by incredible accounts of furniture whirling through the drawing-rooms of London that the scientist Michael Faraday decided to investigate. The results of his experiments were published in the *Athenaeum* on 2 July. According to him, the spirit messages were simply caused by unconscious pushing. Those who gathered around the table wanted to believe, so they made it happen.[75]

Effie agreed with Faraday. She tried it twice that summer, and on both occasions the table refused to move. Effie complained, after the second attempt at a party hosted by Lady Glasgow, that it was all humbug. But John was less sceptical. His mother's deeply superstitious nature had left him susceptible to the supernatural. Although there is no evidence that John took part in séances in 1853, he certainly did so later in life, and was eager to meet Daniel Home, the most sensational medium of the 1860s. John's willingness to believe is made clear by his account of a conversation he had over dinner in November 1853. Two of the guests told gruesome ghost stories that John

95

eagerly wrote up in his diary. One, Dr James Simpson, Effie's gynaecologist, had attended a lady who claimed to have seen 'the head of a sweetheart, long dead' appear across the table from her at a dinner party. Another guest topped this with his personal experience. He swore that, riding home one night through a storm, he 'felt the skeleton of his brother get up on the horse behind him' and wrap his arms and legs tight around him. The spectre held him fast for nearly twenty minutes. Both men tried to explain away the apparitions, putting them down to ill health and 'nerves'. But John's vivid retelling of the tales reveals that he was troubled by the spirits making contact in such concrete ways. He was not alone in this. Like many of his generation, John felt that an open-minded attitude to the recent surge in supernatural activity was completely compatible with his Christian faith.[76]

Simpson's story of the dead sweetheart bears an uncanny resemblance to the drawing that Everett began the same year of *A Ghost Appearing at a Wedding Ceremony*. It seems an oddly appropriate image given the circumstances of the Ruskins' marriage. It is possible that Everett heard the tale directly from Dr Simpson when they met at Effie's uncle's house in Edinburgh later that summer. Like Simpson's patient, the woman in the picture is the only one who can see her dead lover.

This was one of a series of drawings that Everett was working on in the months after Effie first sat for him. Some of them were sketches for paintings, others became book illustrations. Although they tackle different subjects, they have a unifying theme – sight. In each case, Everett explores ways of looking, and what his figures see or do not see. This focus on observation becomes almost obsessive. The idea of sight, and seeing 'rightly', had always underpinned the Pre-Raphaelite project, but now the act of looking is itself made visible and becomes central to the image. So, in his ghostly picture, Everett draws attention to the apparition through the stare of the terrified bride, and equally through the incomprehension of everyone else. It is the bride that they are staring at.

This series of drawings includes a number that also treat the subject of marriage. In fact the desire to look and the desire to love seem intertwined. But the images bring into focus the tensions and dissatisfactions of the modern marriage market.

Occasionally Everett allows his characters to touch as well as see. Even so, this is not always a sign that desire has been satisfied. In his drawing *Accepted*

we would hope to find a happy ending to a courtship. However, the image is not straightforward. As the man kneels before his beloved, he hides his face in their clasped hands. So he cannot see her. Rather than looking down at him, she turns her head away and gazes back at the party they have just left. Is this a sign of embarrassment or regret? Is the man she really loves dancing with another girl? Everett leaves the questions hanging, and denies us the chance to see the expressions on the faces of the couple, so we cannot scrutinise them as we would like. We are left unsatisfied.

There are two possible explanations for Everett's compulsive reimagining of the sense of sight from the spring of 1853 onwards. The first is that he was listening to John Ruskin. 'To see clearly is poetry, prophecy and religion – all in one,' John said. He praised the Pre-Raphaelites for the intensity of their observation. Now Everett was demonstrating the spiritual, moral and social implications of not looking in the right direction, through the averted eyes of the fiancée in *Accepted*. There is, however, a second possibility. In March 1853 Effie modelled for Everett for the first time. That summer he sketched her at every opportunity. He learnt every detail of her face, her hands, her hair. He looked and looked but could not touch. And so perhaps his images of thwarted love and confused glances became a way of channelling the desire of his eyes.

We do not know exactly when Everett fell in love with Effie, but by the end of May he was planning to spend the summer in Scotland with her and John. Effie's father helped to arrange accommodation for the party, which also included Everett's brother. William Millais was a keen sportsman as well as a painter, and was attracted by the promise of good fishing as much as the landscape. Hunt was supposed to join them, but preparations for his expedition to the Holy Land intervened and he went east instead of north. By the middle of June, Everett and John were both desperate to get away from the constant round of parties; Everett told Effie he had had enough of London. John would also be able to write better in the quiet of the Trossachs, away from the hubbub and heat of a summer in London.

One of Everett's drawings, *The Blind Man*, gives a sense of the clamour that Effie and John experienced every time they stepped outside the door of their Mayfair apartment. Everett flings us into the busy street, with the cries of the bus conductors, the whinnying of cab horses, the yapping of dogs and the rumbling of wheels. A blind man is led through the noise and

commotion by a smartly dressed young lady. As in his other drawings of this period, the artist builds up layer upon layer of references to vision and blindness. In doing so, he gives us multiple viewpoints of the event. The young woman raises her head to catch the eye of a cab driver and make him stop. The horses coming at the blind man from both directions are themselves blinkered. His dog, pulling at the lead, is wild-eyed with fright. And observing the mayhem is the tall figure of a gentleman holding up an eyeglass to get a better look.[77]

The contrast between the dust and din of the city, and Effie's holiday in the north country could hardly be greater. The Ruskins and the Millais brothers stopped for a week at Wallington, the Northumberland home of John's old friends Sir Walter and Lady Trevelyan. Hours after they arrived, Effie was running into the woods and down to the trout streams without a bonnet. Freed from the formal parties and crowded streets of London, she felt invigorated by the open spaces of the moors. Meanwhile Everett was drawing constantly, and his ability to capture a likeness was soon recognised by his hosts. Lady Trevelyan asked him to draw John. The resulting pencil portrait was not a success. Thomas Woolner, a fellow Pre-Raphaelite, later said that John's expression reminded him of a hyena. Undeterred, Everett began sketching Sir Walter, and redeemed himself with a portrait that sent his wife into raptures. Then he turned his attention to Effie.

Everett chose a three-quarter profile, as he had for *The Order of Release*, but this time Effie's whole face is lit. Her eyes, looking out from under their long lashes, are slightly unfocused as if her thoughts are far away. Unlike John's portrait, which is only lightly touched with a brown wash, Effie's drawing has been carefully coloured. Everett goes over the pencil lines with his brush, following the sweep of her hair away from her temples, indicating its auburn highlights, placing delicate dabs of coral at her throat. The intricate folds of her hair ribbons are moulded from deepest violet, and set against the softness of her lace head-dress and cape. Everett was so pleased with the likeness that he would not give it up to his hostess. Writing to Hunt that evening, he could not conceal his growing affection for Mrs Ruskin, 'who is the sweetest creature that ever lived'. The portrait drawing remains in his family's collection to this day. Lady Trevelyan had to be satisfied with a second version.[78]

In this picture, Effie still looks pale, and her letters reveal that she was

suffering from a severe sore throat again. As ever, her symptoms seem to fluctuate, depending on how much fun she is having. Her sore throat certainly did not stop her driving nine miles across the moors with Sir Walter and Everett in an open dog cart. They were continuing their journey towards the Trossachs, via Jedburgh and Melrose. John and William Millais preferred to ride in their travelling coach, better protected from the wind. They arrived in Edinburgh late on Thursday, 30 June 1853.

On Friday Effie saw her doctor at her uncle's house; they were all invited there for the evening. Dr Simpson was a great ally for Effie. He had pioneered the use of modern pain relief in childbirth, even persuading the Queen to try it. Just a few months earlier, in April, Queen Victoria had given birth to her eighth child, Leopold, with the help of 'that blessed chloroform'. She said the effect was 'soothing, quieting and delightful beyond measure'. Simpson was also a supporter of women's medical education, an anti-slavery campaigner and a convivial host who encouraged his patients to drink plenty of red wine. He examined Effie's throat, and Everett's too, as he was suffering from the same complaint. Dr Simpson prescribed chloroform pills to ease the pain and suggested that Effie should rub herself all over with olive oil every night 'to fatten her up'. Her letters do not tell us whether the massage treatment worked, but then she would have been hard pressed to find the oil once she reached the Highlands. Effie was already concerned about how she was going to get her hands on sherry, tea and sugar, and had prepared a hamper of these essentials before leaving London. At least she was well supplied with chloroform pills. Unfortunately, over the coming years, Effie became increasingly reliant on them. Her insomnia worsened until she found she could not sleep without medication. Effie was in good company. It was not unusual for women in the London art world to become dependent on their painkillers. Both Jane, wife of William Morris, and the unfortunate Lizzie Siddal suffered from unexplained symptoms like Effie. They took opiates to relieve their discomfort. Lizzie died of an overdose in 1862. Effie's chloroform pills were supposedly less addictive, but she was never able to break the habit.[79]

After only two nights in Edinburgh, the party was on the move again. They caught a fast train to Stirling, where they met Effie's father for a brief lunch. He was able to bring news of her family, who were staying on at St Andrews for their summer holiday. But there was little time to catch up. The Ruskin party had to press on. They stopped briefly to sketch and stretch their legs at

Dunblane and Doune, and then they all squeezed back into the carriage. They wanted to arrive at the new inn at Brig o' Turk before nightfall. The tiny village was overshadowed by the bulk of the Trossach mountains rising above Loch Katrin. It was in many ways the ideal setting for a troubled romance: claustrophobic, isolated, at the mercy of the elements, and with flashes of delicate beauty.

While Everett was clambering about the ruined castle of Doune with Effie and his brother, he had an idea. He had been watching Effie as she looked out across the river towards Stirling. She was framed in the arch of the window, turned towards the brightness. She seemed to have strayed from a painting by Memling or Van der Weyden. Everett longed to paint her like this. On the road to Brig o' Turk he explained his plan. He would make two portraits, one of Effie in the castle, and the other of John standing beside a mountain stream. He was sure that they would find a suitable setting somewhere near their inn.

In his imagination, Everett had already mapped out the details. His picture of Effie would be a sort of homage to John's writing, a visual equivalent of 'The Nature of Gothic'. Under a pointed arch – the most potent symbol of the medieval – Effie would be seen against a background of rivers, trees and hills. Everett would work in the spirit of the Middle Ages, breathing life into his art through his love of the natural world. It would be a demonstration of his pleasure in labour. And John's wife would stand at the heart of the picture. Everett had come away to Scotland without any real sense of purpose, other than to enjoy the fishing and the company of his brother and the Ruskins. Now he could turn the summer months to good purpose. He told Hunt in his next letter how he had been feeling idle this past year, but at last he had a focus. He would concentrate on painting Effie – 'the most delightful unselfish kind hearted creature I ever knew' – and her 'gentle and forbearing' husband. Effie and Everett never went back to Doune to complete the portrait, but the picture of John would become a Pre-Raphaelite icon.

They had intended to stay at Brig o' Turk for only one night, and then move on to Callander, but on Sunday morning after church they set out in search of a background for John's portrait. Why not take rooms at the inn for a full week, to enjoy the scenery and the lochs nearby? Everett's first impression of their Scottish retreat was of rocky streams and far-stretching mountains, a melancholy landscape that seemed a world away from his friends in London. The kirk sat at the water's edge, hemmed in by mossy trees,

with splashes of colour – foxgloves, early honeysuckle, forget-me-nots. It was clear from looking around the congregation that many were feeling the pinch of poverty. Rural communities across Scotland had suffered in the recent potato famines. Potatoes had become a staple over the last century, as the climate was too damp to allow most cereal crops to flourish. Like oats, the other Highland essential, potatoes could survive the rain and poor soil. When the potato blight struck in 1845 and then again in 1846 and 1851, many Highland parishes were sorely hit. The blight was the latest affliction to fall on these communities. Many still felt a raw sense of dislocation caused by the clearance of crofts to make way for sheep-farming. Brig o' Turk had not suffered as much as some more westerly areas of the Highlands. As the Ruskins had discovered, it was barely an afternoon's drive from the railway at Stirling. The industrial heartland of Glasgow was also within easy reach for those who were prepared to leave the land and find jobs in the textile mills. But, for all its outward respectability and breathtaking beauty, Brig o' Turk was poor. William Millais was moved by the spectacle of two girls at the Sunday service. They looked well dressed but had only a farthing to put in the offertory box, and then after church they took off their best shoes and stockings to walk home barefoot. They could not afford to muddy their decent boots. We can hardly imagine how they felt to be scrutinised by a party of London folk.[80]

The area was growing reliant on tourists like the Ruskins to bring in extra cash. The previous year Prince Albert had bought the estate of Balmoral, farther north on Deeside. This set the seal of royal approval on the Highlands as a holiday destination, a place to find privacy and good sport. It was hoped that the regular progress of the Queen to her new estate would encourage other fashionable tourists to follow. In the meantime hotel owners knew that the holiday season was short – only three months out of twelve – so they had to make the most of their guests. When the Ruskin party took rooms at the New Trossachs Inn, they paid £13 altogether for the week. This was very dear. A housemaid might not earn as much in a year. But, on Monday, 4 July, Everett found the ideal site for John's portrait, by a stream in Glenfinlas, just a few minutes' walk up the valley from the hotel. So the decision was made to stay on.

And then the rain started to fall. Letters home invariably began, 'Another pouring wet day'. It became clear that, if the weather did not improve, it

would be weeks before Everett could make any headway with the portrait. They grew bored and restless. Everett described how they sat hour by hour looking out of the sitting-room window, 'with anxious faces, trying to read the sun through Scotch mist and rain'. Effie and Everett started blowing bubbles at each other. John suggested a game of shuttlecock; he and Effie used to have fun playing it in Venice to keep warm. Everett and John became competitive as 'the Jersey Stunner' tried to outpace 'the Herne Hill Gamecock'.

On 8 July they ventured outside for a picnic beside the stream, about a mile from the inn. The rain held off long enough for Effie and the three men to sit on the rocks, 'painting and singing and fishing'. William and John took off their boots, rolled up their trousers and waded into the water with long poles in their hands. Effie and Everett were in fits of laughter; their legs were so tremendously white. Everett decided that he needed some practice before painting the rushing water that would form the background to John's portrait. He wanted it to be a technical *tour de force*. He positioned himself so that he could see the fast-flowing stream, foaming and bright against the folds and curves of the rocks. He asked Effie if he could include her in his picture. She was stitching a red pinafore for one of her little sisters. Wrapped up against the breeze and the midges, she was sitting with her face shaded by a wide-brimmed hat. She liked to pick a few flowers every morning, to wear at her throat, tucked into a broad green ribbon. Everett worked swiftly, knowing that it was only a matter of time before the rain came again. The result was a miniature masterpiece. *The Waterfall at Glenfinlas* was praised by John as a beautiful thing. It boded well for his own portrait.

That evening John, Effie and Everett helped Crawley pack up their luggage. If they were going to stay in Brig o' Turk it made sense to find cheaper lodgings. The village schoolmaster, Alexander Stewart, had offered them part of his cottage for £1 a week each, bed and board. They could even play badminton in his barn. It was used as the schoolroom in the morning, but it was empty every afternoon. On Saturday, 9 July they walked across the road with their bundles and bags to their new holiday home. William Millais decided to stay on at the hotel. In any case, there was hardly enough space for the Ruskins and Everett. Crawley seemed willing to make the best of it, even though he had to sleep in a storeroom 'among the Peats'. There were no proper bedrooms, only tiny dens for Effie and Everett. John chose to sleep on the sofa.[81]

Why did Everett not stay at the inn with his brother? Was it simply because he hoped to save money? Perhaps John was bothered by his young friend's behaviour and wanted to keep a closer eye on him. Certainly Everett had been complaining of feeling seedy, and was suffering from mood swings. At times he felt very tired and low-spirited, worrying whether he would see Hunt again before he set off for Palestine. And then suddenly he would spring into life, walking the hills, plunging into waterfalls to bathe, building dams across the streams. All the time his mind would be active, so full of invention, that he could hardly stay quiet a moment without sketching, and then lying awake all night planning pictures. John expressed his fears to his father: 'He cannot go on this way.' With careful handling and close observation, maybe Everett's equilibrium would be restored, and the portraits could then be finished.

There is another explanation: Everett wanted to stay close to Effie. Perhaps doubts were already creeping in about her relationship with John. Everett was starting to question John's way of looking at the world. On 17 July he wrote to Hunt about some of his concerns. John Ruskin, he said, was 'a good fellow but not of our kind'. He went on: John 'theorises about the vastness of space and looks at a lovely little stream in practical contempt'. Everett found that John could be blind to everyday beauty. Was he beginning to see that John treated his own wife with the same indifference?

While the rain fell, John was working hard at his papers. He was so bound up with the complexities of indexing *The Stones of Venice* that he was offhand with Effie. In any case, he had always hoped that the Millais brothers would keep her entertained. That was one of his reasons for inviting them. But with the paths ankle-deep in mud, they were forced to stay inside for much of the day. Even William was fed up. Fishing in this weather was no fun. He sat in his hotel room, grumbling into his whisky. Everett could not get on with his waterfall picture, and John was concerned only with finishing his book. So Effie found herself sitting by the cottage window, with the light falling on her needlework, sensitive to the silence in the room. John had his back turned to her. These days he barely seemed to look at her. And yet Everett could not take his eyes off her.[82]

Chapter Seven

The Eve of St Agnes: 1853–4

JULY 24TH 1853, Glenfinlas, the Trossachs. Effie bent over Everett as she trimmed his hair. She was using her sewing scissors to cut the curls at the nape of his neck. Everett could feel her skirts pressed against his back, and the swift touch of her fingers as they brushed against his skin. He tried to concentrate on keeping his head still. He looked down at his bandaged left hand. Everett had badly bruised his thumb a few days before while trying to build stepping-stones for Effie. The pain had made him feel so shaky that he had put his arm around her shoulder as she led him back to the house. He had hurt his nose too, earlier in the day, diving into a shallow pool when he was bathing. 'It bled awfully,' Everett told Hunt, 'streaming all down my naked-ness', and John Ruskin had rushed to the inn for some whisky to revive him. Everett spent Saturday night aching and miserable, reading Tennyson's long poem *In Memoriam* by candlelight. Effie heard him as she lay in her little bed on the other side of the partition.

Effie thought of Everett's gallantry. She had perched on the bank of a trout stream, watching him work in his shirtsleeves, splashing through the water as he gathered large stones so she could cross without getting her feet wet. He had wanted to help Effie reach the far side of the valley, so they could look down on Glenfinlas from a new vantage point. But then one of the stones had overbalanced and crushed his thumb. She hoped it would not stop him working. In the rainy afternoons she liked to sit beside him, watching him make sketches of 'costumes, helmets with crests of animals and necklaces of flowers'. Effie did not mention in her letters home that many of these drawings were portraits of her in fancy dress. Everett imagined Effie wearing a head-dress of field mice, with a bodice covered in squirrels and lizards. On other wet days Everett gave her drawing lessons. He thought she showed skill: 'It is wonderful how well she gets on,' he wrote to Hunt. Everett made Effie laugh with his caricatures of her as an ambitious artist, standing on a ladder

to reach the top of her vast canvas, looking down on the men gathered around her easel. He called her by his own pet name, 'the Countess'.

When it was fine Effie and Everett went walking together. Caught in a shower, Effie threw her plaid over both their heads as they hurried for the trees. They sheltered under the shawl, standing side by side in the dripping wood. Effie took Everett's arm and they made their way back along the path. Their days sparkled with these shared touches: he guided her pencil across the page of a sketchbook, she reached out to take a cup of spring water from his hand, he tickled her nose with a fern-leaf. In the evenings, when John and William Millais were busy with spades and pickaxes building a miniature canal, Effie and Everett took a walk up the glen.

In the mornings they chatted to each other through the paper-thin walls of their cottage as they dressed. Everett thought it was delightful to wake up 'in his little emigrant crib', so close to Effie that he could hear her breathing. He admitted to Hunt that his work was not going as well as he had hoped. The midges were terrible, so Everett resorted to wrapping his head in a handkerchief to avoid being bitten while he painted. The rains had transformed the stream into 'a theatrical Swiss torrent'. It looked 'like writhing liquid amber, so immensely beautiful', but he could not continue painting John's portrait until the water was calmer. 'It would be quite impossible to stay here,' Everett confided to his friend Hunt, 'if it was not for Mrs Ruskin, who is more delightful every day.'[83]

Everett had never been in love before. His Pre-Raphaelite Brothers had far more experience with women but Everett, at twenty-three, was new to romance. He had watched his friends' affairs with interest, but also with a little distaste. He could see that Annie Miller had not made Hunt happy, and he blamed her for driving his friend abroad. It seems the closest Everett had come to a sweetheart was a young lady called Fanny. He described to a friend how he bumped into her again, after she married. Everett was dreadfully embarrassed by the chance meeting. His 'old flame', he said, seemed 'horribly changed', and her husband was old enough to be her father. He could take no pleasure in memories of the past. But now he was spending every day with Mrs Ruskin. She was irresistible: pretty, caring, eager to listen, and a little sad. Everett felt for the first time the rush of pleasure that a smile could bring. He tried to concentrate on his work, but he could think of nothing but Effie. Some days he wanted to run away, unable to bear her constant presence. Then

he would pack his bags and move across the road to the hotel for a few nights. He complained to a friend, 'I wish there was a kind of monastery I could go to – I am beginning to be perfectly sick of life.' But he always found himself drawn back to the little house where she slept. He found an outlet for his emotions in the vivid drawings he made of their holiday, a record of his moments of contact with Ruskin's wife. Maybe some of them stretched the truth a touch. Perhaps we should look at them as images created by wishful thinking, rather than snapshots of the summer. But they remain as a poignant memorial to a young man's love.

John became concerned about Everett's fragile health: he was worried that it was holding up the progress of the portrait. He wrote to his father on 9 August 1853 that he would not be returning to London for a long while, as 'Everett does not do above an inch of picture each day'. But every inch that he painted was glorious. John described Everett's ability to capture the sheen of lichen upon the wet rocks, 'like silver chasing on a purple robe'. The intensity of his painting, combined with the misery of his impossible love for Effie, took its toll on Everett. By the end of the summer the young artist was clearly under great strain, 'always restless and unhappy'. He was faint, had headaches and was lethargic, depressed by melancholy news from London. His friend and fellow painter Walter Deverell was dying and Hunt was continuing to make plans to leave for the Holy Land. Everett claimed that this was the cause of his sadness. 'Scarcely a night passes,' he told Hunt, 'but what I cry like an infant over the thought that I may never see you again. I should like to go to sleep for a year and awake and find everything as it was.' Effie could hear her young friend weeping as she lay in the darkness a few feet from his pillow. But what could she do? She could not comfort him. Her kindness only made him more miserable.[84]

In her lettters Effie made no secret of her fondness for Everett and their close friendship. She wrote, for example, to Rawdon Brown about their solitary walks, and described how she had slipped down a muddy bank one evening. Everett tried to hold her, but slid down too, and found himself falling on top of Effie. She was covered in mud. Bedraggled, out of breath and laughing, the pair made their way back to the cottage. Effie thought she had nothing to be ashamed of.

But other, more critical, eyes were upon her. Florence Nightingale accused Effie of flirting quite openly with the young artist. She had spent a few days

with the Ruskins and the Millais brothers on the road to Brig o' Turk. According to Miss Nightingale, Effie's long walks with Everett made 'Ruskin very uneasy all the time'. She also said that Effie had defied her husband by coming down to breakfast with flowers in her hair, even though John had asked her to remove them. Miss Nightingale and her friend Elizabeth Gaskell were apparently not surprised when they heard the following year that the Ruskins' marriage was in tatters. It is hard to know how much of this account was coloured by later gossip about Effie's behaviour. But it rings true enough. By the summer of 1853 Effie was used to making her own entertainment while her husband worked. John had never objected before when she spent time in the company of men he respected. If anything, it improved his opinion of her. And we know that Effie gathered foxgloves to tuck into her hair. Of course she would not dress like that in smart London company, but out in the wild woods of the north she felt a sense of release. In Scotland she was at home, almost a girl again.

In late October 1853 the party was breaking up. John had to go to Edinburgh to prepare for his lectures, while Everett planned to remain for a while in Glenfinlas to work on the large portrait. Effie, of course, would travel with her husband. Concerned about leaving Everett alone, John wrote to Hunt, asking him to postpone his departure for the East. 'I had no idea how much Everett depended on you', he said, and then went on, 'he has no sympathy with me or my ways'. Unfortunately Hunt could not come north, so the Ruskins left Everett at Brig o' Turk, lying in bed too sick to travel. John sent Crawley back to Everett with instructions to look after him. He feared his young protégé might become seriously ill. But Everett had decided to give up for the season. With Effie gone, there was nothing to keep him in the Trossachs. The weather had turned for the worse again. The stream was so swollen that it had washed away the makeshift tent that he put up to keep out the cold. Everett was 'intolerably depressed'. It was time to go home.[85]

So how did Everett find himself in the coffee room of the Gibbs Royal Hotel in Edinburgh, waiting for Effie and her husband? He could not leave Scotland without seeing her again. 'This day is all sunshine,' he wrote to Hunt, 'but I believe I am so sick that all weather is miserable.' Everett stayed close to Effie for the next fortnight, accompanying her to John's lectures and only returning to London on 10 November. The next day John sent a most revealing letter to his father. It was almost an acknowledgement that his

marriage had failed. 'Perhaps for my health,' he wrote, 'it might be better that I should declare at once that I wanted to be a Protestant monk: separate from my wife, and go and live in that hermitage above Sion which I have always rather envied.' It seems that John might even have suggested this arrangement to Effie. Many years later she confessed that John had offered her '£800 a year to allow him to retire into a monastery'. She had refused.

The autumn of 1853 was the beginning of the end of Effie's life with John. She could now see clearly that her husband was never going to make her truly his wife. According to John, this was when Effie's feelings of affection towards him were finally extinguished. Edinburgh was the tipping point. But Effie had no idea that there might be a way out. She just had to endure. She was exhausted. Effie worked hard to maintain the fiction of her marriage, supporting her husband on the public stage. She had acted as hostess for the evening lectures, arranging teas and suppers and showing guests to their seats. She wrote to Rawdon Brown that the 'place was so crowded that people were fainting and being carried out'. Her sleeplessness returned. Dr Simpson advised her to go back to Perth for some peace. Effie went to Bowerswell on 21 November for a month, while John stayed on in Edinburgh, polishing his lectures for publication. She claimed that her feebleness was the result of all 'the talking and nervous exertion'. But the real cause of her weariness occasionally peeped through. She was missing Everett. She told Rawdon Brown that she had left the Highlands with great regret and that she was concerned about the young artist: 'he is very delicate'.[86]

Everett's own life was in turmoil. On 7 November 1853 he was elected Associate of the Royal Academy. He was now accepted by the very establishment that he had rebelled against as a student. He felt he was leaving behind his boyhood and entering a new phase of his career. His Pre-Raphaelite friends were disconcerted by Everett's apparent defection to the Academy. Gabriel Rossetti was particularly upset. He knew he would never receive such an accolade, and complained to his sister Christina that 'now the whole Round Table has been dissolved'. The young men of the Brotherhood were following their different paths to fame.

Everett's portrait of John, his Pre-Raphaelite masterpiece, was far from finished. He had not even begun to paint John's figure on to the canvas and the background still needed work. But he could hardly face the sittings alone with Effie's husband. At some point, probably during their last few days

together in Edinburgh, Effie had let slip the secret of her marriage. Now Everett understood why she seemed so vulnerable. We can only imagine the circumstances which could have drawn this confession from Effie's lips. She had kept the truth hidden from her own mother and her doctor, despite many conversations about her childlessness. But Everett had broken the seal. He must have declared his love for Effie. Perhaps Everett asked her about the rumours that were already circulating about the Ruskins' curious marriage. Perhaps when he voiced his bitterness about John's insensitivity, Effie opened her heart to the tender young man. Whatever happened between them, by Christmas 1853 Everett knew that Effie had never been loved by her husband.[87]

After Everett left Edinburgh he wrote several times to Effie at Bowerswell. However, when John came to stay with the Grays for a few days, Effie's mother became anxious about her daughter's correspondence with an unmarried man. Mrs Gray had met Everett briefly at the Edinburgh lectures. She had seen the frustrated desire in the young man's eyes, and recognised that Effie was dangerously attracted to him. On 19 December, Mrs Gray wrote to Everett herself, asking him to stop contacting Effie directly. It seems that John was no longer going to turn a blind eye to his wife's flirtations. He was keeping a little book in which he made notes of Effie's conduct. Everett described this 'Inquisitorial practice' as 'the most unmanly and debased proceeding I ever heard of'. John was gathering evidence against Effie.

Until he received Mrs Gray's letter, Everett believed that his intimacy with Effie could continue uninterrupted. Now he suddenly realised that the quiet understanding that they had enjoyed in the Highlands could be used to undermine both their reputations. He had only just been admitted to the inner circle of the art world, and already his career as a respectable Associate of the Royal Academy was being threatened. He found himself questioned at dinner parties about what he knew of the Ruskins' marriage. What would happen if John Ruskin, the leading art critic in London, withdrew his support and started to tell tales about Everett's evening expeditions with his beautiful young wife? Everett wrote back to Mrs Gray immediately, in a most agitated state. He needed to clear his name. He tried to tell the Grays the truth about Effie's marriage, but could only drop very heavy hints.

Everett's letters of 19 and 20 December 1853 are jumbled and hyperbolic. They are also vivid proof of his love for Effie. He promised Mrs Gray to do

everything she could desire of him. Everett realised that John's behaviour over the summer could not simply be written off as naivety or absent-mindedness. Effie's husband was trying to ruin her good name. John, he wrote, was delighted that Everett and Effie enjoyed each other's company. He encouraged Everett to travel alone with Effie, but the young artist was uncomfortable with the arrangement. It looked too much like entrapment, so Everett refused. He called John's behaviour sickening, flagrant, revolting, heartless and unworthy. He acknowledged that John was a giant as an author, but saw him as a poor weak creature in everything else. Everett advised Mrs Gray that Effie should bring one of her sisters to London to protect her from both the worst excesses of the Ruskin family's behaviour and the predatory gentlemen who lay in wait for a neglected wife. According to Everett, Effie had 'more to put up with than any living woman'. And then, in the rush to catch the five o'clock post, he added a hasty postscript: 'She has all the right on her side and believe me the Father would see that also if he knew all.' This was the give-away. Everett did know all.[88]

And what of Effie? She was suffering from a nervous tic above her eyebrows, which stopped her going out to dine. Her relations with John were strained and her health was poor. She spent Christmas with John and her little sister Sophy in a hotel in Durham, then all three travelled down to Herne Hill. They arrived just in time for New Year 1854. She had nothing to celebrate. John was unsympathetic. He wrote a brief note to Mrs Gray, saying that Effie 'passes her days in sullen melancholy, and nothing can help her but an entire change of heart'. This was the last letter he ever sent to his mother-in-law.

We can piece together what happened in the Ruskin household in the early months of 1854, because Effie wrote to Bowerswell several times a week, giving her side of the story. As John saw his own parents nearly every day, his version of events was never written down, and his diary was silent about these critical weeks. We have to bear this in mind when we listen to Effie's tale. John did not leave enough evidence to defend his name against his wife's allegations of cruelty and neglect.

Having briefly tasted the affection and companionship of Everett, Effie told her mother, 'I know too well what I have lost in this world.' But she still could not bring herself to tell her parents about the cause of her unhappiness. She did not think it would do any good. Effie wanted to start the New Year afresh, so she tried to talk to her husband about their mutual misery. She

offered to do anything John desired, to help him in his work if he wished. John's reply was harsh. He told Effie that his marriage was 'the greatest crime he had ever committed in acting in opposition to his parents'. Then he added that he was only doing his duty to be 'kind to anybody so unhappily diseased'. John claimed that Effie was mad.

If only John could prove his wife's insanity, then Effie could be sent away, and he would be free to work and travel. Effie could see the way her husband's mind was working. She told her mother that the Ruskins viewed her as 'a maniac in the house'. She had read enough novels as a girl to know what happened to mad wives.

This was not the first time John had suggested that Effie was mentally unstable. In July 1849, barely a year after their marriage, he had written to Mr Gray expressing concern about Effie's tears and depression. He sowed the seeds of doubt: could Effie be suffering from 'a nervous disease affecting the brain'? Otherwise John could not account for her behaviour. In all his sheltered life, he had no experience of dealing with a woman who cried and argued with him. His mother never ranted and his cousin Mary had kept her head down. John could not believe that Effie's emotional outbursts were a normal part of married life. Of course, John's coldness towards her only aggravated Effie's situation. And her chronic insomnia cannot have helped. Unfortunately her erratic behaviour only reinforced John's opinion that he should never consummate the marriage: he could not risk her becoming pregnant and bearing a lunatic child. John never understood that Effie was simply irritable and homesick, miserable at being shut out from her husband's affections.

The older Ruskins made matters worse. John and his parents deliberately made plans that did not include her. Just after her return to Herne Hill she heard them discussing their trip to Switzerland in the spring. Mrs Ruskin turned to Effie and said, 'Oh! John has promised to come with us and you can't travel with us.' No wonder Effie became resentful, moody and a little paranoid.

At the same time, John James Ruskin started another campaign against Effie's conduct, complaining to her father that 'in the few years since their marriage they have had from me £15,500'. Mr Ruskin blamed her upbringing. He wrote to Mr Gray: 'You sent her about visiting and thinking of Dress till she became unsettled and restless.' Her father-in-law believed she 'never

112

cared for John enough to make her Husband's fame a greater object than making a figure herself in Society'. He could not understand that she helped John by becoming the presentable face of the younger Ruskins. If she could gather wealthy patrons, opinion-formers and gossips around her table, then they would spread the word about John's genius. He could write and she would market his work. But she could not keep her side of the bargain if she was shut away in south London.

Effie tried to save herself by inviting old friends to stay. Miss Ainsworth, her teacher from Avonbank, spent ten days at Herne Hill in January. She saw immediately that the Ruskins were in trouble. Miss Ainsworth told Elizabeth Gaskell, another of her former pupils, that Effie, 'with her high temper and love of admiration would not submit to the rather strict rules' that her husband insisted upon. She was afraid 'there would be an outbreak' and left before she was caught up in the storm. Then the sharp-tongued Jane Boswell arrived from Perth for a three-week visit. She was the one friend who could still make Effie laugh. Unfortunately she had never liked Effie's husband, and at this tense time was probably the worst person to have in the house, observing the rifts in her friend's marriage and criticising John.

Effie also devoted herself to looking after her little sister. She listened to Sophy's lessons, played the piano for her and put the little girl's hair in curling papers at night. Without a carriage, Effie found it hard to get into town, but very occasionally she entertained at Herne Hill. Lady Eastlake dined with her, and so did Lord Glenelg and Mike Halliday, one of Everett's friends. Halliday had stayed with the Ruskins at Brig o' Turk towards the end of the summer holiday. He had witnessed the effect that Effie had on Everett. It is possible that Halliday knew all about Effie's marriage problems, because Everett had confided in him 'in the agony of his mind', but he had certainly 'guessed nearly the whole from what he had seen in Scotland'. Everett could not hide his devotion to John's wife.[89]

Although the young artist was forbidden from visiting Effie, he heard about her constantly. Mrs Gray acted as go-between, writing to Everett frequently. Little Sophy also came to his studio to sit for her own portrait. She was willing to tell tales about the Ruskins. And Everett made a point of dropping in at Halliday's house late on the evening of Effie's dinner party. He wanted to know how she looked and whether she had mentioned his name.

Everett did find a way to reach out to Effie in the lonely suburbs. To mark

the Eve of St Agnes's Day, on 20 January 1854, he sent a drawing to Herne Hill, addressed to John and his wife. Effie recognised it as a love token. She hung the picture in her room, where she could gaze at it and try to fathom its secrets. Everett had created an eerie winter scene, with snow lying thick on the roofs of a silent convent. A nun was watching by an open window, her breath misting in the cold air. She had a snowdrop pinned to her breast, St Agnes's flower, and it was this tiny detail that explained the look of longing on the nun's face. Country folk said that on St Agnes's Eve a young woman would dream of her true love. The legend had inspired Keats to write his poem of desire and escape. Effie remembered how Everett read Keats's lines to her as they sheltered from the rain in their cramped Highland cottage. Sitting close together, they had shared the story of the poet's heroine, yearning for her lover. Everett had woven his own love for Effie into the fabric of the picture.

As Effie looked deeper, the contrasts of dark and light reminded her of another sketch, something else Everett had shown her. At the start of their Highland holiday he had dreamed up a remarkable idea for an oil portrait of Effie. She would be standing silhouetted against a Gothic arch, looking into the distance. Here was the same composition, but with a nun standing in Effie's place. Everett imagined his beloved, chaste, enclosed. Yet at the very centre of this picture, the iron gate of the convent was ajar. Perhaps here was a clue. The nun might still flee her captivity, and step out into the world beyond the walls. It would be a hard and icy road. Then Effie noticed another remarkable thing. The face of the nun was not her own. It was Everett's self-portrait, his handsome profile under the veil. Everett was making a promise to Effie. If he could not have Effie by his side, he would have no one. He too would remain unloved and alone.

At first John accepted Everett's picture without question, but he soon became suspicious of Effie's interest in the subject. Within a few days he was taunting her about Everett. Did Effie still write to him secretly? Why did she think it was appropriate to receive gifts from an unmarried man? Effie could hardly bear to part with the drawing, but John's inconsistency was unnerving. One minute he was encouraging her to keep in touch with Everett, and the next he was accusing her of being underhand. Effie offered to send the picture back. Then John suddenly rounded on her, declaring he knew all about Everett being in love with her. His young rival was a fool, John said, and, 'I shall tell him that the sooner he gets over it the better.' Effie was scared. She

wrote to her mother that she believed that Ruskin and his parents were hoping to get her into 'some scrape'. They wanted to force her into another man's arms, and then they could be rid of her. Like Everett, Effie had woken up to the possibility that the young artist's name would be 'dragged before the public'. Knowing that Mrs Gray would pass on her message, Effie was adamant: 'It is a very very important thing for him to keep clear of us altogether.' But, for the first time, she acknowledged that 'things may change'. On Friday, 3 March, Effie wrote, 'I must do something.'[90]

Effie's decision to act was influenced by three people: her two friends Jane Boswell and Lady Eastlake, and her sister Sophy. Jane spent long enough with the Ruskins to see that Effie's life was intolerable. She spoke her mind, warning Effie that her husband was deliberately neglecting her and throwing her into the path of her young admirers. Jane whispered to Effie that John 'was quite mad'. She had come to the conclusion that he had 'a regular deep laid scheme' to blacken Effie's name.

Jane stayed at Herne Hill until mid-April, but Effie never revealed all her troubles to her. Jane was too indiscreet, and might make mischief when she went home. Sophy was also looking forward to going back to Scotland before Easter. Effie was shocked to discover what the Ruskins had been telling her little sister. Mrs Ruskin liked having the pretty ten-year-old with her at Denmark Hill. She fussed over her and stuffed her with fruit and sponge cake, all the while explaining to Sophy that her mother was 'a weak ignorant woman' and Effie was 'a poor silly creature simply raised into respectability by her husband's talents'. John also confided in the little girl. His words were even more damaging. John told Sophy that he intended to begin 'harsh treatment' of his wife when he returned from his trip to Switzerland. Sophy repeated all John's confidences, which were then, of course, passed on to Effie's parents in her frantic letters. In John's eyes, Effie was wicked, bold and impudent. She had ensnared Everett and made him miserable, just as she had ensnared John. And John had announced to Sophy that he could get a divorce from his wife whenever he chose. Effie could not believe that her husband would involve a child in their marital problems. How could he talk about Everett in that way, knowing that Sophy went to the artist's studio? How dare he mention divorce? He could never prove she was an adulteress. But Effie felt hounded into a corner. She had to find a way out 'before either these people kill me or lead me into some scrape'.

On Tuesday, 28 February, Effie had tea with Lady Eastlake at Herne Hill. Elizabeth Eastlake had befriended Effie in 1850, and watched her progress through London society with interest. She was childless, having married late. She was also nearly six feet tall. Lady Eastlake was worried about her young friend. 'She shakes her head at me sometimes for looking weary,' Effie wrote, 'and then kisses me.' On the day before Lady Eastlake's visit, Effie had heard for the first time that her husband was threatening to divorce her. Her head was aching with anxiety. Did John really have enough evidence in his notebooks to bring a case against her? Could he face the public scandal? Lady Eastlake listened as Effie wept. Then she put down her teacup and started to ask some rather penetrating questions. As Elizabeth Rigby, she had grown up in a medical household, where both her father and her brother were obstetric surgeons. She was not squeamish about tackling unladylike subjects. She persuaded Effie to reveal the underlying problem. At last Effie found the words: John had refused to consummate their marriage.

Lady Eastlake smiled a little. If that was the case, then Effie could walk away from the Ruskins with her name intact. Lady Eastlake explained that an unconsummated marriage was not binding. In effect, Effie was not married at all. It would not be easy. Effie would have to prove that, six years after her wedding, she was still a virgin. But then she would be free. Lady Eastlake needed to know one more thing. Did Effie agree to this arrangement before she married John? If so, she could not back out of the marriage contract now. Effie told her friend how eager John had been to marry her. She could show Lady Eastlake his love-letters, full of endearments and promises. It was only once they were on honeymoon that John had said 'he had no intention of making her his Wife'. Relieved, Lady Eastlake offered to make some enquiries about Effie's legal position, and set to work to release Effie from her marriage vows.[91]

Effie sat, stunned and silent, in her darkening room. Her eye was drawn to Everett's picture of the nun, half-obscured by shadows. She could see the convent gate standing a little open. Maybe Everett was right. Maybe there was a way out of her loveless marriage.

Everett had been asking some questions of his own. He had come to the same conclusion as Lady Eastlake – that Effie's marriage was probably not valid – but did not know what he could do about it. John had come to his studio on 2 March 1854 for another portrait sitting, acting as if nothing was

amiss between them. The next day Everett wrote to the Grays again. Frustrated, he could barely keep Effie's secret to himself. '*Something must be done by you* if she continues to be martyred,' he pleaded with Mrs Gray, 'as it is *grossly sinful* to permit matters to stand as they do.' He went on, 'I am not sufficiently acquainted with Law to know whether something more than a separation could be obtained.' But Everett suspected that Effie could be rescued and set free.[92]

On Monday, 6 March 1854 Effie decided it was time to tell her father about her life with John Ruskin. She was so flustered that she put the wrong date on her letterhead. She felt guilty about keeping her parents in the dark, but confessed that she was worried about her adding to her family's difficulties when their finances were still unstable. She feared her father's reaction to the news that she had been 'so ill-treated and abused' by her husband. She also explained that John's parents did not know the full story. It was very hard to reveal the secrets of the marriage bed to her own father, but finally she came to the point: 'I do not think I am John Ruskin's Wife at all.' Effie said that as a bride she knew little or nothing about 'the closest union on earth', but that within days of their wedding John had told her that he would not consummate their marriage. As they still shared a bed, their families never guessed what was wrong. Effie tried to use examples from the Bible to bring John round, but he was unmoved. 'Then he said after six years he would marry me, when I was 25', so in May 1853, just before they left for the Trossachs, Effie had raised the subject again. This time John answered that she was either wicked or insane. He declared that starting a sexual relationship with a diseased woman would be sinful. John and Effie Ruskin's marriage never recovered from this row. Effie now wrote sadly, 'If he had only been kind, I might have lived and died in my maiden state.' But she claimed that her husband was brutal, that he had threatened to beat her and that he threw temptations in her way. John was so gifted and yet so cold. Effie ended the letter with a prayer, thanking God for allowing her to live a virtuous life. She signed herself 'Effie Gray'.[93]

It took seven weeks for Effie and her parents to make good her escape. First they waited for Jane Boswell to go home, and then Effie had to rearrange her travel plans. She told John that she was simply taking her little sister back to Bowerswell, and would soon return to Herne Hill. But when she and Sophy boarded the train on 25 April 1854, Effie knew she was leaving her husband

for ever. At the last moment John realised that he had forgotten to give Effie her allowance. Trotting alongside the moving carriage, he tossed a purse through the open window. It fell into Effie's lap. And then, in a whoosh of steam, she was gone.

Chapter Eight

Waiting: 1854–5

FFIE SAT UP a little awkwardly. She swung her bare legs over the side of the bed and reached for her stockings and petticoats. Dr Locock and Dr Lee had completed Effie's physical examination and tidied away their chill metal instruments. Now the doctors were in the next room with her father, delivering their verdict. Effie made herself decent. She wished her mother had come with her to London, to help her face this ordeal. At least the worst was over. The procedure was uncomfortable and intrusive, but necessary. Effie had to prove that she had never had sex, with her husband or anyone else.

Effie went through into the small drawing-room and sat down next to her father. She found it hard to look the three men in the eye. There on the table was the document, her order of release. Mr Gray passed it to Effie. It was signed and dated 30 May 1854, at 15 Bury Street, St James's. Effie read it: 'We found that the usual signs of virginity are perfect and that she is naturally and properly formed, and there are no impediments on her part to a proper consummation of the marriage.' The doctors' evidence tallied with the deposition that Effie presented to the Ecclesiastical Courts. She had been married to John Ruskin for nearly six years, but Effie was still a virgin.

That evening Effie wrote to her mother at Bowerswell. It had been a difficult day, and she was tired and ready for dinner. Lady Eastlake had very kindly sent a hamper of supplies, including a bottle of port and biscuits, to Effie's lodgings in Bury Street. Effie was sitting by the fire, waiting for her father, who was still being questioned by lawyers. Mr Gray had to swear that his daughter and John had been living together until April. Effie reassured her mother that her case was being handled quietly. There was no need for her to stand up in a public court to answer for her conduct. Neither Effie nor John would be called before the House of Lords to testify about their relationship. But that morning she took an oath in St Saviour's Church, Southwark, to

119

swear that her written deposition was correct. And then came the legal questioning by the Ecclesiastical Courts in Doctors' Commons. This was held in a private room at Bennet's Hill in Upper Thames Street, after her virginity test. Mercifully, the doctors had examined Effie in her own temporary bedroom in St James's.

Only a handful of her friends knew that Effie was in town. But, despite her attempts to keep a low profile, John Ruskin's failed marriage was the talk of London. Both Effie and John were well-known figures in London society. Their visibility – at parties, in paintings and in print – had turned their home life into public property. Effie's success in promoting herself and her husband was coming back to haunt them both. Elizabeth Eastlake wrote to Effie's mother to explain that she was doing everything in her power to silence the 'foolish and malicious people' who talked of 'scandal' and 'exposure'. But Lady Eastlake's own campaign to uphold Effie's name only encouraged the rumour-mongers. They wanted to know more about Effie's loveless marriage, and her extraordinary husband.[94]

Looking back over Effie's correspondence, we can see how Lady Eastlake choreographed her young friend's flight from Herne Hill in the spring, and how she managed the aftermath. Having discovered that Effie's marriage was a sham, Lady Eastlake set about helping to release her. She met Effie's parents soon after they arrived in London on Good Friday, 14 April 1854, and contacted Effie's other great ally, Rawdon Brown. (He was in England for a few weeks to meet his publisher.) She also offered to find new situations for Effie's cook, Rosina, and her maids. They would find themselves out of a job once their mistress left the marital home. The date for Effie's departure kept changing, but was eventually set for Tuesday, 25 April 1854.

It is hard to believe that John had no inkling of Effie's plans. Is it possible that he was unaware of the to-ings and fro-ings, the unusually large pile of luggage bound for Bowerswell, the hurried conversations with servants, and Effie's increasingly agitated state? Surely he would have questioned some of Effie's behaviour. On 10 April, for example, she demanded that John sign a declaration entitling her to keep all of Everett's drawings, including *The Eve of St Agnes*. She said she wanted to 'prevent future misunderstandings on this point'. Evidently they were some of her most treasured possessions, mementoes of happier times, and Effie could not bear to leave them hanging in her abandoned room. Perhaps in his desire for a scholarly life, John hoped his

wife would walk out on him and go back to her parents without a fuss. If so, he underestimated Effie. John had no idea that she would take him to court. On the other hand, maybe Effie was canny enough to make her all arrangements in his absence. After all, as Effie told Rawdon Brown, it was an 'extremely rare occurrence' for her husband to dine at home.

Even if John himself remained in the dark, Effie's intention to run away was one of London's worst-kept secrets. In Herne Hill, Effie confided in John's valet, Crawley. She trusted him to meet her parents at the docks when they came secretly to London at Easter. The obstetrician Dr Lee knew about Effie's plans, because Mr and Mrs Gray consulted him about Effie's marital problems. They found 'his opinion in the highest degree satisfactory'. It also appears that by 18 April, a full week before Effie's departure, Elizabeth Eastlake had told her husband Charles, her mother and her sister. She had already discussed Effie's escape with Rawdon Brown, his best friend Edward Cheney and Lady Davy (Effie's neighbour in Park Street), as well as Lady Westminster and her niece Lady Octavia. Lady Eastlake reassured Effie that she would soon be rallying support from, among others, Dean Milman of St Paul's Cathedral, the painter William Boxall and J.G. Lockhart, the father of John's supposed sweetheart, Charlotte. She also thought it would be a good idea to explain the whole story to the publisher John Murray, 'for his shop is the great rendezvous of report and rumours, and I would like them to find him prepared with the truth'.[95]

Elizabeth Eastlake organised a pre-emptive strike against John and his parents. She feared that Effie's husband would use his talents to blacken her name. If Effie was out of circulation in Scotland, she would need influential friends in London who were ready to refute allegations of extravagance, flirtatiousness or worse. So, as soon as Effie was safely back at Bowerswell, Lady Eastlake did the rounds of tea parties and dinners, giving young Mrs Ruskin's version of events. She revealed Effie's most intimate secrets in hushed tones, insisting that this was not mere gossip. Elizabeth Eastlake believed she had 'the sacred privilege of assisting a long suffering fellow creature'. She spoke out only because she hoped her listeners would also take up the cause, and fight Effie's corner. Lady Eastlake's campaign worked. Gentlemen were heard to mutter 'beast' when John Ruskin's name was mentioned. William Boxall burst into tears at the tales of Effie's torment, while Mrs Murray resorted to 'hiding her face on the sofa to conceal her sobs'.

It strikes us as strange today that these ladies and gentlemen should be so upset that Effie was not having sex. Their reaction challenges our stereotype of a Victorian wife, lying back and thinking of England. This phrase, it turns out, was first used in 1912, and has nothing whatever to do with Queen Victoria, who was unashamedly attracted to her husband. The Queen's own wedding night was very different from Effie's. Her diary was ecstatic: Albert 'took me on his knee, and kissed me and was so dear and kind. We did not sleep much'. Queen Victoria was particularly excited by Albert's shapely legs, and loved to watch him wandering about the bedroom wearing only his shirt.

Lady Eastlake's friends wept at Effie's story because they understood that desire should be a natural part of married life. (Even John's own lawyer recognised that Effie's depression was almost certainly caused by the lack of sex in her marriage.) But this was not the only reason for these emotional outbursts. If Effie never slept with her husband, she would never bear children. For many Victorians, women's sexuality was bound up with ideal-ised notions of motherhood. John Ruskin had denied Effie the chance to fulfil her potential as a mother. No wonder she was miserable and unwell. Effie's supporters were also alarmed that she was willing to put her virtue on trial. By seeking an annulment, rather than a quiet separation, Effie would have to brave physical and legal examinations. The most intimate details of her life with John would be exposed. Her Uncle Andrew worried that Effie was putting herself in a 'delicate and distressing position' and feared the 'unenviable notoriety' that would follow. But Effie was already suffering, both mentally and physically. Perhaps if she could prove that she was the victim of her husband's neglect, Effie would at last shake off the 'look of agony' that her friends found so haunting. She had to free herself from her abusive marriage.[96]

Effie's departure was timed to cause her husband the maximum embarrass-ment. If she had held on for another fortnight, John would have been away to Switzerland with his parents, and the whole affair might have been handled discreetly. Instead Effie left him on 25 April, just three days before the private view of the Royal Academy exhibition. On Friday the 28th, Lady Eastlake was at the Academy, listening to 'the buzz of pity for her and indignation at him'. John Ruskin was nowhere to be seen. But the next day John and his father confronted their critics at the opening of the Watercolours Exhibition. They tried to brazen it out. John fell into conversation with the painter David

Roberts, acting as if nothing was wrong. Roberts was astounded. He told John that 'he could not pretend to be ignorant of what all the world was speaking of'. Rawdon Brown and Lady Eastlake both wrote to Effie to tell her gleefully what happened next. John 'hummed and ha'ed' and said simply that his wife had gone to Scotland. But his father turned on Roberts, complaining about Effie's bad temper and her extravagance, saying that John had been entrapped and that he might have married a French countess instead. As he stamped off, old Mr Ruskin was heard to mutter, 'Come along John – we shall have to pay for it – but never mind we have you to ourselves now.'

John did not attempt to keep out of the public eye. In fact, according to Everett, he seemed 'to be going about rather more than usual'. John reasoned that there was no point in trying to contradict the rumours that were circulating about his marriage. He told his friend Frederick Furnivall that 'the world must for the present have its full swing'. Furnivall had been to tea with John on the day that Effie departed for Bowerswell. He became John's champion in the weeks following, although he also kept in touch with Everett. His correspondence helps us to piece together the thoughts of both men in the late spring of 1854. (Effie dismissed Furnivall as 'an amiable weak young man, a vegetarian, Christian Socialist and worshipper of men of genius'.)

In the early days of the separation, John did not seem to be overly troubled that his wife had just left him. 'I shall neither be subdued nor materially changed by this matter,' he wrote. Now that Effie was not around to disturb him, John threw himself into his work. He chose an unlikely focus for his artistic attention in *The Awakening Conscience*, the latest painting by Everett's great friend William Holman Hunt. The picture was controversial both for its subject and for the Pre-Raphaelite manner in which it was painted. It showed a fallen woman at the moment when she resolved to leave her lover. Hunt had gone to great lengths to ensure the accuracy of his modern morality tale. He had even rented an apartment in a 'maison de convenance' in St John's Wood, to create the right backdrop for his kept woman. Victorian audiences were perplexed and shocked. Such a scandalous subject was surely unfit for the walls of the Royal Academy.

Hunt argued that he intended *The Awakening Conscience* to be an image of redemption. It was the pendant to his painting of Jesus as *The Light of the World*, and Hunt hoped to show that the woman was responding to the 'still, small voice' of God. John decided to defend Hunt's work in two letters to

The Times, published on 5 and 25 May 1854. But John's reading of *The Awakening Conscience* was bleak. He concentrated on the tragedy of the woman's life, imagining her sliding into prostitution, the hem of her white petticoats 'soiled with dust and rain, her outcast feet failing in the street'. He plotted the complex sexual drama played out on Hunt's canvas. John emphasised the young woman's sensuality, and not her spirituality.

With these letters John entered the fevered debates about female sexuality in a very public manner. It did his reputation no good. His comments made him seem even more of a hypocrite in his relations with Effie. How could John's friends claim that he was an unworldly scholar who had fallen prey to a scheming woman, when he was willing to wrestle with Hunt's unsavoury parable? John seemed to see traces of the woman's sordid situation in every item in her room, from a discarded glove to the rosewood piano. (The glove and the young woman were both cast-offs, while the piano reflected her lover's lavish spending.) John clearly knew about sex, but he refused to sleep with his wife.[97]

By the time the second letter was published in *The Times*, John and his parents had reached Switzerland. They left Denmark Hill, as they had always planned, on 9 May. John felt a tremendous sense of freedom to be rid of his 'commonplace Scotch wife'. 'I am very happy among my Alps,' he wrote to Furnivall. Yet John could not help wondering what would happen to his unfinished portrait. He asked what Everett was doing. Had the artist gone to Scotland? 'I wish to know for Millais' own sake, poor fellow.' John tried to sound casual, but he knew very well that Everett's name was mixed up in the tittle-tattle about his marriage.

Everett stayed in London for the opening of the Royal Academy exhibition. He did not have any works of his own on show, but he wanted to support Hunt and his other friends. He was careful to avoid conversations about the Ruskins, but as Everett worked his way around the galleries Lady Eastlake bustled up to him. She could not resist mentioning Effie's name. Lady Eastlake told Mrs Gray what happened next: her own cheek went white, and his turned crimson. Everett asked Lady Eastlake 'with painful blushes' what she knew of Effie's situation. But he did not reveal that he had known the secret of her marriage for months.

In the first few days after Effie's escape, Everett was elated. On 27 April he wrote to Mrs Gray that 'everybody glories in the step she has taken and

only wonder at her delaying so long'. But within a month his tone had changed. He told Rossetti that he was planning to leave town as soon as he could: 'My good fellow,' he wrote, 'I am so thoroughly disgusted with London life and Society (which is false as hell).' He was sickened by the way that Effie's virtue was being generally discussed. Everett described how gentlemen at parties liked to 'retire into corners and talk it over, some expressing grief without utterance', while placidly eating ice-creams. Others found it hard to believe Effie's story, or condemned her for breaking her silence. According to Everett, Thomas Carlyle had declared that 'no woman has any right to complain of any treatment whatsoever, and should patiently undergo all misery'. (But then Carlyle's own marriage to Jane Welsh was probably never consummated, and in the mid-1850s Carlyle was making his own wife miserable by spending rather too much time in the company of his charming patroness, Lady Harriet Ashburton.) Dr Acland, who had been Effie's host in Oxford in 1848, was reluctant to accept that any married couple could be parted except on grounds of adultery. And the artist George Richmond told Everett to his face that he had thought Effie was 'frivolous and unworthy of such a mighty man of intellect'. Having heard Everett's defence of her actions, however, Richmond admitted that he might have misjudged her.[98]

Everett tried to play the part of the detached observer. He sent regular reports back to Mrs Gray at Bowerswell about London gossip, and he also kept her updated about John's movements. Unfortunately his own interest in Effie's affairs was too well known for Everett to maintain his air of neutrality. Barely a month after Effie had left her husband, there were rumours that Everett had 'disappeared with Mrs R. in a romantic elopement'. Everett was horrified when he heard. He told Furnivall that he hoped his friends would 'have the kindness to contradict any absurd conjecture about myself and Mrs R.'. Everett's position was not helped by Lady Eastlake. Now that Effie was safely in Scotland, Elizabeth Eastlake cheerfully discussed with Rawdon Brown and Lord Lansdowne how soon it might be before their lovely young friend could remarry. They reckoned that Effie should stay quietly at home for a year, then she could come back to London for her second wedding. Rawdon Brown joked that they had already planned the menus for the dinner parties that would be held in her honour. He addressed his envelope to Miss Effie Gray, even though she was still legally married to John Ruskin. In their

excitement, Effie's admirers seemed to forget that until the annulment was granted, Effie was not free to marry Everett or anyone else.

Everett had not seen Effie during the last turbulent months of her life in Herne Hill, and he made a point of avoiding any chance encounters either in London or in Scotland. In a letter to Furnivall he said, 'I should indeed be sorry to hear that any friend of mine imagined I had the *bad taste* to see Mrs R. whilst the matter is in lawyers' hands.' When he heard that she was coming to London in late May for her legal examinations, Everett swiftly left for Scotland. On Tuesday, 23 May he was back in Brig o' Turk, trying to finish the background of the hateful Ruskin portrait. He stayed away until the court proceedings were over.

Even though the annulment case was heard in private, Effie was still very anxious. In a letter to Rawdon Brown she revealed her fears that John's parents might bribe her servants to give evidence against her. She believed they were more than capable of using underhand tactics to ruin her reputation. John James Ruskin had already threatened her cook Rosina after Effie left, and tried to turn her out of the house. Effie was worn out by the stresses of the last few months, tearful and sleeping badly. In the end, she had no need to worry. Her husband decided not to contest the case.

On 5 July 1854, while he was staying in Lausanne, John Ruskin signed a document clearing the way for the annulment to go ahead. In this paper his lawyer had suggested several possible lines of defence, but John dismissed them all. Was there any possibility, for example, that the lady might not be 'a pure virgin'? John gave his answer: 'The Lady's conduct has been without reproach.' He added, 'I certainly wish the case to proceed with as little hindrance as possible.' John had, however, drafted a statement two days after Effie left him, giving his side of the story in great detail. This document was never presented to the Ecclesiastical Courts, and it remained secret until 1950.

According to John, he and Effie came to an agreement immediately after their wedding. They would not consummate their marriage on their honeymoon because they did not want Effie's state of health to upset their travel plans. Then, he wrote, they agreed not to have sex until Effie reached the age of twenty-five. John claimed that he had offered to consummate their relationship, 'again and again, and whenever I offered it, it was refused by her'. But he never 'pressed or forced' her. Unfortunately, by Effie's twenty-fifth birthday he had already decided that he did not want to have children with

her. And John wrote that by Christmas 1853 his wife was rejecting 'every attempt of mine to caress her as if I had been a wild beast'.

John gave various excuses for their unusual relationship in a section headed 'Reasons for our agreement not to consummate marriage'. Some of them seemed sensible enough. He said that Effie had been in a 'most weak and nervous state' on her wedding day, and that his 'own passion was also much subdued by anxiety'. This anxiety was caused by the financial difficulties faced by Effie's father. John alleged that he had been kept in the dark about Mr Gray's problems until ten days before the marriage. Perhaps he was unaware of the depth of these problems. We know from their correspondence, however, that John knew about the money troubles at Bowerswell in September 1847, even before he proposed to Effie.

John's declaration that he and Effie agreed not to have sex is perhaps less peculiar than it might first appear. Other newly-weds had made the same decision, and for religious reasons too: we have to remember that the Ruskins were married in Lent. In 1844, for example, the author Charles Kingsley discussed their forthcoming wedding night with his fiancée Frances Grenfell. This couple came to the conclusion that it would better to learn to live with each other before complicating matters further: Charles acknowledged his fiancée's 'terror at seeing him undressed', and was himself worried whether he could 'bear the blaze of her naked beauty'.

Frances's vision of her early married life was strikingly similar to John Ruskin's. He had pictured bringing his bride home, and how they would kneel together in prayer beside her bed. Frances wrote to Charles Kingsley, imagining their first night together: 'After dinner I shall perhaps feel worn out, so I shall just lie on your bosom.' She went on, 'you will kiss me and clasp me and we will praise God alone in the dark night with His eye shining down on us'. They would 'glory in their yearning, please God!', but they would not enjoy a 'fuller communion' for several weeks.

There are, however, several critical differences between the arrangements of the Ruskins and the Kingsleys. First, Charles and Frances came to their decision together, and most importantly, before their wedding day. John and Effie did not. The failure of the Ruskins to consummate their marriage was not planned. It was the result of a muddle. John might have preferred to remain celibate, but Effie was not bound by his decision. Secondly, after a month of self-denial, the Kingsleys did satisfy the yearnings that they

both acknowledged were part of married life. And within a week or two Frances was pregnant. Effie's experience was very different. She had hoped that once the anxieties of the wedding were overcome, once she and John were restored to health, then she too might look forward to becoming a mother.

But John went on in his testimony. The silences between them became impassable. He insisted that, had she been kinder and more devoted, he would have 'longed to possess her, body and soul'. But 'every day that we lived together', he wrote, 'there was less sympathy between us'. Effie wanted to draw him away from his own parents. She was offended when he refused to help her find a job for her brother George. 'On one occasion,' he wrote, 'she having been rude to my mother, I rebuked her firmly, and she never forgave either my mother or me.' Judging from the letters that circulated at the time, there was fault on both sides. John summed up the situation: 'I married her, thinking her young and affectionate that I might influence her as I chose, and make of her just such a wife as I wanted. It appeared that she married me thinking she could make of me just the husband she wanted.' They found they could not change each other.

If John's statement had stopped there, his failed marriage might have been written off as a series of misunderstandings. But John Ruskin could not hide his anger. Effie had cornered him, and forced him to admit that they had been living a lie. As his statement went on, his attack became more spiteful. John acknowledged that most people found Effie attractive, 'but though her face was beautiful', he wrote, 'her person was not formed to excite passion. On the contrary, there were certain circumstances in her person which completely checked it.' John never revealed what he found so unappealing. When the doctors examined Effie they said that nothing was physically wrong with her. Her husband, on the other hand, said he could only love her 'with little mingling of desire'. He also claimed that he could prove his own virility. But John never submitted this document. The Ecclesiastical Courts decided against him and on 15 July 1854, his marriage to Effie was annulled. The courts declared that 'John Ruskin was incapable of consummating the same by reason of incurable impotency'.

John's reputation was permanently damaged by this verdict. He tried to explain to his friends that his conduct towards Effie had been 'guiltless though foolish'. But he found that the charge of impotency could not be shaken off.

Fifteen years later it destroyed John's chance of marrying another young lady, Rose La Touche.[99]

For Effie, the annulment opened up the possibility of a new life, or at least a return to the peace of her childhood. She received the news of her release at St Andrews. Her parents had taken her to the seaside for a holiday with her little brother and sisters, after the court case. In a letter from her proctor, Effie heard that the judge decreed that she had never been married. Her relationship with John was a 'pretended marriage' and the legal papers referred to her as 'Euphemia Chalmers Gray falsely called Ruskin'. Effie was officially 'free from all bonds of matrimony'. She was starting to recover her spirits. The twitch above her eyebrows no longer troubled her, and she told Jane Boswell that her cheeks were becoming quite rosy. Effie loved to swim, and she now had the strength to stride out along the coast. Some days she walked ten miles, blown by the sea breezes. She had given up her fancy silk gowns and wore plain dresses, her hair simply plaited and pinned up. She knew that Scottish folk were gossiping about her, just as they did in London, and she did not want to give her critics any more ammunition. Jane Boswell passed on the rumours in her letters. Some of the Grays' Perthshire neighbours blamed Effie's ambition for the failure of her marriage. Others claimed that she entered the relationship with her eyes open, knowing that her husband never wanted a family. But Jane defended her friend, and praised her for her strength and goodness. 'I know I could no more have done what you have done,' Jane wrote on 10 July, 'or withstood the temptations you have, than I could fly.'

Jane knew what temptations had been put in Effie's way. She was convinced that John had deliberately left Effie and Everett alone together in the Trossachs, hoping that his wife would seek comfort in her young admirer's arms. But Effie had resisted, and continued to resist, Everett's attractions. The handsome young artist had to wait.

Mrs Gray made sure that Everett was sent word of Effie's release. He was staying near Chatsworth when he received the note. He had been painting a little picture called *Waiting*, one of several works with romantic subtexts that he made that year. Everett imagined a girl, who looked remarkably like Effie, sitting on a stile with meadow grass glowing bright against the purple of her skirt. The narrative was ambiguous, the outcome uncertain.

After Everett read Mrs Gray's message, he felt 'crazed with trying to realise

Effie's freedom'. He could not trust himself to begin a letter until his companions were in bed, so it was well after midnight when he sat down to open his heart to Effie. 'Dear Countess,' he began, 'I cannot see that there is anything to prevent my writing to you now.' He told her that it was 'the best news I have ever received in my life'. Everett wanted to see Effie before he went back to London. He urged her to write by return post to reassure him that she was the same woman he had known at Glenfinlas. Everett hoped to recapture the intimacy of the long evening walks they had taken the previous summer. 'Oh Countess how glad I shall be to see you again,' he wrote, and went on, 'this is all I can say now, and you must imagine the rest.' It took Everett the whole night to order his thoughts. His letter revealed his devotion and hinted at his dreams, but still, as he admitted, he had the 'strange feeling of withholding myself'. He did not know how Effie would receive him. Dawn was breaking over the Peacock Inn, and the tables were being laid for breakfast, when Everett finally sealed the envelope and strolled out into the midsummer morning.

Everett was bewildered. He had fallen in love with Effie when she was a married woman. He might have fantasised about freeing Effie from her 'slow inward martyrdom', but he had never really believed that it would happen. Everett had been schooled in the tales of chivalry that inspired his Pre-Raphaelite friends. In the poems of Dante and the Arthurian legends he had found plenty of examples of young men who devoted themselves to queens and married ladies. Everett's adoration of Effie followed this pattern of courtly love. He had given his heart to his mentor's beautiful wife, safe in the knowledge that she was unattainable. Then, in April, Effie had taken the astonishing step of leaving John Ruskin. Everett had hardly been unable to concentrate since. He abandoned his idea of accompanying Hunt to the Holy Land, and instead struggled to finish John's portrait. What should he do? He had declared his love to Effie in Scotland, he had urged her parents to save her from her hateful marriage, and their friends in London insisted that his fate was entwined with hers. Everett needed to see Effie to find out what, if anything, she expected of him.[100]

But Effie held Everett at arm's length. Although she replied immediately to his letter, she said that she could not invite him to Bowerswell just yet. (Very little of Effie's correspondence from this period has survived.) Her health was improving, but she was still far from well. In August Lady Eastlake

was horrified to hear that Effie had been advised to shave her head. 'I strictly forbid it,' she wrote, 'the hair would never come so well again.' Effie needed peace. More than a decade later, recalling the trials of her marriage to John, she reluctantly revealed that the years of distress had nearly killed her. Her nervous system, she said, was so shaken that she feared she may never fully recover.

Effie told Rawdon Brown that she did not want to be hurried into a new relationship. 'Why grudge me my happy security and quiet Life now?' she wrote. She was enjoying a return to the old ways, helping her mother with the household and the children, playing her piano, walking, bathing and riding. But Everett wrote back to Effie on 27 July 1854, still hoping that he would soon be 'trotting up the hill of Kinnoull' with her. He admitted that Lady Eastlake had warned him not to go near Perth that summer, yet he suggested that 'beyond a few close friends, it scarcely matters what the World says'. This letter, like the first, showed his agitation. He wrote, 'I suppose that I am desperately happy (at least I ought and wish to be)', yet he could not get to grips with the implications of Effie's escape. Everett confessed that 'the thought of being near you again numbs my senses in an odd way, so that I almost fear what I look forward to with such pleasure, meeting you again'. (He had originally written 'desire', but crossed it out and replaced it with 'pleasure'.) Everett had spent many hours, many days, in the summer of 1853 exploring Effie with his paintbrush. He had studied each curve of her body, he could describe the softness of her hair, and the lilt of her speech. Now that her husband could not come between them, the idea of being in Effie's presence, and the possibility of touching her, made him breathless. He tried to move his thoughts along, telling Effie about his new painting projects and his commission to illustrate some of Tennyson's poems. But he could not keep his mind on work for long. 'Write to me as often as you can without injuring the education of the small Grays or wearying yourself,' he urged her. Everett signed himself 'Your loving master'.

In her note of 26 July 1854 Effie had asked Everett to 'write more clearly'. Everett did not know how to interpret this. Had his hands been shaking so much that his writing was illegible? Or did she mean more than that? Perhaps she wanted reassurance that he still loved her.

There could now be no doubt of his devotion. His second letter was alive with tremblings and revelations. Comforted by his words, Effie decided that,

for now, Everett's adoration was better from afar. She needed to come to terms with the fallout from her marriage, and the failure of her ambitions. Embarking on another love affair would make her vulnerable. And she did not yet have the strength to cope with Everett's own nerves and confusion. She told Rawdon Brown soon after, 'I am not fit to marry anyone, believe me – and you know it would never do to be wretched twice.'[101]

Everett retreated to Sussex without setting eyes on Effie. He went to Winchelsea in August, with his friend Mike Halliday, to paint the backgrounds to *The Blind Girl* and *The Random Shot*. He had no idea how long Effie intended to remain aloof. He carried on writing to her, but received only the merest scraps of encouragement in return. Effie was beginning to make him feel like a fool. In a letter to Hunt he even talked of giving her up and finding a new passion. He was tempted by the pretty girls who sauntered past him in the evenings, 'bonnetless in the moonlight'. Perched on a stile, smoking his cigarette, Everett sighed, 'What a difficult thing it is to behave properly.' At twenty-five he was tormented by romantic longings. He told Hunt that he had an almost insurmountable desire to stop the girls and speak to them 'as most youths would'. But he resisted their charms.

Another difficult encounter awaited Everett on his return to London in late November 1854. He had to invite John Ruskin for his final sittings. Everett still needed to paint the hands in John's Glenfinlas portrait. Everett's parents had moved out to Kingston-upon-Thames, so he borrowed Charles Collins's studio in Hanover Terrace, Regent's Park, to complete the work. There is no record of what Everett and John talked about during these sittings, but it seems that John was reluctant to allow the business with Effie to come between them. He took the finished portrait home to Denmark Hill in early December and on the 11th wrote enthusiastically to Everett, 'I am far more delighted with it now than I was when I saw it in your rooms.' His parents said it was a perfect likeness, although perhaps John appeared a little bored. He joked that 'certainly after standing looking at that row of chimneys in Gower Street for three hours – on one leg' it was only to be expected.

Everett did not know how to respond. Did John really not know that his young friend was in love with Effie? Was he unaware of the speculation surrounding the annulment? Miss Ainsworth had warned the Grays that half the world was talking about Effie's motive for obtaining a legal annulment instead of a quiet separation, and wondering when Everett would take John

Ruskin's place. Everett was still deciding how best to handle this dreadful social conundrum, when he received another note from John: 'Why don't you answer my letter – it is tiresome of you – and makes me uneasy.' Everett now felt compelled to reply. He was surprised, he wrote, that John would think that they could go on as before. He had expected that John himself 'would have seen the necessity of abstaining from further intercourse'. The problem was personal and not professional, Everett said, and he still sympathised with John's efforts to improve the state of British art. But the friendship was over.

Neither of them mentioned Effie's name. However, in his reply, John referred to their Scottish holiday together and denied that he had invited Everett for 'some unfriendly purpose'. John was deeply hurt by Everett's words. They had, he said, taught him a lesson in 'human folly and ingratitude'. John withdrew with as much dignity as he could. He remained remarkably even-handed in his reviews of Everett's work in the years after this breach. The following summer he described Everett's picture of a fireman, *The Rescue* (1855), as 'the only great picture this year, and it is very great'. But John's father was less restrained. When he heard of the young artist's coolness, he sent a vicious letter to Everett's friend Charles Collins. John James Ruskin hit out at Effie. He claimed that his son was 'caught by a pretty face'. 'Miss G,' he wrote, 'concealed the embarrassed circumstances of her father – courted my son – filled his house with men of her own finding till he could not get a single hour for study.' His anger spilling over, he accused Effie of wasting £15,000 of his money in reckless spending. She was 'lowly born and lowly bred', full of artfulness and falsehood, 'the most abandoned woman'. Then he turned on Everett. He claimed that the young man's conduct had been improper, that he should never have left his work to follow the Ruskins to Scotland, and that he had joined forces with John's enemies and slanderers. The rift between John and Everett was now irreparable. When Everett saw this letter, it only reinforced his relief that Effie had been spared any more of these outbursts. Her life under John's roof must have been unbearable, if his parents thought so little of her. John James Ruskin showed no regrets that the marriage had ended. He acknowledged no failure on the part of his own family. Instead he rounded on the woman who had made a laughing stock of his son, 'the Graduate'.[102]

Now that Everett had finished John's portrait, and broken all communication with the Ruskins, Effie could contemplate meeting him again. They had

not seen each other since November 1853. In February 1855 Effie invited Everett to Bowerswell. It was a fleeting visit, barely two days together. They were reunited under the sharp eyes of Effie's little sisters, Sophy and Alice, and Mrs Gray; she was heavily pregnant for the fifteenth time. It did not go well. Everett's eagerness had evaporated during the long winter months that Effie kept him waiting. Heavy snow made his journey troublesome, and he suffered in the intense cold. Effie too was poorly, with a persistent cough, and she was preoccupied with her mother's impending confinement. Everett left empty-handed.

Effie's mother gave birth to a boy on 19 March 1855, at the age of forty-seven. The Grays named him Everett. This was the first official sign that there was any understanding between Effie and her artist-admirer. Until then family and friends had done their best to play down any talk of a romance. It undermined Effie's claims to have left her marriage to escape a life of mental abuse and neglect. In Miss Ainsworth's words, 'I deny it positively and I do not scruple to say I hope and trust no such thing will ever take place.' Now all the world would know how highly Effie's parents regarded Everett. And the gossips would feel vindicated. But Effie did not have time to think about such things.

Two days after the birth, Mrs Gray became seriously ill, with 'a kind of cholera'. She had been weakened by an attack of influenza earlier in the year, and Effie feared that her mother would be lost. Effie had to concentrate on looking after a tiny baby and a houseful of frightened children. Everett wanted to see her again before the private views began. He was concerned about the awkward questions that he was bound to face, from friends and critics alike. What were her plans? But Effie put him off. She could not invite Everett to Bowerswell while her mother was dangerously ill and the threat of cholera hung over the house. The disease had first been identified in Britain in 1831, and spread swiftly from Sunderland docks across England and Scotland. Since then cholera epidemics had erupted every few years through-out the 1840s and 1850s. Families looked on helplessly as victims retched in pain, tormented by thirst, their skin a bluish-grey. One doctor described cholera as 'outlandish, unknown, monstrous'. It was untreatable, and seemed to strike at random. Effie watched and waited in the shadows of the sickroom. Gradually Sophia Gray recovered from her dreadful cramps and dehydration. By early May she was ready to receive visitors again.[103]

Everett worked frantically on his 1855 Academy exhibits, trying to recover the ground he had lost the previous year, when he had been unable to show any paintings. He was still finishing *The Rescue* at midnight on the very last day for submitting works, with Charley Collins by his side in the studio, helping to touch in the last details. Everett was behaving out of character, becoming argumentative and stubborn. The pressure of work, combined with the strain of waiting to be summoned by Effie, was beginning to tell. On Varnishing Day at the Academy he flew into a rage. *The Rescue* had been hung badly, up against the door. It was too high for anyone to study the shifting colours, from the crimson of the blaze to the grey of dawn. Who would be able to appreciate the heroic action of the fireman from that angle? Everett threatened to resign from his membership of the Academy. Evidently he had enough leverage for the hanging committee to take him seriously. As Effie had said, 'his character stands so deservedly high as the founder of a new school' of British art, that the Academicians could not ignore Everett's complaints. They lowered the picture by three inches, and tilted it forward so that it could be clearly seen from the ground.

Having won this battle, Everett was now able look forward to his next meeting with Effie. He went back to Bowerswell as soon as he had run the gauntlet of the private views. This time the sun shone on Everett and his beloved. Her marriage to John Ruskin had left Effie traumatised. She remembered it as a time when 'hope seemed impossible, interest in life gone', a struggle against 'sickness, distraction of mind, calumny, scandal and enmity, falsehood and crime, and every variety of human depravity'. But now, in the spring of 1855, she could make a fresh start. Effie was finally able to admit everything that she had held in check since their holiday in Brig o' Turk. She loved Everett and was ready to marry him. By the second week of May they were planning their wedding. The intimacy that Effie and Everett had enjoyed in the little cottage in Glenfinlas could at last be renewed and indulged.

Effie's love for Everett was genuine, but she rarely voiced her passion. Her friends tried to put words into her mouth. Lady Eastlake, for example, was convinced, as early as August 1854, that Effie's heart was already engaged and that it was only a matter of time before she married Everett. It was not quite that easy. Until the spring of 1855 Effie was very reluctant to marry again, although she was touched that Everett was still pursuing her. She agonised over the scandal now attached to her name. In the end, she married Everett

out of gratitude, and because this was the only way to retrieve her status. Effie refused to live out the rest of her days under a cloud at Bowerswell, a maiden aunt with a sorry past. Everett offered her the chance to rebuild her life. Her diary of 1855–6 became a hymn of thanks that she was given a second chance. She was grateful to Everett that he had continued to love her, despite the difficulties and distance between them. She was thankful to God for his mercy. She wrote that she had cried from the depths and God had heard her. Effie believed she had been delivered from darkness into light. As Lady Eastlake had predicted, 'Another life lies before you, my dearest child – and one that cannot but sparkle brightly.'

Effie ordered her second wedding dress, a gown covered in Venetian lace. It was a present from Rawdon Brown. She wrote to thank him, saying guardedly, 'I hope I shall be happy.' Everett's letter to Hunt, announcing his engagement, sounded even more anxious. 'I feel desperately melancholy about it,' he wrote. 'I take this fearful risk in desperation.' He went on: 'I have so little faith in my own ability to blot out this ruin in her life, that I am often very desponding in the matter, but I cannot see how this marriage could have been otherwise, everything seems to have happened to work out this end.' Having told Effie that he loved her, when she was still a married woman, he could not back away now. The memory of Everett's loving words had supported Effie in her decision to leave her husband. The vision of his face looking longingly across the snow in *The Eve of St Agnes* had given her the strength to plan her own escape.

But Everett had not realised what a dangerous game he was playing when he fell into his fantasy of courtly love. Effie, her family and her influential friends expected him to live out the role of the gallant knight. He had helped to rescue his beautiful lady from her beastly marriage. Now he needed to marry her. Even John Ruskin thought that this was the inevitable end of the story. Hearing from Furnivall about Effie's marriage plans, he wrote that Everett 'may from the moment of our separation have felt something of a principle of honour enforcing his inclination to become her protector'. But would Everett and Effie live happily ever after? 'There are assuredly dark hours in the distance,' John warned, 'for her to whom Everett has chosen to bind his life.'

Everett returned briefly to London. He had to pack up and move every-thing to Perthshire. Effie was unwilling to leave the safety of her parents, and

could not 'bear the noise of cities or a crowd of unknown people'. After the wedding Everett would live and work at Annat Lodge, next door to Bowerswell. Effie's first husband had always claimed that she had tried to get him 'into a close alliance with her family'. John had refused, but Everett was more compliant. He knew that Effie was unshakeable in her affection for her childhood home. He agreed to her terms.

Despite his initial misgivings, Everett rather enjoyed spending his last weeks as a bachelor at Bowerswell. He travelled to Scotland on 9 June 1855. Everett was a good horseman – he had taken up hunting to beat the gloom he had suffered on his return from Brig o' Turk – so he and Effie rode out together each morning. He thought she looked wonderful in her habit, and sent Hunt a little sketch of Effie in her tailored riding jacket and neat, feathered hat. She showed him the sights around her home, the hallowed places of her girlhood. Their excursion to Stobhall sang in her memory, sustaining her for years after. This was perhaps the first time they were truly alone. Everett and Effie walked to the water's edge through a haze of bluebells. Effie wrote in her diary: 'It was a rest and consolation for both of us to sit still there for the hours we did, hardly speaking and listening to the river rushing past, from which occasionally a salmon would spring.' In the warm spring sunshine, they found the peace that they had both been seeking. The waiting time was over.

On Tuesday, 3 July 1855 Effie and Everett were married in the new drawing-room at Bowerswell. Everett had spent the morning writing to friends and playing bowls with his brother William and young George Gray. This time his letter to Hunt was optimistic. His time in Scotland had refreshed and reassured him. His dreams of Effie had survived the reality of living together under the same roof for three weeks. Everett recognised that 'there must be I suppose a great deal of vagueness in taking this step', but he told Hunt that he was very happy. He said he felt like a fifteen-year-old who was looking forward to his first evening party: he was excited, feverish and slightly out of sorts.

Effie sat by her bedroom window and watched the men out on the lawn. She read a little and tried to think about her old life, and the new life that lay ahead. It made her head ache. She told herself that she should focus on the blessings of the future, giving thanks to God that he had brought her to this day. Effie was roused from her contemplations by Jeannie. It was time to

dress. In the nursery Mrs Gray was busy with the little bridesmaids, Sophy and Alice, and their cousin Eliza Jameson, helping them into their pretty white gowns, tidying their curls. Effie ran her fingers over the lace of her own dress and then stepped into the cage of her crinoline. With Jeannie's help, she buttoned and laced herself into the bridal gown. Everett's parents had not travelled to Scotland for the wedding, but they had sent up a large bouquet of fresh flowers. Effie selected a few roses and fastened them in her coiled hair. She began to feel the thrill of knowing that Everett's eyes would be upon her. She remembered the sensations of two summers ago, as he had painted her with foxgloves framing her face. For months he had followed her with his eyes, with only the briefest of touches. And now here they were, moments from their marriage. Very soon they would be man and wife.

The guests were gathered in the drawing-room. The minister, Mr Anderson, was ready. Effie's father knocked on her door. 'Come away, my dear Lassie,' he said, 'this time I feel happy in putting you into good hands.'[104]

Chapter Nine

The Young Mother: 1855–72

THE SMELL drifting through the window was worse than Venetian canals in hot weather. Effie was glad that they were staying in Rothesay for only one night. She turned back to Everett, beside her in the bed. It was their first night together and he was calmer now. Earlier in the train Effie had cradled his head in her hands as he wept. She had heard him mutter, 'It has added ten years to my life' as she bathed his wet face with eau de Cologne. The wedding ceremony, he said, had passed like a dream. In the railway carriage Effie had taken off her white bridal shawl and wrapped her green plaid around her shoulders. Neither of them wanted to be recognised as newly-weds.

After her months of peace at Bowerswell, Effie had been unnerved by the masses of humanity, the rough voices, the rush of steamers up and down the Clyde. They had arrived at Rothesay as the tide began to ebb, and the stench of mud and rotting seaweed from the foreshore was almost unbearable. Everett had tried to find another hotel, but it was the same everywhere. So he had ordered supper to be brought upstairs. The kitchen sent up fried fish and a pot of tea. By the time Effie slipped into her nightdress, the air in the room was stagnant. Both Effie and her bridegroom were anxious. Would Effie's second wedding night be as dreadful as her first? They need not have feared. In her diary, Effie wrote that they 'were very comfortable'.

The next day, 4 July 1855, Mr and Mrs Millais sailed over to Arran. They spent an enchanted fortnight at Brodick. It was so warm, Effie noted in her diary, that they stayed inside for most of the day. Then, in the cool of the evening, they rowed out into the bay. The sea was exquisite, pale green, transparent, and full of life. Looking down into the clear water Effie saw shellfish and anemones. She listened to the islanders in their fishing boats singing in the moonlight. Effie and Everett cast their lines over the stern and waited, content, until they felt a tug. They caught whiting, and sometimes

flounder and haddock. The days and nights floated by. Effie woke each morning to blue skies, and the sight of figs and peach trees laden with fruit in the garden. The couple stirred themselves to ride along a rose-strewn track towards a ruined castle by a loch.

It was time to move on. Effie and her new husband paid a wedding visit to Jane Boswell's family in Ayr, and then took a steamer back to Glasgow. It began to rain as they made their way by lochs and glens towards Oban. They had their first quarrel at Inverary, where they stopped overnight. Effie wrote about 'some painful moments' there, but she added, they soon 'turned the corner of the passing trial'. As she admired the lovely hills around Oban from the top of a coach, Effie's spirits were restored. She and Everett spent their days in 'sweet walks' and their evenings on the water.

Effie persuaded Everett that they should take a day trip to Staffa and Iona. So they set out early one morning for the grey islands. It was, she wrote later, fourteen hours of perpetual sightseeing and seasickness. But Effie was glad to have made the journey to these places, so wild and strange, like a scene from Ossian's poems. They were impressed by Fingal's Cave, with its vast columns of basalt, this 'cathedral of the sea'. Effie seemed more moved by the savage beauty of Iona. She described it in her diary as feeling like an ancient crossing-place between this world and the next, barbarous, semi-pagan, yet sanctified. Effie wandered through the graveyard, 'full of the bones of Kings of three countries', finding heathens buried next to knights and priests. When they finally returned to their hotel room, Effie and Everett went straight to bed, overcome with tiredness. They gave up the idea of travelling on to Skye, and instead crossed back to the mainland, and up to Aberdeen.[105]

Effie found the granite city very ugly, but she thought it looked as if 'it would last till the end of time'. They moved on swiftly, passing Balmoral, where she and Everett were able to peep at the new palace. That night they slept at Braemar. Everett spent a few hours in the castle, sketching ideas for an illustrated edition of Tennyson. But for most of their tour he put away his work and concentrated on sport instead. Their next stop was Fortingall. Everett's brother William, who had come to Perthshire to act as best man, was staying there for a few weeks, painting and fishing. Effie and Everett had a long drive through Glenshee and then over the Bridge of Tummel to reach William's inn. Effie recalled crossing the same bridge seven years before, on her honeymoon with John. The Ruskins had been heading south after their

unsuccessful wedding night, what John had referred to as Effie's 'trial at Blair Athol'. That confused, unhappy time could now be laid to rest, as Effie and her new husband took the same road. In the twilight, Effie whispered to Everett, unburdening herself. She wrote later that they gave 'tender expression to their thankfulness'. The horses jogged on, and the young couple dozed, close together in the darkness. It was nearly midnight when the coach halted and they heard William's voice welcoming them. Effie could see her brother-in-law, hearty as ever, standing in the doorway of the inn with a lantern. He ordered hot toddies all round.[106]

On 3 August 1855 Effie and Everett returned to Perth to take possession of their new home. They were renting Annat Lodge from a family who had been obliged to go abroad. (One of their children was seriously ill and would not survive another Scottish winter.) From Effie's point of view, the arrangement was ideal. She had her own establishment, but she could see her parents as often as she wished. The two gardens were divided only by a stream and there was a narrow bridge across it, so the Grays could come and go as they pleased.

Effie and Everett did not have much time to enjoy their married life alone at Annat Lodge. No sooner had they unpacked than they were off again to St Andrews for a few days. They wanted to catch up with Effie's family, who were 'all strengthening themselves in the Golf, seabathing and fresh fish'. Everett decided he had better buy his own set of golf clubs if he really meant to settle in Scotland. Mr Gray was an avid golfer, taking a turn on the putting green at Bowerswell most evenings, and Effie's new husband did his best to fit in. The Gray family's dynamics were very different from his own. Everett came from a comparatively small family. His mother had been a young widow when she married John William Millais, so Everett had two half-brothers, Henry and Clement Hodgkinson, as well as his brother William and his sister Emily. Both William and Emily were energetic and very musical. William had a fine tenor voice and was invited to sing at the Hanover Square Rooms. Everett said his sister had 'go': she was lively and great company. She had moved with her husband, Lester Wallack, to New York, and Everett admitted that he had almost forgotten her when he saw her in Kingston-upon-Thames in the spring of 1856. Unfortunately we never find out what she made of Effie. They only exchanged occasional letters with family news.

A studio photograph taken during the honeymoon visit to St Andrews in

1855 has survived in the family archives. It shows Everett on the fringes of the Gray family. He contemplates his place in this clan. Unlike the other sitters, he is seen in profile. This sets him apart. Everett looks down at Effie. They discreetly hold hands, but she does not catch his eye. Instead she looks straight out at the camera with the slightest of smiles. Effie's little brother Melville perches on a cushion at her feet, his arm resting easily in her lap. Behind her stands Sophy. She avoids the camera's scrutiny by lowering her eyes. Is it possible that Sophy is also turning away a little from Everett? Next to her is Alice, who leans against her father, while Mrs Gray sits resplendent in lace jacket, with wide ribbons and ringlets in her hair. Effie's flounced dress and small cap seem restrained by comparison. Jeannie, the nurse, is at Mrs Gray's elbow, carrying a bundle that must be five-month-old Everett. She wears a straw bonnet with ruffles and a paisley shawl. Jeannie looks ruddy, her servant status marked on her face. (The genteel Grays have kept their fair skin, even at the seaside.) Beyond her, young George with his side-whiskers and lopsided bow-tie looks after the two little boys, John and Albert. Albert, who is nearly five, stares mutinously at the camera. His image is rather fuzzier than the rest; he found it hard to stay still for the long exposure. Albert is still in skirts. His white pantaloons with their fancy scalloped hems can be clearly seen. It will be a few months yet before he is breeched. Then, having officially survived the hazards of infancy, he can run about in his hand-me-down corduroy trousers.

This photograph is full of overlapping bodies. It is a record of intimacy and affection, unspoken tensions and allegiances. The Gray family becomes a tangle of arms, legs and clothes, hands lying casually on shoulders, figures leaning towards one another. Effie's husband casts his eye over the group, assessing his position. By marrying Effie he has bound himself to her life and her family. Everett is now committed to staying in Scotland. Yet his patrons and his friends are largely London-based. How would he support a wife, and fulfil his own ambitions, from the cultural backwater of Perthshire?

Effie had no money of her own. She had returned the £10,000 that old Mr Ruskin had settled on her in 1848. She had also claimed no damages when she sued for the annulment of her marriage. Mr Gray could not be expected to help much, although the threat of bankruptcy, which had blighted Effie's early life with John, had passed. Effie's father was beginning to feel his way

with new projects. He became involved with the fledgling Perth Gas Light Company: his brother-in-law Melville Jameson was a director. Many of George Gray's letters to Effie from the early 1860s were written on the company's headed notepaper. At this point his speculations and personal connections finally began to pay off. George Gray already had money in the Dundee-to-London steamer service. Then in 1864 he helped to establish the Standard Life Assurance Company in Perth, which shared offices with the Gas Light Company. He maintained these interests throughout the 1860s and 1870s, while also managing the branch of the Royal Bank of Scotland in the town. He saw all his endeavours as striving towards the same ends. They were civic and financial responsibilities, essential for the development of local trade and helping to raise living standards for the people of Perth. However, in the mid-1850s Mr Gray had little money to spare for his eldest daughter. He was already supporting his six young children. Effie's brother George, who had not settled into a profession at home, recognised that he needed to make his own way in the world. Soon after Effie's marriage, George told his sister that he was planning to emigrate to Australia. He hoped to make a living on the sheep stations. He went to work at Sandy Ridges outside Melbourne, staying there on and off until the late 1870s, 'getting the wool off the sheep's backs to send to London to convert into coin'.

So Effie was entirely dependent on Everett's earnings. In the first months of their marriage, this seemed not to trouble either of them much. Everett sold *The Rescue* to the collector Joseph Arden, which tided them over. But by the autumn of 1855 Effie suspected she was pregnant. It seems likely that she told her husband on 20 October, as that was the day that Everett picked up a paintbrush for the first time since their wedding. Before he married, Everett's income had been erratic. The previous year, for instance, he had not finished a single painting in time for the Royal Academy exhibition. And now he was in self-imposed exile from the art world. What would happen to his career?

Effie has been blamed for persuading her husband to abandon his Pre-Raphaelite principles. But the pictures Everett painted in the first years of their marriage were just as intense and avant-garde as his early works. *The Blind Girl* (1854–6) was a sunlit *tour de force*. The details of the foreground – a patch of grass and harebells, the frayed skirts and rough fingers of the two sisters, a tortoiseshell butterfly – were painted with precision. However, Everett was starting to move away from the microscopic observation of

143

Ophelia (1851–2) and develop an all-encompassing gaze. The slope of the meadow behind the blind girl, rich with colour and life, was evoked in shimmering, rippling strokes. Everett demonstrated his extraordinary ability to construct a work that was both pleasing to the eye and laden with meaning. He emerged from the spiky awkwardness of early Pre-Raphaelitism, while retaining the essentials of that youthful movement. Everett's picture was fresh, bold, symbolic without sentimentality. The pathos of the girl's blindness is heightened by her own beauty and the beautiful landscape in which she sits. She may not be able to see the sky, but she can touch the grass, hear the brook and smell the damp earth.

The background to *The Blind Girl* was painted in Winchelsea in the summer of 1854, with the figures added after Everett's marriage. Effie was the first model for the girl. She sat by the study window in the full sun, her chin tilted, her eyes closed. It was unbearably hot. Even with a flannel on her forehead, she felt nauseous. Effie was newly pregnant, and suffering for her husband's art. After nearly a week of work, Everett gave up, unsatisfied. Later he scratched out Effie's face from the canvas. A local girl, Matilda Proudfoot, appeared in the final version. Everett was unsure about the colour of the blind girl's skirt, which was so prominent in the foreground, but at last he settled on amber to echo her coppery hair. Barely a week before he needed to take the picture to London, he still had not found the right fabric. Then on Saturday morning, Effie was out shopping in Bridgend, just outside Perth. She was buying meat from her poultry-woman, when she spotted an old lady across the street wearing a petticoat that was just the colour for Everett's picture. 'You know that woman, Jean,' she said to the shopkeeper, 'run and ask her if she would lend me her petticoat a night.' Effie was too heavily pregnant to rush anywhere now. She heard the old woman swear as Jean Campbell explained what the artist's wife wanted with her skirt. It was dirty and threadbare, 'but Mrs Millais was welcome to it'. Effie took it home in triumph, kept it for the weekend and sent it back with a shilling for the old woman's trouble.

Everett was always impressed that Effie was able to procure props and models for next to nothing. She had a good eye and was willing to haggle. He told Hunt that Effie was wonderful about 'going into strange habitations and seizing adults and children without explanation, and dragging them here, and sending them back to their homes with a sixpence, when I should have been

doubtful between a sovereign and thirty shillings'. Effie was equally happy to research details of historical costume, and run them up. For Everett's picture of *The Escape of a Heretic*, Effie worked from some sixteenth-century woodcuts of 'condemned prisoners of the Inquisition' that she saw at a friend's house. She said that 'the Girl was to be clothed in a sort of Sacklike garment of black serge painted over with red Devils'. Effie wanted to be involved in Everett's picture-making. She had been frustrated in her first marriage by many things, but John's unwillingness to let her work alongside him had been particularly painful. Everett, on the other hand, valued her skills and intelligence. As Effie wrote in her diary, 'we toiled together', and she was grateful.[107]

With Effie's help, Everett completed four major paintings for the Royal Academy exhibition of 1856. In the final push to complete his canvases, he was working seven days a week. Effie sat beside him on Sundays, reading the prayer-book service aloud, while Everett painted on. She disliked him working on the Sabbath, for practical as well as spiritual reasons. She thought he needed a day of rest. But Everett knew he needed to prove to the London critics that they should not write him off. He also recognised that the public would be thinking about his private life when they looked at his pictures. He decided to dazzle them with the glorious colour of *The Blind Girl*, the subtlety of *Autumn Leaves*, the flesh and carved stone of *L'Enfant du Régiment* and the blessings of home life in *Peace Concluded, 1856*, a picture with Effie at its heart. This last painting had already been sold to John Miller before the Academy exhibition opened. Miller paid 900 guineas for the picture. Everett said it was the most expensive painting in the Academy show, apart from a large work by Landseer.

Everett left for London on 5 April 1856, with his paintings wrapped in tarpaulin against the torrential rain. He took rooms in Langham Chambers, in Marylebone, with Captain John Luard, an artist-soldier who had recently returned from Sebastopol. Everett wrote to Effie on his first evening in London, signing himself, 'your affectionate husband'. Then he added, 'I feel so strange writing to you, I feel a little shy as tho' it wasn't quite right.' They had been married for nine months, and according to Effie, had spent 'every hour of each day together'. Now she was alone in Annat Lodge, contemplating her confinement. Her parents and little sisters were just across the stream, and she had her dog for company. But she was feeling wistful. Effie knew that

the balance of power in her partnership with Everett was shifting. Their roles in the household would become divided. Everett, she wrote, would enjoy more 'public work and association with men in which I cannot join'. The care of a young family was Effie's portion.

Effie's former schoolfellow Elizabeth Gaskell once tried to untangle the dilemma of many young mothers. She wrote to a friend in 1850, 'Women must give up living an artist's life, if home duties are to be paramount', and yet surely they should have some refuge from the 'daily, small Lilliputian arrows of peddling cares'. As she was writing this letter, Gaskell was interrupted by her own children, who 'came down upon us like the Goths on Rome'. Effie had no illusions that she would be able to share fully in the artist's life. Managing a household was time-consuming and complex. But Effie found it hard to resign herself to the domestic sphere, especially when she heard about the 'free and easy fashion' in which Everett was spending his time in London.

Everett's letters were full of endearments and concerns for Effie's health. 'I cannot bear being away from you,' he wrote, and then, 'I shall not get any quiet until I return and lay my head upon you, which I thank God will happen very soon. A woman could not be greater comfort to a man than you are to me.' He fretted about her 'continued sickness' and how she might lose her footing crossing the stream to Bowerswell. He said Luard was impressed by the neat way she had packed his bag. But he sank back swiftly into the rhythms of his old bachelor life. Everett, Luard and their artist friends dined at the Garrick Club, they smoked and drank, slept late and missed church. They took a box at the theatre and laughed so loudly that they were nearly thrown out. They did the rounds of the studios, sizing up the competition. Everett confided to Effie that he was disappointed by Hunt's latest works. Hunt had recently returned from the Holy Land with *The Scapegoat*, a harrowing, heavy-handed image. According to Everett, it was 'a mistake which everybody sees plainly' but he could not admit this to his friend.[108]

Everett was also worried about his own critical reception. There were already reports circulating that he had adopted an 'unfinished style' because of the atmospheric handling of *Autumn Leaves*. His pictures were well hung in the galleries, with *Peace Concluded, 1856* in a good spot next to a Landseer, and *Autumn Leaves* 'beautifully seen'. The dealer Ernest Gambart, after some haggling, agreed to buy *The Blind Girl*, so Everett ate a 'capital dinner' at the

Garrick to celebrate. But the reviews in *The Times* were scathing, and Everett was anxious that Effie and the Grays might be upset. 'You must not disturb yourself by picturing me in the act of tearing my hair for mortification,' he wrote to Effie on 4 May. 'Nothing of the kind, my love; I am quite merry.' Everett felt he was being deliberately targeted not just because of the looser technique of some of his works, but also because of his relationship with Effie. In a birthday letter to his wife, he admitted ,'I am continually the object of unpleasant remarks from women as well as men.' By marrying Effie and moving out of London, he had severed many of his connections with the networks of criticism and patronage. Still, he wrote, for him, what mattered most was finding a 'means of support for both of us', he wrote, adding, 'and this, please God, I shall accomplish in time'.

The need for a steady income was becoming urgent. Everett returned from his London trip to await Effie's confinement. Late at night on 29 May 1856 she went into labour. Effie recognised the very real dangers that she and her child were facing. She had written in her diary, a few weeks before, of her hopes for her future with Everett, 'if we are spared to each other'. Two of her aunts, Lexy and Jessie, had died in childbed. There was nothing that the doctors could do if she contracted puerperal fever (septicaemia), the most common cause of maternal death. It is possible that Effie was attended by her gynaecologist, Dr Simpson, who promoted the use of chloroform to ease the pain. However, it is more likely that a local midwife oversaw the birth, helped by Effie's mother and Jeannie. Everett may have been by Effie's bedside, following the example of Prince Albert and Gladstone. They were both present at the births of their children. Everett wrote to Hunt that Effie 'got through it better than anyone could have expected'. On 30 May 1856 Effie became the 'mother of a fine little boy'. According to Everett, the baby 'has blue eyes and a little downy brown on the top of its head'. They named the child after his father, but he was always known as Evie.

When Effie was strong enough, Everett took her away on holiday, together with the baby and her two sisters, Sophy and Alice. They went back to Brig o' Turk. It seems a strange choice for their first summer as a family. Perhaps it gave Everett and Effie the chance to lay some ghosts. Perhaps, after the bustle of the birth, they needed to remind themselves why they had fallen in love. It certainly allowed Everett to indulge his passion for fishing as well as drawing. While they were staying at the manse in Brig o' Turk, Everett

marked the arrival of the 'little gentleman' by sketching *The Young Mother*. It is a tender image showing Effie nursing her baby son. Her bodice is open, her head is bent over her child, and she lifts his tiny hand to her lips. She is entirely bound up in her new world of touch and smell. She is oblivious to the hills, the loch and the cottages around her. She barely hears the older children playing behind her.

In the winter of 1856 Everett translated this design into an etching, and it was published by the Art Union. *The Young Mother* was one of Everett's first forays into print-making. But it reinforced an idea that the poet William Allingham had proposed the previous year. Everett had provided an illustration for Allingham's *Day and Night Songs* (1855) which was much admired by his fellow artists, including Rossetti. Allingham suggested that Everett should use prints to reach a wider audience: 'Surely one picture a year, shown in London and then shut up, is not result enough for such a mine of invention and miraculous power of reproduction as you possess. This is the age of printing and a countless public.' He exhorted Everett to 'be our better Hogarth'. Everett needed to earn a living. Allingham's scheme would allow Everett to bypass 'the determined cabal' that he had faced at the Academy exhibition in May. Everett had claimed at the time that he had great faith in the mass of the public. Now he would put it to the test.[109]

During the years that he and Effie lived in Perthshire, Everett began to develop his talents as an illustrator. The domestic vignettes that he drew for the wood-engravers often seem like snapshots of Everett's married life. One of his early designs, *A Lost Love*, shows an elegant woman in a window seat, gazing out into the night. Her head is turned away, but she looks like Effie by firelight. In other illustrations he focuses on a young lady playing the piano, sometimes for her own amusement, sometime to entertain her family. The figure in *Practising*, for example, has Effie's hairstyle, her plaits wrapped around her head. In 1859 Everett started supplying images for the publishers of the new magazine *Once a Week*. A year later he began a long-running collaboration with Anthony Trollope and his illustrations for *Framley Parsonage* were published in instalments in the *Cornhill Magazine* in 1860–1. He and Effie became good friends with the novelist. They kept up a lively correspondence and looked forward to hearing Trollope's latest news, sometimes from the Highlands, sometimes from Ceylon or South Africa.

Everett was in the vanguard of a revival in illustration. Many artists had turned away from this popular medium, because their designs were all too often botched in the cutting. But a new generation of engravers led by the Dalziel family showed the finesse that was possible in black and white. Everett took as much care preparing his drawings for the engravers as he did composing his large oil paintings. They were meticulous, full of life and drama. His fellow artists often struggled to make modern dress look picturesque. But as one critic said, Everett could turn 'a hooped skirt into a thing of beauty'. Under Everett's pencil, the billowing gowns of his girls became vehicles for emotion. They swayed or anchored the women in his pictures, they expanded or collapsed according to their wearer's state of mind.

The steady stream of commissions from editors was a financial lifeline for Everett. In 1860 he told a friend that thought he could earn £500 a year just for supplying illustrations for Bradbury and Evans: 'It is so pleasant to hear of my wood-drawings rising to so much value,' he wrote. By the summer of 1860 Everett had four children to support. George had been born on 19 September 1857, followed by young Effie on 28 November 1858 and Mary on 13 May 1860.

Since her marriage Effie had endured five years of near-constant pregnancy and nursing. Each time she told her parents that she was expecting another child, her father would comfort her with the words 'it must get worse and then better'. Effie poured her energies into the business of running a household. With help from her mother and Jeannie, she looked after the brood of Gray and Millais children, managed the servants and made Annat Lodge presentable. On top of that Effie was an active partner in Everett's career. Effie tried to use her own artistic skills to make his life easier. From their first summer together, Everett had encouraged Effie to draw. This was one of the attractions of being married to Everett; he recognised Effie's talents and did not belittle her as John Ruskin had done. She seized the chance whenever she could to concentrate on something other than the house and the children.

So neither Effie nor her husband thought much of it when she set out one November morning in 1859 to the old castle of Murthly with a drawing board and a pencil tin. But as she sat in the damp, stone-flagged hall sketching a piece of tapestry, Effie began to feel unwell. Her eyes were uncomfortable. She could not focus properly. On the ride home the pain grew worse and she could barely see. According to her son, she had 'contracted a chill which

affected the optic nerves of both her eyes'. Her sight was badly affected and never fully recovered. For years afterwards the Gray family letters were peppered with enquiries about Effie's eyes. In the spring of 1861, eighteen months after the problem first emerged, her father wrote that he was 'sorry to find her eyes were still so useless'. It seems that Effie also suffered a miscarriage around this time. There is certainly a gap in her pregnancies, nearly two years between the births of Mary and Alice Caroline, known as Carrie. In early May 1861 Effie was too ill to travel by train; she had gone south to support Everett preparing for the private views. The language used by Mr Gray in his letters suggests that he and Effie's mother were very worried about her: 'Don't come here till you feel strong enough for the journey,' he wrote on 7 May. And then, a day later, 'We both think after what has happened it would be most imprudent to run such a risk'. Her parents never spell out exactly what did happen that spring. But it sounds as if Effie lost a baby, and they did not want to lose her too.[110]

The early years of Effie's marriage ebbed and flowed. On the good days, as she told her father, she felt she had not laughed so much since she was ten years old. But, as Effie had predicted in her diary, being married to an artist brought with it 'annoyance and troubles' as well as 'comforts and blessings'. Sitting in Perthshire, with a baby on her knee, Effie read John Ruskin's withering reviews of Everett's pictures: *Sir Isumbras at the Ford* was, in John's words, 'a Catastrophe; not merely a loss of power but a reversal of principle'. She watched as her husband's success started to ebb away. While he and Effie remained so far from London, Everett could not defend himself. He returned to his rooms in Langham Chambers every spring to prepare for the Royal Academy show, but this was not enough. Effie was torn. She relied on her family for reassurance and practical support. On the other hand, she knew that Everett was becoming unsettled, shuttling between Annat Lodge and his London lodgings. Sometimes he seemed to relish the escape from Scotland. Everett was able to enjoy boating expeditions with his brother and a couple of girls, or 'take too much tipple with his bachelor friends' and sleep it off the next morning. But on other days he would write to Effie, complaining, 'I am dreadfully low-spirited.' He said friends kept telling him 'it was high time I should come and live in London'. He added, 'I am far from well and everybody says they never saw such change in any man for the worse.' For Everett's sake, Effie had to return to London life.[111]

Effie's re-emergence in society was gradual. In the spring of 1857 she and Everett stayed briefly in Savile Row, Mayfair, so that he could work and she could see old friends. The following year they rented a house in town for a few weeks. Finally, in the autumn of 1861, Effie and her young family moved back to London permanently. They made their home in South Kensington, just off the Cromwell Road. Number 7 Cromwell Place was a new townhouse, handsome without being showy. The area was vibrant and close to the South Kensington Museum. Their neighbours were artistic but not bohemian; other local residents included Sir Coutts and Lady Lindsay, and E.W. Godwin. One of the ground-floor rooms at Cromwell Place was remodelled to create a studio for Everett. It was an impressive, high-ceilinged space, with tall windows, a massive mirror over the fireplace and the walls hung with tapestries. A piano stood among the easels and half-finished canvases. Everett liked music while he worked, and Effie would play for him, when she had the time.[112]

In the autumn of 1862 Everett returned to a subject that brought to mind the early days of their love. He wanted to paint a new version of *The Eve of St Agnes*. He and Effie had read Keats's poem together one wet afternoon in Brig o' Turk, and the frisson of that first encounter had sustained Effie in the dreadful winter of 1853. Then the poem had seemed to echo Everett's thwarted desire. Now, nearly a decade later, Everett felt able to explore the eroticism of the heroine, Madeline, a young woman undressing in the moonlight. He asked Effie to be his model.

Sending the children away to her parents, Effie and Everett were free to begin work on the picture. Everett had found the ideal background, the King's Room in the great house at Knole in Kent. Dominated by a shadowy curtained bed, this would be Madeline's chamber. In his poem Keats described a young woman dreamily disrobing, unaware that her lover Porphyro was watching her, unseen. It is this voyeuristic subtext that makes the story so thrilling. Everett puts his audience in Porphyro's hiding place. He offers a glimpse of Madeline 'loosening her fragrant bodice', with her shimmering skirts sliding from her hips. The blue and silver of her gown glints in the moonlight. She thinks she is alone in the vast room. She is bare-shouldered in white linen and lace.

As Effie stood before him, Everett conjured up a heady mixture of the sensual and the spectral. The picture carried with it an eerie reminiscence of

the tragedy of her first wedding night. Then Effie had undressed and been rejected. We would like to believe that this image of Effie/Madeline, desired and desiring, was a vindication of her beauty, Everett's way of showing how blind John Ruskin had been. But the truth was not that simple. Effie's long nights at Knole were far from sensuous. It was December. She shivered in the unheated room, as around the house she heard the clocks striking midnight, then one, then two. Everett struggled with his lighting effects, finding that moonbeams were not strong enough to show the details of Effie's chemise. He refused to allow Effie to warm herself by a fire; the glow from the flames might mar the silvery tones of the picture. Effie remembered these sittings as 'the severest task she ever undertook'. And then, when they went home for Christmas, Everett called in a professional model. He finished the face from a Miss Ford. So the final image was a composite, with Effie's gorgeous hair and bosom and another woman's tilted nose. To make matters worse, when *The Eve of St Agnes* was shown at the Royal Academy in the spring of 1863, the critics thought the figure of Madeline was 'ugly, thin and stiff'. 'Where on earth did you get that scraggy model, Millais?' asked a journalist from *The Times*. Everett could not admit that she was his wife. Perhaps this image of *The Eve of St Agnes* stands as an appropriate metaphor for the rest of Effie's life with Everett. She was an essential part of the production process, but from now on he always had his eye on other women.

Everett tried to remain true to his ideal of painting directly from nature but, as he and Effie found at Knole, some subjects were more beautiful in the imagination than in real life. Still, despite the harsh comments of the critics, Everett found a buyer for his picture among a new breed of patrons. The shipping magnate Frederick Leyland appreciated the poetry in this picture, its ethereality. He saw that Everett had transcended the tightly painted details of his bachelor days, working instead in areas of soft colour and chiaroscuro, with occasional glistening passages of fine brushwork. This was a mature style. *The Eve of St Agnes* represented the final phase in Everett's shift from Pre-Raphaelitism to Aestheticism.

Everett's new, looser style put him at the cutting edge of a wider trend in Victorian art. But it was also encouraged by the commissions he received in the early 1860s. The refined drawings he made for Trollope's books were being superseded by watercolours; London dealers claimed they could sell as

many replicas of popular paintings like *The Huguenot* as Everett could paint. In watercolour, Everett was able to work swiftly, with broad washes enlivened by delicate touches of detail. His growing family also suggested a change of direction, and he found a ready market for pictures of young Effie and her little brothers.

Everett did not abandon his grand Royal Academy paintings. In the 1860s he tackled biblical subjects, including the stories of Esther and Jephthah's daughter. Everett seemed drawn to texts about women wrestling with complex emotions, torn between duty and self-preservation. In his earlier works, like *The Black Brunswicker*, Everett had represented these tensions in psychological struggles between men and women. Now he showed beautiful women like Esther bearing the trouble alone. His ability to convey their internal battles was remarkable. Everett's virtuosity and long apprenticeship underpinned every nuanced gesture, the slight turn of a head, the hint of a frown.

Effie oversaw the workings of the studio, the comings and goings of the models, the search for suitable subjects, as Everett's career regained momentum. She kept a careful list of all the oils, watercolours and engravings that he worked on, making a note of the price whenever one was sold. At Christmas 1863 she proudly told her parents that they were beginning to turn the corner: Everett had earned £4,000 in a year. His income was still sporadic. But now that he had been elected a full member of the Royal Academy their future might be more settled. Mr Gray was delighted. He congratulated Everett on reaching the 'highest step in the ladder', prophesying that perhaps he might yet make President.

With the gradual change in their fortunes, Effie became more confident. After the years of self-doubt, when she had sought refuge in Scotland, Effie began to re-establish herself in London society. She knew she would never entirely escape the scandal of her annulment. Within her own family it was taboo, a matter never to be discussed, but very occasionally she let her guard slip. Effie wanted John Ruskin to see that she was a changed woman, a happily married mother. She had not set eyes on him since she left King's Cross on that bitter spring morning in 1854. She waited seven years to take public revenge. John Ruskin was enjoying a renaissance in his reputation. Since Effie had left, he had thrown himself into his writing, creating visionary essays that wove together art, politics and economics in unheard-of ways. His lectures

were fashionable events. Ladies and gentlemen vied for admission. On 17 April 1861 John Ruskin took to the platform of the Royal Institution. Looking out into the crowded hall, he complained that he was feeling claustrophobic. As he began speaking, there was a clattering at the back of the room, and Effie appeared. A murmur of surprise and disapproval went round the room as she walked straight to the front row and took her seat. Effie glared up at John, holding his eye. His friends saw him turn pale. He wavered and was forced to leave the stage. Although Everett and Lady Eastlake both approved of Effie's actions, not everyone took her side. Elizabeth Gaskell was 'indignant and sorry' to hear of Effie's behaviour. Others used harsher words. The poet Arthur Munby called her 'shameless, barbarous and unwomanly'. He felt that Effie's conduct should exclude her from polite society.

In fact it was at this moment that Effie began to realise her ambition of becoming a successful hostess. She had settled her score with John Ruskin. Now she could concentrate on her new life. In the studio at Cromwell Place, Everett's works could be displayed to advantage. In the evenings, friends and patrons gathered around the piano, surrounded by the paraphernalia of picture-making. These impromptu parties became increasingly elaborate. By 1867 Effie was entertaining international stars including Anton Rubinstein; the charismatic Russian pianist who could 'play like a god' had been introduced to Effie by her friend John Ella. An impresario and an unashamed gossip, Ella responded warmly to Effie's genuine love of music and her discerning ear. His letters to her, tiny scrawls written in purple ink, were conspiratorial and scattered with melodramatic turns of phrase. He described the awful cliques fêting the latest musical sensation as 'parasites around pests'. Effie understood. She could feel the beauty of Brahms. When she was pregnant, Everett told Effie that he was wary of buying her some 'new German music': its extreme loveliness might 'endanger you in your position, if you played it just now', he wrote.[113]

Throughout the 1860s it seemed to Effie that she was constantly in a delicate condition. But pregnancy rarely seemed to slow her down. In April 1862 she gave birth to Alice Sophia Caroline, known at home as Carrie. The following September, Geoffroy William was born, and then in March 1865 her youngest son arrived. John Guille Millais grew up to be Everett's biographer. It is partly thanks to him, and his elder sister Mary, that so much of the

family history was preserved. Effie's last child, Sophia Margaret Jameson Millais, was born on 15 June 1868.

Effie could only keep up her busy social life, and see to Everett's studio, by relying on her parents. George and Sophia Gray were always willing to look after the children, big and small. Everett also liked to make an annual pilgrimage to Scotland for fishing and shooting from August to October, so there was constant movement between Bowerswell and Cromwell Place. But Effie wanted to travel further afield. She remembered the brief happy times in France, Switzerland and Italy that she had enjoyed with John Ruskin. Her first husband, for all his faults, had taught her well, and she had not lost her enthusiasm for the beauties of the Continent. Everett had never climbed the Alps, he had never drifted around Venice. Effie wanted to rediscover these places with him.

In October 1865 Effie and Everett crossed the pass at Chamonix, heading south before the snows came. It seems that, all too often, Effie's continental tours coincided with times of upheaval and unrest: her honeymoon had been delayed by the 1848 revolutions, she had visited Venice under Austrian occupation in the winter of 1849, and now Effie planned to make her way across Italy at the height of the Risorgimento. Garibaldi and his allies were fighting against the entrenched power of the Papacy in an attempt to create a united Italy, and in 1862 Garibaldi had led a bold but unsuccessful campaign against Rome. When Effie arrived, three years later, the papal states were threatened from another quarter – an outbreak of plague – and the travellers faced the indignities of fumigation before they could proceed. They were rewarded by the sight of Pope Pius IX, 'a very nice, benevolent-looking old gentleman' in a black biretta, according to Effie, who nodded as he passed them in St Peter's. This was the backdrop to Everett's first sight of Italy. On the whole, he did not enjoy the experience.

In Venice Everett complained that the mosquitoes were worse than the midges of the Highlands. He wrote to his mother-in-law that Effie was unsatisfied by his response to the delights of Gothic architecture. It was never enough to praise anything once, he grumbled, and there had been 'too much Mr Brown'. Effie, for her part, was thrilled to see Rawdon Brown again, and stay in his palazzo. But Everett did not want to be constantly reminded of Effie's earlier visits, or hear tales of John Ruskin. Everett also lacked the stamina to enjoy the cultural pace set by Brown and

Effie. As Effie explained to her sister, Everett was a bad sightseer at home and even worse in Italy. Then their visit to Pisa was overshadowed by grief. They reached the city in time to see Sir Charles Eastlake on his deathbed, and yet again Effie and Everett were confronted by difficult memories. The Eastlakes had helped Effie to escape John Ruskin and had encouraged her union with Everett, but the annulment was an episode that Effie had fought hard to forget.

Everett cheered up in Florence, where he dined in a Medici villa and danced with the opera star Adelina Patti. But he had little time for the glories of the Renaissance. His tastes had changed since his Pre-Raphaelite days. He revelled in the Van Dycks he saw in Genoa and yearned to see the works of Velasquez, far away in Madrid, but he never did. After this one fretful tour, Everett and Effie decided not to venture abroad together again.[114]

Instead, as soon as her son Evie was old enough to go with her, Effie chose him as her travelling companion. Like his younger brother George, Evie had begun his education in the lower school at Rugby. In September 1870 their housemaster reported that neither Evie nor George had passed their exams to move up the school. He suggested that they should be sent away to a private tutor before trying again. So they spent three months cramming with a rector in Alford, Lincolnshire, who found his new pupils 'willing to work, but rather careless and inaccurate'. In January 1871 they both moved to Marlborough College. Effie's boys loved the outdoor life there. Effie kept the letters they sent home, scribbled in pencil and finished in haste: 'I can't write mor now becaus it is the bell.' In one note George explained that his hands were 'very cold becaus I have been out cutting bows and arrows'. He apologised that it was 'not my best ritting'. In another letter, her eldest boy, Evie, promised to send Effie a box of 'wild hysenths, mosses, wild roses and all colloured panzies', as well as a corncrake and some young rabbits which he had snared, 'to make a pie for papa and you'. Evie asked his mother to post him 'a present and some grub' in return.

In the summer of 1871, when Evie had just turned fifteen, Effie decided it was time for her son to cross the Channel. It would be just the two of them. Their first stop was Ghent, to see the Van Eyck altarpiece *The Adoration of the Lamb*. Effie was entranced by the glowing colours. It was, in her words, 'lovely, and so clear and bright as if finished yesterday'. Evie soon wearied of the pictures, but enjoyed hunting for moths in the hotel gardens at dusk. In

Ghent they met up briefly with one of Effie's little brothers who was studying French and German in Brussels. Effie was irked by the unhurried quiet of the Flemish towns: 'the cab horses almost walk' and she feared they would miss their train. She was also annoyed that she had heard nothing from her husband since he set off for his fishing trip in the Highlands. 'Do not be lazy any more about writing,' she urged him, 'and send me a letter to the Grand Hotel Paris.' However, by the time she and Evie reached Paris, Effie had more serious matters on her mind.

The French capital was a sorry sight. Paris had been bombarded and besieged by the Prussians in the winter of 1870. Then, after the retreat of the French army, the city was briefly governed by the Commune, a radical council that hoped to establish 'la république démocratique et sociale'. But the rule of the Communards lasted only a matter of months. By May 1871 Paris was again facing a bloodbath at the barricades, as the regular army began to fight its way back into the city, street by street. Tens of thousands of Parisians are thought to have died in the 'Bloody Week' of 21–8 May. Effie and Evie arrived barely two months later. Effie's letters home described the Hôtel de Ville and the Tuileries, so badly damaged that 'they look like some great middle age ruins'. The city was full of soldiers, and everyone was very subdued, 'not a smile on a face', she said.

The heat was stifling. On 22 July Effie decided to stay in the hotel, but Evie wanted to go out in search of souvenirs. She watched her boy head off towards the pock-marked Place Vendôme. He hoped to find some relic of the great Napoleonic monument that had been toppled by the Commune in early May. Evie returned empty-handed. He was feeling feverish and sick. Effie sat by his bed that night, cooling his forehead with a rosewater compress, offering him sips of iced water and champagne. The next day Evie was much worse. A rash erupted on his stomach and then spread to his face. His skin burned, his bowels griped. Evie had smallpox. Effie needed to tell Everett, but she could hardly move from her son's bedside to fetch pen and paper. 'If I leave him a moment, he screams,' she explained in a note written after six days of continuous nursing. 'I have to be beside him, and hold him constantly up and down and soothe him.' Evie was delirious, dreaming that his school was ablaze. He tore at the sores on his face. Every few hours, a frenzy of pain would seize him, and Effie struggled to hold her son safe in his bed. She sang until she was hoarse, hoping to calm him. She ran out of tunes and told him

stories, but he was still 'screaming frightfully'. The hotel manager threatened to turn her out.

As soon as he received her note, Everett made plans to relieve Effie in Paris. He ordered his passport, drove the girls to Euston Station and packed them off to their grandparents in Scotland. He forwarded Effie's notes as well, but as an afterthought urged Mrs Gray, 'Don't let any of the children touch these letters of Effie's'; the message was frantically underlined. He feared the letters might be contaminated. Effie needed help. But on Saturday, 29 July she wrote to her husband, urging him to stay at home. 'I dread your coming into contact with Evie,' she said, 'and seeing him would distress you excessively.' She had managed to find a friend in Paris, M. Armand Baschet, an historian who knew Rawdon Brown. M. Baschet argued Effie's case with the hotel manager, suggesting that a well-placed letter to *The Times* could seriously damage the hotel's reputation. The manager was persuaded that Effie and her sick son should stay. He arranged for groceries to be delivered to her door and an extra bed to be brought into Evie's dressing-room. Perhaps then Effie could snatch a few minutes' sleep.

M. Baschet sent his manservant to attend Evie. At last Effie had someone with her who was strong enough to lift her son, and hold him when he thrashed about. Feeling helpless, Everett decided the best thing he could do was to contact Dr Noël Guéneau de Mussy, one of the best doctors in Paris. Dr de Mussy checked Evie's eyes, and prescribed mercurial ointment for the blisters. He was also concerned about Effie. She had sat up with Evie night after night. The doctor sent her to her own bed and ordered her to have a hot bath. She told Everett in her next letter that she 'felt much better for it' and hoped to take a short walk in the cool of the evening. It was her first chance to escape the sickroom for eight days.

By early August, Evie was out of danger. He was hungry and looked forward to the baskets of grapes that M. Baschet brought every day. He wanted to hear news from home, so his grandmamma sent him copies of the *Dundee Advertiser*, while Effie visited Galignani's *librairie* to find books to keep him amused. 'His eyes are perfectly strong and bright,' she reassured her father. But now she began to worry about all the arrangements Everett had hastily made for the other children. Her girls were stuck in a seaside hotel in Broughty Ferry with their Aunt Sophy. Effie was concerned that it would be 'too much for Mother' to have them all to stay

at Bowerswell. Her son George had been asked to join a shooting party on the 12th, but Everett could not go with him. He would not be clear of Royal Academy business until later in the week. And they had still not acknowledged an invitation to a ball sent by Mrs Lemprière. Effie was anxious: 'she will think it very careless if we don't reply'. Without Effie, life in the Millais household quickly began to unravel.[115]

When Evie was well enough to travel, Effie took him home. She did manage to salvage something of her time in Paris: Dr de Mussy asked if he could have the honour of her company on a tour of the Louvre, and M. Baschet escorted her to M. Tissot's studio. But she was exhausted. In her desire to save her son, Effie had not spared herself. 'I have lost all fear of the complaint,' she wrote to her brother on the worst day, 'being obliged to do everything about him.' Evie recovered, but Effie's health was shattered. And now she discovered she was pregnant. The child must have been conceived just before she left London.

Effie was forty-three years old. Her mother had been safely delivered of a son after her forty-seventh birthday. Perhaps there was no need to fear. But this pregnancy did not start well, and by Christmas-time Effie was very ill indeed. Her parents offered to look after Evie and George for the holidays, and when the children returned to school in the New Year of 1872 they were clearly upset by the bad reports from home. Their letters were full of enquiries about their mother's health. 'I hope you are better now and having better nights,' Evie wrote on 7 January 1872, and a few days later, 'I send you a box of violets which are very sweet.' His sister Effie was particularly worried: 'We are anxiously awaiting news from you. Get Papa to write as soon as there is any news.' Then she added, 'I do hope you are going to allow us to come home this term, once, you really must. You say you are so dull, we could come and cheer you up.' But Effie kept the older children at arm's length. Her whole family were waiting for what Mr Gray called 'the final catastrophe'.

They had not lost all hope. In mid-February Effie was 'holding on, even though in an uncomfortable state'. On 5 March she was 'a shade better'. Her father made enquiries after a wet-nurse, and on 7 March he wrote to Effie to tell her that they had found a local girl who might suit. He sent their servant Jeannie down to look after Effie. But on 10 March it was all over. Effie's son was stillborn, and Effie herself was barely alive. She had lost a great deal of blood and was very weak. The doctor and Jeannie bandaged her as best they

could. Mrs Gray's reaction to Effie's ordeal did not help her recovery. Either Effie's mother did not understand how close to death she had come, or perhaps Mrs Gray was simply relieved that her daughter had been spared. On 12 March Sophia Gray wrote, 'I think I may venture to write a few lines to congratulate you on having got over your confinement safely in the end.' Her mother made no mention of the lost baby. Instead she went on about a party they had thrown at Bowerswell for the directors of the Gas Company, with 'as much champagne as they could drink'. Mrs Gray closed her letter by advising Effie to 'pay great attention to being properly bound this time to preserve your shape – as you lost it a little after Sophie's birth'. Effie was hardly able to lift her head, and this was all her mother could think about. It was not surprising that Effie became depressed in the weeks that followed.[116]

Confined to her bed, mourning her baby, Effie suffered from migraines and 'nervousness'. She had been tested to the limit. Privately, she felt desperately low. But she also had a public face. In her mother's words, Effie was the wife of 'the first painter of the time'. Everett's paintings were in demand. He had just completed a magnificent triple portrait, *Hearts Are Trumps*, a picture that was described in the *Athenaeum* as 'brilliant, lucid and forcible as a Velasquez'. Everett and his family were now moving in the very highest circles of London society. Hearing of Effie's indisposition, Lady Constance invited her to join her at Cliveden 'for a breath of fresh air'. A few weeks later her husband, the Marquess (subsequently the Duke) of Westminster, was making arrangements for Everett to stay at his hunting lodge.

Everett wanted to cement their new position, and Effie needed something to hope for after the disappointments of the spring. Just a few weeks after her confinement, she wrote to Bowerswell with the news that Everett had bought a parcel of land 'for the erection of a mansion'. It would take five years to complete and saddled the family with a significant overdraft. But in Effie's eyes it was worth it to be able to walk down her own marble stairs to greet her guests. As her father remarked wryly, 'nothing is left now but a peerage and Westminster Abbey'.[117]

Chapter Ten

The Tower of Strength: 1872–85

JOHN EVERETT MILLAIS sold out. That was the verdict of Everett's critics in his own lifetime, and the slur has stuck. It was Gabriel Rossetti who first suggested that Everett had abandoned his Pre-Raphaelite principles in favour of easy money. Then William Morris joined the attack, calling him 'a genius bought and sold and thrown away'. Even the BBC's 2009 documentary *The Pre-Raphaelites* used this phrase in a final flourish, effectively condemning all Everett's work after his marriage. And the critics have always blamed Effie. According to Roy Strong, it would have been better if Everett had 'been drowned in a Scottish loch instead of running off with Mrs Ruskin'. In his words, 'Effie has an awful lot to answer for'. Her husband could have been the greatest painter of his age. Instead, to satisfy her demands, he became the richest.[118]

In the years following his marriage, Everett's style did change. His pace of production quickened. His brushwork became looser and more atmospheric. He chose fewer literary and historical subjects, concentrating instead on studies of mood and character. These same changes were also visible in works produced by his contemporaries like Gabriel Rossetti and James Whistler. In fact Everett pre-empted the vogue for Rossetti's glamorous half-lengths with his portrait of Effie's sister, titled *Sophie Gray* and painted in 1857. And Everett's subtle exploration of colour and transient beauty in *Autumn Leaves*, finished the previous year, anticipated Whistler's own experimental *Nocturnes* and *Arrangements*. Whistler himself acknowledged Everett's achievements. He called *The Eve of St Agnes* (1862–3) 'a real painting, something completely artistic'.

So why was Everett's art condemned when Whistler and Rossetti were both hailed as champions of the avant-garde? Why were Everett's later pictures written off as 'cheap, vulgar, surface-imitation, a whirlpool of crumbly paints' when Whistler's swift brushstrokes were seen as liberating and

radical? Why was it such a sin for Everett to want to make a living as an artist, to work in a mansion rather than a garret? There were a number of reasons, but none of them was really Effie's fault.

Everett had always avoided the conventional trappings of an artistic lifestyle. He never wore the bohemian uniform of 'flowing neck-tie, open collar and velveteen coat'. He liked to be properly dressed, and even as a young man he 'looked like a successful and fashionable businessman'. Furthermore, he was neither languid nor enigmatic. According to his friends he was straightforward, boyish, jolly. His family knew him to be short-tempered and at times uncomfortably emotional. Journalists described him as 'Anglo-Saxon from skin to core, vigorous and bluff'. All this was in direct contrast to Rossetti, whom Everett very deliberately called 'mysterious and un-English', and Whistler, who perfected the art of witty self-fashioning. Whistler was also un-English, having been born in America and trained in France. Rossetti and Whistler saw themselves as set apart. They painted for the initiated, for those inside 'the gentle circle of art' and not, in Whistler's words, for the 'mob of mediocrity'. They claimed they did not want to be popular. Everett, on the other hand, was more than happy to sell his paintings and to see them reproduced in magazines. He was not interested in his art acquiring cult status. He wanted it to be enjoyed by a wide audience.

However, in the early years of his marriage, Everett's work did not sell. Marrying Effie did not trigger a sudden burst of marketable pictures. The late 1850s and early 1860s were lean years, when he was lucky to earn thirty shillings a week. His new, broader style was heavily criticised, and as Paul Barlow has pointed out, 'whatever reasons we may give for Millais's development, money-making seems an inadequate one'. It was only in the early 1870s that public taste finally seemed to catch up with Everett's mature techniques.

In the end, it all came down to presentation. Everett's reputation as an innovator suffered because he refused to conform to the image of the artistic rebel. His critics accused him of smugness, and even his friends agreed that he was egotistical: in Valentine Prinsep's words, Everett 'had made his own way, and as he gloried in his pictures, so he gloried in his success.' Everett disapproved of artists who affected 'a mysterious air' and who had 'never learnt the grammar of their art'. He never hid his ambitions. He just wanted to live like a gentleman and earn enough to indulge his passion for sport. Everett was happiest in the Highlands, with a fishing rod or shotgun in his

hand. As he explained to a friend in 1885, 'for the last ten years I should have made £40,000, had I not given myself a holiday of four months in the year'. In the second volume of his official biography, the business of painting was overshadowed by descriptions of deer-stalking and salmon fishing. Perhaps Effie could be held responsible for opening Everett's eyes to the beauties of Scotland. But in truth, he had taken up hunting in an attempt to forget her. In the winter of 1853, after the holiday in Brig o' Turk, Everett had been so depressed that his friend John Leech decided he needed a new enthusiasm. Leech soon had Everett booted and spurred and riding to hounds. By the end of the first season, Everett was galloping boldly across the shires. He never looked back.[119]

Everett's zeal for country sports reinforced his image as a manly painter, and as resolutely British. This worked in his favour, especially in the early 1870s. It was a time of anxiety in London's art world, as galleries and critics tried to come to terms with a French invasion. Driven into exile by the Franco-Prussian war, Monet, Pissarro and Daubigny all exhibited in New Bond Street. Young British artists had their heads turned by the fresh Impressionist canvases. According to Everett, students who hoped to escape the grind of the Academy schools 'by studying in Paris the methods of the impressionist school' were deluded. 'The apparent ease and simplicity' of works exhibited by the dealer Paul Durand-Ruel in his London shows 'betrayed no sign of the arduous toil by which the artists had attained their skill'. Young men who had never learnt to draw only ended up producing 'mere hazes of paint'.

Seen from some angles, Everett's later works have rather a lot in common with paintings by Whistler and his French contemporaries. Everett 'had a fear of appearing laborious'. Like Whistler, he would often scrape a picture back to the bare canvas and begin again, rather than risk overworking a figure. His portraits are full of energetic brushstrokes, the restlessness of his sitters expressed through slight inconsistencies; we seem to see, for instance, Gladstone's nostrils quiver as Everett marks three overlapping outlines for the Prime Minister's nose. Or we could look at Everett's study of Moses, *Victory O Lord!*, criticised in 1871 for its 'unfinished – or almost unbegun – background'. Such comments were usually reserved for the Impressionists.

But the shimmering, shifting strokes of Everett's brush were not inspired

by modern French painting. Instead they could be traced back to very British roots. Everett was the heir to Gainsborough and Reynolds. He admired the grand manner of Van Dyck's portraits of the English aristocracy. And the descendants of those aristocrats appreciated Everett's ability to create updated versions of their family heirlooms. Everett's portraits toned in well with the originals. By acknowledging his place in a long-standing tradition, Everett also made it easier for patrons to tell him what they wanted. The Duke of Westminster, for example, wrote that he had been looking at the Van Dycks in Munich. He particularly liked the ladies 'in black silk with white collars', and he hoped Everett would take this hint when composing the new portrait of the Duchess. On another occasion Westminster asked whether Everett would 'consent to do "Gainsborough" sketches of three of the children'. Both artist and client knew what was meant by this, in terms of size, finish and colour. There would be no unwelcome surprises.

For similar reasons, the newly wealthy began to commission Everett to paint their wives and daughters. His portraits were underpinned by centuries of tradition, and gave *nouveau riche* patrons instant gravitas. In 1871 the merchant Walter Armstrong paid 2,000 guineas for his girls to appear in *Hearts Are Trumps*, a playful reworking of Reynolds's *The Ladies Waldegrave*. Armstrong knew he was purchasing a picture that would rival the great artworks of the past. And Effie also hinted that the three young ladies would find the London season much more exciting after they had sat to Everett. Effie was right, of course: Mary Beatrice, Diana and Elizabeth Armstrong 'were recognised wherever they went, and people at once asked to be introduced to such pretty girls'. Everett's picture paid homage to its eighteenth-century model, but was at the same time a very modern work. It assimilated many of the key features of Aesthetic art, from the claustrophobic, flower-filled setting to the careful choice of props – the Japanese screen, the oriental table and blue-and-white teacup. The girls, in their identical dresses, were presented as variations on a theme of female beauty. They could be called an arrangement in lavender.[120]

Everett's portraits were virtuoso performances. He began to find himself in demand. Everett's patrons were wooed by the winning combination of his technique – swift, painterly and pleasing to the eye – and Effie's social skills. She was adept at using parties as a backdrop to negotiations. At a private concert Effie managed to speak to the MP William Cunliffe Brooks. She had

just heard that his daughter Amy was to marry the Marquess of Huntly. According to Effie, 'Brooks was charmed and very grateful' when she suggested that Everett could paint the new Marchioness as a souvenir of her marriage. 'He didn't hesitate a moment' about the cost, which Effie mentioned would be 2,000 guineas. It was 'worth double the money', said Amy's proud father, for a portrait 'to hand down in the family'. This exchange gives an insight into the networks of patronage that Effie and Everett explored. The way that Effie presented it to her potential client, Everett would be doing a favour for a friend. At this party the patron and the painter's wife were meeting as social equals. It would have been awkward for Cuncliffe Brooks to start quibbling over cash when he could be overhead by several of Everett's satisfied customers; Mrs Bischoffsheim and the Penders, whose daughters had sat for *Leisure Hours* in 1864, were also invited to hear Sir Charles Hallé play that evening.

But to reach the very best clients, Everett needed to put on a good show himself. Cromwell Place was elegant and spacious enough, but it was not magnificent. He and Effie understood that success breeds success. This was why, in March 1873, they paid £8,400 for a plot of land in Palace Gate. Their new house would combine splendid entertaining spaces with a lofty purpose-built studio. It would be the fulfilment of Effie's wishes, the dreams she had been denied by John Ruskin. Finally she could hold court with her husband, surrounded by patrons and friends, novelists and ambassadors, new money and old.

Everett painted Effie's portrait at this moment of anticipation in 1873. It had taken Effie a long time to recover from the loss of her baby the previous spring. She looked, as one acquaintance said, 'elegant of figure, but worn'. Everett did not make her stand; it would have been too tiring. She sat on a sofa, with a blue satin cushion at her back, and looked at her husband. Her gaze was direct and slightly challenging. She had not mellowed as she reached her forties.

Everett captured the spirit that had made him fall in love with her. But this same determination could make her uncompromising and, at times, hard to live with. Effie chose a sumptuous red velvet gown for the sittings, trimmed with lace. It was stylish and emphasised the slight flush of her full cheeks and lips. The yards of fabric that filled the foreground also allowed her husband's brush to play with the texture, sheen and rich colour of the velvet. Effie's gold

and agate necklace was a gift from her old friend Clare Ford. It held locks of hair from each of her four boys.

Effie tried to maintain some ties with her past. Jane Boswell, reminiscing about their time together in London in the 1850s, wrote that 'some old friends are always the same'. Effie kept up her correspondence with Jane, and the Pagets and the Jamesons, exchanging news about family ups and downs. And she was pleased to see how well Clare Ford had turned out, after his flighty early career. As a young man he had been one of Effie's most ardent admirers. Now a respected diplomat, he sent her regular letters about his wife's confinements, his hopes for promotion, his holidays at the seaside. He shared with Effie his worries about taking his family to Buenos Aires, where he had been offered the post of ambassador. In the end, he went with his son Ricky. They found the young ladies there 'exceedingly pretty, nicely dressed and very musical', and Ricky was able to 'get as much flirting as he wants'. When the time came, Ford also gave Effie advice about her own sons and their chances of landing a position in the Foreign Office. And many years later, when he was ambassador in Madrid, he invited Effie's daughter Carrie to stay. Ford took her to see the Velasquez paintings in the Prado. 'How like Papa's style,' she exclaimed.[121]

In his letter describing Carrie's visit, Ford called Velasquez 'the Prince of Painters'. It was a title that was starting to be applied to Everett himself. The new house at 2 Palace Gate, overlooking Kensington Gardens, was described as a mansion or a Genoese palazzo. It was designed in a rather severe Italianate style by Everett's friend Philip Hardwick. The two men had set up the Artists' Benevolent Fund together in 1871, and Hardwick understood Everett's requirements. The Millais family finally moved into Palace Gate in the spring of 1877.

The house was more than a home: it was a showcase for Everett's art. The children's bedrooms were tucked away on the upper floors, and the school-room was downstairs at the back of the house. But the walls of the breakfast room were rather self-indulgently covered with prints of Everett's work. Effie's portrait hung above the fireplace in pride of place among dozens of images that had made her husband's fortune. Every morning, at precisely half past eight, the family would sit down to their porridge, kidneys and kedgeree, surrounded by reminders of their father's popularity.

The overall effect at Palace Gate was meant to be luxurious without

affectation. The façade was red-brick with carved stone detailing; there were no modish Queen Anne touches, or Arts-and-Craftsy quirks. The beating heart of the house was Everett's studio. Nearly fifty feet long and two storeys high, the studio was on the first floor, at the head of the grand staircase. The walls were painted a fashionable Pompeian red and hung with tapestries. It was heated by a vast marble fireplace and hot water pipes, and lit by three electric chandeliers. Windows facing north and south were fitted with shutters and blinds so that Everett could perfectly control the fall of light. His sitters were posed on a small dais in the centre of the room. It is said that when Cardinal Newman arrived for his first sitting, Everett pointed to the raised chair with the words, 'Oh, your Eminence, on that eminence if you please. Come on, jump up, you dear old boy.' The Cardinal was, at that time, eighty years old. Photographs, taken by Beatrix Potter's father Rupert, show that when Everett was painting small children he would perch them on piles of books to get them in just the right position. With a deer-stalker on his head and a pipe clamped between his teeth, he moved constantly backwards and forwards, adding a touch, and then retreating to see the effect. Sir Henry Thompson, who sat for Everett in 1881, reckoned that he walked a mile every sitting.

The studio was set towards the back of the house, away from the noise of the street. It was fitted out with everything a successful painter would need, including a very tall, very narrow external door. Everett could slide his largest canvases out into a waiting van without damaging them. The studio was also supplied with a second staircase, leading to a dressing room (with a water-closet) on the ground floor. Professional models came into the house through a special side door, disrobed and emerged in the studio, without ever having to bump into the family. Everett and Effie were careful to keep these working girls segregated from their own daughters and their teenage sons. Patrons who had commissioned a portrait, on the other hand, were ushered up the marble staircase and into Everett's presence. So were journalists from *The Magazine of Art*, *The Art Annual* and *The Builder*, which all ran articles about the spectacular new house. And friends were welcomed in the studio every Sunday morning when the family was at home, to share the week's news and cast their eye over Everett's latest canvases.[122]

The house really came into its own in the spring. The weeks leading up to the Royal Academy's annual exhibition were frantically busy for the Millais

household. On 'Show Sundays' in April artists across London kept open house. Everett's studio was always filled with a fashionable throng, eager for a first glimpse of this year's offerings. Palace Gate was designed to provide the best possible space for entertaining. The interconnected rooms on the first floor were thrown open, and the wide landings allowed guests to move effortlessly from drawing-room to studio. Effie had endured too many 'crushes' in her time. Everett even wrote a poem about the awfulness of private views, where 'friends say what a treat | As they stand on your feet | In the hullabaloo'. They wanted to be sure their guests had room to view the pictures in comfort.

After the move to Palace Gate, everybody was angling for invitations to Effie's parties. She catered well. For their first summer party in 1877 she restocked the cellar, ordering 280 bottles of red wine, the same quantity of white, a couple of cases of brandy and nine bottles of liqueurs, including the delicious crème de vanille Martinique. Effie also had a knack of gathering friends, acquaintances and visiting celebrities. Anthony Trollope and the Marquess of Lorne could meet under her roof. The Manchester merchant Samuel Mendel was a regular guest, and so was Lord Wharncliffe. Effie's magic did not always work: in May 1877 Richard Wagner visited the studio, and promised to dine with them a few days later. Then, disaster: on the day of the dinner the 'great poet-musician' sent his apologies, and his wife Cosima arrived alone. Effie and her guests were dreadfully disappointed. Still, Effie's evenings were usually a great success, as she mingled with the 'extraordinary mixture of actors, rich Jews, nobility, literary, etc.' that made up her social set. Beatrix Potter spotted Oscar Wilde for the first time at one of Effie's balls in 1884, looking 'fat and merry' and with 'his hair in a mop'. She was rather disappointed that he was not wearing his trademark lily. The previous year Wilde had been left off the guest list for the Academy soirée at Palace Gate. He had to write to request an invitation. Effie's house was evidently the place to be seen.[123]

Effie and Everett also received their share of invitations to dinners, 'at homes' and visits to country seats. (Before the term 'weekend' had been coined, guests were asked to stay 'from Saturday to Monday'.) They dined with Gladstone in Downing Street and at Hawarden, and were welcomed by the Westminsters in town and at Cliveden. Effie told her parents that she thought Lady Constance 'really is the jolliest woman I know, and so clever'.

She liked to drop by to chat with Effie about 'her daughter's love-affairs' and flirt with Everett. After he finished her portrait, Lady Constance wrote to him, saying, 'If I had only been thin and 25, I'd have gone on sitting till Domesday, for you know you're very pleasant to sit to.' The Duchess of Westminster seemed bothered by her weight. In a note to Effie she confided that she envied her friends who kept their figures despite giving birth to child after child: 'Mine totally departed after number five!' she wrote. Her weight gain was sadly a sign of a severe illness, and she died in 1880, bloated and wretched. Lady Constance, the best loved of all the great hostesses of London, had once been so full of life. Her balls at Grosvenor House were legendary, with suppers served on Sèvres and gold-plate, and the Duchess herself urging 'the flagging band to yet one more waltz in the early hours'. Effie was excited to be part of her world.

The relationship with the Westminsters was not entirely straightforward. Although Lady Constance enjoyed joking and flirting, the friendship was founded on a commercial transaction: a portrait commissioned by Constance's husband in 1869. It was the same with many of Effie's new circle. Effie had to maintain the balance between the pleasures of intimacy and the potential for sales. All too often her London friends were also Everett's patrons. This meant that sometimes she and Everett appeared rather artificial. They could not let their guard down for an instant. At one musical soirée, for instance, their behaviour was scrutinised by Arthur Munby. He noted in his diary that Everett 'spoke gruffly to his wife, who answered not, and so they went upstairs to smile'. On these social occasions, neither Effie nor Everett could switch off and simply enjoy the evening. They were surrounded by prospective customers, clients and critics.[124]

There was another reason why Effie was not always at ease in society. Her life with John Ruskin had left a stain on her reputation that could not be erased. The Queen refused to receive Effie at Court. After her marriage to Everett, some hostesses followed the Queen's lead and dropped Effie from their guest lists. Behind her back, Effie was whispered to be 'the wife of two men'. Lady Eastlake had seen this problem coming, and tried to deal with it the very moment that Effie sued for an annulment. In April 1854 she went to see Lady Charlemont, who had sponsored Effie at her presentation in 1850. Lady Eastlake tried to explain the circumstances of John and Effie's marriage, but Lady Charlemont seemed unable to grasp the situation. John's 'particular

wickedness' was beyond her comprehension. For Effie's sake, the Queen needed to be told the full story; in Lady Eastlake's words, 'would Lady Charlemont take care that H.M. heard it rightly?' But Lady Charlemont was too frightened to tell 'the little woman' Effie's side of the story.[125]

Most of the time it did not matter. It was not until twenty years later, in the spring of 1874, that memories of Effie's earlier marriage seriously began to threaten her status. Effie was invited to a reception by Millicent, Duchess of Sutherland. Queen Victoria was expected to attend the event, so the names of all guests had to be vetted by the Lord Chamberlain. Effie's card was rejected. The Duchess wrote back to the Palace immediately, 'urging for an exception being made in Effie's case to the usual rule against anyone being presented who has been divorced'. Her Majesty, however, was adamant, and the Duchess had to break it to Effie: 'I hardly know how to tell you what it gives me so much pain to write.' She apologised, saying, 'I feel I was very stupid not at once to remember the possible annoyance.'

This was a dreadful blow to Effie. She wrote to the Duchess the next day, distressed and shocked beyond measure by the Queen's response. 'I have never been divorced,' Effie insisted: 'I was given my freedom' and declared stainless and blameless by 'the Church of which Her Majesty is the Head'. Surely if the Queen were told the true facts of Effie's first marriage, then she would relent. So the Duchess tried again. And again the Lord Chamberlain said that no exceptions could be made. Effie and Everett decided to ask the Duke of Westminster for his advice. They even sent him some of the legal documents relating to Effie's annulment. The Duke looked at the notes and agreed to pass them on to his friend, the Prince of Wales, who was staying at Balmoral with his mother. This caused a flurry of correspondence among the courtiers. But still no one was brave enough to broach the subject directly with Her Majesty. As the Keeper of the Privy Purse, Sir Thomas Biddulph put it, 'The question is not a very easy one for me to explain to the Queen.' How could he possibly tell his black-clad monarch all the ins and outs of Effie and John's relationship? With much regret, the gentlemen at the Palace said there was nothing more they could do. The Queen would not receive 'a lady who has been the wife of another man still living'.

Effie felt defeated. Even if Victoria changed her mind, she was not strong enough now to face the ordeal of passing before Her Majesty. Her private life had been exposed and picked over. In Everett's words, 'the indignity has

completely upset her'. Because Effie was excluded from the Queen's presence, 'everyone, even to her own children, will conclude there must be something against her character'. Everett wanted to prove that his wife 'was entirely free from a shadow of misconduct'. What should they tell their daughters when the time came for them to make their debuts in society? The Prince and Princess of Wales, the Marquess of Lorne and his wife Princess Louise were happy to be seen with Effie. Everett argued that it was unjust to treat his wife as if she were an adulteress. But palace protocol was against her.[126]

Throughout the 1870s Effie's former life as Mrs Ruskin kept coming back to haunt her. In October 1870 the parents of Rose La Touche wrote to Effie. Their daughter wanted to marry John Ruskin; he said he had loved Rose since she was a little girl. They had met in the New Year of 1858, when Rose was ten years old. John had described her then as having 'eyes rather deep blue' and 'lips perfectly lovely in profile'. He treated her childish letters like relics, wrapped in gold leaf, tucked inside his waistcoat, close to his heart. Rose was now twenty-two. Mr and Mrs La Touche were disturbed by Ruskin's fascination with their daughter. They needed evidence of Ruskin's incurable impotence to stop the marriage. Could Effie provide this evidence? Effie was forced to retrace the awful events of the court case, the poking, the prying. Replying to Mrs La Touche, Effie tried to explain that for years she submitted to Ruskin, 'not knowing what else to do'. She claimed that Ruskin was 'utterly incapable of making a woman happy'. 'He is quite unnatural,' Effie wrote, and 'his conduct to me was impure in the highest degree'. Troubled by the act of remembering, Effie closed her letter by saying, 'My nervous system was so shaken that I never will recover, but I hope your daughter will be saved'.

The La Touche family recognised Effie's distress, and feared for their own child. But they still needed independent evidence that Ruskin was not fit to marry. Ruskin himself, they said, wanted 'the fiercest light thrown on his past history'. After all, he had always claimed that he could demonstrate his virility and that the fault lay with Effie's 'person'. And, in fact, Effie could not prove that John Ruskin's impotence was incurable. The doctors had shown that she had been married to him for six years and was still a virgin. That was all. Perhaps with a different woman, he would have become a willing husband and father. John Ruskin had not defended himself when Effie brought the case against him because, at the time, he wanted to walk away from the marriage. As a result, he was judged in his absence to be permanently

impotent. But there had never been any hard proof to support this verdict. Now Ruskin, utterly enthralled by Rose, would not be content unless he married her. But the judgement of July 1854 ruined his hopes of making her his wife.

Everett could see the strain that the La Touche affair was putting on Effie. He wrote to Rose's parents begging them to leave his wife alone. He insisted that 'the facts are known to the world, solemnly sworn in God's house'. Why was this 'indelicate enquiry necessary'? Would Rose really listen to Effie when she clearly would not heed her parents' warnings? Everett put it bluntly: 'Mr R's conduct was simply infamous, and to this day my wife suffers from the suppressed misery she endured with him.' That was enough.

But then, in a postscript, Everett could not help asking the question that had clearly been bothering them both for twenty years: 'Will Mr R now submit to a medical examination?' Ruskin never did. So we will never know whether he might have made Rose a good husband. Her parents would not give their consent, and Rose herself was dangerously ill. She died in 1875, of anorexia, or brain fever, or a broken heart, depending on which account you believe. Rose became, in Ruskin's memory, even more beloved in death than she was in life. Her loss undoubtedly contributed to his own breakdown. Many years later, still grieving, he wrote, 'Rose, in heart, was with me always, and all I did was for her sake.' This little lost girl meant more to him than his wife ever did.[127]

After Rose's death, John Ruskin's physical and mental health became unstable. In November 1878 he was called to defend his reputation in another court case, but was too ill to attend. This time it was his role as an art critic, rather than as a husband, that was being called to account. The outcome, however, was equally devastating. Ruskin had written an unflattering review of one of James Whistler's pictures. He claimed it was unacceptable for Whistler to 'ask two hundred guineas for flinging a pot of paint in the public's face'. The painting in question, *Nocturne in Black and Gold: The Falling Rocket*, was, he argued, unfinished. In Ruskin's eyes, Whistler was just demonstrating his 'cockney impudence'. Whistler disagreed. He argued that as Ruskin 'held perhaps the highest position in Europe and America as an art critic' one unjust word from his pen could ruin an artist's livelihood. Whistler took Ruskin to court for libel and asked for £1,000 in compensation.

In court Ruskin's expertise, indeed the whole edifice of his ideals – beauty,

truth to nature, rightness, craftsmanship – were demolished by Whistler's rapier wit. Perhaps if he had been stronger, Ruskin might have taken on his adversary face to face and won. He could have shredded the gossamer-thin arguments that made the journalists in the public gallery chuckle. He could have demonstrated the difference between a sketch and a finished composition. He could have spoken with the fiery wisdom that made his lectures a joy. Instead Ruskin lost. Whistler became a household name, but he was awarded only a farthing in damages. After paying his legal bill, he was worse off than before. However, the verdict was a sign that the tide of opinion was swinging towards a new breed of 'Modern Painters'.[128]

Effie read the account of each day's proceedings in the newspapers, but she did not have time to dwell on John Ruskin's troubles. She had enough of her own at home. 1878 was a hard year for the Millais family. They were mourning Effie's father, who had died the year before. Effie had spent Christmas 1876 at Bowerswell with her daughter Mary. They had travelled to Scotland when George Gray's health became increasingly precarious. Perhaps they hoped that their presence would help him to rally a little; he had told Effie that just chatting with his darling Mary made him feel better. In recent months it had become clear that Effie's father was fading. He was 'in the dumps', his legs ached, he could not be bothered to shave, he suffered from indigestion and was losing weight. The attacks of breathlessness were the worst: 'I feel as if I would go off with suffocation, a most horrible thing.' But he kept hoping that he would turn the corner. 'What I want is a change of scene and society,' he wrote to Effie. 'The old fabric is wearing out.'

George Gray's body might have been weakening, but his mind was as sharp as ever. In his last birthday letter to Effie he took her back to that early morning in May 1828 when he had waited in the garden for his first-born child to be delivered. Effie was still his best-beloved: 'the love which then filled our anxious breasts has never flagged and never will'. Still, he could not hide his melancholy when he thought of Effie far off in London. 'I am wearying to see you again at the piano, and hear all your old Scotch tunes,' he told her the summer before he died. His spirits were not improved by news from Australia. Effie's brother John was planning to marry 'a scullery wench'. 'To see this Boy disgracing himself is hard to bear,' George Gray told Effie. 'Sleep has left me for ten days, and I walked about in Sophy's room or read

the papers all night.' He could not write any more, he said: 'my head is swimming and my hand shakes'.[129]

In September 1876 George and Sophia Gray set off for Buxton in a 'dreadful blast of wind and rain'. They had been advised that a course of douches and massages in the Derbyshire spa town might relieve Mr Gray's symptoms. But he was sceptical: 'I will never believe they can lengthen my days by artificial means.' Effie treasured this final letter from her father. He told her that he was thinking of her among her family and friends. 'I am very tired,' George Gray wrote at last, 'so excuse my saying more.'

George Gray died on Friday, 5 January 1877 with his wife Sophia, Effie and Mary at his bedside. Back at Palace Gate, Effie's other children were stuck in the house, dreading the arrival of a telegram. Everett kept the boys off school and had to decline invitations to New Year parties. They all knew that they would be called north for the funeral sooner or later. When the news reached London early on Saturday morning, Everett and his sons began to make their travelling plans. They were in Scotland in time for the burial service at Kinnoull on 9 January.

The family were devastated by the death of Grandpapa. George Gray was the linchpin of their lives. His wisdom and good humour brightened their days when they were staying at Bowerswell, and his letters were passed lovingly around by his sons and daughters when they were far from home. In his lifetime, Bowerswell was a refuge. Year after year the grandchildren looked forward to the summers here: they longed to see the peaches ripening in his hothouse and taste fresh cream and honey on their porridge. At Bowerswell, they said, the perpetual noise of London traffic was replaced by the hum of bees. Now that sense of security and peace was gone. Young Evie tried to put his sadness into words, but had to give up: 'My fingers cannot well express what I would say'.[130]

Evie was hard hit. He was supposed to be studying for his Foreign Office exams. Clare Ford had promised to put in a good word for him, but he could not concentrate. In the months following the death of his grandfather, Evie's behaviour started to deteriorate and his future as a diplomat seemed shaky. Meanwhile his younger brother George had gone up to Trinity College, Cambridge. He looked set to become a successful lawyer, following the family line.

Then suddenly young George was struck down. In the autumn of 1877,

just after returning to his studies, he developed a cough and curvature of the spine, and his weight dropped dramatically: the classic symptoms of tuberculosis. His doctor, Sir William Harcourt, advised that he should go abroad, away from the fog of the Fens. Harcourt was sure that George would 'come back next April all right, and go on with Cambridge'. The boy was keen to head for Australia, where his uncles were working. His doctor thought a cruise down the Nile would be another possibility, but 'whatever is done should be decided quickly as November is a bad month'. Effie dropped everything. Within a fortnight George and his mother were in the South of France, and young Mary was with them. The three of them spent Christmas 1877 in Cannes.[131]

The winter sunshine seemed to relieve the worst of George's symptoms. Effie watched him slowly recover his strength, all the time knowing she was needed at Palace Gate. Everett was not coping well in her absence. So Effie travelled back to London in early March, leaving Mary to keep her brother company. When the weather was warm enough, they hoped he could return home. His doctor still thought that he might be back at Cambridge within the year. George travelled to Bowerswell at midsummer to stay with his grandmother. (The rest of the family were all over the country, from London to the Highlands.) Mrs Gray was sitting down to breakfast when George appeared on the lawn, 'looking the picture of health'. Sadly, his cough soon returned. His grandmother called in an Edinburgh doctor, 'the first for lung complaints'. Professor Sanders told George there was no cause for alarm. He should just try to keep taking 'wine and nourishment' and stay indoors until the cough cleared. This was more than George could bear. He loved to be out in the hills, riding his bicycle, shooting, fishing. He was bored, surrounded by fussing women. Aunt Sophy, Effie's sister, tried to cheer him up with her chatter and music, but Great-Aunt Maggy was simply depressing.

Then, in late July 1878, George's condition worsened. It seems he had contracted typhus. His grandmother sent at once for Everett, who left his sport as soon as he heard the news. He found his son exhausted by fever and in great pain. Over the next few days Everett saw George 'wasting away to a skeleton', but 'he lived on'. At least there was time for Effie to join the family at Bowerswell to say goodbye to her son. It was dreadful to watch this bright young man fading before their eyes. He knew he was dying, 'maintaining his senses to within a day of his death'. Finally, on 30 August, he was beaten. He

died a fortnight before his twenty-first birthday. George was buried beside his grandfather in Kinnoull. Effie wrote to her sister Alice about the service. They agreed it was better that he should lie there in the churchyard, a stone's throw from Bowerswell, rather than among 'strangers in London': 'It is such a sweet little spot.'[132]

The family retreated to Dhivach, a house near Loch Ness. Effie and Everett were heart-broken. Even the promise of fishing and deer-stalking could not lift Everett out of his depression. Every moment on the hillside or at the water's edge reminded him of George. The boy had loved this life. Eventually Everett decided there was nothing to do but paint. The ruined castle of Urquhart, on the shores of the loch, seemed to match his mood. Buffeted by storms, broken by time, it stood defiant, silhouetted against the grey skies. Everett chose a quotation from Tennyson for the title: '*The tower of strength which stood | Four-square to all the winds that blew*'. In the foreground an oarsman, like a modern-day Charon, pulled hard across the choppy waters. Everett laid the paint on the canvas in rough swirls and lumps. He fought against the elements, and his own grief, to fix the image. At least he had his work. He admitted to his friend Louise Jopling that painting was 'the surest means, not to forget, but to occupy your mind wholesomely and even happily'.[133] Effie had to find solace in other ways. It was time to get back to London and focus on the children that were left.

Effie was worried about Evie. This was one of the reasons why she had hurried home from Cannes, leaving George with his sister Mary. Evie's future in the Foreign Office looked precarious. Clare Ford had held open an attachéship for Evie, in the hope that the boy would be ready to apply for the post. But in March 1878 Everett received a series of increasingly angry notes from Evie's tutor. Evie had been skipping lectures. Now he had gone missing completely. He had last been seen at a ball several nights before, where he was spotted 'smoking with two fellows' until five o'clock in the morning. Evie had mentioned to a friend that he fancied going to Lowestoft for a few days, but no one knew for sure. His tutor was scrabbling around trying to find him, and promised to send a telegram when Evie turned up. His behaviour was 'abject folly', 'suicidal'. Unsurprisingly Evie failed his exams. His crash was spectacular: he ploughed four papers. Clare Ford suggested he try again in three months' time. But Effie knew there was little point, whatever her friend might say. Evie was not cut out to be a diplomat.

After the shock of George's death, Evie's behaviour degenerated further. He was drinking hard, and could not settle to any career. He seemed interested only in animals. Effie remembered him as a boy intently turning over leaves and pebbles hunting for beetles. She thought of the posies of wild flowers he had sent her from school. All that innocent energy seemed to have ebbed away. By New Year 1881 it was clear that Evie's alcoholism was unmanageable. In March he disappeared on a drinking binge. Effie was away again in the South of France and Everett felt overwhelmed, so he telegraphed Alice Stibbard, Effie's sister. She found Evie and brought him back to her house in Stanhope Gardens, South Kensington. 'I can never be too thankful I went for him when I did,' Alice wrote to Effie. 'He is better the last few days,' she reassured her sister. 'Now he has told me all, it has been a great relief to his mind, poor boy.' But he refused to see his father or anyone else from Palace Gate.

Evie needed to leave London, for his own sake and for the sake of his family. The shadow of insanity hovered over the Millais household: it brought back dreadful memories of the Ruskins who had several times suggested that Effie herself was mad. She and Everett were worried that word would spread that Evie's instability was hereditary. This would destroy their daughters' chances of marrying well, and blight their sons' prospects. Again it was Alice who acted. She booked Evie's passage to Australia. 'Everyone knows how ill he has been,' she explained to Effie, so 'there won't be the slightest suspicion in anyone's mind'. Aunt Alice packed for him, kitted out his cabin and acted as go-between with Palace Gate. Just before he sailed, she took Evie to say goodbye to his father. While she waited in his bedroom, putting the last of his things into a bag, the two men tried to overcome their anger and resentment. Evie later told his aunt that 'his father had not said one word to hurt his feelings'. He came away deeply affected and determined to start afresh.

First reports from Australia seemed promising. Evie's letters home seemed to show 'no signs whatever of a weak mind'. But then he fell in with a fellow called Rattison and started drinking again. His uncles placed him in the care of a doctor; they told him he must either be cured or face the asylum. Evie ran away and booked himself on to a sailing ship bound for England. It was dreadful news for his parents. They could not bear the idea of shutting him up when he landed, but they feared it might be the only way to stop him

drinking himself to death. Everett found it hard to believe that his son could retrieve his position in society. And Effie went into exile, staying with friends in Florence while the drama played out at home. But Aunt Alice still held out some hope: 'If for a time the poor boy could only be kept from himself, he might yet be saved.' She trusted that then 'everything would be forgotten'.[134]

Alice was proved right. Evie returned, sober and contrite. His later letters to Effie were as devoted and conscientious as the ones he had sent from Marlborough. Everett, who had always tried to offer his son 'manly, sound and honest good advice', gave him another chance. Evie took up dog-breeding professionally, and became an expert in his field. He was still far from well, however. In the early months of 1885 he and his younger brother Johnnie travelled to Cannes for a break. In March, Johnnie had to go back to his studies: his *femme de chambre* found a prayer book, a bottle of magnesia and half a dozen tennis balls' left behind in his room. Evie moved on to Aix-les-Bains. He needed treatment for his leg. His knee joint was permanently painful and his hip ached. The treatment he was prescribed was almost worse than the condition. After a douche, Evie's doctor blistered his leg: in Evie's words, 'he fried me with his hot instruments'. In one letter Evie said he was writing to his mother while resting, 'to keep my mind off the burns'. He had to stay in bed for several days after each session while the blisters healed.[135]

In the evenings, when he was well enough, Evie went down to the ballroom of the Grand Hôtel. Sometimes he even managed to polka. It seems it was here that he met Mary Hope-Vere. She lived with her mother, Lady Hope-Vere, who moved between Paris and the South of France. When Mary visited England she often stayed at Cassiobury Park, in Hertfordshire, with Lord Essex, who, so Evie said, was 'a sort of father to her'. Mary was quiet, ladylike, well connected but not well-off.

When Evie returned to London in the autumn of 1885, Miss Hope-Vere was with him. Effie's daughters invited Evie and his young lady for lunch. They made no secret of wanting to inspect their potential sister-in-law. Carrie wrote to her mother with the verdict. Mary was 'a tiny little thing and round'; she barely reached the Millais girls' shoulders. But Carrie was pleased for her brother. Evie seemed much improved: 'his knee was quite big and strong, and had lost all that shrivelled look'. She thought, 'Happiness is a very becoming thing.'

Everyone wanted to know whether Evie intended to marry Miss Hope-Vere. Even Mary herself was not quite sure 'what her position would be' when she returned to France after the trip to London. On 11 October she asked Evie outright. 'Of course there is an engagement between us,' he told her, and 'took her in his arms'. Evie agreed to write to his parents, Aunt Alice and his grandmother: it was not 'worthwhile keeping it to ourselves', he said. His sisters were adamant that Evie had to do things properly. He was suddenly tipped into a matrimonial maelstrom, choreographed by Carrie and young Effie. He must announce the engagement in the *Morning Post*. Mary needed to negotiate a financial settlement from her family. He had to find presents for the bridesmaids. Lady Hope-Vere claimed she could not afford to pay for a wedding in France. Evie certainly did not want it to be 'a swell affair'. No one approved of long engagements. He admitted to his mother, 'I don't know whether I am standing on my head or my heels at present.'

Evie spent Christmas 1885 in Paris with his fiancée and his future mother-in-law. He made Effie smile with his tales of the Douane: 'seven men in attendance over a 2lb box of Scotch shortbread,' he wrote when he arrived. It had been a frightful crossing, but at least he was safe. Earlier in the week a passenger steamer had gone down off Guernsey with all hands.

That Christmas it seemed to Effie that her children were scattering, leaving Palace Gate huge and empty. Mary had sailed for Australia in the summer of 1885. She was not due back for a year. Young Effie was already married, and Carrie was making last-minute preparations for her own wedding. Evie and Mary planned to marry in early April 1886 in Pau, just north of the Pyrenees. Effie was going, but Everett was not. It was a bad time for him, just before the exhibitions opened in London. Geoffroy agreed to travel to France with his mother. He wanted to take some photographs of the happy couple. But then he was all set to steam towards the United States.

Geoffroy wrote to his mother in May from his ranch. The ship's propeller had been broken by 'striking against a whale or floating log', he told her, and it was pure luck that he was not 'still knocking around the Atlantic now'. Then he had been three days on the train before he reached Wyoming. He sounded cheerful, though. The only thing he lacked was something new to read. He asked his mother to send him out her magazines every week when she had finished with them. It was always 'such a treat to have them out here at the ranch'. Geoffroy could hear about his father's pictures and his mother's

parties, but he did not have to endure the noise and bustle that went with them. He read the London papers by lamplight on the porch of his log cabin. The moon rose behind the great mountains. In the vast open spaces he was alone with his camera, his horse and his gun. Palace Gate, and all it stood for, was half a world away.[136]

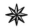

19. John Everett Millais, *Sophy Gray*, 1857, oil on paper laid on wood, Private Collection, courtesy of Peter Nahum at the Leicester Galleries, London.

). John Everett Millais, *'Guilty', Illustration for Orley Farm*, 1862, wood engraving, engraved by the Dalziel Brothers, with pencil corrections by J.E. Millais, V&A Museum, London.

21. John Everett Millais, *The Eve of St Agnes*, 1862, oil on canvas, The Royal Collection, Her Majesty the Queen Elizabeth II.

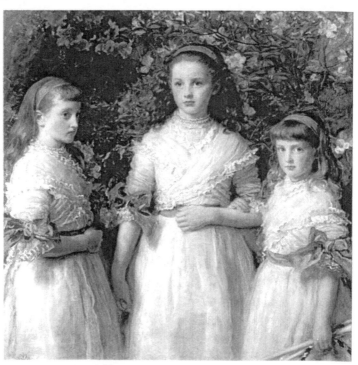

22. John Everett Millais, *Sisters*, 1868, oil on canvas, Private Collection, c/o Christie's London.

23. *Effie Millais*, July 1870, photograph from Mary Millais's album, Geoffroy Richard Everett Millais Collection (© Tate, London, 2010).

24. *George Gray, Effie's father, in a kilt,*
photograph from Mary Millais's album,
Geoffroy Richard Everett Millais
Collection (© Tate, London, 2010).

25. *Alice Stibbard, née Gray, Effie's sister,*
photograph from Mary Millais's album,
Geoffroy Richard Everett Millais
Collection (© Tate, London, 2010).

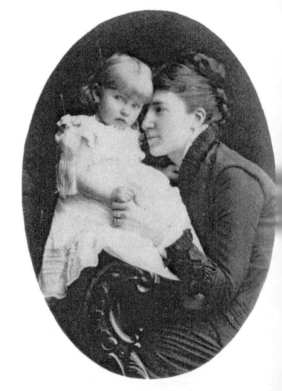

26. *Sophy and Beatrix Caird,* photograph
from Mary Millais's album, 1876,
Geoffroy Richard Everett Millais
Collection (© Tate, London, 2010).

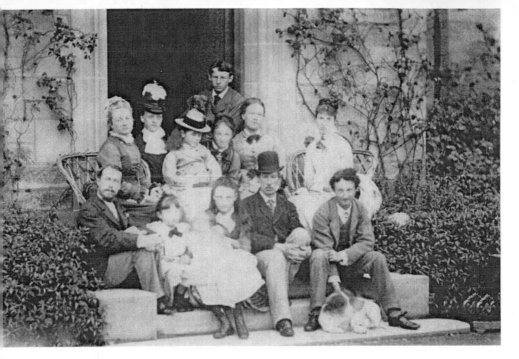

27. *Millais family at Erigmore, Perthshire*, photograph from Mary Millais's album, 1875, Geoffroy Richard Everett Millais Collection (© Tate, London, 2010). Back row, left to right: Effie Millais, her daughter young Effie, her son George holding Dachs, [uncertain], her daughter Mary, [uncertain], her sister Sophie Caird. Front row, left to right: [uncertain, possibly James Caird], her daughter Tottie, her daughter Carrie holding Beatrix Caird, [uncertain], her son Evie.

28. F.G. Kitton, *Millais's House at Palace Gate, Kensington*, wood engraving, published in *The Art Annual*, Christmas 1885, V&A Museum, London.

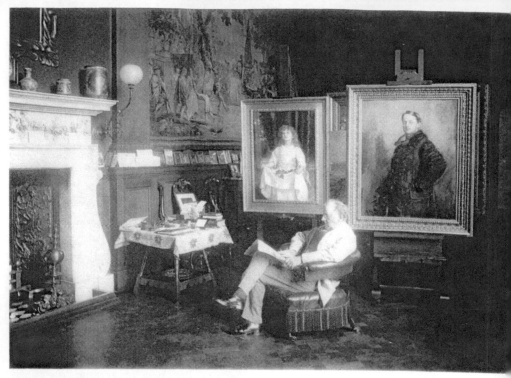

29. Rupert Potter, *John Everett Millais in his studio (with Lilacs and unfinished portrait of the Earl of Rosebery)*, July 1886, photograph, National Portrait Gallery, London.

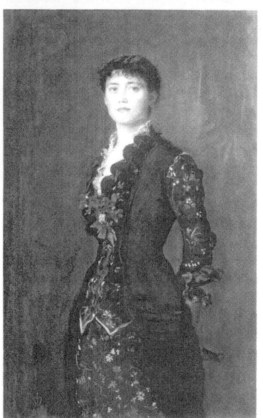

30. John Everett Millais, *Portrait of Louise Jopling*, 1879, oil on canvas, National Portrait Gallery, London.

31. John Everett Millais, *Portrait of William Ewart Gladstone*, 1885, oil on canvas, The Governing Body, Christ Church, Oxford.

32. Rupert Potter, *Gladstone in Millais's Studio*, 28 July 1884, photograph, National Portrait Gallery, London.

33. Baron Carlo Marochetti, *Effie Millais*, marble, 1862, Geoffroy Richard Everett Millais Collection (© Tate, London, 2010).

34. *The Gray Family and John Everett Millais at St Andrews*, studio photograph, 1855. From left to right: George Gray jnr. with John and Albert, Sophia Gray (Effie's mother), Jeannie with baby Everett, George Gray snr. (Effie's father) with Alice and Sophy, Melville, Effie and Everett Millais, Private Collection.

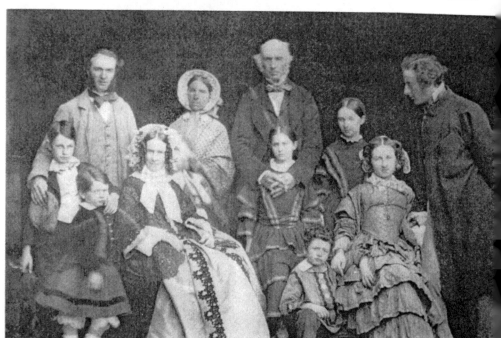

Chapter Eleven

Sisters: Effie and Her Daughters

EVERETT HAD MADE a small fortune from his daughters. Their faces shone out from his most popular pictures: *My First Sermon*, starring young Effie, born in 1858, had earned him £620 in 1863. Then there was an extra £180 for the oil replica. Two years later he was selling images of Mary, born in 1860, in *Waking*, and Carrie, born in 1862, in *Sleeping*, for 1,000 guineas apiece. Even little Tottie, born in 1868, starred in one of her father's paintings before her second birthday. She played the part of a baby adrift in its cradle in *The Flood* of 1870. The children were essential to the financial success of his business.

But often the girls were reluctant models. It was a wearying task. Their mother had always complained of headaches and stiffness after sitting for Everett, and at least she had some choice in the matter. Carrie was three and Mary was five when they modelled for *Sleeping* and *Waking*. They became disgruntled about being bundled back into bed in the studio day after day: 'It was so horrid, just after breakfast, to be taken upstairs and undressed again.' They rebelled as best they could, kicking off the covers, and messing up the carefully arranged folds. Mary decided to hurry the process along. One morning as she was sitting up in bed, holding the *Waking* pose for her father, he was called away. She slipped to the floor, and taking a brush loaded with paint, tiptoed towards the easel. There was her doppelgänger, wide-eyed and angelic. It was infuriating. She reached up as high as she could, and began covering the canvas with broad brown streaks.

According to Everett's son John Guille Millais, the artist never said a word of reproach to little Mary. Perhaps Everett really was as soft-hearted as his son makes out. Perhaps he was just relieved that the damage was limited to the lower part of the picture: the easel was set too high for Mary to obliterate her own face. Perhaps she was beaten like her brothers when they misbehaved: after they were caught making mischief in the garden at Bowerswell,

Grandpapa gave young Evie and George a 'good whipping on the posterior', with Effie's consent.

It was hard for the children to live up to the idealised images that their father put before the public. Pictures of the Millais girls were a highly effective showcase for Everett's talents. At Christmas-time Effie dressed her daughters up in the costumes made famous by their father's paintings, and sent them off to their friends' parties. Everybody recognised them. As one guest commented, 'there was no mistaking their likeness to the pictures of last year'. Little Effie stood out in the red cloak she had worn for *My First Sermon*. There is something disconcerting about the way that strangers, like the writer Arthur Munby, took advantage of her visibility. Meeting her for the first time at a party in 1864, when she was five, Munby found her so pretty and self-possessed that he kissed her. But little Effie seems to have become used to being the centre of attention. She was a walking advertisement for her father's business.[137]

As they grew up, each of the Millais girls responded to this celebrity status in her own way. Their affluent lifestyle gave them a variety of options. London in the closing decades of Victoria's reign was a modern, vibrant city, and young women now enjoyed much greater freedom than their mothers had ever known. This is one of the reasons why Effie's relationships with her daughters so often proved unsatisfactory. And, as we shall see, there were plenty of flash-points. She became exasperated with young Effie, who was happiest being whisked from one ball to another by her tireless chaperones, while Mary preferred travelling. Mary enjoyed her teenage trips to Paris and Cannes, and by 1886 she was visiting relatives in New Zealand and Australia. Carrie was a pianist and composer. At the age of sixteen her musical studies took her to Brussels, and she later became a close friend of Edward Elgar. And then there was Tottie, the baby of the family. She was christened Sophia Margaret, like her grandmother and aunt, but she was her grandpapa's pet. He coined her nickname, and called her 'the flower of the flock'. It was Tottie who felt the greatest sense of distance from her mother's experience. As she grew older her letters to her mother revealed her boredom and frustration.

Effie could remember the capital as it had been forty years ago. Then the Crystal Palace had sparkled in Hyde Park, and she had swept along the wooden pavements in her bell-shaped crinoline. As a respectable lady, Effie had been taught to keep her eyes lowered and not be distracted by shop

windows or the spectacle of street life. She was expected to be unobtrusive, although quite how she should achieve this given the width of her skirts was not made clear. Her passage along the street was supposed to be the antithesis of the fashionable gentleman's saunter through the city. The ideal male gaze was direct, observant, even cynical. The 'man-about-town' of the mid-century had modelled himself on the Parisian *flâneur*, a dandy with the leisure to watch the world go by.

But by the late 1880s, when Tottie was in her early twenties, the London scene had changed dramatically. Girls on bicycles were speeding through the city, heading for tennis lessons or university lectures. Women were claiming the streets for their own pleasures. They could spend the morning promenading along Oxford Street and Regent Street, browsing in John Lewis (opened 1864) and Liberty (opened 1876), then meet friends at a club catering especially for women. The *Woman's Gazette* published a handy list of twelve restaurants recommended for ladies who lunched in the West End. There were other signs of increasing independence. Blocks of flats were being built just behind the British Museum, exclusively for professional women. The interiors were fitted out by the fashionable designers Agnes and Rhoda Garrett. There was a real shift in attitudes towards women who worked – at least as long as they remained unmarried. It was no longer impossible for Tottie to think about earning her own living. She could have turned her privileged position at the heart of artistic society to her advantage; why not set herself up as an arbiter of good taste, and write advice manuals on fashion and art? Plenty of other ladies had done just that. As she wrote to her mother, 'I want something to do'.[138]

Tottie and her sisters were used to being involved in their father's work. Their studio-home was a site of activity and commerce. Both Mary and Tottie were reluctant to settle quietly into the sedate domesticity that their mother seemed to think was appropriate. Ever since they were tiny, they had been at the heart of the family's enterprise. As we trace the girls' lives, we see how the tensions of running a successful business alongside the family home coloured Effie's relationships with her daughters.

Looking back, we see how Everett's images of his children helped to build his portrait practice. They demonstrated his technical skills and his willingness to engage with younger sitters. If he could present his own children prettily, no doubt he would do the same for his clients. A picture like *Sisters*

(1868) showcased Everett's facility in this field. It was also evidence of his desire to remain at the forefront of London's rapidly changing art scene. This painting is a fascinating document. Not only does it record a shift in Everett's technique, it is also a prism through which we can view the different characters of his daughters. And the spring of 1868, when this painting was put on display, was a critical time, not just for Everett's art, but for Effie's family circle.

Sisters was an ambitious triple portrait. It represents Everett's daughters Effie, Mary and Carrie (aged nine, seven and five) dressed in identical white muslin frocks. This painting was Everett's riposte to Whistler's *Symphonies in White*, a direct engagement with contemporary debates about Aestheticism and the cult of beauty. Everett took up Whistler's notion of a restricted palette, creating three 'little white girls' of his own. The children are presented as one element in a delightful pattern of ruffled petals and frilled fichus, blue bows and blonde ringlets. There is no sense of depth or space around the figures. They are pressed up against the azaleas that fill the background. The flowers are pale – pink and white – except for a sudden flash of red above Mary's head, on the extreme left. It is at this point that we start to question the apparent simplicity of the subject. These girls are not just objects for our visual pleasure. They are also individuals, known and loved by the artist. With this flash of colour, Everett picks out Mary – the adventurer – and sets her slightly apart from her sisters.

Everett was playing a double game. He painted his daughters' precious girlhood, both as a sign of his status as an affectionate *paterfamilias* and as proof of his powers as a painter. He wanted to show the Aesthetes that he could be just as modish as them. The Royal Academy exhibition of 1868, where this portrait was first shown, was the moment when Aestheticism burst upon the British public. A new generation of artists and critics were challenging the supremacy of John Ruskin's vision. William Michael Rossetti (Gabriel's brother) and his friend Algernon Swinburne, in their review of the 1868 exhibition, drew attention to a group of pictures that heralded a new age in British Art: pictures 'in pursuit of the beautiful'. Swinburne singled out an image by Albert Moore – his *Azaleas* – as the epitome of this approach. An unashamedly anachronistic scene of a Grecian woman with a pot of Victorian hothouse flowers, it had no meaning beyond its beauty. In Swinburne's eyes at least, it could not be criticised for its rejection of reality. This art was

self-sufficient. It did not need moral underpinning. Can it really have been a coincidence that Everett also chose azaleas for his triple portrait? Like his adoption of Whistler's 'white girl' motif, it seems that Everett was showing off. The ease with which he could transform his art to reflect the concerns of his age meant that he always remained at the cutting edge.

Everett's engagement with Aestheticism led to disagreement among the prophets of this new artistic creed. Swinburne condemned *Sisters* for having 'no subtlety or beauty', but his collaborator W.M. Rossetti felt differently. He believed it demonstrated Everett's 'pure unforced, untrammelled mastery'. For Rossetti, the artificiality of the composition enhanced its appeal. He liked the way that Everett did not disguise the fact that these were real children in an unreal setting, posing for their portraits. The tension between reality and artifice was part of the pleasure.[139]

So what was real life like for the young Millais girls at this point? A few weeks after the exhibition opened, while their portrait was still being picked over by the critics, their new sister arrived. Effie's last surviving child, Tottie, was born on 15 June 1868. Effie had a hard pregnancy. She had turned forty by the time she was confined. She was also shaken by the sufferings of her sister Sophy, who had been taken ill in March. When the telegram came to Bowerswell announcing the arrival of the new baby on that same day, Mary was staying there with her brothers. She and her Aunt Alice enthusiastically discussed names for the little girl. Alice suggested Ethel, and Mary wanted her new sister to be called Emily. But they were both overruled.

For much of the pregnancy, Effie's daughters had been packed off to their grandparents at Bowerswell. In 1867 the girls had enjoyed a lively autumn in Scotland with their brothers. It was not until mid-November that they had caught the train south to Euston, well wrapped up and supplied with hot pans to keep them warm on the long journey home. Carrie returned to Scotland soon after Christmas. She provided a welcome diversion for her grandparents, increasingly worried about the behaviour of Effie's younger sisters, Sophy and Alice. They loved to hear Carrie's voice around the house. At five years of age she was already showing promise as a singer and had a good ear for music. In early February 1868 George Gray wrote to Effie, suggesting that his little granddaughter should stay another three months, before he brought her back to London himself. He was quite willing to look after her on the long journey. It is true that he had drawn the line at taking her overland on the

crowded mail coach to London a couple of years before, but that was hardly surprising. Even Effie could not expect her father to endure a twelve-hour journey with a wriggling three-year-old on his lap. But Carrie had stayed at Bowerswell so often in recent years that he had begun to 'look upon her as a child of his own'.

Unhappily, within a few weeks George Gray had to warn Effie that a crisis was approaching at Bowerswell. Sophy and Alice were both unwell and driving their parents to distraction. It was time for Carrie to go home, and, as Mr Gray noted, the 'poor little dear says "you know, I must go back to my own Papa"'. She had often made the journey before, but this time there was no one to travel with her. The five-year-old was booked to travel alone on the steamer to London. On 11 March 1868 her grandfather held her hand as they climbed the steep gangplank at Dundee. Carrie was in good spirits, looking forward to the trip home. When she was introduced to Captain Findlay 'she called him a jolly old boy, and gave him a kiss'. Then came the moment of separation. Her grandfather left her in the care of a stewardess, and had to walk away, back to the dockside: 'It will break my heart to part with her,' he wrote. The little girl stood on deck waving down at him as dusk fell, and then she was taken below to her cabin. The wind was rising when the captain gave orders to cast off. By the time the steamer reached the harbour mouth, it was no longer safe to cross the bar. The sea was too heavy for the ship to reach the open water safely. All that long night, Carrie lay alone in her bunk shaken by the storm. She should have been home soon after dawn. (In good weather the overnight passage to London was wonderfully swift.) Instead she was riding the swell, and listening to the confusion around her: the shifting timbers of the vessel, the seasick strangers, the waves outside in the darkness. Mercifully, by daybreak the squall had cleared, and the steamer was able to make the journey south in full sunshine.[140]

George Gray did his best to reassure Effie, waiting for her young daughter to arrive in London. He wrote to explain the delay, and his letter arrived in the morning post. For Effie, though, it was yet another worry. She was uncomfortable, six months pregnant and again suffering from sleeplessness. Her doctor had just sent her another prescription from Scotland, and asked for an update on her health. Effie felt the perennial strain of spreading herself too thinly. She simply could not satisfy all the demands on her time and energy. She relied on her parents to plug the gaps, by looking after the

younger children for long periods. But now her little Carrie was in limbo between Dundee and the London Docks, and there was nothing Effie could do to comfort her. Her father's advice to stop fretting about other people's problems and put her feet up by the fire was hardly helpful. At the back of her mind were the tales of other sea voyages: the *Colombo*, wrecked at Christmas 1861, carrying letters from her brother George in Australia. (Only the envelope had arrived on the Bowerswell tea table, as the message inside had been washed away.) Or, closer to home, the *Scotia*, one of the Dundee steamers, that had been going too fast in the fog. It had ploughed into a brig at anchor in the Thames and three of the crew were drowned. Two of Effie's brothers had been booked on the *Scotia*'s previous passage. That was back in the spring of 1863. The Gray and Millais families depended on the steamer service to keep in touch, and George Gray was caught up in the finances of the service. But the journey was not without its risks, and Effie knew it.

Carrie did arrive home safely, and was soon looking forward to her sixth-birthday celebrations on 10 April. Her grandfather sent her a paintbox and asked her to make a picture for him. He missed Carrie. They had played games at breakfast time, racing to see who could finish their porridge first. He wrote sadly 'this is all over now'. Fears about Sophy's illness overshadowed all his correspondence, however hard he tried to shield the younger children. He was also anxious about Effie's imminent confinement, and invited her three girls back to Bowerswell, despite the upheavals there. At least they would put some life in the house. In the end, it was decided that it was best to get the boys away before Effie went into labour. This time her mother would not be with her. Mrs Gray stayed in Scotland to take care of Effie's older children. So Mary was sent up on the overnight train with her brothers, while young Effie and Carrie remained in London with their parents.[141]

Everett's picture of the three *Sisters*, on show at the Academy in that eventful summer of 1868, seems to embody the distance between Mary and the other girls. Evidently it was accepted as quite natural by the family that Mary would go off with the boys. In the portrait, Carrie and young Effie are presented as a pair: Carrie's hand nestles in the crook of her elder sister's arm. This touch gives her the assurance to look out of the picture. She catches our eye with a questioning glance. She is nearly smiling, only just keeping her cheekiness under control.

On the other side of the picture there is a flower-filled space between the figures of Effie and Mary. It is only when we study the composition carefully that we notice the girls are holding hands. Mary's fingers are just visible, entwined with her sister's. She has turned so we see her in profile: this creates a gap between their two bodies. Mary's gaze crosses the canvas. She is not looking at the viewer but instead is focusing on something else beyond the frame. Even as a young girl, Everett seems to hint, she and her sisters look at the world from different angles. She is an observer, a traveller, a gatherer of information. Her parents were prescient when they asked William Holman Hunt to be her godfather; Mary Hunt Millais grew up to share many of his enthusiasms, including his taste for travelling.

As a toddler Mary had grown used to the regular movements by steamer or locomotive between London and Scotland. Returning home for Christmas, she sat beside her big sister, looking out of the carriage window while the train sped south through the wintry countryside. But with the older children at school, Mary often spent long months with her grandparents. At times she was almost a stranger to Cromwell Place. Growing up, Mary became her grandpapa's companion. He looked forward to playing golf with her on the Bowerswell putting green in the evenings. She lifted his spirits. George Gray recognised that she was wise beyond her years, and loved her for her choice expressions and common sense. She was bright, but not bookish: her grandfather remembered her convulsive laughter when she was tickled. She got grubby, larking around with her brothers. Even after she went away to school herself, Mary made the journey north to Bowerswell as often as she could.

Mary started at boarding school with her big sister Effie in the autumn of 1869. Effie was nearly eleven years old and Mary was just nine. Unlike their mother, who had been sent from Scotland to Stratford for her schooling, they were able to stay closer to home. Everett and Effie chose Haighlands for their girls. It was advertised as a Ladies' Collegiate School, only five miles south of London. Established in the 1850s in the suburb of Forest Hill by a husband-and-wife team, the school offered a winning combination: the cosmopolitan experience of the German-born Professor Waetzig and the domestic supervision of his English wife. As a result, the girls could expect to gain a thorough grounding in modern languages and music, while at the same time receiving a polite English education. By 1869, when Effie and Mary Millais began their studies, Haighlands was being run by

Miss Waetzig, daughter of the original principals. It had maintained its reputation as a high-class school.

Miss Waetzig's establishment was within walking distance of the new site of the Crystal Palace. The huge edifice had been moved to Sydenham in 1852, and proved a great hit with Londoners. Up to two million people a year came on day trips thanks to the new rail network. The Crystal Palace provided a kaleidoscopic range of attractions: ancient Egyptian statues, fountains, palm trees, contemporary sculpture, life-size models of dinosaurs, and massed choirs. The Handel festivals were particularly popular, attracting audiences of up to 18,000 people. The Millais girls would have been able to hear the 'Hallelujah Chorus' from their classroom, as 4,000 singers reached the climax of Handel's *Messiah*.[142]

Mary and her sister did well at school. Mary enjoyed the challenge of exams – 'they are very interesting and extremely difficult,' she wrote to her mother – and came top of her class. Both girls were fond of their teacher, who appeared as a sympathetic presence in their letters. Miss Waetzig coped with the trials of a houseful of girls with admirable calmness. Even when Mary was hopping around the schoolroom, unable to sit down because she was 'almost crazy with worms', her teacher remained unflustered. The girls needed her compassion. Effie in particular suffered dreadfully from homesickness. Her letters are sometimes painful to read, as she tried to be brave. Just a few weeks after going back to school in 1872, Effie was missing her little sisters and longing to see her mother again: 'We are overjoyed at hearing that you and Papa and Carrie are coming to see us Please, please bring Jeannie and Tots, do.' But she also revealed her anxiety about her mother: 'Do try and come don't disappoint us.' There is a sense in these letters that the girls could not always rely on their mother for reassurance. She was too taken up with her own health problems, especially her chronic insomnia.

At Christmas 1872 their mother was still very unwell; Effie had not fully recovered from the stillbirth she suffered in the spring. She took her usual course of action, escaping to Bowerswell where she could be looked after by her own parents. In the meantime her daughters were facing a sombre holiday. They could not even look forward to their father coming to collect them at the end of term: he had gone off shooting, fed up at being left alone in London. 'Our Christmas at home I am afraid will be a blank without you,' wrote young Effie to her mother.[143]

Very few of Mary's letters from her schooldays survive, but we can still build up a vivid picture of her as a young girl. She hovers in the background of young Effie's correspondence, and her grandfather wrote about her frequently and with great fondness. Like her mother, Mary was witty but she lacked her good looks. It was almost as if Effie's features – her distinctive long nose, large eyes and strong chin – were exaggerated to the point of caricature in Mary. She made up for her plainness, though, with engaging conversation and a passion for music and cards. When she stayed at Bowerswell, her grandfather would gladly give up his place at the whist table on a Saturday night so she could play against the local gentlemen: 'She showed herself quite equal to any of them.' Mary was an enthusiastic pianist too. Music was one of the core subjects at Miss Waetzig's school, although the girls were rather in awe of their music master, Mr Westlake. On the days when he was teaching, all the pupils would moan: 'Oh today is terrible Mr W.' But he taught them well. When Mary visited her grandparents in the summer of 1875, she pestered them into hiring a piano especially for her. George Gray sat happily in his study, listening to her polishing her dance tunes in preparation for a party. It reminded him of the old days when his house was full of music and children's laughter.

That Christmas, when Mary was fifteen and young Effie was just seventeen, the two girls were sent off to Paris. They were meant to finish their education by improving their French and Italian, and practising hard at the piano. They promised their Aunt Sophy, who was keeping an eye on them from her rooms in the Hôtel des Iles Britanniques, that they would be at their desks by 9 o'clock every morning. But the two teenagers were distracted by the nightlife, their invitations to parties and the Opera. Their teacher was not going to push them. According to Sophy, Mlle Stanovitch was rather deaf and had 'a sort of vagueness' in her manner. The girls picked up very little from her, except a dubious French accent: 'Mademoiselle' was not a native Parisienne, and did not bother to correct their pronunciation.

Mary's next visit to France was under much more painful different circumstances. She travelled to Cannes with her mother and her brother George when he was taken ill with tuberculosis in the autumn of 1877. Sitting on the terrace of their hotel, Effie should have been able to enjoy the winter sunshine. But every time she saw Everett's handwriting on one of the letters from home, she had to brace herself before she slit the envelope. His messages

were often as evasive as they were distressing. In early February he wrote to say that little Tottie had been 'upset'. Everett gave no more details, but the accident must have been serious as he had called Dr Morgan out to see the child. Effie felt the familiar sensation of failure. She simply could not be in two places at once. Her son George seemed to be recovering, but his progress was slow, and in the meantime she could do nothing to help her daughter, a long way off in London. Effie had to wait three more days before she heard how Tottie was. The little girl had suffered a blow to the back of her head and was kept in bed for several days, but now she was well enough to go back to school. Tottie had just begun to attend Miss Reeve's academy as a day pupil. It was very close to their home, just around the corner in the Cromwell Road, but it seems from the letters that Effie was not even consulted about Tottie's starting school. Everett clearly found it too hard to cope with having the little girl in the house all day while Effie was away, and had decided this was the best option.[144]

On top of the anxiety about her children, Effie had to deal with Everett's money worries. The cost of Christmas – all the presents and parties – was starting to take its toll on the family finances. He complained that there were more bills landing on his breakfast table with every post, and all their friends were talking about hard times ahead. It looked as if sales would be slack this season. If recession hit, Everett's wealthy patrons would need to retrench, and artistic commissions would be one of the first things to go. Even Constance, Duchess of Westminster, had said she needed to economise and would be giving up her London home at Easter. And the Millais family were still trying to get their finances straight after the massive expense of building and furnishing their new house at Palace Gate.

As if that news were not bad enough, young Effie, now nineteen, was struggling to manage the household in her mother's absence. She complained that her father refused to settle the invoices that arrived every day, because he said that the constant interruptions destroyed his ability to work. He needed to keep painting. Although his pictures now came with very substantial price tags – he could charge at least 1,000 guineas for a half-length portrait – Everett did not have a steady income. He could only support his family by a regular output of pictures and a constant supply of patronage. What would they do if either of these dried up? He could not afford to become distracted by mundane domestic problems.

The Millais marriage worked because Everett earned the money and his wife managed it. But now Effie was away, and their eldest daughter was unable to persuade Everett to help with the accounts. She had no experience of handling this side of the family business. So she had taken to stuffing the bills into a drawer, hoping that her mother would come home soon to sort them out. This was no way to run a household. The girl should have been using this opportunity to learn the skills she would need to manage her own establishment when she married. But clearly she was doing nothing of the sort: she was more interested in her own social life. As Aunt Alice looked on, sending regular reports to Effie in France, the Millais family seemed set to slide into domestic chaos. Young Effie was gadding about with her friend Mrs Bentinck, going to balls and parties. Meanwhile Everett sat down to dinner without his usual glass of wine because, all too often, his eldest daughter went out with the keys to the cellar still in her pocket. After four months in France, Effie bowed to the inevitable. The family could not function without her.[145]

So in the spring of 1878 Mary was left alone in Cannes to look after her brother George. At last all those years learning modern languages at Haighlands School would finally pay off. Her parents knew that even at the age of seventeen Mary was reliable and independent – very different from her elder sister Effie. At first the sunshine seemed to be doing George good. His letters back to London told of tennis parties and picnics. But Mary's reports were less rosy. George was still very thin, weighing barely eight and a half stone, and he was easily tired. He often had to take his breakfast in bed.

By early May the Riviera was starting to become uncomfortably hot. So Mary arranged to pack up their luggage at the Hôtel Beau Site and take the train to Italy. They headed for Lake Como, in the foothills of the Alps. En route, the border guards at Ventimiglia insisted on inspecting their bags. They took exception to George's dog, Dachs, who had travelled with him from London. Mary described how the little dog was evicted from the first-class carriage, reluctantly shut up in his basket and made to travel the rest of the way in the luggage van. After an overnight stay in Genoa, Mary, George and Dachs found a suite at the Grande Bretagne in Bellagio, on the lakeside. George took the large salon, while Mary made do with a little room next door.

Everyone hoped that George would recover, and be back at Cambridge for the autumn term, though there was no guarantee of this, even in the clear air

of the Italian Lakes. But Mary was in no hurry to return home. Unlike young Effie, who had just come out in society, Mary was not currently in the market for a husband. She had plenty of friends in London and Scotland: her grandfather talked of her enjoying long walks and evening parties with the young people around Bowerswell. Even so, Mary never married, and judging from chance remarks in her sisters' letters, was never expected to. Her health seems to have been a little fragile; there are references throughout the family letters to her tiredness. At times she was 'feverish and low'. Mary was also not as pretty as her sisters. But she was more self-sufficient, and she outlived them all.

When Mary and George did return to Bowerswell in the high summer of 1878, it was a hard homecoming. The house was quiet without their grandfather. And it soon became clear that George would never be well enough to see his Cambridge friends again. His cough worsened. As Everett said, he 'died hard'.[146]

While Mary was abroad, young Effie had developed a talent for throwing herself into fashionable society. She might not have had her mother's ability to run a large house and studio; she did not have her eye for detail. But the little girl whose retroussé features and frank gaze had caught the attention of party-goers back in the 1860s had grown into a beautiful woman. As her grandfather hinted, young Effie looked set to rival her mother as a magnet for admiring gentleman. It must have been difficult for Effie to take a back seat while her daughter enjoyed the 'fluff and feathers and brilliant silk' of the party circuit.

Young Effie had been launched on the London scene in the spring of 1876. The idea behind the social whirl of the Season was to introduce girls to as many eligible gentlemen as possible. It was an intense and highly formalised marriage market. Two years later Effie was still not engaged, but she was certainly much in demand for dances and 'at homes'. Her notes to her mother were full of gossip about her evenings out: in one week alone she attended a reception, a dance and a concert, and her next letter enthused about a beautiful ball at Lady Salisbury's. If she was not paying much attention to her duties at home, at least she was putting herself in a good position to secure a husband.

Major William James seems to have appeared in young Effie's life in early 1878, when her mother was still abroad. William's uncle, the politician Henry James (later Lord James of Hereford), was a friend of Everett's from the smoking-room of the Garrick Club. Everett saw the potential in Henry

James's two nephews, Arthur and William, and invited them to his studio: he was looking for a model for the dashing Lord Ravenswood in his picture of *The Bride of Lammermoor*. William evidently caught young Effie's eye as well, as she mentioned his visits in a letter to her mother. She wrote that 'Papa is painting his head for Ravenswood'. Looking at the picture today, we can see why young Effie was so struck by William. He was over six feet tall, with broad shoulders and a fine moustache, the image of the romantic hero. Photographs in Mary's album confirm the impression that he was a striking young man. William was an officer in the Royal Scots Greys, a cavalry regiment that had made a name for itself at the battle of Waterloo. On 11 February 1879, Londoners woke to the news that more than 1,000 British troops had been killed by Zulu warriors at Isandhlwana. Within a fortnight William was sailing to South Africa as part of the reinforcements.

The evening before he left, the young officer was invited to dinner at Palace Gate. It was snowing hard that night, and William was late: he did not arrive until the other guests had finished their soup. As the evening wore on, and conversation flagged, family and friends drifted off to bed. But William seemed reluctant to say goodnight. Effie was growing tired, so she did her rounds of the house, checking that the studio was tidy and secure, looking in on the younger children. When she came down the great marble staircase, she found her daughter Effie and William standing in the hall, 'behind the statue of Leda, in very earnest conversation'. She did not disturb them, but slipped into the front drawing-room. She could not go to bed herself, and leave her daughter alone with a young man, however well liked. She dozed. Effie woke to find William standing over her. He apologised for staying so late, but then burst out: 'I have asked Effie to be my wife, and she has consented, and I couldn't go away without speaking to her.' Then he bent down and kissed his future mother-in-law. William was aware that his prospects were precarious. He regretted that he might seem 'a very poor offer'. But Effie was delighted for the young couple. Although Everett was away, she reassured William that he would give his consent. Their only concern was that he was sailing into danger. 'We must hope he will be preserved,' she wrote to her own mother. In her letter Effie did not mention her own daughter's feelings or fears. She knew that young Effie would be writing to Bowerswell the same day – they had already sent a telegram with the news – so perhaps she thought it was best for her daughter to speak for herself.

According to Aunt Alice, not everyone was pleased about this engagement. Some of Effie's circle, whose daughters were still single, made unkind remarks about the match. Why was their response so unenthusiastic? We find a clue in the diary kept by Beatrix Potter, whose father worked closely with Everett. It seems that Effie was boasting about her strapping son-in-law. In Beatrix Potter's account, Effie claimed that William James had won the Victoria Cross, when he had done nothing of the sort. Perhaps this was just hyperbole on the part of the teenage diarist, but it suggests a certain smugness about young Effie's 'catch'.[147]

This was the first wedding that Effie and Everett had to organise for one of their children. Young Effie was married at the new church of St Peter's in Cranley Gardens, South Kensington. The couple chose this neo-Gothic setting for its aristocratic and artistic connections. The vicar, Francis Byng, was Chaplain to the Queen and then Chaplain to the Speaker of the House of Commons. In 1899 he became the 5th Earl of Strafford. The first organist, appointed when the church was consecrated in 1867, was the composer Arthur Sullivan. He had been a friend of Everett since 1863. Although he had given up the post in February 1872, he left behind a rich legacy of choral music in the best English cathedral tradition.

So Effie's eldest daughter was married on a chilly winter's day, 28 November 1879. Almost immediately William was posted to Belfast. Young Effie had to leave the familiar world of London society and begin married life without the support of her friends. Mercifully, after the trouble she had keeping order in the Millais household, her first home was much more modest. A letter from Constance, Duchess of Westminster, gives us an insight into the conflicting emotions of those first weeks after the wedding. Her words suggested that young Effie's father felt the gap in the family more than her mother. Constance comforted Everett on the shock of having given away his daughter but went on to congratulate him on having gained a son '(and such a good looking one)'.[148]

Now that her elder sister had married, Mary might have been next in line. But she had other plans. We can think of her, in the autumn of 1878, just after her brother died, as she contemplated the gaps in the family circle. Carrie was away in Brussels, studying the piano under M. Dupont, with Aunt Alice as her chaperone. The rest of the family were spending a few months together in Scotland, grieving for Grandpapa and George. Everett had been to Paris, to

receive a gold medal from the Exposition Universelle, but had arranged for Mary to pick him up from the train at Inverness on his return. So she drove the fifteen miles from their holiday home through the Great Glen in her pony cart. Mary had time to remember her travels with her brother and to consider her own future. She was eighteen. As she skirted the shore of Loch Ness she mulled over her options. In the short term she could stay in Scotland with her grandmother. But what would she do after that? Perhaps she could look abroad. Since George's death, his Cambridge friend Henry Russell had kept in touch with the Millais family. In his letters to Effie he made especial mention of Mary and sent 'a pat for poor old Dachs' the dog. Russell had grown up in New Zealand: George had said that was the reason why he was 'so awfully shy'. Did this friendship plant the seed of an idea in her mind? Why should she not take advantage of her family's colonial connections? She had heard tales of sea voyages and sheep stations from her uncles: since the mid-1860s Effie's brothers George and John had both spent time working in Australia. Mary began to dream of seeing the South Pacific. But it was not until the early summer of 1885, when she had just turned twenty-five, that she sailed for New Zealand.

Mary's letters to her mother reveal her as a confident, sociable young woman. She evidently made friends easily on board, and enjoyed her games of whist in the evening. At dinner there was the novelty of eating frozen mutton, loaded on the outward journey from New Zealand and still tasting fresh. She did, however, admit to feeling wretched with seasickness for the first few days. In the heat of the Tropics the captain gave her the use of a cabin on the upper deck, to make her more comfortable. When the ship stopped at Cape Town to refuel, Mary was glad to get ashore for a day with some of her fellow travellers. She took the train inland to visit the vineyards at a 'very pretty place where they make Constantia wine'. When she was back on board her ship and they were steaming south, the weather worsened. Mary wrote of snow storms and the bitter cold as she neared New Zealand. It was winter when she reached Port Chalmers outside Dunedin. Waiting for high water to enter the harbour, she received news from London. Everett had been awarded a baronetcy. She wrote as soon as she could to congratulate her father and the new 'Lady Millais', telling her parents that her companions at the captain's table had drunk a toast to her family's success.

Mary's first stop was at Glenfalloch, five miles from Dunedin. She stayed

here with the Russell family; they had moved to New Zealand in 1864, when Dunedin was still a young colony. This site for the settlement known as 'New Edinburgh' had been established only twenty years previously and had attracted a large number of Scots, including George Gray Russell (1828–1919). Born in Perthshire, he had inevitably known Effie's family back home. George Gray Russell set up an export business in Dunedin, shipping wool, grain and other produce back to Britain. By the time Mary arrived in 1885 he was contemplating retirement from trade, but he continued to be involved with the local community, as a school governor and a benefactor to the fledgling university. Russell also gave his name to the creek that flowed beside the family's house on the Glenfalloch estate.

The house, built in 1871, sat close to the water's edge and was shaded by the greenery of the gardens. Glenfalloch means 'hidden valley' in Gaelic. The Russells made the most of the spectacular site by planting the slopes with exotic imports. Rhododendrons, azaleas, magnolias and fuchsias jostled for space among the native tree-ferns. The garden was almost an Empire in miniature. Each species had been gathered by plant-hunters, nurtured and then sent out again to this colonial outpost on the Otago peninsula. Glenfalloch and its grounds embodied the spirit of the Victorian age: exploration, entrepreneurship, conquest and colonisation, all held together by family networks that extended from Perthshire to Dunedin. Seen in this context, Mary's voyage to the Southern Hemisphere was not so daring. She and her hosts in New Zealand spoke with the same Scots accent, tempered by time in London. They had grown up in the same circles. Even the landscape around Dunedin was reminiscent of the hills and pastures of Mary's beloved Scotland. The new technologies of the steamship and the telegraph, along with a regular postal service, allowed ties of friendship and family to stretch across oceans. In her letters home, Mary sent news of cousins and uncles, on both her mother's and her father's side, who were trying their luck in the colonies.[149]

When Mary crossed to Australia in the spring of 1886, she encountered another familiar figure from home. Everett's painting of *The Captive*, modelled by Ruby Streatfield, was hanging in the new art gallery in Sydney. Mary reassured her father that the picture 'really looks lovely in the centre of the long room there'. It was part of a display of contemporary British art that also included Frederic Leighton's *Wedded*. Mary mentioned that Leighton's work was shown next to her father's, but she did not dwell on it. Was it too sensitive

a subject? In January 1886, while she was still travelling – a spinster on tour – Mary's younger sister Carrie, now twenty-three, had married the diplomat Charles Stuart-Wortley. They had been engaged since October 1885, so Mary could have made it home in time to act as bridesmaid like her little sister Tottie. It is not clear why Mary chose to stay away, but certainly other members of the family thought the event was overblown: Evie Millais was scathing about the pomp and unnecessary swagger of the wedding. It was a very grand affair in Kensington, attended by the American and Spanish ambassadors and the Lord Chancellor. The bride wore diamonds and duchesse satin, trimmed with antique Venetian lace.

The lace was Effie's gift to Carrie. She had kept it safe for thirty years, a souvenir of her visits to Venice with John Ruskin. As she lifted it out of the layers of rustling tissue, Effie was reminded of herself as a young wife. In Italy, she and John had enjoyed themselves in their own ways. He had indulged his passion for architecture and she had caused a stir among the Austrian officers. The lace flowed through her hands, fragile and complex like a spider's web. Effie traced its patterns, thinking about the days when she had been young enough to wear it. When she passed the lace on to her daughter, it would take on other meanings, becoming a tangible symbol of the threads of kinship that Effie was trying to hold together: Mary in Australia, her sons Geoffroy and Evie, one in Wyoming and the other in Paris, her mother in Scotland, and now Carrie leaving home. Effie herself had experienced the pleasures of living abroad. She had known the excitement of Carnival and the thrill of crossing the Alps. But recently her trips to the Continent had all been driven by health worries, and Everett struggled to run the household on his own. Effie no longer had time to travel for fun.

Meanwhile her daughter Mary was enjoying her tour of Australia and seemed in no hurry to return. She said she wanted to see her uncle, John Gray, before she left. In April 1886 she moved on to Melbourne, visiting some of Everett's family. She brought with her a collection of songs composed by Carrie and taught them to her young cousin. But her hosts were becoming anxious that she should make plans to head back to England. If she stayed too long the summer heat would make the route via the Red Sea and the Suez Canal unbearable. She had to go home.[150]

Mary seems to have found her role in the family. She acted as a link between the scattered outposts of the Gray and Millais clans. When she was

not travelling she collected photographs and sorted letters. It is largely thanks to her that we know so much about her parents. She lived until 1944 and was able to help the first generation of scholars as they pieced together the story of Effie's life with Everett.

Her little sister Tottie was less sure about what she should do. Effie had been forty years old when Tottie was born and, as her youngest daughter grew up, it became clear that they had very different expectations. By the spring of 1891, when Tottie was twenty-two, she and Effie were constantly squabbling. Tottie's notes to her mother were a string of complaints about money and marriage plans. How was she supposed to look smart on an allowance of £100 a year? It was completely unreasonable, given that her father was able to sell his 'fancy pictures' for £1,500 each and his portraits were in high demand: the Gladstones, the Chamberlains and the Rothschilds were all queuing up to be painted. Tottie needed to dress like the daughter of a baronet. Even her sister Mary found it hard on their pin-money, and everyone knew that she was the plain one in the family. For Tottie it was impossible. Perhaps she could manage if her parents would pay for a lady's maid who could look after their clothes and their hair, but Effie and Everett had refused the girls this luxury. By the summer of 1891 Tottie had effectively moved out of Palace Gate. 'I don't like being at home,' she told her mother. 'I can't get on with you.' She went to stay with her eldest sister, Effie James.

Effie's four daughters, as we have seen, were eager to take advantage of the new opportunities that were opening up for young, affluent women. They had benefited from their father's success; his portrait business brought with it money and social connections. He made his children visible outside their family circle. Effie advised a friend, who was launching her daughters into London society, that if Everett painted their portraits 'they will be the girls most talked of in the coming season'. But Tottie did not want to be just decorative. She wanted to use her time productively. In Effie's view the only options for a respectable young woman were marriage or living quietly at home. Tottie had other ideas. She had found the man she wanted to marry, Douglas MacEwan of the Cameron Highlanders, but he was not yet in a position to support a wife. They had agreed to wait until he turned twenty-five before becoming officially engaged. 'In the meantime,' as Tottie put it, 'I want something to do.'

What role models did Tottie have close to home? Her mother treated the

management of her household and Everett's studio as a full-time job. Both her sisters Effie and Carrie now had their own establishments to run. But she knew other women who had followed different paths. Take Louise Jopling, for instance, a close friend of her parents. Beautiful, talented and outspoken, Mrs Jopling had made a successful career as a painter without losing her status as a gentlewoman. The Millais girls knew her well. She had been a familiar figure in their father's studio when she sat for a portrait in 1879. Everett captured her poise and glamour as she modelled a Parisian dress that skimmed her hips: she might have got her hands dirty when painting, but you would never know it from this picture. The girls admired her as a spirited hostess even though they thought her a little reckless with her invitations. After one evening concert, young Effie described the crowd to her mother; Mrs Jopling had asked so many people that the Millais girls never got beyond the anteroom, and in the crush one of the guests had suffered fainting fits and palpitations.[151]

Louise Jopling was a great advocate for women's education. She did not just talk about change, she made it happen by founding her own art school for girls in 1887, a few minutes' walk from Palace Gate. Everett demonstrated his sympathy for this cause by advising Mrs Jopling on her teaching methods. But her involvement with the campaign for women's suffrage was more controversial in the Millais household. Attempts to get women the vote had begun in earnest by the late 1880s, when Louise Jopling signed a petition along with 2,000 others, urging the Government to let women have the same electoral rights as men. If they paid tax, the suffragists argued, why should they not influence how that tax was spent? Suffragists believed that professional women should be able to elect an MP to represent their interests, just like male householders. Effie did not agree with these radical ideas. She was a conservative in her politics. In March 1885 a ladies' wing of the Primrose League was founded by a committee that included the Millais's friend Mrs Bischoffsheim, whose portrait Everett had painted in 1873. Within a few months, on 21 July, Effie was enrolled as a Dame of the League. The Primrose League had been established in 1883 in memory of Benjamin Disraeli and named after his favourite flower. Its members vowed to 'uphold and support God, Queen and Country, and the Conservative cause'. In short, it promoted Toryism. The timing of Effie's enrolment was significant, coming less than a week after Everett's baronetcy. It seemed like an acknowledgement by the

inner circle of respectable ladies that Effie was one of them – although the Queen herself still refused to recognise her.

Given their parents' obvious political allegiance, it was unlikely that the Millais girls would have found any sympathy at home if they had been in favour of electoral reform. Certainly none of their names crops up among the lists of activists for feminist causes during Victoria's reign. But the suffrage movement was only one aspect of a wider debate about the 'Woman Question' in the closing years of the century. Louise Jopling's life choices represented one possible trajectory. Her mother represented another, as the home-maker and social networker. For a young woman like Tottie, there was a third way: she could follow the example of the New Woman.

The New Woman was a controversial stereotype. To a large extent she was the product of outrage in the press. But, as with all caricatures, there was a grain of truth. Some well-educated young ladies were breaking the taboos of their mother's generation, by smoking, living independently and adopting more masculine dress. They felt encumbered by the corsets and picture hats worn in polite society. Why not try a blouse and neck-tie and sturdy boots, and leave your petticoats at home? Popular magazines suggested that every-one knew a 'manly woman' who cut her hair short and strode around town with her walking stick and her dog. She might even refuse to wear gloves. Her boyish costume and relative independence seemed to suggest something more troubling: transgressive sexuality. Certainly some New Women seemed an-tagonistic towards conventional relationships. In the vanguard of the attack on modern marriage was the 'New Woman' writer Mona Caird, who argued for a union of equal partners.

Even after the passage of the Matrimonial Causes Act in 1857, the balance of power within marriage still remained very much with the husband. In August 1888 Mona Caird published an article in the *Daily Telegraph* which asked 'Is Marriage a Failure?'. The response was overwhelming. Twenty-seven thousand letters were sent to the paper, describing the intimate agonies of couples from every walk of life.[152]

Despite this very public backlash against matrimony, Tottie decided that marriage would be her path. She found her focus in the autumn of 1891 by pressing ahead with plans to wed Douglas MacEwan. It was not an easy decision. She had to negotiate hard with her father before he would agree to a financial settlement. As Tottie wrote to her mother, 'What is the use of

telling me I shall have some money when he dies?' Tottie acknowledged that Effie had been acting more kindly towards her recently. Even so, she was upset by the muddle in announcing her engagement. Tottie's friends in London began sending letters of congratulation before Douglas's family in Edinburgh had officially agreed to the marriage going ahead. Tottie was disconcerted; Effie was usually so businesslike in her correspondence, but she had failed to reply to Douglas's mother, who was now sending telegrams asking what the matter was. Would Tottie's parents settle £200 a year on her? It seemed very little. Her father could easily afford it, 'with all the money he has made, and still makes', and the young couple could not rely on Douglas's family financially. Effie was stalling. It is not clear why she was so slow to step in and resolve the mess. Tottie knew that, without her mother, the settlement would never be agreed: as she said, 'you manage Papa in everything'. Was Effie hoping Tottie would get a better offer? If so, it never came.

On 9 December 1891 Tottie arrived triumphant at St Mary Abbots church in Kensington, arm-in-arm with her father. In the cold air, the steam rising from the carriage horses mingled with the mist of her breath. As she approached the South Door she could hear the choir singing Mendelssohn. Tottie was greeted by her eight bridesmaids, among them her elder sister Mary. Passing into the church, she saw Douglas waiting for her, silhouetted against a backdrop of palm leaves and white flowers. As Tottie and her father approached the chancel steps, Everett placed her hand in Douglas's and stepped back to take his place beside Effie. He had given away a daughter for the last time.[153]

When his first daughter had married, Lady Constance had commiserated with Everett on losing his girl to another man. But then she went on to imagine the future and speculated about 'what you will feel when you are a grandpa'. Her comments proved very perceptive. Everett's success as a popular painter had relied on ready-made models: his eight children. Now they had grown up and were having families of their own. Everett found even greater celebrity with his portraits of the next generation. In the 1880s his grandchildren Willie and Phyllis James took over from their mother, young Effie, as the inspiration for Everett's 'fancy pictures'.

Everett's paintings of children were not just money-spinners. They were an attempt to reconnect with the glory days of British painting, the age of Gainsborough and Reynolds. He dressed his sitters in eighteenth-century

mob-caps as a nod towards his artistic forebears. Of course, it was undeniable that their costumes also made the subjects endearing, but the underlying theme of his work was more serious. Everett wanted to highlight the transient beauty of innocence. He depicted his little daughters and his grandchildren as thoughtful, even wistful. He has been accused of presenting a saccharine vision of childhood. It was a slur that stuck, particularly after *Bubbles*, a portrait of his grandson Willie James, was used as a soap advert. (Pears spent £30,000 on producing a publicity poster of Everett's painting in 1889. The soap manufacturer had bought the copyright as well as the original painting from the editor of the *Illustrated London News* for £2,200.) But even this image was more complex and melancholy than it first appeared. If we take a second look at *Bubbles*, and a portrait of Phyllis James, we can see how Everett was trying to remind the viewer of the fragility of childhood. Painted bubbles had been a symbol of vulnerability and fleeting pleasure since the seventeenth century. They were to be wondered at, before they burst.

The plucked flowers in the picture of Phyllis told a similar story. Everett chose a title from Tennyson's *In Memoriam*: 'The Little Speedwell's Darling Blue'. The associations triggered by this line of poetry – a contemplation of mortality – were reinforced by the blooms the little girl had gathered. The speedwell she studied so intently would soon fade. Today the portrait of Phyllis, young Effie's daughter, is made even more poignant given our knowledge that she died in 1894, aged only seven. Her ephemeral beauty, captured by her grandfather, outlived her. Everett's life with Effie was punctuated by such personal tragedies. Since the death of their son George, he was all too aware of his children's mortality. Remembering his loss, when Everett was made baronet he took as his motto 'Ars longa, vita brevis' (Art endures, life is short).[154]

Of course 'The Little Speedwell's Darling Blue' was not a posthumous portrait. Everett did not know that his granddaughter was going to die before she grew up. But even when he was painting her, he was conscious of the brevity of her childhood. There is no record of how Everett or Effie received the news of Phyllis's death. We do not know what young Effie and William James did in the weeks and months after they lost her. So we cannot say whether Effie was able to comfort her own daughter by offering the consolation of the shared experience of losing a child. However, by piecing together the evidence of her surviving letters, we begin to understand how Effie

responded to the ebb and flow of her daughters' lives, their joys and sorrows. Effie often seemed to hold her girls at arm's length. When they were at school, it is clear that they longed for their mother – her advice, her sympathy, her physical presence – but their longings were rarely satisfied. In dealing with her daughters, Effie came across as unreliable and easily distracted. By contrast, she was much more concerned about her sons. She nursed them, worried about their school reports and fretted about their futures.

Reading Effie's correspondence, there is a sensation of something missing. Where are the candid exchanges between mother and daughter? Where are the excited notes about the latest London fashions and art-world gossip? We find them in the letters to her own mother and in the correspondence with her sisters Sophy and Alice. Her tone when she wrote to her four girls was more usually one of exasperation or deliberate distance. Perhaps, yet again, she found herself pulled in too many directions. Effie wanted to keep up the close, chatty relations with her mother and sisters that had sustained her in her twenties. Maybe she simply did not have the energy to devote to developing the same intimacy with her own girls. Between 1856 and 1872, when they needed her most, Effie was almost always pregnant. In those early years the girls were sent Scotland for months at a time while Effie held the fort in London. They found the affection they craved with their grandparents at Bowerswell.

While Effie's strength had carried her through the difficulties of her marriage to John Ruskin, it left little room for sentimentality. We are offered a glimpse of her at a children's New Year ball in 1867, when she was enduring her eighth pregnancy. In his diary Arthur Munby described Effie appearing 'in sky blue, elegant of figure … and not tender'. We know from other of his comments about the Millais family that he was an unsympathetic observer. However, Munby seemed to put his finger on something. There was steeliness in Effie's character that cast a shadow over some of her relationships, including those with her daughters.

Effie herself had helped to transform Victorian conventions by taking a stand against her abusive marriage to Ruskin. She had shown young women that they could control their own destinies. Of course, this was only one small step on the road to emancipation, but the impact of her actions on her own daughters was complex and fraught. On one hand, Effie had made it clear by her own flight from the Ruskins that girls should not have to suppress their

own desires. And her single-mindedness and strength of character were inherited by many of her children. On the other hand, Effie had felt the ill effects of gossip and slander in her private affairs. Inevitably she wanted to protect her daughters from the notoriety that still attached to her, by ensuring that her girls were whiter than white. That is why she seemed so meddlesome. She had found out the hard way what happened to women who picked the wrong man in the marriage market.

Effie's sociability masked the reserve that underpinned her character. It had always been there – we can think back to Ruskin's comment that Effie was more likely to be condemned as a prude than a flirt – but it intensified after the collapse of her first marriage. And then came the family disaster of March 1868. At the very moment when Everett was putting the final touches to his picture of the three *Sisters*, and when Effie was heavily pregnant with Tottie, bad news arrived from Bowerswell. Her sister Sophy was suffering from a serious mental illness. The family had been concerned about her health for some months, but now there was no denying it: Sophy was mad. George Gray wanted to keep it as quiet as possible. Effie was expected to take charge of her and take her to London, where she could be looked after discreetly. The distress of seeing her sister's breakdown, and Sophy's later sorrows, left a permanent scar on Effie's spirit.[155]

Chapter Twelve

Sophy Gray

STEPPING OUT into the sodden streets of Rothesay, Effie's sister Sophy hurried to catch the last post. She had lingered too long in the ladies' room of the baths. Rain lashed the sea front, and Sophy felt for the letter, tucked into her purse to keep dry. It was addressed to Effie at Bowerswell. Her family would be waiting to hear from her, but Sophy confessed to her sister that she was so low she hardly had the heart to write. Sophy had come to the Isle of Bute in June 1867, hoping to find a cure for her nameless ills. Instead depression had settled on her like a veil. Catching sight of herself reflected in a shop front, she shuddered. Her face seemed swollen and discoloured. She longed to go away and never be seen again. The only person she could bear was Effie: 'I wish you could come here for a day or two,' she pleaded. She valued her elder sister's advice.

That morning Sophy had visited Dr Priestley, weeping as she walked to his house. How could he possibly understand her self-loathing or her perpetual headaches? 'A fever,' she wrote, 'would be far more bearable than the state I am in.' At least then the doctor could do something practical. Instead he had nothing to offer except platitudes. Her case would take time. She must persevere. This was the story of her life: patience and self-denial. Inside she raged. She took out her anger on her own body.[156]

Effie's greatest heartache was the slow decline of her sister. Until now, Sophy's tale has never been fully told. Her sadness clouded Effie and Everett's lives, from her breakdown in her early twenties until her untimely death in 1882. She was thirty-eight. Everett wrote to Hunt just after her funeral: 'Sophy (my wife's sister) was *buried* yesterday. Her last illness was so distressing I have denied myself to everybody.' Rumours soon began circulating that Sophy had committed suicide. But the reality was far more complex: her final years were blighted by disappointed love,

eating disorders and mental illness. Sifting through the parcels of private letters treasured by the family since Sophy's death, we begin to understand the central role she played in Effie and Everett's marriage. It becomes clear that her presence transformed Everett's art. And for Effie, who was fifteen when her little sister was born in 1843, Sophy was a source of concern and consolation in equal measure.

Sophy Margaret Gray was christened Sophia, after her mother. But she was also given the name of another sister who had died, aged six, in the dreadful summer of 1841. The death of three little girls that year had left a gap in the family. Effie and 'the second Sophy' were nearly a generation apart. This age difference coloured the tone of their correspondence. Mr and Mrs Gray expected Effie to act as a second mother to both Sophy and Alice (who was born in 1845). As they grew up, Effie was called upon to referee disputes between the girls and their parents. Sophy and Alice benefited from having a big sister settled in London. They visited Effie regularly and were taken on trips to the theatre, to concerts and to the zoo. But these trips south were not always straightforward. At ten years old Sophy witnessed the collapse of Effie's first marriage. To some eyes, she looked like a co-conspirator in Effie's escape from the Ruskins.

Sophy acted as a go-between for Effie and Everett in the critical early months of 1854. When the Ruskins' marriage was in its death-throes, Sophy was a regular visitor to Everett's studio in Gower Street. Everett had promised Mr and Mrs Gray that he would draw Sophy's portrait. The pretty ten-year-old sat quietly as he sketched her in pencil and watercolour. Her parents were delighted with the result, a shy girlish image, very different from the later pictures Everett made of Sophy. On one occasion Effie accompanied her as far as Everett's door, but would not cross the threshold. Even so, she relied on Sophy to bring news of Everett's ups and downs. Through her sister, Effie heard how he was mourning the end of their intimacy.

It was an uncomfortable position for a little girl to be put in. On one hand, Sophy was an intermediary between her sister and the man who loved her. On the other, she was being fawned over by Mrs Ruskin. Ruskin's mother tried to poison Sophy's relationship with her elder sister, telling her that Effie was merely a 'merely a Scotch girl with bad manners'. Mrs Ruskin was also openly rude about the girls' parents. And while the Ruskins were behaving badly, Effie was hardly more reliable. Suffering from stress, Effie had mood

swings that unsettled her ten-year-old sister. Mrs Ruskin was hardly exaggerating when she described Effie as 'a maniac in the house'.

Knowing the tragedy of Sophy's later life, we must wonder how the antagonism and subterfuge of the Ruskin household affected her. It is clear from Everett's letters to Mrs Gray that Sophy was a thoughtful child. In Herne Hill, her head bowed over her school books, Sophy could feel the air around her crackle with resentment. As she practised her piano exercises she had time to ponder the angry silences. And when she visited Everett in his studio, she knew that he was looking for echoes of Effie in her face. Yet he appreciated her for her own sake too. Everett praised her patience. Sophy was very different from most of the young models Everett had encountered. She held her position as he drew her, until eventually her head started to nod from weariness. In Everett's eyes she was delightful, shrewd and extremely beautiful. Most importantly for him, she was unaware of her beauty. It was this innocence, which he acknowledged 'could not last long', that made Sophy such an attractive subject.[157]

In the late 1850s Everett kept returning to the same theme: a young girl on the cusp of womanhood. Sophy's face haunts his work from this time. She changes before our eyes from a child to a stunning teenager. In a sequence of pictures painted in Scotland shortly after his marriage to Effie, Everett traces Sophy's increasing self-awareness. She catches our eye across the smoke of a bonfire in *Autumn Leaves* (1855–6). She toys with her loosened hair, kneeling in the orchard in *Spring (Apple Blossoms)* (1856–9). And she holds our gaze in an unnerving close-up portrait completed in 1857, when Sophy was just thirteen. Why did Everett paint her so often?

The simple answer is that she was convenient. From 1855 Everett and Effie were living at Annat Lodge, next door to the Grays at Bowerswell. The two houses could not have been closer. Everett was short of funds. Effie was pregnant within two months of their marriage, so he needed to paint saleable pictures to cover the rent and prepare for the arrival of the baby. He could not afford to waste money on models and he knew that Sophy was a good sitter. George and Sophia Gray were always supportive of Everett's enterprise, and readily gave permission for their young daughter to help him. They trusted their new son-in-law.

But perhaps the reason behind Everett's desire to paint Sophy was more complicated. She was starting to upstage Effie in his work. After their

marriage, Effie seldom appeared in Everett's oil paintings. His art no longer betrayed a compulsion to capture her image. Now that the drama of their courtship had been played out, Effie's charisma was beginning to fade. When she modelled for the placid wife in *Peace Concluded, 1856*, it was a solid performance. Everett used the distinctive way she wore her hair – her long plaits wound around her head – to transform Effie into a domestic saint, complete with halo.

By contrast, Sophy seemed to inspire him to create works of fleeting loveliness and subtlety. According to Effie, in the autumn of 1855 Everett decided that he 'wished to paint a picture full of beauty and without subject'. He wanted to move away from the dramatic themes that had made his name, and instead focus on mood and colour. Twice he asked Effie to model for his new project – she sat for him in the garden, under the great cedar and then among the apple trees – but, disappointed with the results, he gave up. Then they went away for a few days' partridge shooting. The holiday cleared his head, and by the time he came home, Everett was itching to start afresh. He abandoned his plan to paint Effie and instead put Sophy's face at the heart of his new image. *Autumn Leaves* began as a study of Effie's younger sister in the back garden of Annat Lodge. A glowing sunset and the distant peak of Ben Vorlich made a gorgeous backdrop to Sophy's portrait. In her diary Effie described Everett's high spirits as he worked swiftly: he wanted to put down on canvas 'the golden sky, the town lost in mist and the tall poplar trees just losing their leaves'.

As the picture developed, Everett added three other figures, standing with Sophy around a smouldering bonfire of fallen leaves. The first was her little sister, ten-year-old Alice Gray. Everett felt that he had successfully reproduced the 'very lovely expression in little Alice's eyes'. Both Alice and Sophy were wearing their everyday dresses of 'green linsey-wolsey, their hair unbound hanging over their shoulders'.[158]

Everett also painted Matilda Proudfoot, a pupil at the local School of Industry. She stood behind Sophy, holding a rake. Effie had visited the school in the hope of finding new talent, but the girls were all so plain that she engaged only Matilda. Effie picked her out because of her brilliant-red hair. In Everett's picture Matilda wore her school uniform, the roughness of her dress reinforcing her lower-class status. The contrast between the Millais household and Matilda's own upbringing was acknowledged by Effie, who

wrote in her diary that the girl seemed to be struck dumb when she was at Annat Lodge. Neither Effie nor the servants could get a word out of her. Matilda simply seemed relieved to spend quiet days away from her school work and her over-crowded home, soaking up the warmth of Effie's kitchen between sittings. She was even willing to peel potatoes for Everett's dinner. Effie was glad to have found such an undemanding model. She noted that Matilda sat for nothing more than a decent meal and a few pence invested for her in the Savings Bank. Occasionally Effie would give her an orange as a treat. She was so reliable that Everett used her again for his painting of *The Blind Girl*, completed in 1856. She replaced Effie as the model for the main figure.

The third girl added to *Autumn Leaves* was Isabella Nicol. Effie discovered her in the smoke-blackened home of a bed-ridden old lady. When Effie visited her ailing neighbour, she found Isabella sitting by the fire, hungrily keeping an eye on two pears that were toasting in a tin. Like Effie, the pretty little girl must have seemed out of place in this scene of palsied poverty. The newly-married Mrs Millais was worried about her own finances, but she continued to offer charity to the poor of Perth. Not only was this generosity essential to maintain her own reputation, it was one of the foundation stones of her own faith. So she found herself in the tiny living-room, listening to the old woman's grumblings. At least the sweet smell of baked fruit helped to mask the stench of the sickbed. As Effie was about to leave, she called Isabella over to the window, to look at her in the fading daylight. The little girl lifted her head and Effie saw that she was rosy-cheeked and fair – ideal as a model for the youngest child in Everett's picture. Isabella's mother, who had come in to clean the cottage, agreed that the little girl would visit Annat Lodge in the morning. Effie suggested that Isabella should have her blonde hair washed and tightly plaited overnight, to frame her face with soft, golden waves.

In Everett's hands the four girls – Sophy, Alice, Matilda and Isabella – were transformed into a meditation on ephemeral beauty. They gather and burn the relics of summer, at the close of the day. The implication is that, with every passing season, some of the loveliness of youth is lost. By depicting children of different ages, the picture shows the process of growing up. The apple held by little Isabella recalls the fruit of the Tree of Knowledge eaten by Eve in the garden of Eden. It is a reminder that even she will, in time, leave

innocence behind. Sophy, as the eldest, seems almost ready to pass over into adulthood, facing the world with her frank gaze.

Everett was not alone in his urge to paint growing girls. His pictures of Sophy were startling examples of a wider trend in mid-Victorian art. *Autumn Leaves* touched a nerve. The young female body was a site of anxiety and fascination. Painters, novelists, journalists and doctors all explored the intricacies of this sensitive subject. How much should teenage girls know? What exercise should they take? Was it safe for them to write poetry, to wear corsets, to eat cheese? These questions were debated in the popular press, and discussed in hushed tones in polite drawing-rooms. Not only Everett, but many of his contemporaries, among them Charles Dodgson (Lewis Carroll), Wilkie Collins and Edward Burne-Jones, found the spectacle of the child-woman intriguing. John Ruskin too was preoccupied with the notion of girlhood, and was soon to become infatuated with young Rose La Touche. We should not be surprised, then, to find that he was impressed by Everett's picture. Ruskin described *Autumn Leaves* as 'the first instance of a perfectly painted twilight', comparing Everett's work to the sublime art of Giorgione. He found the combination of wide-eyed beauty and exquisite colour ravishing.[159]

To modern minds, this focus on young girls is uncomfortable. And perhaps we should question the motivation of men who dwell on the details of early adolescence. Certainly, in some cases, Victorian children were sexualised. Until 1885 the age of consent was fourteen. It was only raised to sixteen after the newspaper editor W.T. Stead ran an exposé on child-trafficking. To show how it was done, he procured a girl called Eliza. She was thirteen. Stead paid her mother off with a sovereign, chloroformed her and then spirited her away to Paris for a few days. On their return, Eliza was put into the care of the Salvation Army, and Stead ran his sensational story. He was imprisoned for his stunt – after all, he had admitted kidnapping the child on the front page of the *Pall Mall Gazette* – but his campaign revealed the reality of the 'white slave trade' in Britain. He confronted the unpleasant truth: children could be objects of desire.

So what should we make of Everett's artistic attraction to young Sophy? Did it mask a more disturbing degree of intimacy? According to Mary Lutyens, there was a story circulating in the Millais family that Everett and Sophy became too fond of each other and Effie sent her away. But the

evidence is conflicting. Certainly when Sophy needed her most, Effie did not hesitate to take her in. Perhaps there was a more complex truth hidden behind the tittle-tattle.

The strongest hint of an illicit understanding between Everett and his sister-in-law is the portrait of Sophy he painted in 1857. It is extraordinary in its sensuality. Hidden from public view until after the artist's death, it shows the thirteen-year-old with cascading hair, flushed cheeks and full red lips. There is no attempt to pass her off as 'Juliet' or some other romantic heroine. This is Sophy as Everett saw her. Her chin is lifted, exposing her long white throat. Her eyes are mesmerising. The contrast with her image in *Autumn Leaves* is startling. In the earlier picture her gaze is questioning, innocent. Two years on and she has a new knowing look. She is self-possessed, aware of her own loveliness and the power it brings. Her appearance is disturbingly direct and modern.

The afterlife of this painting demonstrates its erotic potential. Sophy's portrait was not kept by her family. Instead it was quickly sold to the artist and collector George Price Boyce for £63. Boyce was a close friend of Gabriel Rossetti, and in 1859 he commissioned from him a picture to act as a pendant to Sophy's portrait. Rossetti agreed to paint his housekeeper (and mistress) Fanny Cornforth in the same manner, with flowing hair and bared neck. But Rossetti's portrait lacked the immediacy of Everett's. It was set in a fantasy space, accessorised with exotic jewellery. And it was given a title – *Bocca Baciata* – that suggested a literary source, lending an air of distance to the subject. The title fooled no one. It meant 'the kissed mouth' and referred to the story of a girl who had been passed from one man to another. When Hunt saw Rossetti's picture, he was scandalised. He condemned it for displaying 'gross sensuality of the most revolting kind', not only in the artist's choice of subject, but also in his loose handling of the paint. For others, *Bocca Baciata* represented a watershed in Victorian art. It became an icon of Aestheticism, a symbol of the triumph of sensation over morality. Boyce fell in love with it. Friends described how he embraced the picture as if it were a real woman: they feared he would 'kiss the dear thing's lips away'. Did Sophy suffer the same fate? Her portrait hung alongside Fanny's in Boyce's home. Her expression was far more direct and engaging than the dreamy caprice conjured up by Rossetti. It is hard to believe that Boyce could resist Sophy's challenge.[160]

And what about Everett? Could he create such a desirable image of his teenage sister-in-law and yet remain untouched by her presence? In later years, when portraiture became his bread and butter, he developed a talent for detachment. It was part of his professionalism. He was happy to joke and flirt with his sitters, while his mind was on the job in hand. But this picture of Sophy was painted when Everett was still only twenty-eight. While they were alone in his studio, Effie was preoccupied: she was upstairs chasing after her toddler or nursing her newborn son. We do not know what she thought of Everett's depiction of Sophy. Almost raw in its realism, it seems to betray a disquieting emotional connection.

Perhaps we can trace Sophy's later troubles back to this moment. She gave Everett a focus when he was wrestling with his art, 'going through', as he put it, 'a sort of cross examination within myself lately as to a manner of producing beauty'. He found this beauty in Sophy. However, it is hard to believe that the relationship went any further, despite the unspoken eroticism of Sophy's portrait. Everett was under constant surveillance: Effie's parents and her younger sister Alice were always dropping in to Annat Lodge to see the children. Everett was also careful not to show any favouritism towards Sophy. After completing her portrait, he offered to paint Alice too. But the result was very different. He drew her as a little girl. She had none of the self-awareness of her big sister. Did Everett fall in love with Sophy? He certainly found her fascinating, and from the evidence of his paintings at this time, it is possible. Yet, as he was always very frank about his fondness for Sophy, maybe he had nothing to hide. He just wanted to celebrate the way she was changing from a little girl into an enchanting young woman.

Everett's friends and family accepted that he had an eye for the ladies. His outspoken admiration of the female form was laughed off as one of his quirks, like his passion for smoking a pipe. Louise Jopling's description of her first meeting with Everett gives a flavour of his banter: catching sight of her at a private view of old-master paintings, he exclaimed, 'Old masters be bothered! I prefer looking at the young mistresses!' and flashed her a smile as he walked off. Everett had a clear sense of his ideal woman. He longed to paint gentle, lovable creatures made of flesh and blood. He wanted to break away from the overblown beauties chosen by Titian, Raphael or Rembrandt. As he said, they were 'magnificent as works of Art; but who would care to kiss such women?'.

Given his reputation, it is not surprising that Sophy seems to have become

was shown in London in 1859, and received a mixed reception. Ruskin disliked what he called 'this fierce rigid orchard – this angry blooming', but other critics enjoyed its 'relaxed moody dreaminess'. Effie was just glad when it was finally sold. [162]

Despite Effie's misgivings about Everett's choice of subject, she never directly voiced any jealousy towards Sophy. She took a close interest in both her sisters. When Effie and Everett moved back to London in 1861, they made a point of inviting Sophy and Alice to stay. Effie listened patiently to her parents' concerns about their teenage daughters, giving advice on every issue, from fashion and etiquette to music lessons. And then, in March 1868, the crisis came, and the Grays asked Effie to take care of her sister. She did so willingly.

We can relive the misery of Sophy's mental collapse, because her father described it in desperate detail. Mr Gray's letters in the early months of that year showed that he was worried about his daughter. She was often ill, but her exact ailment was unclear. To add to his unease, it seemed that she was being courted by James Caird, a wealthy manufacturer from Dundee, yet nothing was resolved. Mr Gray explained to Effie that Caird was spending more time at Bowerswell: he and Sophy amused themselves arranging flowers for family dinner parties. But he had not declared himself as an official lover, and Sophy seemed to be holding back. Sophy and Caird were helping to organise a concert that was planned for early March. It was to be the highlight of the Perth social calendar – a performance by the young, German-born singer Therese Tietjens, who made her Covent Garden debut that season. This event turned out to be the trigger that shattered Sophy's peace of mind.

On 17 March 1868 Everett opened an envelope from his father-in-law. Knowing that Effie was pregnant again, George Gray decided to ask Everett to pass on the bad news. He felt she needed to be prepared for the shock of hearing about Sophy's insanity. Even today, finding the letter among the family papers, it is distressing to read. It also shows how much George Gray felt he could confide in Everett: he was very frank in explaining Sophy's symptoms.

Over the past year, he wrote, Sophy had suffered constantly from stomach upsets. She had lost so much weight that she was reduced to 'a perfect skeleton and stopped her monthly illness'. In George Gray's telling phrase, 'she was under the delusion that she was getting too fat'. Sophy was anorexic.

besotted with Everett. He was charming, handsome, chatty and young. She could spend hours alone with him, watching him work, and was flattered by his desire to paint her. She was thrilled by the alchemy of his art, transmuting her long chestnut hair into golds and coppers on his canvas. She remembered when she had been his confidante, while Effie was still married to Ruskin. Add to this the fact that he was near at hand, but completely unattainable, and it was hardly surprising that Sophy was smitten. It was the ideal scenario for a hopeless teenage crush. Unfortunately, rather than her growing out of it, Sophy's fixation with her flirtatious brother-in-law probably contributed to her breakdown.

Mr and Mrs Gray were not unduly worried by the closeness between Everett and Sophy. They allowed Everett to chaperon Sophy, then fourteen, and Alice who was twelve, on a steamer to London in the summer of 1858. He took them to visit his parents in Kingston-upon-Thames, while Effie stayed in Scotland. When Sophy was seventeen the Grays were happy for Everett and their granddaughter to travel alone on an overnight train to London. It did not cross their minds that this would be improper.[161]

Did Effie object to Everett's fondness for Sophy? She never referred to it directly, but there is a hint in her notes about Everett's picture of *Spring (Apple Blossoms)*. It seems that she felt sidelined by his interest in painting younger models. This work, which took nearly four years to complete, was a celebration of girlhood. The sitters – ranging in age from twelve to fifteen years old – were in full bloom, just like the orchard behind them. Of course, it was only a matter of time before both the girls and the apples would be ready to be plucked. Sophy appeared in profile with her hair down, wearing a striped gown. Alice Gray reclined in the foreground in an eye-catching yellow dress. Her pose, gazing out of the canvas with a blade of grass between her lips, might uncharitably be described as provocative. She was clearly growing up fast. Effie called *Spring* 'the most unfortunate of Millais's pictures'. Ostensibly, this was because it took so long to paint. However, there was another, more personal reason. This bevy of young beauties posed a threat to her own self-image. While Everett was struggling to capture the ephemeral prettiness of spring, Effie turned thirty. She was still handsome, but had lost the freshness of his favourite models. Now she was looking after three children, all under three years old. She went through two tough pregnancies while this painting remained unfinished in Everett's studio. Eventually it

Although self-starvation was recognised as a symptom of mental illness by mid-century doctors, Sophy's condition was not effectively diagnosed or treated. Dr Priestley had taken a look at her at Rothesay in the summer of 1867. For a while Sophy seemed to recover under his regime of early rising, warm baths and walks before breakfast. Her father had noted that she was starting to eat again. However, her psychological problems had recently taken a new form: she had become obsessed with music. In the early stages this did not trouble her parents. Sophy had always loved to play the piano, and her renewed interest in music seemed to coincide with regaining her appetite. George Gray had breathed a sigh of relief and turned his attention to Alice and her complicated love-life. Alice had recently burst into his office to tell him that she had broken off her engagement with Harry Mendel. (Mendel would have been a good catch, as he was the son of one of Everett's richest patrons.) The Grays were still trying to regroup, when the full force of Sophy's musical mania hit the family.

A fortnight before the Perth concert Sophy wrote to Effie's friend, the impresario John Ella, about the pianists he promoted. Then she became very excitable, playing the piano most of the day and late into the night. On the evening of the concert she waited outside the music room, eager to be introduced to the musicians. The moment arrived: she spoke to Therese Tietjens and her pianist James Wehli, overjoyed to find someone who shared her passion. She returned home buoyant. The next morning she would not stop talking about their conversation. Nor the next day, nor the next. She refused to go to bed. Her words became incoherent and she could not sit still, but whirled from room to room, filling Bowerswell with her babbling. For the first few days her parents kept hoping she would calm down, but eventually they had to call the doctor. He advised them to get her out of the house and away to friends, so she would not disturb the younger children. But she was 'daily becoming worse'. The Grays could not bear their neighbours discovering that their beautiful daughter was mad. She would certainly have no chance of marrying James Caird, once he heard about her hysteria. They turned to Effie and Everett for help.[163]

The plan was to say that Sophy had gone south for a change of air. In the meantime George Gray begged Everett to find the most suitable sanctuary for 'poor Sophy' in London. By 30 March 1868 he and Effie had found a place for her in Chiswick, under the supervision of Dr Harrington Tuke. Dr Tuke

was an ideal choice from several angles. He was already known to them because he had treated Everett's friend Edwin Landseer, who since 1840 had suffered episodes of dementia and alcohol abuse. Dr Tuke was also respected for his humane treatment of his patients. Mr Gray had been adamant that Sophy should be looked after with kindness, and the doctor had pioneered the policy of unshackling his patients. Even in the late 1860s, it was common practice to restrain the mentally ill by strapping them to their beds or confining them in a *camisole de force*. It seems that in the early stages of her treatment, Sophy's movements were restricted: her father wrote to Effie, 'I do hope it may not become necessary to put her under greater restraint and trust you will avoid this if possible.'[164] There was one other factor that attracted them to Dr Tuke. He was the leading expert in the 'causes of self-starvation in the insane'. If anyone could treat Sophy's anorexia, it was him. The results of his research were published in 1858 under the chilling title 'On Forced Alimentation'. If Sophy refused to eat, she would be force-fed.

Reading Tuke's article is a sobering experience. It highlights the differences between the brutal regimes of other mad-doctors and Tuke's own, more sympathetic treatment. He always tried to overcome a girl's 'morbid repugnance to food by gentle and patient soothing'. But as a doctor he had a duty to treat her. He could not bear to see a girl in his care 'die slowly, yet certainly before our eyes'. Tuke described the various methods traditionally used for force-feeding: pap-boats wedged between patients' lips; nostrils pinched shut; girls chloroformed, blindfolded and buckled into strait-jackets, their heads pressed between the knees of a nurse, their legs held down; teeth knocked out so a tube could be thrust into their throat. Tuke condemned these tortures. He claimed that his approach – a well-oiled rubber catheter pushed up the nose and down into the stomach – was 'certainly disagreeable but not painful'. He did acknowledge that even this method was not foolproof. In one case, he noted, a girl bled to death as she struggled to free herself, because the feeding tube pierced an artery in her neck. Other patients suffocated when soup was pumped into their lungs by mistake. But Tuke believed his treatment was preferable to the alternatives – a slow, silent suffering, or the screams and violence of funnels and forcing spoons. At least he recognised that girls like Sophy who refused to eat should not be intimidated and roughly handled. And, above all, he wanted to treat the causes of their self-starvation, rather than just the symptoms.[165]

Discovering the origins of anorexia nervosa can be notoriously difficult. Today doctors agonise over the best way to deal with this devastating disease, just as Tuke and his colleagues did 150 years ago. There are few certainties. Sophy's case is particularly complex, as her eating disorder was bound up with her musical mania. However, anorexia can be a sign of a girl's 'paralysing feeling of ineffectiveness: the only control she can exert is over her own body'. If a young woman grows up being praised for her compliant attractiveness and docility, then she responds by pushing this self-denial to extremes. Looked at in this light, modelling for Everett's paintings of idealised girlhood may have laid the foundations for Sophy's illness. Certainly the language Everett used to describe her as a good sitter – her patience, her prettiness, her toleration of discomfort – comes eerily close to the descriptions of modern anorexic girls. They stress the sufferer's desire to remain childlike. Young women try to starve their bodies back into innocence, shedding the curves of adulthood. If they persist, they can interrupt their monthly cycles, making themselves infertile, unwomanly.

In Everett's pictures, Sophy saw her youth crystallised and held intact. Her mental illness seems to have been connected with her attempts to embody the youthful perfection of his paintings, even after she reached womanhood. It appears that her anorexia did not become visible to her family until she was twenty-three years old. This was the moment when James Caird appeared on the scene, as her first serious suitor. Knowing that she could no longer avoid the marriage market, Sophy underwent a dramatic deterioration in both her mental and physical health.

Sophy's eating disorder can be seen as an exaggerated attempt to prolong her childhood, when she was valued for her quietness and tender beauty. Her musical mania, on the other hand, grew out of another facet of her character. Her parents had encouraged her performance at the piano. It was not unusual for girls in the mid-century to spend several hours a day practising. It was a domestic discipline. As one contemporary commentator said, it made a girl sit up straight and pay attention to details. It reinforced her gentility and was a sign of submission to the feminine ideal. But piano-playing could also be subversive. It offered an outlet for emotion. The clergyman H.R. Haweis, writing in 1871, recognised that a young woman could feel impotent. 'What is she to do,' he asked, 'with the weary hours, with the days full of intolerable sunshine?' Redundant, she became dissatisfied and listless. Such women could find relief in music.[166]

At first, Sophy's musicality seemed no different from her sister's. Effie was an excellent amateur pianist, and her daughters also enjoyed playing. Carrie Millais was the most accomplished, pursuing her studies overseas and writing songs and church music. Despite her talent, however, Carrie never attempted to earn her living as a musician. Her performances were always ladylike. It was possible for Carrie to present her skills to an invited audience of several hundred, in a salon or drawing-room, yet remain respectable. Her compositions could be sung at her sister's wedding, but were not published for the general market. Her skills were recognised, encouraged and accommodated by her family, who maintained the polite fiction that she was simply entertaining private guests, like any young lady. So Carrie trod a fine line between amateur and professional performance, but always came down on the correct side.

Sophy, by contrast, seemed drawn to the public stage. Her correspondence with the musical agent John Ella was a catalyst for her breakdown in March 1868. It was at this point that her practising became excessive and her health began to suffer again. She developed an obsession with meeting professional musicians at the Perth concert. She wanted to quiz Therese Tietjens about her career, which was just taking off. Here was a woman who would understand her enthusiasm. Tietjens was clearly not content to stick to singing for her intimate circle. She had struck out into the open. Now perhaps Sophy could discover the secrets of professional performance. But at what cost?

Sophy's insanity manifested itself in two ways – her anorexia and her musical mania. It looks as though she could not cope with being pulled in two different directions. Her anorexia was a sign of her desire to stay in control of her body and to recover the innocence of her childhood. Her musical mania, on the other hand, was a symptom of her struggle to break out of the domestic sphere, on to a public platform. This was inconceivable for a respectable young lady. She would immediately lose caste. A professional musician was seen as well as heard. She was a public spectacle. Perhaps in Sophy's mind this was not so different from being gawped at by the visitors to the Royal Academy show who swarmed round Everett's paintings. She had already crossed the line, her face and figure scrutinised by critics since she was twelve years old.

Sophy could not satisfy both her desires. However hard she tried, she could

not remain childlike for ever. Yet her craving for public recognition as a musician was also impossible. She was torn. So her music began pouring out of her, unquenchable, exhausting. Six weeks after the Perth concert, Sophy was still singing and dancing incessantly. Dr Tuke suggested that she should stay with his colleague Dr Andrew Wynter, who lived at Chestnut Lodge in Chiswick. This was close enough to Tuke's practice for Sophy to remain under his supervision, but Dr Wynter and his wife took care of her day to day. They too were firmly opposed to using physical restraints on their lunatic lodgers, and sent regular updates to the Grays. Effie visited her sister as often as she could before her confinement: Tottie was born on 15 June 1868. At this point Alice Gray took over. She reported that Sophy was busy with her needlework and reading when she saw her on 3 June. She was being treated like a friend of the family rather than a madwoman. She was also playing the piano again.[167]

Neither her family nor her doctors tried to stop Sophy playing altogether. They recognised it was essential to her well-being. The music was not to blame for her madness. Rather, it channelled her psychological torment into physical acts of singing, touching, swaying and twirling. In recent years Dr Oliver Sachs has made a study of psychiatric patients who, like Sophy, develop musicophilia. His findings show that she is not alone. Sachs demonstrates that obsessive music-making can have many triggers. The symptoms are similar, but the causes are not. In one case he described a man struck by lightning who became passionate about playing Chopin; in another, an elderly woman with dementia began to sing constantly in English, Yiddish, Spanish and Italian. Sachs could hear her before he saw her, as she sat in his waiting-room singing 'A Bicycle Made for Two'. These patients seem to have suffered brain damage, specifically to the area of the temporal lobes that govern judgement and social inhibition. But there is no evidence that Sophy suffered a trauma that might have damaged this key area of her brain. And, over time, she recovered her equilibrium and returned to Bowerswell. Her psychological troubles had not gone away, but they no longer manifested themselves through music.[168]

By the New Year of 1869 Sophy was well enough to be moved to new lodgings in nearby Hammersmith. From here she wrote to Effie, explaining that she was still getting headaches and felt lethargic but her appetite had improved. She only brightened up when she described the 'very nice piano'

which she played every evening. In mid-February her parents were looking forward to her coming home. Her enforced stay in London had been a great worry to them, emotionally and financially. Dr Tuke had waived his fees and said he was willing to treat Sophy in exchange for one of Everett's drawings. But the Wynters needed to be paid. George Gray settled their final bill for £17 just before Christmas 1868.

It seems that Effie and her family managed to keep Sophy's bizarre behaviour quiet. John Ella clearly knew nothing about it when he airily suggested that Effie and Everett should host a musical soirée in their studio. 'Send for La Sorella Sophia,' he wrote. Ella thought she would enjoy the evening. Even Everett's closest friend, Hunt, did not know about the family troubles until they seemed to be over. On 2 March 1869 Everett revealed in a letter to Hunt that his 'wife's sister Sophie Gray had been ill a whole year and away from home with hysteria'. Now she was ready to go back to Bowerswell. Sophy and Alice travelled together, both chastened by the experiences of the past months: Alice had shouldered much of the burden of visiting Sophy since Effie was confined, and was not well herself. Her eyes troubled her. Their parents waited for them anxiously. George Gray had decided to keep a tighter rein on them. He had warned Sophy a year ago that her lack of self-control would lead to 'consumption, brain fever or insanity'. Surely he had been proved right. He did not see that Sophy's struggle to maintain her self-control had triggered her illness.[169]

On her return, Sophy began to re-establish her routines. Within a few days she was writing to Effie about hats. She wanted to dazzle her friends with the latest London fashions. In April she made a sortie to her Uncle Andrew's house in Edinburgh, and felt strong enough to do the rounds of dinner parties and musical evenings. She spent part of the summer holidays with Effie at St Andrews, helping to look after the children. By Christmas 1869 it seemed that the traumatic events of the previous year were behind her. Sophy was almost back to her old self, playing the piano for her family and looking forward to New Year balls. She and Alice had regained their *joie de vivre*. They were causing their father sleepless nights again with their flightiness: he complained to Effie how the 'girls often worry me with their want of sympathy and common sense'. The underlying concern, of course, was that Sophy and Alice were no longer girls. One was twenty-six and the other was twenty-four.

A year later, at Christmas 1870, George Gray could stand it no longer. He

blurted out his fears in a letter to Effie. He had two unmarried daughters who showed no sign of settling down: 'They are blinded obstinate fools and certain to live old maids before their eyes get open.' Alice had already broken off two engagements, while Sophy seemed to have lost any chance of marrying James Caird, having fallen ill at the critical moment. People were starting to talk. George Gray was mortified when he overheard fellows gossiping about Alice at the golf club: they said the reason she had refused two good offers was because she was in love with a young man who had modelled for Everett. 'She has committed social suicide,' he wrote despairingly to Effie.[170]

Effie was unimpressed. She had done her best to find a husband for Alice, by encouraging her intimacy with Harry Mendel. Their on-off engagement lasted four years, before Alice refused him for the last time, and he decided to marry a Miss MacLaren instead. For a while this break-up soured Effie's relationship with Alice. She could not understand why Alice rejected a man who seemed to offer security and family connections. Writing to her sister in the aftermath of the affair, Effie made no attempt to hide her irritation: she called Alice 'a donkey' and 'a little noodle'. It was not until her father shed some light on the situation that Effie relented. Harry had been too passionate: he stormed, he pushed. George Gray had seen his youngest daughter rush breathlessly out of a room to escape Harry's ardent attentions. He had become convinced that if Alice and Harry married, they 'would be at war in a month'. Eventually Effie was flattered by her father into accepting his explanations: 'You have double her brains, so you can afford to overlook her weaknesses,' he wrote. In April 1871 Effie invited Alice to visit her in London, and they were reconciled.

As it turned out, Alice had a lucky escape. The Mendels lost their money in the 'oil bubble' crash of 1875 and had to sell up. Their estate at Manley Hall, just south of Manchester, with its collection of contemporary art, came on the market a few months later. By then Alice had finally found a husband to everyone's liking. Early in the New Year of 1874, she and George Stibbard were married. In the end, it all happened very quickly. Stibbard was the family's lawyer and an old friend. He was generous and likeable. In her father's words, Alice had finally won her prize in the matrimonial lottery. Effie and the children always looked forward to Stibbard's visits, as he invariably booked a box for them all at the theatre or the pantomime. At Christmas 1873 he turned up at Bowerswell with an immense turkey for the

dinner table, and whisked Alice up Kinnoull Hill for a *tête à tête*. By February 1874 they were honeymooning in Florence.[171]

Alice and George Stibbard were well matched. Their energy endeared them to their friends and family. Settled in London, Alice was able to look after Everett when her sister Effie was called away. She steered the Millais household through domestic crises, from George's consumption to young Evie's drinking bouts. As she grew up, she also grew closer to Effie.

Sophy's fate was very different. Having, as her father put it, 'dallied through the last ten years', she was married at last on 16 July 1873. Her husband was James Caird, the man who had helped her organise the ill-omened concert in 1868. Since then Sophy's parents had grown wary of Caird. When it became clear that this suitor was back on the scene, Mr Gray made some enquiries about his background. On the surface he seemed like a good catch. Sophy would be settled close to her family. Caird's business in Dundee was thriving. His linen and jute works exported canvas for tents and sacking to outposts around the Empire. George Gray managed to get some inside information from Caird's bankers in Dundee – he had £30,000 in bonds there. But Sophy's parents disliked Caird. Effie heard all about it in a series of revealing letters. In the first, written in May 1872, George Gray described Caird as a mean sneak, who had been barred from visiting Bowerswell. According to her father, Caird dogged Sophy's steps. But despite her parents' displeasure, she seemed devoted to Caird. The reasons for their opposition were simple. Caird was two-faced in his business dealings and in his personal relations. As George Gray explained, Caird and his sister 'had a deceitful smile on their lips for strangers but at home quarrelled like cats and actually dined in separate rooms'. For Effie's father, who set so much store by family unity, this was inexcusable.[172]

Sophy's family tried to reason with her, but it was no good. She was convinced that she should marry Caird. She recognised that he could appear odd, but reassured her father that she would cure him of his eccentricities once they were settled in their new home. And as she grew more adamant, Sophy's parents became scared about upsetting her. They were increasingly worried about her state of mind. The last time Sophy had come close to marrying Caird, she had suffered a total breakdown. Now, five years on, there were signs that the same thing was happening again. In March 1873 Mrs Gray had to call the doctor as Sophy suffered a fainting fit. Writing to Effie, George

Gray admitted that it had looked very much 'like her former illness'. Effie was appalled when she heard this and pulled no punches in her reply. She urged her father to 'kick Caird out!'. But the Grays could not. They were scared that if they interfered now, Sophy would collapse completely and they would have to 'send her back to Dr Tuke'. No one could bear that. So they watched and waited, hoping that Caird would fail to set a date for the marriage. Then they would have a legitimate cause for stepping in. At the end of April it seemed that this might still be possible. According to her father, Sophy was 'as happy as a woman can be in the prospect of getting married in the beginning of June', even though Caird continued to drag his heels.[173]

Eventually, after further delays, Sophy and Caird were finally wed in the high summer of 1873. A discreet notice in the *Pall Mall Gazette* announced that the marriage was held at Bowerswell on Wednesday, 16 July. Once again the Grays' drawing-room was filled with the scent of roses and lilies, as the bride came downstairs to greet her husband. And once again Mr and Mrs Gray tried to shake off the shadow of the Ruskin marriage. Most of the time they could forget that fiasco. But they were haunted by memories of that first Bowerswell wedding as they waved Sophy off on her honeymoon. Like Effie, she seemed to have chosen a man ill suited to make her happy.

Sophy was pregnant within a month of the marriage. She went back to Bowerswell in May 1874 for her confinement. Her parents were delighted when baby Beatrix was born, and wrote excitedly to Effie about the new bairn. They engaged a local wet-nurse, and Sophy was soon sitting up on the sofa. After a fortnight's rest she was well enough to walk in the gardens. There was no sign of Caird. He not did bother to visit his wife or daughter until late June, when he came to take them off to Dundee. Sophy was distraught at leaving her parents again, and George Gray found it hard to remain civil in the presence of his son-in-law. In his letters to Effie he recalled his own first thrills of fatherhood: 'My heart was swimming with joy,' he remembered, as he held his own baby girl. He could not understand Caird's coldness.[174]

For Sophy, the antagonism between her husband and her family was intolerable. She tried to mask her misery by travelling, dividing her time between Dundee and Paris. Her plan to manage her husband had failed. At Christmas 1875 Caird refused to let his wife stay with Effie en route for

France. Effie voiced her anger in a letter to her sister. She reassured Sophy that she would always find a kind welcome at Cromwell Place. 'But as regards J. K. Caird,' Effie wrote, 'the case is quite different and neither Everett nor I will brook his behaviour.' He had struck at the heart of her parents' teaching. The Gray girls had been brought up to believe in the sanctity of kinship. Effie was outraged.[175]

Here the letter breaks off. Someone in the family thought it best to destroy the second sheet of Effie's note. This action only deepens the mystery surrounding Sophy's situation after her marriage. We catch sight of her from time to time in the correspondence between Effie and her parents, and occasionally hear from Sophy herself. In the New Year of 1876 she was in Paris, suffering from neuralgia and missing her daughter Beatrix, left behind in Scotland. Even when she was at home in Dundee, there was little peace. Mrs Gray described Caird's house as Sophy's prison. A despairing letter, written in October 1881 as she turned thirty-eight, exposed Sophy's failing health. She had 'never had a more sad birthday', she said. Depression had taken such hold on her that she felt 'incapable of fixing with intelligence or interest on anything'. She was hardly eating. She envied Effie her latest pregnancy, knowing that she had made herself infertile through self-starvation. There was no mention of Caird. Sophy's life was solitary, except for seven-year-old Beatrix.

On Sophy's birthday Beatrix appeared at her mother's bedside with a bouquet of flowers. Sophy's chestnut hair was streaked with white, her face was pale. The previous summer she had been put on display for the last time, a pensive portrait by Everett exhibited at the Grosvenor Gallery. Then her emaciated state had been concealed by her fashionable dress: the wide sash at her waist, the fabric swathed across her hips, the puffed sleeves. But now in the privacy of her bedroom, her young daughter watched as Sophy wasted away.[176]

Sophy did not live to see another birthday. In the spring of 1882 she was committed again to Dr Tuke's care. Exhausted by depression and hunger, she could not fight as fever took hold. The doctors gave up attempts to force-feed her. She was too weak to be tormented by their tubes and pumps. Effie was in Florence when the end came, and heard about Sophy's last days from her mother. Mrs Gray's harrowing letter makes it clear that Sophy did not take her own life in an act of violence, but there was a grim deliberation in her

refusal to eat. Finally Sophy felt she was in control. She 'passed away – so calmly – knowing she was dying and longing to be at rest'. As she lay in her narrow white bed, Sophy spoke the names of her family, from Mama to little Beatrix. One by one, she sent them her love.

Many years before, writing from Rothesay, Sophy had voiced her desire to disappear. Her wish came true. She died on 15 March 1882. Harrington Tuke gave her cause of death as 'Exhaustion, 10 days. Atrophy of nervous system, 17 years.' The agonising battle between mind and body was over.

Sophy's family responded to their loss in different ways. Mrs Gray was sustained by an outpouring of affection from her neighbours. Their letters of condolence were full of love, admiration and pity. Friends recalled how fascinating Sophy could be. One wrote, 'She had an inimitable manner of describing people and events that made them live before you.' Effie, far off in Italy, could hardly believe that Sophy was really dead. She still expected to see her sister at the window of a cab, ready to jump out and join her. At home, Everett shut himself in his studio. Even there he was haunted. His last portrait of Sophy hung next to the fireplace, her clasped hands displaying her wedding ring, her gaze steady. Everett remembered how he had sketched her in the twilight once, before she had known she was beautiful. He had seen Sophy bloom and then fade. She had hoped to fulfil his dreams. Instead she starved herself into a skeletal parody of the girl he had glimpsed in the garden, one autumn evening long ago.[177]

Chapter Thirteen

Time, the Reaper: 1885–97

MAY 31ST 1894. Effie sat on her balcony overlooking the lagoon. Venice was a blur now. She could barely make out the shape of the Salute across the glistening water. The letter lay in her lap. She put down her magnifying glass and softly started to cry. Her mother was dead. Even if Effie could summon the strength, there was no point in hurrying home. The news came too late. Sophia Gray was being buried today. Effie's brother George, writing from Bowerswell, spoke of the 'terrible void at the heart' of the house. Without their mother, Bowerswell seemed only a shell, a storehouse for memories.

Effie stood up slowly and crossed the hotel room. She picked up a strand of beads, a souvenir for her granddaughter. Effie was fond of their name, *Fiori di Mare*, Flowers of the Sea; she wanted to tell the little girl how the sand washed up on the shore was transmuted into the flowing colours of the glass. The beads were a talisman, a tangible connection to Venice. The floating city had shared her sorrows. But Effie had also found beauty and happiness here. In her mind's eye, at least, she could still follow the lines of the carved capitals on the palazzi. She recalled the sway of her skirts as she was whirled around the ballroom. Her dancing days were over now, her partners long since perished. Effie found a pen and sank back into her chair. She began to write in large ungainly letters, answering her brother's message. She could not focus on the sheet of notepaper. She just had to hope that the words were legible to him.

Effie was alone in Italy. She was stopping in Venice for a few days, but she knew she had to turn north soon, towards Wiesbaden. Effie needed to visit her eye surgeon, Dr Hermann Pagenstecher. Even after enduring his scalpels, bleeding, bandages and baths the previous summer, she still could not see properly. Effie was sixty-six, and her failing eyesight and aching limbs made her feel old and impotent. Unable to read, she could no longer

help Everett with his correspondence. She could not even admire the paintings he produced.

Back at home, Everett was struggling with his own ill health. He had been advised against travelling to the Continent, so Effie had hardly seen him that spring. Her husband had spent March and most of April in Bournemouth, trying to shake off a bout of influenza. It seemed to have left him with a permanent sore throat. Everett wrote regretfully to Effie that he was too unwell to attend his mother-in-law's funeral.

The burial was a quiet affair. George counted twenty-five mourners gathered around her graveside. He and his brothers Melville and Albert shouldered her coffin from the drawing-room to the churchyard. Effie's eldest son, Evie, had come from London just for the day. Her sister Alice Stibbard was there too; according to George, 'she was feeling it acutely'. Alice had been at Bowerswell for weeks, sitting by her mother's bedside. But then she was called away to London. Sophia Gray died on 28 May, two days after Alice left. At the very end, her daughters were unable to soothe her suffering. Mrs Gray had seemed indestructible. She had borne her husband fifteen children and outlived him by seventeen years. Evie thought her passing marked 'the end of Bowerswell': 'The place is looking lovely just now', he wrote to his mother. 'I have had a walk all round it today and feel that I have probably seen the last of it.'[178]

Far away, Effie grieved for her mother and for the end of an era. It was time to take stock. She cast her mind back ten years, to when it still seemed there was everything to play for. In 1885 Everett had been made a baronet, an acknowledgement that her husband was the outstanding artist of his generation. A year later he was honoured with a one-man show at the Grosvenor Gallery. This exhibition made Effie and Everett realise how far they had come since their marriage. For Effie, it was a vindication of her faith in her husband's ability. But Everett was troubled by seeing so many of his pictures together in one place. The exhibition brought home to him how much his art had changed. As *The Huguenot* (1851-2) was brought out of its packing case, he called to his fellow Pre-Raphaelite Frederic Stephens to come and admire it: 'Really, I did not paint so badly in those days, old man!' he said.

But another friend gave a very different version of events. William Holman Hunt claimed that, after looking at his paintings from the 1850s, Everett had rushed from the gallery, 'his head bowed and tears in his eyes'. 'You see me

unmanned,' he muttered as he dashed down the steps and out into the bustle of Bond Street. That evening in Palace Gate, surrounded by the evidence of his success, Everett considered his career. Maybe the critics were correct, maybe he had failed to fulfil the potential of his youth. Perhaps he had been, as Hunt put it, 'tempted to meet the public taste, to forget his higher aspirations'. Everett admitted to the Irish artist Briton Rivière that now every time he tried to tackle a serious subject, 'people pass it, and go to a little child-picture, and cry, "How sweet!". He had never wanted his work to become synonymous with sentimentality. Surely there was still time to defy the critics and clear his name.

In the wake of the 1886 exhibition, Everett returned to themes that had haunted him for many years. Works like *St Stephen* and the ghostly image *'Speak! Speak!* showed him wrestling with the ambiguities and doubts of his age, trying to visualise moments of collision between this world and the next. Writing to Briton Rivière again, Everett explained, 'I am painting subjects I have thought of years back.' But he confessed he was 'dreadfully despondent at times, overwhelmed by a recurring conviction that the game is played out'. Everett was right.

In 1895, when these pictures were exhibited, Everett was diagnosed with throat cancer. The pipe-smoking had finally caught up with him. For three years Everett had complained that his voice was sometimes 'inaudible and always husky'. Now he knew why.[179]

Everett and Effie were now, all too often, saying farewell to beloved friends. In the winter of 1895 they lost their son-in-law, Major William James. He had suffered head injuries after 'an accident out pig-sticking' in India. Major James had fallen from his horse trying to spear a wild boar. Pig-sticking was a fast, tough and often brutal sport, but it was excellent training for cavalry officers. The Army allowed Major James leave to convalesce after his fall, but he died soon after returning to duty in India.

A few months later, in January 1896, Everett and Effie were mourning the passing of another friend, Frederic Leighton. Everett had known him for forty years; they had both been volunteers in the Artists' Rifles regiment in 1855. The two artists had enjoyed a friendly rivalry ever since, after Leighton's painting of *Cimabue's Madonna* (1853–5) had been the sensation of the season and was snapped up by the Queen. They never lost their competitive edge, even in Leighton's last months. In 1895 Leighton's *Flaming June* was

hung in the Academy opposite *'Speak! Speak!'*. To their friend Val Prinsep, Leighton's picture seemed 'like music', it was 'self-contained, melodious and monumental', while Everett's was 'drama – full of humanity and feeling'.

Leighton had always recognised Everett's worth and enjoyed his company. His studio-house, like Palace Gate, was designed for entertaining, and he would regularly drop Everett a line of invitation. Leighton's notes were nonchalant: 'I hope a few pictorial pals are going to eat their soup and smoke their pipe with me on Thursday next,' he wrote in 1874. 'Come too like a good fellow.' But as well as these informal all-male suppers, Leighton also organised exquisite parties. His Academy soirées became the stuff of legend. Effie aspired to hosting an evening as beautiful as those she attended at Leighton's house. It was one of the reasons for building their own mansion.

Leighton had a particular talent for combining music, paintings and architecture, creating a spectacle for the senses. His studio was not just a workroom, but a carefully constructed performance space. The screen behind which his models undressed could be transformed into a minstrel's gallery. At the other end of the great red room, the curved ceiling was lined with gold leaf. In April 1871 he wrote to his sister about the latest musical feast for his friends: 'The most striking thing of the evening was Joachim's playing of Bach's "Chaconne" up in my gallery. I was at the other end of the room, and the effect from the distance of the dark figure in the uncertain light up there, struck me as one of the most poetic and fascinating things that I can remember. At the opposite end of the room in the apse was a blazing crimson rhododendron tree which looked glorious where it reached up into the golden semi-dome.' A solo violin soaring high above their heads, a musician silhouetted black against gold: that was a show-stopper. Effie's pianists would always seem rather tame by comparison.[180]

In 1878 Leighton was elected President of the Royal Academy. He was ideal for the role. A lifelong bachelor, he devoted himself to the institution. But by the spring of 1895 it became clear that Leighton's health was failing; weakened by heart disease, he could no longer fulfil his duties as President. It was the worst possible time for him to fall ill, with the opening of the annual exhibition only weeks away. But an emergency council agreed that he should allow another Academician to deputise for him at the opening banquet. The next morning Leighton wrote to Everett. 'My dear old friend,' he said, 'there

is only one man whom everybody without exception will acclaim in the chair.'
Would Everett stand in for him, just this once?

Everett was delighted to be asked. But he always dreaded having to make
a speech. And now it was even worse, as he could not rely on his voice. On a
previous occasion Lord Derby had taken him aside to congratulate him on his
performance: 'When you were speaking you were exactly like Blondin –
always pretending to fall off, and never doing so.' This time Everett was
carried through on a wave of goodwill. Everyone could hear the huskiness in
his throat and they feared the worst.

Leighton never returned to his post. In his last days he asked his sister to
'give my love to the Academy'. He was buried in St Paul's Cathedral. On that
bleak January morning, Everett followed his friend's coffin into the echoing
cathedral. He placed a large wreath on the lid, a tribute from his fellow
Academicians, and watched as Leighton's body was lowered into the crypt.
He could not help thinking that it would be his turn next.

Everett was unanimously elected President on 20 February 1896. It was
the highest honour the art world could offer him. One artist summed up the
feeling of his colleagues: 'It is a great thing for our profession that the official
head of it should be the greatest British painter of the century.' Everett had
originally been reluctant to accept the position. He had always maintained in
private that it was too arduous a job. But when the time came, he could not
resist. He told a friend 'he supposed he must take the damned thing'. He had
finally fulfilled his father-in-law's prediction made in 1863, when Everett had
joined the ranks of the Academicians. In Hunt's words, Everett had gone
'from P.R.B. to P.R.A'. But Everett already knew that it could not last.[181]

The cancer in his throat was gradually taking hold. In 1895 Everett
exhibited *Time, the Reaper*, a thinly disguised self-portrait. The decision to
paint himself as Old Father Time, with scythe and long white beard, was both
an homage to the art of the past and a recognition of his own mortality. For
the past decade his studio had been dominated by a painting by Van Dyck,
Chronos Clipping the Wings of Love. This image of an old winged man hung
above the dais where Everett's clients sat to have their portraits painted. It
was in his line of sight as he worked, inspiring, cajoling. Eventually Everett
decided to take on the masterpiece and recreate it in his own image. Many
years earlier he had drawn his own face looking out across the snow in *The
Eve of St Agnes*. That too had been a moment of anticipation, caught between

hope and fear. In *Time, the Reaper*, Everett again showed himself on the threshold, about to step into the unknown. He faced his illness bravely. As he told a fellow artist, 'I am ready and not afraid; I have had a good time, my boy, a very good time!'

Everett threw himself into his work at the Academy. In the last week of April he did the rounds of the galleries. On Varnishing Day he watched with interest as men half his age put frantic finishing touches to their canvases. He was still handsome, his silver hair like a halo or laurel wreath on his temples, his eyes sharp, his smile as quick as ever. Only his voice had withered, disappearing to a whisper. And his legs ached. On Saturday, 2 May 1896 it was Everett's responsibility to give the Prince of Wales a private tour of the Academy. But he simply could not keep pace with his guest. He was worn out by the exertions of hanging the exhibition. Reluctantly Everett took one last look at the gallery, turned his back on the pictures and ever so slowly walked down the wide marble staircase. In his youth the Academy had been his battleground. In recent years it had become his shop-window. Now it was time to go home.

A few days later Everett was sitting in his studio playing patience. He found it comforting when he got stuck in the middle of a painting to pull out a pack of cards and see how the game worked out. His daughter Carrie was in the next room practising the piano to pass the time. Almost inaudibly he asked if she had heard anything new by Parry. She began a Prelude in six flats which her father did not know. 'Beautiful,' he whispered. And then, with painful steps, he made his way to the door of the studio and passed through for the last time. Taking Carrie's arm, he managed to get to his bedroom on the floor below. As she remembered, 'the next day he was worse, and he never came upstairs again'.[182]

The sickroom became his world. Everett's voice evaporated altogether, and he had to scratch his words out on a slate. Effie and her daughters came and went, sitting by his bed. He was rarely alone. His mind kept returning to the places he had loved and would never see again. Effie's niece Eliza Jameson spent an hour with him one morning, holding his hand a little. He was very quiet but composed. And then she mentioned a sprig of heather on the table, sent by a friend from Perthshire. At the thought of those hills and moors, of the sport and the company, Eliza said, 'he broke down and I came away'.

The tumour was slowly suffocating him. Late one night, less than a

fortnight after the opening of the Royal Academy, Everett woke gasping for breath. Effie thought he was going to choke to death before her eyes. When his two doctors arrived they explained that Everett needed an emergency tracheotomy. It was one o'clock in the morning. Surely they would not attempt the operation by candlelight? They had no choice. As Dr Treves's assistants set up the sterilising equipment in the dressing-room next door, Effie's husband stopped breathing. For ten vital minutes he was kept alive by artificial respiration. Then the doctor began to slice through Everett's wind-pipe. He tried to ease a tube into the wound, but it would not slide in. On the far side of the door, Effie and her children sat in the library, listening to the confusion of noises coming from Everett's crowded bedroom. At last the breathing tube was safely in place, and Everett was back with them.

The tracheotomy kept Everett alive for three more months, but he was in a bad way. The tubes had to be changed regularly to stop them blocking up with fluid. Effie employed three nurses on eight-hour shifts to stay with him day and night. He lost weight, wasting away as his white beard lengthened. He was dosed with morphine to ease the pain. He was dumb.

As President of the Royal Academy, Everett was a public figure. The Queen was kept informed about his state of health. And knowing how close they had come to losing him, family and friends flocked to Palace Gate hoping to grasp his hand one more time. One morning a magnificent bouquet was brought up to Effie, with a note from Princess Louise. Effie was all but blind, but Mary read it aloud to her mother. The Queen's daughter asked if she might see Everett. Louise, known as the Marchioness of Lorne since her marriage, had been a regular visitor to Everett's studio. She was also an artist in her own right, having trained as a sculptor at the South Kensington Schools and then in the atelier of Edgar Boehm. Utterly unlike her mother in many ways, although equally stubborn, Louise had refused to marry a minor Prussian prince. She smoked, gossiped and promoted women's education. There were rumours of more serious indiscretions, but nothing was ever proved.

Of course Effie would welcome the Marchioness. Everett would be delighted if she sat with him for a while. And so it was arranged. Everett could only communicate via his slate, but he nodded and smiled as best he could. The Marchioness was making her farewells when she remembered: her mother had asked if there was anything she could do for Everett at this

difficult time. Effie stiffened. Everett saw and reached for his pencil: 'Yes, let her receive my wife,' he wrote.[183]

On 2 July 1896 Effie was helped into her carriage. She looked sumptuous in satin gown and gloves, wearing her Venetian lace once more. Her daughter brought out the box containing Effie's tiara and veil. She placed it on the seat beside her. On her way to Windsor, Effie cast her mind back to 1850 and her first face-to-face encounter with the Queen. Then she had been Mrs Ruskin, young, beautiful, poised in her white and yellow silk. The courtiers had murmured appreciatively when she approached the throne, her plumes dipping as she made her low curtsey. Now she was Lady Millais, wife of the President of the Royal Academy. Forty-six years on, she was blind, halting, anxious about leaving her husband.

The Marchioness of Lorne greeted her friend at the door of the Drawing-Room. Her name was called. With an effort she lifted her head and began her long, slow walk to the far end of the salon. The ladies and gentlemen hushed as she passed. They knew her history. The Queen, tiny and black, looked up as Effie approached. Effie paused for a moment, and then curtsied to Her Majesty. Between the two old ladies hung years of resentment and misunderstanding. The Widow of Windsor received Effie because she was the wife of a dying man. For Effie, this was no time for triumph. Relief, perhaps, that her name had finally been cleared, but not joy. Back at Palace Gate, her children gathered to read the details of her reception in the Court Circular. Perhaps, Everett thought, there was some point in his accepting the presidency of the Royal Academy: it had enabled him to do this one good thing for his wife.

A month later Everett was in a coma. His family stayed close, expecting every day to be his last. National newspapers printed regular bulletins about his condition. At dawn on 13 August he regained consciousness for a few hours. He saw Effie by his bedside. There was a brief moment of hope, a final flash of connection. But then he slipped away again. Everett died at tea-time that afternoon, with Effie's hand in his.

Even in death Everett was beautiful. His son said he looked like a medieval saint. Everett's body was washed, his beard shaved. At the request of his friend Lord Rosebery, Everett's features were preserved in plaster, a death-mask, the final portrait of the artist. Effie managed, as she always did. She dictated letters to her daughter Mary: as word spread, Effie answered messages of condolence from friends, colleagues, admirers. In the quiet moments she sat

in her room and listened to the comings and goings downstairs as preparations were made for Everett's funeral. The Academy said it would handle all the arrangements. No doubt this was the right thing, but it left Effie on the sidelines. Everett was being taken out of her hands. Like Leighton, he would be carried into St Paul's on the shoulders of his fellow artists. His family would have to follow in his wake.

William Holman Hunt, Everett's staunchest friend, was a pall-bearer. So was Sir George Reid, President of the Royal Scottish Academy, with another painter Philip Calderon and the actor Sir Henry Irving. A viscount, two earls and a marquess also offered to bear Everett's coffin into the Cathedral. The funeral was held on 20 August 1896 in Painters' Corner. Just a year before, Everett had been out on the grouse moors of Perthshire. He had written then to his son John about the excellent sport he was enjoying. 'In the four days,' he claimed, 'we got upwards of 400 brace.' He never felt better than when he was standing by a river in spate or striding through the heather. This had been Effie's great gift to him. When he fell in love with her, he had fallen in love with Scotland too.[184]

With Everett gone, Effie's reasons for staying in London seemed to fade. She had many acquaintances, but few real friends left. Palace Gate was a house for painting and parties. She could not bear the loneliness of the empty drawing-rooms, so different from the dazzle and brightness of the past. It was not a family home. And anyway, her sons and daughters were settled now. All except Mary, who felt as she did. A few months after Everett's death, Effie asked George Stibbard's firm of solicitors to prepare the particulars for Palace Gate. She was selling up. In March 1897 the 'Handsome Freehold Town Mansion of the Late Sir J.E. Millais' was put on the market. Effie went back to Bowerswell.

Her brother George welcomed Effie as she walked through the double doors of her father's house. Her sight had gone, but she felt her way around the old place, guided by the creaks of the floorboards, the gurgles of the plumbing, the solid smoothness of the banister. In her mother's room, a faint, familiar scent still lingered. Her father's study held the letters of a lifetime, the record of his family's loves and losses. Effie would never climb Kinnoull Hill again, but she could sit by her bedroom window and feel the warmth on her face. It was good to be home.

Effie had been unwell for years. Ever since she left John Ruskin she had

been plagued by sleeplessness. She had quickly become dependent on the chloroform pills that were prescribed for her insomnia. She tried one spa town after another in the hope of shaking it off. Even before her sight had failed her, Effie made regular pilgrimages to France, Austria, Italy and Germany, seeking respite. Perhaps, at some level, her ill health gave her the excuse to see the great cities of Europe. While her husband went north, she sailed south. She knew she would never persuade him to trail round Venice with her again. But Effie loved to travel, and seemed drawn back to these places where her eyes had once been opened.

A young girl, visiting Everett's studio in his heyday, remembered catching sight of Effie convalescing. She was lying on a sofa in a 'beautiful glowing dress', her head resting on a gilt-leather cushion, 'which made a background of pale gold to her face'. She looked glorious, even in her weakness. As she edged closer to the end of her days, Effie was still impressive. Beatrix Potter found Effie's spirit undimmed when she met her for the last time in London. She saw Effie in Gloucester Road trying to escape a tiresome acquaintance. Recognising Beatrix, Effie took her young friend's arm and turned to go. She paid no attention to the girls on bicycles swerving to avoid them, but simply 'expressed a wish to die together' and, laughing, stepped into the road.[185]

Effie left town soon after. Having followed her so far, tracing each step of her life, we begin to lose sight of her. The letters dry up, many of our questions go unanswered. Effie could not see to write, and who would she have written to anyway? Her parents were dead, so was her husband, and her brother George was with her. Effie's final months have to be pieced together from snippets and glimpses. At Bowerswell she retired into her private world. Here she rarely had to wear her public face, as the widow of a national treasure. She could put her ambitions behind her. In her childhood home she was safe to explore the memories of life before she became Mrs Ruskin or Lady Millais. Effie might have lived on here for years, as her brother did: George survived until 1924. But on 7 September 1897, a year after she lost Everett, Effie had another blow. Her son Evie died, very suddenly, from pneumonia. Hard drinking had left him vulnerable, and he had never fully recovered from the death of his own little girl three years before.

Losing Evie was more than Effie could stand. She was sixty-nine, and in the past three years she had buried her mother, her husband and now her eldest son. Effie was finally diagnosed with bowel cancer. As Christmas

approached, Mary and her sisters watched while she grew weaker. Then Effie's intestines ruptured. Dr Stirling was called, but it was a painful passing. Effie died in the early hours of 23 December 1897. She could not be laid to rest next to Everett; that was the price she had to pay for his presidency. News of Effie's death reached the London papers, but it was overshadowed by the opening of a major exhibition of her husband's pictures in Piccadilly. One journalist reported that the death of Lady Millais would 'add to the melancholy interest' in Everett's work. Now she was dead, visitors to the Royal Academy searched more eagerly for Effie among the hundreds of faces her husband had painted. Young ladies in fancy hats stood in front of Everett's portrait of John Ruskin and the waterfall, and whispered about Effie, the wife of both men.

But Effie was beyond their reach. In Kinnoull churchyard she was reunited with her parents, all the little sisters and brothers who had died half a century ago, and her boy George. After her trials and travels, her desires and her achievements, Effie was back where she began. The minister read a brief service; the small group of mourners left their flowers on the bare earth. Then they drifted away from Effie's graveside, and down to the warmth of Bowerswell.[186]

The Gray and Millais families

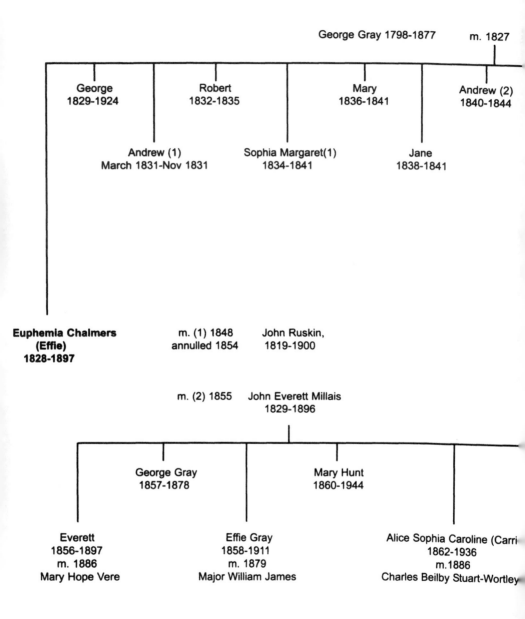

George Gray 1798-1877 m. 1827

George
1829-1924

Robert
1832-1835

Mary
1836-1841

Andrew (2)
1840-1844

Andrew (1)
March 1831-Nov 1831

Sophia Margaret(1)
1834-1841

Jane
1838-1841

**Euphemia Chalmers
(Effie)
1828-1897**

m. (1) 1848
annulled 1854

John Ruskin,
1819-1900

m. (2) 1855 John Everett Millais
1829-1896

George Gray
1857-1878

Mary Hunt
1860-1944

Everett
1856-1897
m. 1886
Mary Hope Vere

Effie Gray
1858-1911
m. 1879
Major William James

Alice Sophia Caroline (Carri
1862-1936
m.1886
Charles Beilby Stuart-Wortley

Sophia Margaret Jameson 1808-1894

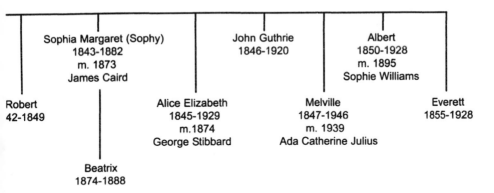

Sophia Margaret (Sophy)
1843-1882
m. 1873
James Caird

John Guthrie
1846-1920

Albert
1850-1928
m. 1895
Sophie Williams

Robert
42-1849

Alice Elizabeth
1845-1929
m.1874
George Stibbard

Melville
1847-1946
m. 1939
Ada Catherine Julius

Everett
1855-1928

Beatrix
1874-1888

Geoffroy William
1863-1941
m. 1901
Madeline Campbell Grace

Sophia Margaret Jameson (Tottie)
1868-1907
m. 1891
Douglas Lilburn McEwan

John Guille
1865-1931
m.1894
Frances Margaret Skipworth

Notes

1. John Everett Millais, *Spring*, 1856–9, oil on canvas, National Museums Liverpool, Lady Lever Art Gallery; Effie Ruskin to Rawdon Brown, Bowerswell, 27 April 1854, Mary Lutyens (ed.), *Millais and the Ruskins* (London: John Murray 1967), p.182; Effie Ruskin to George Gray snr., 6 March 1854, *Millais and the Ruskins*, pp.154–7; Tim Hilton, *John Ruskin: The Early Years 1819–1859* (Yale University Press: New Haven and London 1985), paperback edition 2000, p.73.

2. The Hon. Mrs Norton, *A Letter to the Queen on Lord Chancellor Cranworth's Marriage and Divorce Bill*, 3rd edition (London: Longman, Brown, Green and Longmans 1855), pp.8–11; John Ruskin, letter to F.J. Furnivall, 18–19 August 1854, *Millais and the Ruskins*, pp.232–3; Susan Kingsley Kent, *Gender and Power in Britain, 1640–1990* (London and New York: Routledge 1999), p.251; *A Letter to the Queen*, p.16; Effie Ruskin to Rawdon Brown, 17 April 1854, *Millais and the Ruskins*, p.177.

3. John James Ruskin to George Gray snr., 2 August 1852, *Millais and the Ruskins*, p.13; Effie Ruskin to Sophia Gray, 24 February 1852, Mary Lutyens (ed.), *Effie in Venice: Unpublished Letters of Mrs John Ruskin Written from Venice between 1849 and 1852* (London: John Murray 1965), new edition (London: Pallas Editions 1999), p.275; John Ruskin, *Modern Painters*, vol. 1, E.T. Cook and Alexander Wedderburn (eds.), *The Works of John Ruskin: Library Edition* (London and New York: George Allen 1903–12), vol. 3, p.624; John Ruskin to John James Ruskin, 6 July 1853, *Millais and the Ruskins*, p.60; John Everett Millais to Mrs William Collins, 10 July 1853, *Millais and the Ruskins*, p.68; John Everett Millais to Charles Collins, 25 September 1853, *Millais and the Ruskins*, p.90; John Everett Millais to Sophia Gray, 19 December 1853, *Millais and the Ruskins*, p.120; William Gladstone quoted in French Fogle, *The Huntington Library Quarterly* (Berkeley: University of California Press), vol. 20, no. 1 (November 1956), p.51.

4. *The Times*, Tuesday, 13 February 1838, p.5; Effie Gray to George Gray snr., 20 April 1844, Transcriptions of the Bowerswell Papers, p.45; Phyllis D. Hicks,

A Quest of Ladies: The Story of a Warwickshire School (privately published 1949), p.14; George Gray snr. to Effie Millais, 5 May 1876, Geoffroy Richard Everett Millais Collection, loan C, parcel 7A.

5. Judith Flanders, *The Victorian House: Domestic Life from Childbirth to Death* (London: HarperCollins 2003), pp.41–4; John Mackenzie (ed.), *The Victorian Vision: Inventing New Britain* (London: V&A Publications 2001), p.113; Matthew Sweet, *Inventing the Victorians* (London: Faber and Faber 2001), p.86; Robert Woods and Nicola Shelton, *An Atlas of Victorian Mortality* (Liverpool: Liverpool University Press 1997), pp.48, 65, 69.

6. Melville Jameson to Sophia Gray, 27 November 1831, Transcriptions of the Bowerswell Papers, p.10; Sophia Gray to George Gray snr., 21 July 1843, Transcriptions of the Bowerswell Papers, p.43; George Gray jnr. to Sophia Gray, n.d. November 1844, Transcriptions of the Bowerswell Papers, p.44.

7. Judith Flanders, *The Victorian House*, pp.22–4; Melville Jameson to George Gray snr., 17 March 1831, Transcriptions of the Bowerswell Papers, p.9.

8. *A Quest of Ladies*, pp.14, p.81.

9. Census return for 1841; *A Quest of Ladies*, p.86; J. Chapple, *Elizabeth Gaskell: The Early Years* (Manchester: Manchester University Press 1997), pp.241, 251; Jenny Uglow, *Elizabeth Gaskell: A Habit of Stories* (London and Boston: Faber and Faber 1993), p.38.

10. Elizabeth Gaskell, *Lady Ludlow* (1858), in *A Quest of Ladies*, p.81; Effie Gray to Sophia Gray, 25 May 1841, Transcriptions of the Bowerswell Papers, p.16.

11. Effie Gray to Sophia Gray, 2 September 1840, Transcriptions of the Bowerswell Papers, p.14; *Elizabeth Gaskell: The Early Years*, p.241; Effie Gray to Sophia Gray, 25 May 1851, Transcriptions of the Bowerswell Papers, p.16.

12. Effie Gray to Sophia Gray, 14 June 1841, Transcriptions of the Bowerswell Papers, p.24; Melville Jameson to George Gray snr., 12 August 1841, Transcriptions of the Bowerswell Papers, p.38.

13. Melville Jameson to George Gray snr., 15 July 1841; Melville Jameson to Andrew Jameson snr., 17 July 1841; Melville Jameson to Sophia Gray, 27 July 1841, Transcriptions of the Bowerswell Papers, pp.25, 31, 34.

14. Mary Lutyens (ed.), *The Ruskins and the Grays* (London: John Murray 1972), pp.2–6. This account of events at Bowerswell in the autumn of 1817 is based on the recollections of Mrs Andrew Gray, Effie's great-aunt, who was 'an intimate friend of Jessie'.

15. *The Ruskins and the Grays*, pp.6–9.

16. *The Ruskins and the Grays*, pp.150–1; John James Ruskin to George Gray,

15 September 1834, Transcriptions of the Bowerswell Papers, p.10; *John Ruskin: The Early Years*, pp.36, 52–4.

17. *John Ruskin: The Early Years*, p.62; John Ruskin, *The King of the Golden River or the Black Brothers* (London and New York: J.M. Dent & Sons and E.P. Dutton & Co. 1850), Everyman's Library edition 1907, reprinted 1960, frontispiece, pp.250, 285; John Ruskin, 'Unto this Last' (1860), *The Works of John Ruskin*, vol. 34, p.40.

18. John Everett Millais, *A Ghost Appearing at a Wedding Ceremony*, 1853–4, pencil, pen and ink, Victoria and Albert Museum; Quentin Bell, *Ruskin* (London: The Hogarth Press 1963), new edition 1978, pp.131, 138; John Ruskin to Effie Gray, 30 November 1847 and 13 March 1848, quoted in Admiral Sir William James, *The Order of Release* (London: John Murray 1947), pp.58, 63, 92; John Ruskin, diary, 8 December 1843, *The Ruskins and the Grays*, p.21; Effie Gray to George Gray snr., 13 March 1848, Transcriptions of the Bowerswell Papers, p.198.

19. Elizabeth Gaskell (née Stevenson) to John Forster, 17 May 1854, John Chapple and A. Pollard (eds.), *The Letters of Mrs Gaskell* (Manchester: Manchester University Press 1966), p.287, letter 195; Mrs Parker to Sophia Gray, 29 February 1844, Bowerswell Collection, Morgan Library; Miss Mary Ainsworth to Sophia Gray, 9 May 1841 and 15 June 1844, Bowerswell Collection, Morgan Library; George Gray jnr. to Sophia Gray, n.d. May 1844, Bowerswell Collection, Morgan Library.

20. Elizabeth Gaskell (née Stevenson) to John Forster, 17 May 1854, *The Letters of Mrs Gaskell*, p.287, letter 195; Effie Gray to George Gray snr., 17 May 1847, Transcriptions of the Bowerswell Papers, p.69; John Everett Millais to Charles Collins, 19 June 1855, *Millais and the Ruskins*, p.260; *Millais and the Ruskins*, p.33; *John Ruskin: The Early Years*, p.74; Effie Gray to George Gray jnr., 17 June 1847, Transcriptions of the Bowerswell Papers, p.86; Effie Gray to Sophia Gray, 2 and 18 June 1847, Transcriptions of the Bowerswell Papers, pp.74, 87.

21. John Ruskin to Effie Gray, (11) November 1847, Transcriptions of the Bowerswell Papers, p.113; *The Ruskins and the Grays*, pp.66–7.

22. Effie Gray to Sophia Gray, 29 April and 3 June 1847, *The Ruskins and the Grays*, pp.34–8; Effie Gray to Sophia Gray, 7 May 1847, Transcriptions of the Bowerswell Papers, p.63; *The Ruskins and the Grays*, p.25; John Ruskin, 'Praeterita', *John Ruskin: The Early Years*, p.108; Effie Gray to Sophia Gray, 14 May 1847, *The Order of Release*, p.35; Effie Gray to Sophia Gray, 4 and 5 May 1847, *The Ruskins and the Grays*, pp.30, 35.

23. John Ruskin to Effie Gray, 19 December 1847, *The Order of Release*, p.73;

Effie Gray to Sophia Gray, 28 April and 2 June 1847, *The Order of Release*, pp.28, 36; John Ruskin to Effie Gray, 24 January 1848, Transcriptions of the Bowerswell Papers, p.169; Effie Gray to George Gray jnr., 17 June 1847, Transcriptions of the Bowerswell Papers, p.86; Effie Gray to Sophia Gray, 2 June 1847, Transcriptions of the Bowerswell Papers, p.74. The hooped cage crinoline did not come into fashion until the 1850s. In the 1840s a crinoline referred to a petticoat made of horsehair (*crin*) and linen (*lin*); Effie Gray to George Gray snr., 3 and 15 June 1847, Transcriptions of the Bowerswell Papers, p.84; Effie Gray to Sophia Gray, 12 and 18 June 1847, Transcriptions of the Bowerswell Papers, pp.82, 87.

24. John Ruskin, 'For a birthday in May', *The Order of Release*, p.27; John James Ruskin to George Gray snr., 28 April and 3 May 1847, *The Order of Release*, pp.21, 25; Margaret Ruskin to John Ruskin, 11 September 1847, *The Order of Release*, pp.44–5; Margaret Ruskin to John Ruskin, 4 September 1847, *The Ruskins and the Grays*, pp.52–3; John James Ruskin to John Ruskin, n.d. September 1847, *The Ruskins and the Grays*, pp.49–50; John Ruskin to Sophia Gray, 1 September 1847, *The Order of Release*, p.39.

25. John Ruskin to William Macdonald, 5 October 1847, *The Ruskins and the Grays*, p.61, and *The Order of Release*, pp.45–6; in Mary Lutyens's account of Effie's courtship, she reported that Willie MacLeod had been posted to India, and was due to return in November 1847 (see *The Ruskins and the Grays*, p.66). However, regimental records for the 74th Highlanders show that they were not sent to India until the 1850s. Before that, the Regiment had been in Barbados and Canada, but were stationed in Scotland from September 1846 until March 1851, when they sailed for South Africa; John Ruskin to Sophia Gray, [September] 1847, Morgan Library, MA1338 D.07; John Ruskin to Sophia Gray, 30 November 1847, *The Ruskins and the Grays*, p.74; Effie Gray to John Ruskin, 10 February 1848, *The Order of Release*, p.94.

26. John Ruskin to Effie Gray, 9 and 30 November and 15 December 1847, *The Order of Release*, pp.48, 58–9, 67.

27. Effie Gray to John Ruskin, 9 February 1847, Transcriptions of the Bowerswell Papers, p.172; John Ruskin to Effie Gray, 30 November 1847, Transcriptions of the Bowerswell Papers, p.131; John Ruskin to Sophia Gray, 9 December 1847, Transcriptions of the Bowerswell Papers, p.140; John Ruskin to Effie Gray, 11 November 1847, *The Order of Release*, pp.49–52.

28. John Ruskin to Effie Gray, 11 February 1848, *The Order of Release*, p.86; Effie Gray to John Ruskin, 10 February 1848, *The Order of Release*, pp.94–5; John Ruskin to Effie Gray, 22 December 1847, *The Order of Release*, p.79; John Ruskin to Effie Gray, 19 December 1847, *The Order of Release*, p.75.

29. John Ruskin to Effie Gray, 19 December 1847, *The Order of Release*, p.75;

Margaret Ruskin to John Ruskin, 27 November 1847, *The Ruskins and the Grays*, p.71; John Ruskin to Effie Gray, 2 March 1848, *The Ruskins and the Grays*, p.93; Andrew Jameson to Sophia Gray, 21 March 1848, Transcriptions of the Bowerswell Papers, p.208; John Ruskin to Rev. F.A. Malleson, 28 November 1872, *The Ruskins and the Grays*, p.67; John James Ruskin to George Gray snr., *The Ruskins and the Grays*, p.110.

30. Andrew Jameson to Sophia Gray, 21 March 1848, *The Ruskins and the Grays*, p.102; John Ruskin to Effie Gray, 24 January 1848, *The Ruskins and the Grays*, p.81; Effie Ruskin to Sophia Gray, 11 April 1848, *The Order of Release*, p.97; John Ruskin to Mary Russell Mitford, April 1848, *The Order of Release*, p.98.

31. John Ruskin to Effie Gray, 15 December 1848, *The Order of Release*, p.68; John Ruskin to Margaret Ruskin, 12 August 1862, *The Ruskins and the Grays*, p.108.

32. John Everett Millais, *The Ruling Passion (The Ornithologist)*, 1885, oil on canvas, Glasgow City Council (Museums); Effie Ruskin to Sophia Gray, 22 and 28 April and 3 May 1848, *The Order of Release*, pp.100–4; John James Ruskin to George Gray snr., 24 May 1848, *The Order of Release*, p.102.

33. Samuel Rogers, Richard Porson and William Maltby, *Recollections of the Table Talk of Samuel Rogers* (New York: D. Appleton & Co. 1856), p.155; John Ruskin, *Modern Painters*, vol. V (New York: John Wiley 1863), pp.v, 329; Robert Hewison, Ian Warrell and Stephen Wildman (eds.), *Ruskin, Turner and the Pre-Raphaelites* (London: Tate Publishing 2000), p.84.

34. Effie Ruskin to Sophia Gray, 24 May, 1 June, 1 July and 16 November 1848, *The Order of Release*, pp.109–14, 169; Effie Ruskin to Sophia Gray, 20 July and 27 October 1848, *The Ruskins and the Grays*, pp.116, 127, 166; Effie heard in July 1848 that the Taskers believed that she and Prizie had been engaged for a year, Effie Ruskin to Sophia Gray, 23 July 1848, Morgan Library, MA1338 F.35.

35. John James Ruskin to George Gray snr., 24 August 1848, 31 August 1848, *The Ruskins and the Grays*, pp.136, 145; John James Ruskin to George Gray snr., 1 August 1848, *The Order of Release*, p.131; John Ruskin to John James Ruskin, 29 August 1848, 8 August 1849, *The Ruskins and the Grays*, pp.137, 247.

36. John Ruskin, 'On the Nature of Gothic', *The Stones of Venice* [1853], new edition J.G. Links (ed.) (London: Collins 1960), p.164; Effie Ruskin to Sophia Gray, 1, 4, 20 and 27 July 1848, *The Order of Release*, p.115, pp.117–18; Effie Ruskin to Margaret Ruskin, 25 April 1854, *The Order of Release*, p.119.

37. Effie Ruskin to Sophia Gray, n.d., *The Order of Release*, p.119; Effie Ruskin to Sophia Gray, 28 June 1848, *The Ruskins and the Grays*, p.121; John

Ruskin to George Gray snr., 29 June 1848, *The Ruskins and the Grays*, p.122; Effie Gray to Sophia Gray, 9 August 1848, from Abbeville, *The Order of Release*, pp.120–1.

38. Effie Ruskin to Sophia Gray, 14, 17 and 27 August and 3, 9 and 17 September 1848, *The Order of Release*, pp.120–4, 126–8; John Ruskin to Margaret Ruskin, 20 August 1848, *The Ruskins and the Grays*, pp.133–4; George Gray snr. to Effie Ruskin, 28 August 1848, *The Ruskins and the Grays*, p.139; Effie Ruskin to Sophia Gray, n.d. [7 October 1848], *The Ruskins and the Grays*, p.160; John Ruskin, *The Seven Lamps of Architecture*, preface to 1st edition, *The Works of John Ruskin*, vol. 8, p.3n; John Ruskin to John James Ruskin, 4 and 9 September and 7 October 1848, *The Ruskins and the Grays*, pp.140–1, 160.

39. *John Ruskin: The Early Years*, p.127; Effie Ruskin to Sophia Gray, 27 October 1848, Ruskin Library, Lancaster University, T110, Box 1; Effie Ruskin to Sophia Gray, 16 November 1848, *The Order of Release*, p.133; John James Ruskin to George Gray snr., 1 August 1848, *The Order of Release*, p.132.

40. Effie Ruskin to Sophia Gray, 7 June and 21 and 24 November 1848, *The Ruskins and the Grays*, pp.120, 170; John Ruskin to John James Ruskin, n.d. [September 1848], *The Ruskins and the Grays*, p.152.

41. John Ruskin to Effie Ruskin, 4 January and 24 June 1849, *The Order of Release*, pp.137, 146; John James Ruskin to George Gray snr., 30 March 1852, *The Order of Release*, p.191; George Gray snr. to John James Ruskin, November 1849, *The Order of Release*, p.156; Effie Ruskin to Sophia Gray, 1, 4 and 5 January 1849, *The Ruskins and the Grays*, pp.173–4; Andrew Jameson to Sophia Gray, 24 January 1849, Morgan Library, Bowerswell Papers MA1338 H.09.

42. George Gray snr. to Sophia Gray, 21 and 25 January and 6 February 1849, Morgan Library, Bowerswell Papers, MA1338 H.07, H.10, H.12; Robert Gray to Sophia Gray, 24 January 1849, Bowerswell Papers, MA1338 H.08

43. John Ruskin to Effie Ruskin, 10 May 1849, *The Order of Release*, p.142; John Ruskin, 2 September 1849, *Effie in Venice*, p.36.

44. *Effie in Venice*, pp.39–40; Effie Ruskin to Sophia Gray, 19 November 1849, *Effie in Venice*, p.76.

45. William Morris, preface to 'On the Nature of Gothic', reprinted 1892 by the Kelmscott Press, quoted in J.W. Mackail, *The Life of William Morris* (London, New York and Bombay: Longmans, Green and Co. 1901), vol. ii, p.275.

46. *The Stones of Venice*, p.168.

47. William Morris, preface to 'On the Nature of Gothic', reprinted 1892, *The Life of William Morris*, vol. ii, p.275; Effie Ruskin to Sophia Gray, n.d. October 1851, 29 December 1849, *The Order of Release*, p.179, 151; Effie

Ruskin to Sophia Gray, 17 October 1849, *Effie in Venice*, p.49; Effie Ruskin to George Gray jnr., 14 October 1849, *Effie in Venice*, p.48.

48. Effie Ruskin to Sophia Gray, 13, 24 and 27 November, 3 and 30 December and 11 March 1849 (last dated from postmark), *Effie in Venice*, pp.64, 74, 77, 81, 100, 156; Effie Ruskin to George Gray jnr., 15 November 1849, *Effie in Venice*, p.70.

49. Effie Ruskin to Sophia Gray, 28 October and 19 and 27 November 1849, *Effie in Venice*, pp.53–4, 71, 76.

50. Effie Ruskin to George Gray snr., 6 January 1850, *Effie in Venice*, p.106; Effie Ruskin to Sophia Gray, n.d. [February 1850], *Effie in Venice*, p.132.

51. Effie Ruskin to George Gray jnr., n.d. January and 18 February 1850, *Effie in Venice*, p.112, p.143; Effie Ruskin to Sophia Gray, 9 February and 5 July 1850, *Effie in Venice*, pp.137, 158.

52. Effie Ruskin to Rawdon Brown, 2 July 1850, *Effie in Venice*, p.136n.; Effie Ruskin to Sophia Gray, 22 December 1850, *Effie in Venice*, pp.91–3.

53. Effie Ruskin to George Gray jnr., 9 March 1850, *Effie in Venice*, p.154.

54. John Everett Millais, *A Dream of Fair Women*, wood engraving by the Dalziel Brothers, for the Moxon Tennyson, 1857, V&A Museum; Effie Ruskin to Sophia Gray, 20 June 1850, copy held by Ruskin Library, Lancaster University, T110.

55. Effie Ruskin to Sophia Gray, 18 June and 30 October 1850, *The Order of Release*, pp.161, 163; Effie Ruskin to Sophia Gray, *Effie in Venice*, p.172. Effie arranged her 'At Homes' for Friday evenings from 9 to 11pm, beginning on 28 February 1851 and running through to the end of March. John Ruskin to Margaret Ruskin, *The Order of Release*, p.159.

56. John Ruskin, *The Seven Lamps of Architecture* (1849), in *The Works of John Ruskin*, vol. 8., p.219, and 'The Opening of the Crystal Palace Considered in Some of Its Relations to the Prospects of Art' (1854), in *The Works of John Ruskin*, vol. 12, pp.419–20; John Ruskin, diary, 1 May 1851, *Effie in Venice*, p.173.

57. Effie Ruskin to Sophia Gray, n.d. [2 May 1851], copy held by Ruskin Library, Lancaster University.

58. Effie Ruskin to Sophia Gray, 2 July 1850, *The Order of Release*, p.162.

59. Queen Victoria, journal, 1 May 1851, Christopher Hibbert (ed.), *Queen Victoria in Her Letters and Journals* (London: John Murray 1984), new edition (Stroud: Sutton Publishing 2000), p.84; A.N. Wilson, *The Victorians* (London: Hutchinson 2002), p.137.

60. Effie Ruskin to Sophia Gray, n.d. [2 May 1851], copy held by Ruskin Library, Lancaster University; John Ruskin, *The Opening of the Crystal Palace*, p.144.

61. Effie Ruskin to Rawdon Brown, n.d., *Effie in Venice*, pp.170–1.

62. Effie Ruskin to Rawdon Brown, n.d. 1850, *The Order of Release*, p.162; Effie Ruskin to Mr and Mrs Gray, 27 October 1851, *Effie in Venice*, pp.205–6.

63. *Effie in Venice*, pp.171–2, 190n., 250n.; John James Ruskin to George Gray snr., 15 December 1851, *The Order of Release*, p.185; Effie Ruskin to George Gray jnr., 19 September 1851, *Effie in Venice*, p.190; Effie Ruskin to Sophia Gray, 20 October and 1, 6 and 30 November 1851 and n.d. [January 1852], *Effie in Venice*, pp.202, 207, 213, 222n., 250, 253.

64. Effie Ruskin to Sophia Gray, 8 and 24 February 1852, *Effie in Venice*, pp.264, 275; John Ruskin to John James Ruskin, 27 December 1851 and 17 March 1852, *Effie in Venice*, pp.261, 288.

65. Effie Ruskin to Rawdon Brown, 22 July 1852, *Effie in Venice*, p.340; Effie Ruskin to George Gray snr., 10 October 1851, *The Order of Release*, p.184; *Effie in Venice*, p.331.

66. Effie Ruskin to Sophia Gray, 12 June 1852 and n.d. [15 June 1852], *Effie in Venice*, pp.320, 323; *Effie in Venice*, pp.341–3; John Ruskin to John James Ruskin, 28 December 1852, *Effie in Venice*, p.262.

67. Effie Ruskin to Sophia Gray, 1851, *Effie in Venice*, p.175; Effie Ruskin to Sophia Gray, 19 July 1851, *The Order of Release*, p.165; Effie Ruskin to Sophia Gray, 5 May 1851, Ruskin Library, Lancaster University, T110, Box 2; John Ruskin to George Gray snr., 8 August 1852, Ruskin Library, Lancaster University, T110, Box 1.

68. *John Ruskin: The Early Years*, p.173; Effie Ruskin to Sophia Gray, 25 February 1853, *The Order of Release*, p.197; Effie Ruskin to Sophia Gray, 26 July and 2 August 1852, *Millais and the Ruskins*, p.9.

69. John Everett Millais, *Effie with Foxgloves* (oil on board, 1853, Wightwick Manor, The Mander Collection/The National Trust); John Everett Millais, *Christ in the House of his Parents* (oil on canvas, 1849–50, Tate). Charles Dickens, 'Old Lamps for New Ones', in *Household Words* (London 1850), p.266; John Ruskin, 'Pre-Raphaelitism' (London: Smith, Elder & Co. 1851), pp.15, 20, 21.

70. John Everett Millais, *The Order of Release 1746* (1852–3, oil on canvas, Tate); Effie Ruskin, spring 1850, *The Order of Release*, pp.159, 167; Effie Ruskin to Sophia Gray, 20 June 1853, *Millais and the Ruskins*, p.51; William Holman Hunt, *John Everett Millais* (dated 12 April 1853, pastel and coloured chalks, National Portrait Gallery, London). Hunt, Millais, Rossetti and F.G. Stephens met to draw portraits of one another on this day. They wanted to send them to their Pre-Raphaelite Brother Thomas Woolner, who was sailing for Australia, as a memorial of their friendship.

71. Many modern British artists, notably Queen Victoria's favourites William Etty and Frederic Leighton, prided themselves on sketching all their figures in the nude first, and then draping them. They claimed that this made their paintings more convincing.

72. John Everett Millais, *The Race Meeting* (1853, pen and sepia ink, Ashmolean Museum). The spectacle of Derby Day was popular among artists and illustrators, including Everett's friend John Leech. Everett's own picture predates William Powell Frith's sensational panorama of the event, *Derby Day* (1858, oil on canvas, Tate), by three years.

73. Effie Ruskin to Sophia Gray, 3 May 1853, *Millais and the Ruskins*, p.45; the sketch is in the Whitworth Art Gallery, Manchester. Anne Ryan was the model for the women in *A Huguenot, on St Bartholomew's Day, Refusing to Shield Himself from Danger by Wearing the Roman Catholic Badge* (1851–2, oil on canvas, The Makins Collection) and *The Proscribed Royalist 1651* (1852–3, oil on canvas, The Lord Lloyd Webber Collection), Leslie Parris (ed.), *The Pre-Raphaelites* (London: Tate Publishing 1984), p.108; Rev. John Eagles, 'The Fine Arts and Public Taste', *Blackwood's Edinburgh Magazine*, July 1853, quoted in *Millais and the Ruskins*, p.46.

74. Effie Ruskin to Sophia Gray, 8 May 1853, *Millais and the Ruskins*, p.47; From the memoir of Jane Ellen Frith, quoted in Edwina Ehrman, 'Frith and Fashion', Mark Bills and Vivien Knight (eds.), *William Powell Frith: Painting the Victorian Age* (New Haven and London: Yale University Press 2006), p.117; John Ruskin to John James Ruskin, 23 February 1852, *Effie in Venice*, p.275.

75. Effie Ruskin to Sophia Gray, 14 May 1853, *Millais and the Ruskins*, p.48; The journalist G.H. Lewes, future husband of George Eliot, attempted to reveal Maria Hayden as a charlatan after attending a séance at which he had asked the spirits the question: 'Is Mrs Haydon [sic] the Medium, an impostor', to which they apparently answered 'Yes'. *The Leader*, 12 January 1853, quoted in Peter Lamont, *The First Psychic: The Peculiar Mystery of a Notorious Victorian Wizard* (London: Little, Brown 2005), p.42; 'Faraday on table-moving', *Athenaeum*, 2 July 1853, pp.801–3, *The First Psychic*, p.41.

76. Effie Ruskin to Sophia Gray, 14 May 1853, *Millais and the Ruskins*, p.48; *The First Psychic*, pp.163–5; Joan Evans and John Howard Whitehouse (eds.), 26 November 1853, *The Diaries of John Ruskin 1848–1873* (Oxford: Clarendon Press 1958), p.484.

77. John Everett Millais, *Accepted* (1853, pen and ink, Yale Center for British Art); John Everett Millais, *The Blind Man* (1853, pen and ink, Yale Center for British Art).

78. John Everett Millais to William Holman Hunt, 28 June 1853, *Millais and*

the Ruskins, p.55. The picture (John Everett Millais, *Effie Ruskin*, 1853, pencil with watercolour) is now in the Geoffroy Richard Everett Millais Collection.

79. Queen Victoria's journal, 22 April 1853, *Queen Victoria in Her Letters and Journals*, p.97; Malcolm Nicholson, 'Sir James Young Simpson, first baronet (1811–1870)', H.C.G. Matthew and Brian Harrison (eds.), *Oxford New Dictionary of National Biography* (Oxford: Oxford University Press 2004), vol. 50, pp.695–7; Effie Ruskin to Sophia Gray, 2 July 1853, *Millais and the Ruskins*, pp.57, 264.

80. John Everett Millais to William Holman Hunt, 3 July 1853, *Millais and the Ruskins*, p.59; William Millais, July 1853, *The Order of Release*, p.203.

81. John Ruskin to John James Ruskin, 4 July 1853, *Millais and the Ruskins*, p.60; John Everett Millais, August 1853, *The Order of Release*, p.204; John Everett Millais to Charles Collins, *Millais and the Ruskins*, p.72; Effie Ruskin to Sophia Gray, 10 July 1853, *Millais and the Ruskins*, pp.65–6.

82. John Ruskin to John James Ruskin, 24 July 1853, *Millais and the Ruskins*, p.72; John Everett Millais to William Holman Hunt, 17 July 1853, *Millais and the Ruskins*, p.69.

83. John Everett Millais, *The Eve of St Agnes*, 1854, pen and ink, private collection; John Everett Millais to William Holman Hunt, 24 July and 29 August 1853 and n.d. [after 3 September 1853], *Millais and the Ruskins*, pp.70–1, 88–9; Effie Ruskin, diary 1856, p.7; John Ruskin to John James Ruskin, 1 August 1853, *Millais and the Ruskins*, p.75; John Everett Millais, *Cruel Treatment of a Master to his Pupil*, (31 July 1853, pen and brown ink, private collection); John Everett Millais to Charles Collins, 14 August 1853, *Millais and the Ruskins*, p.80; John Guille Millais, *The Life and Letters of Sir John Everett Millais, President of the Royal Academy* (London: Methuen & Co. 1899), vol. i, p.141; John Everett Millais to Mrs Collins, *Millais and the Ruskins*, p.90.

84. John Ruskin to John James Ruskin, 9 August and 11 and 16 October 1853, *Millais and the Ruskins*, pp.77, 93, 97; John Everett Millais to William Holman Hunt, 20 October 1853, *Millais and the Ruskins*, p.99.

85. Effie Ruskin to Rawdon Brown, 10 October 1853, *Millais and the Ruskins*, p.95; Elizabeth Gaskell to Catherine Winkworth, 11–14 October 1854, *The Letters of Mrs Gaskell*, p.309. It has not been possible to identify exactly where Florence Nightingale met Effie. It may have been with the Trevelyans in Northumberland, with Mr MacNaughton of Inver Trossach or with Mr Stirling MP at Keir; John Everett Millais to Charles Collins, 28 October 1853, copy held by Ruskin Library, Lancaster University, T110, Box 1; John Ruskin to William Holman Hunt, 20 October 1853, *Millais and the Ruskins*, pp.100–1; John Everett

Millais to William Holman Hunt, 21 October 1853, *Millais and the Ruskins*, p.102.

86. John Everett Millais to William Holman Hunt, 29 October 1853, *Millais and the Ruskins*, p.103; John Ruskin to Margaret Ruskin, 11 November 1853, *Millais and the Ruskins*, p.109; Effie Millais to Mrs La Touche, 10 October 1870, copy held by Ruskin Library, Lancaster University, T110; Effie Ruskin to Rawdon Brown, 30 November 1853, *Millais and the Ruskins*, p.113.

87. Dante Gabriel Rossetti, quoted in *The Life and Letters of Sir John Everett Millais*, vol. i, p.217.

88. Effie Ruskin to Sophia Gray, 27 February 1853, *Millais and the Ruskins*, p.142; John Everett Millais to Sophia Gray, 19 and 20 December 1853, *Millais and the Ruskins*, pp.120–4.

89. John Ruskin to Sophia Gray, 27 December 1853, *Millais and the Ruskins*, p.126; Effie Ruskin to Sophia Gray, 1 January 1854, *Millais and the Ruskins*, pp.128–9; *Jane Eyre*, by Charlotte Brontë [Currer Bell], the most notorious fictional account of an insane wife, was published in 1847; Effie Ruskin to Sophia Gray, 22 July 1852, *The Order of Release*, p.195; Effie Ruskin to Rawdon Brown, 4 February 1854, *Millais and the Ruskins*, p.133; Elizabeth Gaskell John Ruskin to John Forster, 17 May 1854, *The Letters of Mrs Gaskell*, p.288; George Gray snr., 5 July 1849, *The Order of Release*, p.146; John Ruskin to George Gray snr., 16 February 1853, *Millais and the Ruskins*, pp.135–6; Mike Halliday to William Holman Hunt, 5 May 1854, *Millais and the Ruskins*, p.93n.

90. Effie Ruskin to Sophia Gray, 27 February and 2 and 3 March 1854, *Millais and the Ruskins*, pp.144, 147–9.

91. Jane Douglas Boswell to Effie Ruskin, *The Order of Release*, p.204; Effie Ruskin to Sophia Gray, 27 February and 3 and 26 March 1854, *Millais and the Ruskins*, pp.140–1, 152, 160; Effie Ruskin to Rawdon Brown, 4 February 1854, *Millais and the Ruskins*, p.132; Effie and Lady Eastlake initially thought they might consult Lord Glenelg, retired MP and former President of the Board of Trade, but he was evidently unwilling to get involved in the potential scandal.

92. John Everett Millais to Sophia Gray, 3 March 1854, *Millais and the Ruskins* pp.150–1.

93. Effie Ruskin to George Gray snr., 6 March 1854, *Millais and the Ruskins*, pp.154–7.

94. John Everett Millais, *Waiting*, 1854, oil on canvas, Birmingham Museums and Art Gallery; Effie Ruskin to Sophia Gray, Tuesday evening, 6 o'clock [30 May 1854], copy held by Morgan Library; deposition signed by Dr Charles Locock and Dr Robert Lee, 30 May 1854, *Millais and the Ruskins*, pp.218–19. Dr Lee was an obstetric physician and lecturer, Dr Locock attended the Queen at the

birth of all her children; Lady Eastlake to Sophia Gray, 31 May 1854, *Millais and the Ruskins*, p.219.

95. Lady Eastlake to Effie Ruskin, 3 May 1854, Morgan Library, MA1338 (UV13); *Millais and the Ruskins*, p.172; Effie Ruskin to Rawdon Brown, 10 April 1854, *Millais and the Ruskins*, p.173; Effie Ruskin to Rawdon Brown, 14 April 1854, Morgan Library, MA1338 (T.34); Sophia Gray to George Gray jnr., 24 April 1854, *Millais and the Ruskins*, p.180; Lady Eastlake to Effie Ruskin, 18 April 1854, Morgan Library MA1338 (T.37); Lady Eastlake to Sophia Gray, 18 April 1854, Morgan Library, MA1338 (T.36).

96. Lady Eastlake to Effie Ruskin, 27 April 1854, Morgan Library, MA1338 (UV05); 'I lie down on my bed, close my eyes, open my legs and think of England', Lady Hillingham, private journal, 1912, *Inventing the Victorians*, p.xii; *Queen Victoria in Her Letters and Journals*, p.64; John Champley Rutter to John James Ruskin, 23 May 1854, *Millais and the Ruskins*, p.192n.; Andrew Jameson to Sophia Gray, 27 April 1854, Morgan Library, MA1338 (UV03); George Gray jnr. to Sophia Gray, 22 April 1854, Morgan Library, MA1338 (T.39); Miss Mary Ainsworth to Effie Ruskin, Thursday, 27 April 1854, Morgan Library, MA1338 (UV04).

97. Lady Eastlake to Sophia Gray, 29 April 1854, Morgan Library, MA1338 (UV06); Lady Eastlake to Effie Ruskin, 3 May 1854, *Millais and the Ruskins*, p.199; Rawdon Brown to Effie Ruskin, Monday, 1 May 1854, Morgan Library, MA1338 (UV09); John Everett Millais to Mrs Gray, 5 May 1854, Morgan Library MA1338 (UV14); John Ruskin to Frederick Furnivall, 1 May 1854, *Millais and the Ruskins*, p.202; William Holman Hunt, *The Awakening Conscience*, (1853–4, oil on board, Tate Gallery); William Holman Hunt, *The Light of the World*, (1851-3, oil on canvas over panel, Keble College, Oxford); John Ruskin, 'Letter to the *Times*', 25 May 1854, *The Works of John Ruskin*, vol. 12, pp.333–5.

98. John Ruskin to Frederick Furnivall, 9 June 1854, *Millais and the Ruskins*, p.213; Effie Ruskin to Rawdon Brown, 9 May 1854, *Millais and the Ruskins*, p.207; Lady Eastlake to Sophia Gray, 29 April 1854, Morgan Library, MA1338 (UV06); John Everett Millais to Sophia Gray, 27 April and 10 May 1854, *Millais and the Ruskins*, pp.197, 209–10; Phyllis Rose, *Parallel Lives: Five Victorian Marriages* (New York: Alfred A. Knopf 1983), pp.60, 248; John Everett Millais to Dante Gabriel Rossetti, 22 May 1854, 'Unpublished Letters of Ruskin and Millais, 1854–1855', p.47.

99. John Everett Millais to F.J. Furnivall, 23 May 1854, *Millais and the Ruskins*, p.215 and 'Unpublished Letters of Ruskin and Millais, 1854–1855', p.45; Rawdon Brown to Effie Ruskin, Monday, 1 May 1854, Morgan Library,

MA1338 (UV09); Effie Ruskin to Rawdon Brown, 9 May 1854, Morgan Library, MA1338 (UV20); *Parallel Lives: Five Victorian Marriages*, p.59; J. Howard Whitehouse, *Vindication of Ruskin* (London: George Allen and Unwin Ltd 1950), pp.12–16; 'Unpublished Letters of Ruskin and Millais, 1854–1855', p.51; John Ruskin to Mrs Cowper Temple, 20 September 1870, *Millais and the Ruskins*, p.231.

100. J.I. Glennie (Proctor) to George Gray snr., 15 July 1854, *Millais and the Ruskins*, p.229; Jane Douglas Boswell to Effie (Copy by Clare Stuart Wortley), 10 July 1854, Morgan Library, MA1338 (UV86); another image of this type that Everett painted in 1854 was *The Violet's Message*, (oil on panel, private collection); John Everett Millais to Effie Gray, 21–2 July 1854, *Millais and the Ruskins*, pp.234–6; John Everett Millais to Sophia Gray, 18 April 1854, *Millais and the Ruskins*, p.178.

101. Elizabeth Eastlake to Effie Gray, 10 August 1854, Transcriptions of the Bowerswell Papers, p.143; Effie Gray to Rawdon Brown, 9 October 1854 and 5 January 1855, *Millais and the Ruskins*, pp.241, 253; Effie Millais to Mrs La Touche, 10 October 1870, copy held in Tate Archive; John Everett Millais to Effie Gray, 27 July 1854, *Millais and the Ruskins*, pp.236–9.

102. John Everett Millais to William Holman Hunt, 25 August 1854, *Millais and the Ruskins*, p.243; John Ruskin to John Everett Millais, 11, 16 and 20 December 1854, *Millais and the Ruskins*, pp.247–8; Miss Mary Ainsworth to Sophia Gray, 31 July 1854, *Millais and the Ruskins*, p.242; Miss Mary Ainsworth to Effie Gray, 26 August 1854, Transcriptions of the Bowerswell Papers, p.152; John Everett Millais to John Ruskin, 18 December 1854, *Millais and the Ruskins*, p.248; John Ruskin, *Academy Notes 1855*, quoted in Jason Rosenfeld and Alison Smith (eds.), *Millais* (London: Tate Publishing 2007), p.247; John James Ruskin to John Everett Millais, 20 December 1854, *Millais and the Ruskins*, p.250; John James Ruskin to Charles Collins, 28 December 1854, *Millais and the Ruskins*, pp.250–1.

103. Effie Gray to Rawdon Brown, 21 March and 18 April 1854, *Millais and the Ruskins*, pp.254, 255; Miss Mary Ainsworth to Effie Gray, 26 August 1854, Transcriptions of the Bowerswell Papers, p.152; www.victorianweb.org/science/health/health10.html

104. Effie Ruskin to Sophia Gray, n.d. [2–3 March 1854], *Millais and the Ruskins*, p.149; Lady Eastlake to Effie Gray, 10 August 1854, Transcriptions of the Bowerswell Papers, p.142; Effie Millais, diary 1856, private collection, pp.3, 5, 7, 9; John Ruskin to Frederick Furnivall, 3 June 1855, 'Unpublished Letters of Ruskin and Millais, 1854–1855', p.50; *Vindication of Ruskin*, p.14; John Everett

Millais to William Holman Hunt, n.d. [19 June 1855], n.d. [3 July 1855], *Millais and the Ruskins*, pp.260, 261.

105. John Everett Millais, *The Young Mother*, (1856, etching, Victoria and Albert Museum); Effie Millais, diary 1856, private collection, pp.12–15; John Keats, 'Staffa', *Selected Poetry* [Oxford: Oxford University Press 1994], new edition 1998, p.114.

106. Effie Millais, diary 1856, private collection, pp.15–17.

107. Effie Millais, diary 1856, private collection, pp.3, 17–18, 22–4; *The Life and Letters of Sir John Everett Millais*, vol. i, pp.327, 340; George Gray snr. to Effie Millais, 'Address by the Directors of the Perth Gaslight Company to the Consumers of Perth', 27 November 1861 and 30 April and 2 November 1864, Geoffroy Richard Everett Millais Collection, Tate loan C, parcel 7; George Gray jnr. to Effie Millais, 4 October 1876, Geoffroy Richard Everett Millais Collection, Tate loan C, parcel 9A; John Everett Millais, *The Blind Girl*, (1854–6, oil on canvas, Birmingham Museums and Art Gallery); John Everett Millais to William Holman Hunt, 1855, *Millais and the Ruskins*, p.266.

108. John Everett Millais, *L'Enfant du Régiment*, (1854–6, oil on prepared paper, laid on canvas, Yale Center for British Art); John Everett Millais, *Peace Concluded, 1856*, 1856, oil on canvas, Minneapolis Institute of Arts, *Millais*, p.108; John Everett Millais to Effie Millais, 5, 6, 8 and 9 April 1856, Morgan Library; Effie Millais, diary 1856, private collection, p.3; *Elizabeth Gaskell: A Habit of Stories*, p.45; *The Life and Letters of Sir John Everett Millais*, vol. i, pp.291–7; William Holman Hunt, *The Scapegoat*, (1854–5, 1858, oil on canvas, City of Manchester Art Galleries).

109. *The Life and Letters of Sir John Everett Millais*, vol. i, pp.296–9, 304–5; John Everett Millais to Effie Millais, 10 April 1856, Morgan Library; it is estimated that five women died for every 1,000 live births in mid-Victorian Britain. *The Victorian House*, p.16; John Everett Millais to William Holman Hunt, 30 May 1856, *Millais and the Ruskins*, p.264; William Allingham to John Everett Millais, 10 November 1855, *The Life and Letters of Sir John Everett Millais*, vol. i, p.257; John Everett Millais to Effie Millais, 4 and 8 May 1856, *The Life and Letters of Sir John Everett Millais*, vol. i, pp.299, 303.

110. George Gray snr. to Effie Millais, n.d. April 1861 and 7 and 8 May 1861, Geoffroy Richard Everett Millais Collection, Tate loan C, parcel 7.

111. John Everett Millais, *A Lost Love*, (1859, wood engraving by the Dalziel Brothers, published in *Once a Week*, vol. I, Victoria and Albert Museum); John Everett Millais, *Practising*, (1860, wood engraving by Joseph Swain, published in *Once a Week*, vol. II, Victoria and Albert Museum); Leonée Ormond, 'Millais and Contemporary Artists', in Debra Mancoff (ed.), *John Everett Millais: Beyond the*

Pre-Raphaelite Brotherhood (New Haven: Yale University Press 2001), p.38; *The Life and Letters of Sir John Everett Millais*, vol. i, pp.339, 343, 358; Effie Millais, diary 1856, p.3; Effie Millais to George Gray snr., 29 July 1856; *The Works of John Ruskin*, vol. 14, p.107; George Gray snr. to Effie Millais, 8 December 1871 and 7 April 1859, Geoffroy Richard Everett Millais Collection, Tate loan C, parcels 7, 7A.

112. Jeremy Musson, '"Has a Pot of Paint done all this?" The Studio-House of Sir John Everett Millais, Bt.', in *John Everett Millais: Beyond the Pre-Raphaelite Brotherhood*, pp.99–100. Number 7 Cromwell Place currently houses the offices of the National Art Collections Fund; *The Life and Letters of Sir John Everett Millais*, vol. i, p.334.

113. *The Life and Letters of Sir John Everett Millais*, vol. i, p.372; Effie Millais, *Manuscript Catalogue of the Work of John Everett Millais (1859–1864)*, Morgan Library, MA4987; Elizabeth Gaskell to Charles Eliot Norton, 24 June 1861, *The Letters of Mrs Gaskell*, p.661; Arthur Munby, diary, 1 June 1861, Derek Hudson (ed.), *Munby: Man of Two Worlds* (London: Abacus 1974), p.97; Eduard Hanslick, quoted in Harold C. Schonberg, *The Great Pianists* (New York: Simon and Schuster 1987), p.275; John Ella to Effie Millais, 30 April 1868, Geoffroy Richard Everett Millais Collection, Tate loan B, file D; John Everett Millais to Effie Millais, 8 April 1856, Morgan Library.

114. John Everett Millais to Sophia Gray, 3 November 1865, *Millais and the Ruskins*, p.267; Effie Millais to Sophia Gray, 24 October 1865, *Millais and the Ruskins*, p.267; *The Life and Letters of Sir John Everett Millais*, vol. i, pp.391–2.

115. C. Elsee, master at Rugby School, to Effie Millais, 24 September 1870, Geoffroy Richard Everett Millais Collection, Tate loan B, file D; John Bond to Effie Millais, 4 October 1870, Geoffroy Richard Everett Millais Collection, Tate loan B, file D; George Millais to Effie Millais, [1872], Geoffroy Richard Everett Millais Collection, Tate loan B, parcel 10; Evie Millais to Effie Millais, 21 April [1872], Geoffroy Richard Everett Millais Collection, Tate loan C, parcel 10; Effie Millais to John Everett Millais, 13, 23 and 29 July 1871, copies held by Ruskin Library, Lancaster University, T110; Effie Millais to George Gray jnr., 29 July 1871, copy held by Ruskin Library, Lancaster University, T110; Everett Millais to Sophia Gray, 31 July 1871, copy held by Ruskin Library, Lancaster University, T110; Effie Millais to George Gray snr., 3 August 1871, copy held by Ruskin Library, Lancaster University, T110.

116. Evie Millais to Effie Millais, 7 January and 22 February 1872, Geoffroy Richard Everett Millais Collection, Tate loan C, parcel 10; Effie Millais jnr. to Effie Millais, 18 February 1872, Geoffroy Richard Everett Millais Collection, Tate loan C, parcel 10; George Gray snr. to Effie Millais, 23 January and 17

February 1872, Geoffroy Richard Everett Millais Collection, Tate loan C, parcel 7A; Sophia Gray to Effie Millais, 5 and 12 March 1872, Geoffroy Richard Everett Millais Collection, Tate loan C, parcel 6.

117. John Everett Millais, *Hearts Are Trumps: Portraits of Elizabeth, Diana and Mary, Daughters of Walter Armstrong, Esq.*, (1872, oil on canvas, Tate Gallery); *Athenaeum*, 4 May 1872, quoted in *Millais*, p.194; Sophia Gray to Effie Millais, 6 May 1872, Geoffroy Richard Everett Millais Collection, Tate loan C, parcel 6; Constance, Duchess of Westminster, to Effie Millais, 30 March 1872, Geoffroy Richard Everett Millais Collection, Tate loan B, file D; Hugh, Duke of Westminster to Effie Millais, 18 July 1872, Geoffroy Richard Everett Millais Collection, Tate loan B, file D; George Gray snr. to Effie Millais, 22 March and 7 May 1872, Geoffroy Richard Everett Millais Collection, Tate loan C, parcel 7A.

118. John Everett Millais, 'The tower of strength which stood four-square to all the winds that blew', (1878–9, oil on canvas, Geoffroy Richard Everett Millais Collection); William Morris, *Today*, 1884, quoted in *John Everett Millais: Beyond the Pre-Raphaelite Brotherhood*, p.3; Arthur Symons, *Savoy Magazine*, 1896, quoted in *Millais*, p.14; Roy Strong, 'Down with Effie', *Spectator*, 20 January 1967, p.72.

119. James Whistler to Henri Fantin-Latour, quoted in Paul Barlow, *Time Present and Time Past: The Art of John Everett Millais* (Aldershot: Ashgate 2005), p.55; 'Down with Effie', p.72; Beatrix Potter, journal, 1 August 1884, *The Journal of Beatrix Potter from 1881 to 1897, transcribed from her code writing by Leslie Linder* (London and New York: Frederick Warne 1966), p.103; 'Reminiscences of Millais by Valentine Prinsep, R.A.', *The Life and Letters of Sir John Everett Millais*, vol. ii, pp.379, 381; *The Life and Letters of Sir John Everett Millais*, vol. i, pp.52, 265, vol. ii, pp.262, 354; James Whistler, 'The Ten o'Clock Lecture', *The Gentle Art of Making Enemies*, 2nd edition [1892], new edition (New York: Dover Publications 1967), p.152; Malcolm Warner, 'John Everett Millais', *Oxford New Dictionary of National Biography*.

120. *The Life and Letters of Sir John Everett Millais*, vol. ii, pp.2, 401; John Everett Millais, *Gladstone*, (1879, oil on canvas, National Portrait Gallery, London); John Everett Millais, *Victory O Lord!*, (1871, oil on canvas, Manchester Art Gallery); *Time Present and Time Past*, pp.147, 189–90; Hugh, Duke of Westminster to John Everett Millais, 23 November 1875, 10 March 1876, Geoffroy Richard Everett Millais Collection, Tate loan B, file B; Louise Jopling, quoted in Peter Funnell (ed.), *Millais: Portraits* (London: National Portrait Gallery 1999), p.203.

121. Effie Millais to John Everett Millais, 1 June [1869], quoted in *Millais*, p.192; 19 March 1873, note confirming sale of land, Transcriptions of the

Bowerswell Papers, 1/107; Arthur Munby, diary, 1 January 1867, *Munby*, p.235; Jane Boswell to Effie Millais, 3 March 1869, Geoffroy Richard Everett Millais Collection, Tate loan B, file D; Clare Ford to Effie Millais, 1 December 1876, 28 December 1877, 21 January 1878, 31 December 1878, Geoffroy Richard Everett Millais Collection, Tate loan B, file B; Clare Ford to Effie Millais, [1890], quoted in *Millais*, p.178.

122. *The Life and Letters of Sir John Everett Millais*, vol. ii, p.386; *Millais: Portraits*, p.173; A similar slit-door for large canvases can still be seen at Leighton House Museum, Holland Park, London. Servants and models also had access to Leighton's studio via a small spiral staircase, concealed behind a screen. Models would undress on the far side of the screen before entering the main studio space; 'Mr Millais's New House and Studio', *Birmingham Daily Post*, 17 April 1876.

123. *The Art Annual*, 1885, p.29, quoted in 'The Studio-House of Sir John Everett Millais, Bt.', p.108; *The Life and Letters of Sir John Everett Millais*, vol. ii, p.239; 21 July 1877, order to A. Perpignan et Frères, Bordeaux, Geoffroy Richard Everett Millais Collection, Tate loan B, file B; Cosima Wagner to Effie Millais, 6 May 1877, Geoffroy Richard Everett Millais Collection, Tate loan B, file B; Richard Wagner to Effie Millais, 22 May 1877, Geoffroy Richard Everett Millais Collection, Tate loan B, file B; Beatrix Potter, journal, 12 July 1884, *The Journal of Beatrix Potter*, p.97; *Time Present and Time Past*, p.182.

124. *Millais: Portraits*, p.167; Effie Millais to George Gray snr., 19 November 1875, Geoffroy Richard Everett Millais Collection, Tate loan B, file D; Constance, Duchess of Westminster, [1873], Geoffroy Richard Everett Millais Collection, Tate loan B, file D; Arthur Munby, diary, 22 March 1862 and 30 May 1870, *Munby*, pp.118, 284.

125. Arthur Munby, diary, 30 May 1870, *Munby*, p.284; Lady Eastlake to Effie Ruskin, 27 April 1854, *Millais and the Ruskins*, p.196.

126. Millicent, Duchess of Sutherland, to Effie Millais, 1 May 1874, Morgan Library, MA1485 (H2); Effie Millais to Millicent, Duchess of Sutherland, 2 May 1874, Morgan Library, MA1485 (H3); Sir Thomas Biddulph to Francis Knollys, 17 June 1874, Morgan Library, MA1485 (H10); John Everett Millais to Millicent, Duchess of Sutherland, 4 May 1874, Morgan Library, MA1485 (H6).

127. John La Touche to John Everett Millais, 3 October 1870, copy held by Ruskin Library, Lancaster University; John Everett Millais to John La Touche, 5 and 10 October 1870, copies held by Ruskin Library, Lancaster University; Effie Millais to Mrs La Touche, 10 October 1870, copy held by Ruskin Library, Lancaster University; 'Praeterita', *The Works of John Ruskin*, vol. 35, pp.525, 533.

128. *The Gentle Art of Making Enemies*, pp.1–2.

129. George Gray snr. to Effie Millais, 3 January, 17 February, 2 and 22 July

and 31 December 1875, 15 January and 5 May 1876, Geoffroy Richard Everett Millais Collection, Tate loan C, Parcel 7A; Alice Gray to Effie Millais, 2 July [1867], Geoffroy Richard Everett Millais Collection, Tate loan C, parcel 8E; Effie Millais jnr. to John Everett Millais, 13 February 1872, Geoffroy Richard Everett Millais Collection, Tate loan C, parcel 10.

130. George Gray snr. to Effie Millais, 11 June 1875 and 5 September 1876, Geoffroy Richard Everett Millais Collection, Tate loan C, parcel 7A; Sophie Millais (Tottie) to Mary Millais, 4 January 1877, Geoffroy Richard Everett Millais Collection, Tate loan C, parcel 11; Evie Millais to Effie Millais, 6 January 1877, Geoffroy Richard Everett Millais Collection, Tate loan C, parcel 11; George Gray snr. to Effie Millais, 10 May 1871, Geoffroy Richard Everett Millais Collection, Tate loan C, parcel 7A.

131. J. Prior, Master of Trinity College, Cambridge to Effie Millais, 28 October 1877; Sir William Harcourt, n.d. [Sunday night, October 1877], Geoffroy Richard Everett Millais Collection, Tate loan B, file B.

132. Sophia Gray to Effie Millais, n.d. [1878], Geoffroy Richard Everett Millais Collection, Tate loan C, parcel 6; John Everett Millais to Thomas Barlow, 6 September 1878, quoted in *Millais*, p.200; Alice Stibbard to Effie Millais, 8 September 1878, Geoffroy Richard Everett Millais Collection, Tate loan C, parcel 8E.

133. *The Life and Letters of Sir John Everett Millais*, vol. i, p.433, vol. ii, p.92.

134. Clare Ford to Effie Millais, 29 April and 1 December 1876, Geoffroy Richard Everett Millais Collection, Tate loan B, file B; W.D. Scoone to John Everett Millais, n.d. March 1878, Geoffroy Richard Everett Millais Collection, Tate loan B, file B; Alice Stibbard to Effie Millais, 22 and 24 March 1881 and 12 and 18 April 1882, Geoffroy Richard Everett Millais Collection, Tate loan C, parcel 8E.

135. In 1885 Evie proudly reported to his mother his recent experience in Paris. He wanted to show his younger sister Tottie around the Jardin d'Acclimation. When he presented his card at the gate, the Head Manager of the Dog Department recognised Evie's name and insisted on taking them on a tour of his finest animals. He made them laugh and offered them both glasses of lemonade. Evie Millais to Effie Millais, 18 June 1885, Geoffroy Richard Everett Millais Collection, Tate loan C, parcel 12; 31 March, 7 May and 13 June 1885, Geoffroy Richard Everett Millais Collection, Tate loan C, parcel 12.

136. Carrie Millais to Effie Millais, 13 October 1885, Geoffroy Richard Everett Millais Collection, Tate loan C, parcel 12; Evie Millais to Effie Millais, 11 and 16 October and 31 December 1885, 12 and 14 March 1886, Geoffroy Richard Everett Millais Collection, Tate loan C, parcel 12; Geoffroy Millais to

Effie Millais, 11 May 1886, Geoffroy Richard Everett Millais Collection, Tate loan C, parcel 12.

137. John Everett Millais, *My First Sermon*, (1863, oil on canvas, Guildhall Art Gallery, London); 1865, *Waking*, oil on canvas, Perth Museums and Art Gallery; *Sleeping*, (1865–6, oil on canvas, private collection). *The Life and Letters of Sir John Everett Millais*, vol. i, p.378, and *Millais*, pp.173–4. A watercolour copy of *My Second Sermon*, exhibited at the Grosvenor Gallery in 1886, is held at the V&A Museum, London. See Suzanne Fagence Cooper, *Pre-Raphaelite Art in the Victoria and Albert Museum* (London: V&A Publications 2003), p.33. Effie's third daughter, born 1862, was christened Alice Sophia Caroline, but was known as Carrie, to distinguish her from her aunt Alice Stibbard (née Gray). Effie's fourth daughter, Sophia Margaret Jameson, was born in 1868 and named after her grandmother and aunt. Her grandfather called her Tottie. I have used these family nicknames to avoid confusion between the different generations. Effie's eldest daughter, also christened Euphemia Gray, I have referred to throughout as 'young Effie'; Effie Millais, diary, April 1856, private collection, p.22; *The Life and Letters of Sir John Everett Millais*, vol. i, p.395; George Gray snr. to Effie Millais, 12 November 1867, Geoffroy Richard Everett Millais Collection, Tate loan C, parcel 7A; Arthur Munby, diary entry for 2 February 1864, party held by Theodore Martin, *Munby*, p.176.

138. George Gray snr. to Effie Millais, 11 June 1872, Geoffroy Richard Everett Millais Collection, Tate loan C, parcel 7A; Elizabeth Lynn Linton, 'Out Walking', *Temple Bar*, 5 (1862), p.136, quoted in Lynne Walker, 'Vistas of pleasure: Women consumers of urban space in the West End of London 1850–1900', p.75, Clarissa Campbell Orr (ed.), *Women in the Victorian Art World* (Manchester and New York: Manchester Evening Press 1995), pp.71–85; Sophie Millais (Tottie) to Effie Millais, 12 February 1891, Geoffroy Richard Everett Millais Collection, Tate loan C, parcel 12.

139. John Everett Millais, *Sisters* (1868, private collection), *Millais*, cat. no. 90, p.146. James Whistler's *Symphony in White, No. 1: The White Girl* was exhibited in 1862 and *Symphony in White, No. 2: The Little White Girl* in 1864; William Michael Rossetti and Algernon Swinburne, *Notes on the Royal Academy Exhibition 1868*, Parts I and II (London: John Camden Hotten 1868), (Rossetti) pp.2, 13 and (Swinburne) pp.32–3.

140. George Gray snr. to Effie Millais, 5 May and 23 December 1865, 18 November 1867, 27 January, 18 February, 2 March, 6 May and 16 June 1868, Geoffroy Richard Everett Millais Collection, Tate loan C, parcel 7.

141. George Gray snr. to Effie Millais, 2 and 12 March 1868, Geoffroy Richard Everett Millais Collection, Tate loan C, parcel 7; Dr R. Cockerell, 25 Tay

Street, Dundee, to Effie Millais, 7 March 1868, Geoffroy Richard Everett Millais Collection, Tate loan C, parcel 1; George Gray snr. to Carrie Millais, 9 April, 11 May and 3 June 1868, Geoffroy Richard Everett Millais Collection, Tate loan C, parcel 7.

142. George Gray snr. to Effie Millais, 3 December 1861, n.d. 1866, 16 June 1868 and 25 February and 9 March 1874, Geoffroy Richard Everett Millais Collection, Tate loan C, parcel 7; *The Times*, advertisements, 6 May 1858, 9 January 1861 and 7 January 1878; Michael Musgrave, *The Musical Life of the Crystal Palace* (Cambridge: Cambridge University Press 1995), p.36.

143. Mary Millais to Effie Millais, 8 December 1872; Effie Millais jnr. to Effie Millais, 23 October and 8 December 1872, Geoffroy Richard Everett Millais Collection, Tate loan C, parcel 12.

144. Sophy Caird to Effie Millais, 30 December 1875, 7, 13 and 24 January 1876, Geoffroy Richard Everett Millais Collection, Tate loan C, parcel 8H; John Everett Millais to Effie Millais, 16 February 1878, Geoffroy Richard Everett Millais Collection, Tate loan C, parcel 11; Effie Millais jnr. to Effie Millais, 19 and 22 February 1878, Geoffroy Richard Everett Millais Collection, Tate loan C, parcel 11.

145. Sophy Caird (née Gray) to Effie Millais, 30 December 1875 and 7, 13 and 24 January 1876, Geoffroy Richard Everett Millais Collection, Tate loan C, parcel 8H; John Everett Millais to Effie Millais, 16 February 1878, Geoffroy Richard Everett Millais Collection, Tate loan C, parcel 11; Alice Stibbard to Effie Millais, 22 January 1878, Geoffroy Richard Everett Millais Collection, Tate loan C, parcel 8E; Effie Millais to John Everett Millais, 1 June [1869], quoted in *Millais*, p.192.

146. George Millais to Effie Millais, 17 March and 4 May 1878, Geoffroy Richard Everett Millais Collection, Tate loan C, parcel 11; Mary Millais to Effie Millais, 4 May 1878, Geoffroy Richard Everett Millais Collection, Tate loan C, parcel 11; George Gray snr. to Effie Millais, 19 June and 2 July 1875, Geoffroy Richard Everett Millais Collection, Tate loan C, parcel 7; Sophie Millais (Tottie) to Effie Millais, 12 February 1891, Geoffroy Richard Everett Millais Collection, Tate loan C, parcel 7A and 12; John Everett Millais to Effie Millais, n.d. 1865, Morgan Library; Sophie Millais (Tottie) to Effie Millais, 13 October (1880), Geoffroy Richard Everett Millais Collection, Tate loan C, parcel 12; John Everett Millais to Thomas Oldham Barlow, 6 September 1878, Geoffroy Richard Everett Millais Collection, Tate loan B.

147. Arthur Munby, diary entries for 2 February 1864, 1 January 1867 and 30 May 1870; George Gray snr. to Effie Millais, 5 May 1876, Geoffroy Richard Everett Millais Collection, Tate loan C, parcel 7A; Effie Millais jnr. to Effie

Millais, 8 and 19 February 1878, Geoffroy Richard Everett Millais Collection, Tate loan C, parcel 11; John Everett Millais, *The Bride of Lammermoor*, (1878, oil on canvas, Bristol City Museum); *The Life and Letters of Sir John Everett Millais*, vol. ii, pp.403, 478; Effie Millais jnr. to Effie Millais, 6 January 1878, Geoffroy Richard Everett Millais Collection, Tate loan C, parcel 11; Effie Millais to Sophia and Alice Gray, 23 February 1879, Morgan Library, MA1338(ZW.03); Beatrix Potter, *The Journal of Beatrix Potter*, p.104; Alice Stibbard to Effie Millais, 27 [February] 1879, Geoffroy Richard Everett Millais Collection, Tate loan C, parcel 8E.

148. *The Life and Letters of Sir John Everett Millais*, vol. ii, p.421; [unsigned], 'Sir Arthur Sullivan as a Church Musician', *The Musical Times*, 1 January 1901, pp.21–4; Constance, Duchess of Westminster, to John Everett Millais, 15 December [1879], Geoffroy Richard Everett Millais Collection, Tate loan B.

149. Alice Stibbard to Effie Millais, 25 October 1878, Geoffroy Richard Everett Millais Collection, Tate loan B, parcel 8F; H. Russell to Effie Millais, 19 September 1878; Effie Millais to H. Russell, 4 October 1878, Geoffroy Richard Everett Millais Collection, Tate loan C, file B (transcript)/file F (original), 2/255 and 2/257; George Millais to Effie Millais, 4 May 1878, Geoffroy Richard Everett Millais Collection, Tate loan C, parcel 11. Before she went to New Zealand, Mary visited North America. There is a record of her sailing by the Cunard Line from Liverpool to Boston on 23 April 1884, and her photograph album contains pictures of the Niagara Falls taken in May of that year, pp.25, 26. See 20 October 2005, Geoffroy Millais, notes on Mary Hunt Millais's photograph album, Millais Papers on loan to Tate Archive B; Mary Millais to Everett Millais, 25 July 1885, Geoffroy Richard Everett Millais Collection, Tate loan C, parcel 12; *Cyclopedia of New Zealand* (Christchurch, NZ: Cyclopedia Company Ltd 1903); Otago Peninsula Trust website (www.otagopeninsulatrust.co.nz). It seems that Mary's host, George Gray Russell, was not related to her brother's friend (Thomas) Henry Russell, who was awarded his Law Tripos (First Class) in 1879. Henry's family were originally Irish, from County Cork. His father, Thomas Russell, was one of New Zealand's leading property developers. He brought his family to England in 1874, and lived close to the Millais in London, at 22 Kensington Palace Gardens (www.dnzb.govt.nz).

150. Mary Millais to Everett Millais, 19 April 1886, Geoffroy Richard Everett Millais Collection, Tate loan C, parcel 12; Evie Millais to Effie Millais, 20 October and 31 December 1885, Geoffroy Richard Everett Millais Collection, Tate loan C, parcel 12; 'Marriage of Mr Stuart-Wortley. M.P. and Miss Millais', *The Times*, 7 January 1886, p.10.

151. Sophie Millais (Tottie) to Effie Millais, 12 February and n.d. 1891, Geoffroy Richard Everett Millais Collection, Tate loan C, parcel 12; in 1892

Everett sold *'The Little Speedwell's Darling Blue': 'In Memoriam' – Tennyson* for £1,500 to Agnews, *Millais*, cat. no. 108, p.186; *Rt. Hon. W. E. Gladstone, M.P. and His Grandson* (1890), *Mrs Joseph Chamberlain* (1891), *Master Anthony de Rothschild* (1892), John Guille Millais, *The Life and Letters of Sir John Everett Millais*, vol. ii, pp.484–5; *Millais: Portraits*, p.190; John Everett Millais, *Louise Jopling*, (1879, oil on canvas, National Portrait Gallery, London), *Millais*, cat. no. 118, p.204; Effie Millais jnr. to Effie Millais, 8 February 1878, Geoffroy Richard Everett Millais Collection, Tate loan C, box 11.

152. Diploma of a Dame, The Primrose League, no. 20839, presented to Lady Millais, 21 July 1885, private collection; suffrage campaign records held at the Women's Library, London; *Women's Penny Paper*, 26 January 1889, p.5, quoted in Judith R. Walkowitz, *City of Dreadful Delight: Narratives of Sexual Danger in Late-Victorian London* (London: Virago Press 1992, reprinted 1998), pp.62, 167. Mona Caird (1854–1932) was not related to James Caird of Dundee, who married Effie's sister Sophy Gray in 1873. Rather, she was the wife of another Scot, Sir James Alexander Henryson Caird, whom she married in 1877. Contrary to some reports, it was Sophy's, not Mona's, portrait which was exhibited at the Grosvenor Gallery in 1880.

153. Sophie Millais (Tottie) to Effie Millais, n.d. [1891], Geoffroy Richard Everett Millais Collection, Tate loan C, parcel 12; *The Times*, 10 December 1891, p.9.

154. John Everett Millais, *Bubbles*, (1886, oil on canvas, Unilever, on long loan to Lady Lever Art Gallery, Liverpool), *Millais*, cat. no. 107, p.184; Constance, Duchess of Westminster, to John Everett Millais, 15 December [1879], Geoffroy Richard Everett Millais Collection, Tate loan B; Willie James grew up to become an admiral. He was one of Effie's most vehement defenders, publishing *The Order of Release* in 1947; George Gray jnr. to Effie Millais, 16 November 1880, Geoffroy Richard Everett Millais Collection, Tate loan C, parcel 9A; John Everett Millais, *'The Little Speedwell's Darling Blue': 'In Memoriam' – Tennyson*, (1891–2, oil on canvas, National Museums Liverpool, Lady Lever Art Gallery), *Millais*, cat. no. 108, p.186.

155. Arthur Munby, diary entry for 1 January 1867, children's ball given by Mrs Senior and Miss Thackeray in Chelsea, *Munby*, p.235.

156. I have used George Gray's preferred spelling of her name – Sophy – to distinguish Effie's sister from her mother, Sophia, and Effie's daughter, known as Tottie. All three were christened Sophia Margaret. Sophy Gray to Effie Millais, 6 June 1867, Millais Papers on loan to Tate Archive II, parcel 8H.

157. John Everett Millais to William Holman Hunt, 19 March 1882, William Holman Hunt papers, Huntington Library, *Millais: Portraits*, p.211; Effie Millais

to Sophia Gray, 25–7 February 1854, *Millais and the Ruskins*, p.140; Effie Millais to Sophia Gray, 1 January 1854, *Millais and the Ruskins*, p.129; John Everett Millais to Sophia Gray, 17 January 1854, *Millais and the Ruskins*, p.130; *Millais*, p.173; *The Life and Letters of Sir John Everett Millais*, vol. ii, p.343.

158. *Autumn Leaves*, (1855–6, oil on canvas, Manchester City Galleries); *Spring*, (1856–9, oil on canvas, National Museums Liverpool, Lady Lever Art Gallery); *Sophie Gray*, (1857, oil on paper, laid on wood, private collection); Effie Millais, diary 1856, describing 20 October 1855, private collection, p.18; Everett Millais to Charles Collins, autumn 1855, *Millais*, p.132; Effic Millais, diary 1856, private collection, p.19.

159. *The Life and Letters of Sir John Everett Millais*, vol. i, p.291.

160. *Millais and the Ruskins*, p.153; F.G. Stephens, *The Crayon*, November 1856, p.324, quoted in Malcolm Warner, 'John Everett Millais's 'Autumn Leaves', in Leslie Parris (ed.), *Pre-Raphaelite Papers* (London: Tate Gallery 1984), p.128; Arthur Hughes to William Allingham, W.E. Fredeman (ed.), *The Correspondence of Dante Gabriel Rossetti* (Cambridge: D.S. Brewer 2002), vol. 2, p.278.

161. Everett Millais to Charles Collins, Autumn 1855, *Millais*, p.132; *The Life and Letters of Sir John Everett Millais*, vol. ii, pp.147, 443; George Gray snr. to Effie Millais, March 1861, Geoffroy Richard Everett Millais Collection, Tate loan C, parcel 7; *The Life and Letters of Sir John Everett Millais*, vol. i, p.327.

162. *The Life and Letters of Sir John Everett Millais*, vol. i, p.323; *Millais*, p.136.

163. Sophy Gray to Effie Millais, 6 June 1867 (misdated 1869); George Gray snr. to John Everett Millais, 16 March 1868; George Gray snr. to Effie Millais, 29 July 1867, Geoffroy Richard Everett Millais Collection, Tate loan C, parcels 8H, 7.

164. George Gray snr. to Effie Millais, 10 April 1868, Geoffroy Richard Everett Millais Collection, Tate loan C, parcel 7.

165. Dr Harrington Tuke, 'On Forced Alimentation', *The Journal of Mental Science* (London), January 1858, pp.204–22.

166. Sandra M. Gilbert and Susan Gubar, *The Madwoman in the Attic: The Woman Writer and the Nineteenth-Century Literary Imagination* (New Haven and London: Yale University Press 1979, reprinted 1980), pp.390–1; H.R. Haweis, *Music and Morals* (London: Daldy, Ibster and Co. 1871), p.110.

167. George Gray snr. to Effie Millais, 6 May 1868, Geoffroy Richard Everett Millais Collection, Tate loan C, parcel 7; P.W.J. Bartrip, 'Andrew Wynter (1819–1876), physician and author', *Oxford Dictionary of National Biography*.

168. Oliver Sacks, *Musicophilia: Tales of Music and the Brain* (London: Picador 2007), pp.5, 306.

169. Sophy Gray to Effie Millais, n.d. 1869; Alice Gray to George Gray snr., 1868 (undated); George Gray snr. to Effie Millais, 6 December 1868, Geoffroy Richard Everett Millais Collection, Tate loan C, parcels 8H, 8E, 7; John Ella to Effie Millais, 30 April 1868, Geoffroy Richard Everett Millais Collection, Tate loan B, parcel 1; Everett Millais to William Holman Hunt, 2 March 1869, Huntington Library, Holman Hunt Collection, 412; George Gray snr. to Effie Millais, 24 March 1868, Geoffroy Richard Everett Millais Collection, Tate loan C, parcel 7.

170. George Gray snr. to Effie Millais, 15 January 1867 and 28 November 1869, Geoffroy Richard Everett Millais Collection, Tate loan C, parcel 7.

171. The Mendel collection included *Jephthah* (1867) and *Chill October* (1870) by John Everett Millais. George Gray snr. to Effie Millais, 17 April 1867, 22 January 1868, 17 February and 23 March 1871 and 24 May 1872, Geoffroy Richard Everett Millais Collection, Tate loan C, parcel 7.

172. Sir James Caird (1837–1916) is remembered in Dundee as an entrepreneur and philanthropist. He donated £100,000 towards the City Hall and paid for a 270-acre public park. He was also a major contributor to a women's hospital, the pioneering Caird Cancer Hospital, and to Shackleton's Imperial Transantarctic Expedition of 1914–16. The Expedition's lifeboat and a section of Antarctic coastline were named after Caird. George Gray snr. to Effie Millais, 24 May 1872, Geoffroy Richard Everett Millais Collection, Tate loan C, parcel 7.

173. George Gray snr. to Effie Millais, 24 and 28 March and 23 April 1873, Geoffroy Richard Everett Millais Collection, Tate loan C, parcel 7.

174. George Gray snr. to Effie Millais, 29 May and 6 and 18 June 1874, Geoffroy Richard Everett Millais Collection, Tate loan C, parcel 7.

175. Effie Millais to Sophy Caird (née Gray), 26 December 1875, Geoffroy Richard Everett Millais Collection, Tate loan C, parcel 8C.

176. Sophy Caird (née Gray) to Effie Millais, 28 October 1881, Geoffroy Richard Everett Millais Collection, Tate loan C, parcel 8H. John Everett Millais, *Sophie Caird*, (1880, oil on canvas, Geoffroy Richard Everett Millais Collection).

177. Sophia Gray to Effie Millais, March 1882; Alice Stibbard to Effie Millais, n.d. 1882, Geoffroy Richard Everett Millais Collection, Tate loan C, parcels 6, 8E; Louise Jopling, *Twenty Years of My Life 1867–1887* (London and New York: John Lane and Dodd, Mead 1925), p.67.

178. John Everett Millais, *Time, the Reaper*, (c.1895, oil on canvas, location unknown); George Gray to Effie Millais, 31 May and 10 June 1894, Geoffroy Richard Everett Millais Collection, Tate loan C, parcel 9A; Effie Millais to Clare

Stuart Wortley, 21 June 1894, Morgan Library, MA1338 (ZX03); Evie Millais to Effie Millais, 31 May 1894, Morgan Library, MA1338 (ZX02).

179. *The Life and Letters of Sir John Everett Millais*, vol. ii, p.196; William Holman Hunt, *Pre-Raphaelitism and the Pre-Raphaelite Brotherhood* (London: Macmillan 1905), vol. ii, pp.392–3; John Everett Millais to Briton Rivière, 18 January 1894, *The Life and Letters of Sir John Everett Millais*, vol. ii, p.300; John Everett Millais, *St Stephen*, (1894–5, oil on canvas, Tate); John Everett Millais, ('*Speak! Speak!*', 1894–5, Tate); John Everett Millais to George du Maurier, 17 October 1892, *The Life and Letters of Sir John Everett Millais*, vol. ii, p.274.

180. *Millais*, p.168; Frederic Leighton to John Everett Millais, n.d. [spring 1874], Geoffroy Richard Everett Millais Collection, Tate loan B; Mrs Russell Barrington, *The Life, Letters and Work of Frederic Leighton* (London: Allen 1906), vol. ii, pp.216–17.

181. Frederic Leighton to John Everett Millais, 27 March 1895, *The Life and Letters of Sir John Everett Millais*, vol. ii, pp.315, 408; John Collier to John Everett Millais, 21 February 1896, *The Life and Letters of Sir John Everett Millais*, vol. ii, p.329; Beatrix Potter, journal, 25 February 1896, *The Journal of Beatrix Potter*, p.409; William Holman Hunt to John Everett Millais, 24 February 1896, *The Life and Letters of Sir John Everett Millais*, vol. ii, p.330.

182. *The Life and Letters of Sir John Everett Millais*, vol. ii, pp.381, 426, 429.

183. *The Life and Letters of Sir John Everett Millais*, vol. ii, pp.258, 335; 'The late Sir John Millais: the pathetic story of his illness', *Glasgow Evening News*, 15 August 1896; *Millais and the Ruskins*, p.196.

184. *Millais and the Ruskins*, p.196; *The Life and Letters of Sir John Everett Millais*, vol. ii, pp.335–6; John Everett Millais to John Guille Millais, 1 September 1895, *The Life and Letters of Sir John Everett Millais*, vol. ii, p.321.

185. *The Life and Letters of Sir John Everett Millais*, vol. ii, p.381; Beatrix Potter, journal, 25 February 1896, *The Journal of Beatrix Potter*, p.408.

186. Effie Millais, death certificate, registered 30 December 1897; 'How the World Wags', *The Penny Illustrated Papers and Illustrated Times* (London), Saturday, 1 January 1898, p.6; John Everett Millais, *John Ruskin*, exhibited 1898, cat. no. 55.

Bibliography

Manuscripts

Geoffroy Richard Everett Millais Collection: on temporary loan to the Tate Archive:

A. Transcriptions of the Bowerswell Papers (in the Morgan Library and Museum, New York) made by Clare Stuart Wortley, Effie's granddaughter.

B. Letters to John Everett Millais found among the letters to his wife, 1868–94: transcriptions and originals. Plus albums of photographs and press-cuttings. On loan since 2005.

C. Unlisted letters to Effie Millais from friends and family, 1846–96. On loan since 2009.

The Morgan Library and Museum, New York:

A. The Bowerswell Papers, acquired from Millais family in 1950.

B. The Millais Papers, acquired from Millais family in 1953.

Private collection: Effie Millais, diary, 1856, describing the first year of marriage to John Everett Millais.

Ruskin Library, Lancaster University: letters and papers relating to John Ruskin's marriage to Effie Gray, including Mary Lutyens's research material.

Publications

Barlow, Paul, *Time Present and Time Past: The Art of John Everett Millais* (Aldershot: Ashgate 2005)

Barrington, Mrs Russell, *The Life, Letters and Work of Frederic Leighton* (London: Allen 1906)

Bell, Quentin, *Ruskin* (London: The Hogarth Press 1963, new edition 1978)

Bills, Mark, and Knight, Vivien (eds.), *William Powell Frith: Painting the Victorian Age* (New Haven and London: Yale University Press 2006)

Chapple, John, and Pollard, A. (eds.), *The Letters of Mrs Gaskell* (Manchester: Manchester University Press 1966)

Chapple, John, *Elizabeth Gaskell: The Early Years* (Manchester: Manchester University Press 1997)

Cook, E.T., and Wedderburn, Alexander (eds.), *The Works of John Ruskin: Library Edition* (London and New York: George Allen 1903–12)

Cooper, Suzanne Fagence, *Pre-Raphaelite Art in the Victoria and Albert Museum* (London: V&A Publications 2003)

Dickens, Charles, 'Old Lamps for New Ones', in *Household Words* (London 1850)

Evans, Joan, and Whitehouse, John Howard (eds.), *The Diaries of John Ruskin 1848–1873* (Oxford: Clarendon Press 1958)

Flanders, Judith, *The Victorian House: Domestic Life from Childbirth to Death* (London: HarperCollins 2003)

Fogle, French, 'Unpublished Letters of Ruskin and Millais, 1854–1855', *The Huntington Library Quarterly* (Berkeley: University of California Press, vol. 20, no.1, Nov 1956)

Fredeman, W.E. (ed.), *The Correspondence of Dante Gabriel Rossetti* (Cambridge: D.S. Brewer 2002)

Gilbert, Sandra M., and Gubar, Susan, *The Madwoman in the Attic: The Woman Writer and the Nineteenth-Century Literary Imagination* (New Haven and London: Yale University Press 1979, reprinted 1980)

Haweis, H.R., *Music and Morals* (London: Daldy, Ibster and Co. 1871)

Hibbert, Christopher (ed.), *Queen Victoria in her Letters and Journals* (London: John Murray 1984; new edition Stroud: Sutton Publishing 2000)

Hicks, Phyllis D., *A Quest of Ladies: The Story of a Warwickshire School* (privately printed 1949)

Hilton, Tim, *John Ruskin: The Early Years* (New Haven and London: Yale University Press 1985; paperback edition 2000)

Hilton, Tim, *John Ruskin: The Later Years* (New Haven and London: Yale University Press 2000)

Hudson, Derek (ed.), *Munby: Man of Two Worlds* (London: Abacus 1974)

Hunt, William Holman, *Pre-Raphaelitism and the Pre-Raphaelite Brotherhood* (London: Macmillan 1905)

James, Admiral Sir William, *The Order of Release* (London: John Murray 1947)

Jopling, Louise, *Twenty Years of My Life 1867–1887* (London and New York: John Lane and Dodd, Mead 1925)

Kent, Susan Kingsley, *Gender and Power in Britain, 1640–1990* (London and New York: Routledge 1999)

Lamont, Peter, *The First Psychic: The Peculiar Mystery of a Notorious Victorian Wizard* (London: Little, Brown 2005)

Lutyens, Mary (ed.), *Effie in Venice: Unpublished Letters of Mrs John Ruskin Written from Venice Between 1849 and 1852* (London: John Murray 1965; new edition London: Pallas Editions 1999)

Lutyens, Mary (ed.), *Millais and the Ruskins* (London: John Murray 1967)

Lutyens, Mary (ed.), *The Ruskins and the Grays* (London: John Murray 1972)

Lutyens, Mary, and Warner, Malcolm (eds.), *Rainy Days at Brig o' Turk: The Highland Sketchbooks of John Everett Millais* (Westerham, Kent: Dalrymple Press 1983)

Mackail, J.W., *The Life of William Morris* (London, New York and Bombay: Longmans, Green and Co. 1901)

Mackenzie, John (ed.), *The Victorian Vision: Inventing New Britain* (London: V&A Publications 2001)

Mancoff, Debra N. (ed.), *John Everett Millais: Beyond the Pre-Raphaelite Brotherhood* (New Haven: Yale University Press 2001)

Matthew, H.C.G., and Harrison, Brian (eds.), *Oxford Dictionary of National Biography* (Oxford: Oxford University Press 2004)

Michie, Helena, *Victorian Honeymoons: Journeys to the Conjugal* (Cambridge and New York: Cambridge University Press 2006)

Millais, John Guille, *The Life and Letters of Sir John Everett Millais, President of the Royal Academy* (London: Methuen & Co. 1899)

Musgrave, Michael, *The Musical Life of the Crystal Palace* (Cambridge: Cambridge University Press 1995)

National Portrait Gallery, *Millais: Portraits*, exhibition catalogue, ed. Peter Funnell (London: National Portrait Gallery 1999)

Norton, The Hon. Mrs, *A Letter to the Queen on Lord Chancellor Cranworth's Marriage and Divorce Bill* (3rd edition, London: Longman, Brown, Green and Longmans 1855)

Orr, Clarissa Campbell (ed.), *Women in the Victorian Art World* (Manchester and New York: Manchester University Press 1995)

Potter, Beatrix, *The Journal of Beatrix Potter from 1881 to 1897, transcribed from her code writing by Leslie Linder* (London and New York: Frederick Warne 1966)

Rogers, Samuel, Porson, Richard, and Maltby, William, *Recollections of the Table Talk of Samuel Rogers* (New York: D. Appleton & Co. 1856)

Rose, Phyllis, *Parallel Lives: Five Victorian Marriages* (New York: Alfred A. Knopf 1983)

Rossetti, William Michael, and Swinburne, Algernon, *Notes on the Royal Academy Exhibition 1868*, Parts I and II (London: John Camden Hotten 1868)

Sacks, Oliver, *Musicophilia: Tales of Music and the Brain* (London: Picador 2007)

Strong, Roy, 'Down with Effie', *The Spectator*, 20 January 1967

Sweet, Matthew, *Inventing the Victorians* (London: Faber and Faber 2001)

Tate Britain, *The Pre-Raphaelites*, exhibition catalogue, ed. Leslie Parris (London: Tate Publishing 1984)

Tate Britain, *Ruskin, Turner and the Pre-Raphaelites*, exhibition catalogue, ed. Robert Hewison, Ian Warrell, and Stephen Wildman (London: Tate Publishing 2000)

Tate Britain, *Millais*, exhibition catalogue, ed. Jason Rosenfeld and Alison Smith (London: Tate Publishing 2007)

Tuke, Dr Harrington, 'On Forced Alimentation', *The Journal of Mental Science* (London: January 1858)

Uglow, Jenny, *Elizabeth Gaskell: A Habit of Stories* (London and Boston: Faber and Faber 1993)

Walkowitz, Judith R., *City of Dreadful Delight: Narratives of Sexual Danger in Late-Victorian London* (London: Virago Press 1992, reprinted 1998)

Whistler, James, 'The Ten o'Clock Lecture', in *The Gentle Art of Making Enemies* (2nd edition 1892; new edition New York: Dover Publications 1967)

Whitehouse, J. Howard, *Vindication of Ruskin* (London: George Allen and Unwin 1950)

Wilson, A. N., *The Victorians* (London: Hutchinson 2002)

Warner, Malcolm, 'John Everett Millais's "Autumn Leaves"', in Parris, Leslie (ed.), *Pre-Raphaelite Papers* (London: Tate Gallery 1984)

Woods, Robert, and Shelton, Nicola, *An Atlas of Victorian Mortality* (Liverpool: Liverpool University Press 1997)

Index